Lecture Notes in Computer Science 5531

Commenced Publication in 1973
Founding and Former Series Editors:
Gerhard Goos, Juris Hartmanis, and Jan van Leeuwen

Editorial Board

Andreas Butz Brian Fisher
Marc Christie Antonio Krüger
Patrick Olivier Roberto Therón (Eds.)

Smart Graphics

10th International Symposium, SG 2009
Salamanca, Spain, May 28-30, 2009
Proceedings

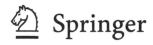

Springer

Volume Editors

Andreas Butz
Ludwig-Maximilians-Universität München, 80333 München, Germany
E-mail: butz@ifi.lmu.de

Brian Fisher
Simon Fraser University at Surrey, Surrey BC V3T 5X3, Canada
E-mail: brian.fisher@acm.org

Marc Christie
Equipe BUNRAKU IRISA-INRIA Rennes, 35042 Rennes Cedex, France
E-mail: marc.christie@irisa.fr

Antonio Krüger
Westfälische Wilhelms-Universität 48149 Münster, Germany
E-mail: kruegera@wwu.de

Patrick Olivier
University of Newcastle upon Tyne, School of Computing Science
NE1 7RU, United Kingdom
E-mail: p.l.olivier@ncl.ac.uk

Roberto Therón
Universidad de Salamanca, Departamento de Informática y Automática
37008 Salamanca, Spain
E-mail: theron@usal.es

Library of Congress Control Number: Applied for

CR Subject Classification (1998): H.5, I.3.4, I.3.7, H.2.4, I.3

LNCS Sublibrary: SL 6 – Image Processing, Computer Vision, Pattern Recognition,
and Graphics

ISSN 0302-9743
ISBN-10 3-642-02114-X Springer Berlin Heidelberg New York
ISBN-13 978-3-642-02114-5 Springer Berlin Heidelberg New York

springer.com

© Springer-Verlag Berlin Heidelberg 2009
Printed in Germany

Typesetting: Camera-ready by author, data conversion by Scientific Publishing Services, Chennai, India
Printed on acid-free paper SPIN: 12688555 06/3180 5 4 3 2 1 0

Preface

Smart graphics are pervasive in our lives nowadays. The ways artists and designers produce images that effectively support human cognition and communication are continuously changing and evolving as they incorporate novel methods provided by the advances in science and technology. As a counterpart, the radically new visions in most art forms have stimulated scientists to breath-taking levels of achievement.

This symbiotic relationship between art and science (and technology) is one of the foundations of the technological culture of contemporary society and is especially evident in the creation of smart graphics. Such a process rests on a deep understanding of the fundamentals of perception and cognition as they relate to interaction and communication technologies, together with artificial intelligence and computer graphics techniques, to automate reasoning and enhance cognition.

The International Symposium on Smart Graphics 2009 was held from May 28–30 in Salamanca, Spain. With this edition we celebrated our tenth anniversary: a successful series of inspiring and exciting meetings originating in 2000 as an American Association for Artificial Intelligence Spring Symposium.

This year we proposed a specific emphasis on visual analytics as well as all kinds of transversal research that harnesses the power of humans and technological artifacts in order to convey, understand and deal with complex scientific and social processes. We were lucky to have Daniel Keim and Jörn Kohlhammer, two internationally renowned experts on this area of research, as invited speakers.

Smart Graphics, beyond a conventional symposium, was intertwined with the 5th International Arts Festival of Castilla y León, and we brought together artists, technologists and scholars from the fields of computer graphics, artificial intelligence, cognitive science, graphic design and fine art. Complementary to the usual sessions, during the symposium system demonstrations, exhibitions, performances, panels and discussions were opened to the public as part of the festival program. Artists hired by the festival and from entertainment studios were invited to foster dialog, and the Organizing Committee would like to warmly thank them here.

The quality of the submitted papers was as high as in previous years. The Program Committee decided to accept 15 full papers, 8 short papers, and 2 system demonstrations. This year we also had an arts track; four artworks were selected for live performance and one of them (dream.Medusa) was awarded the best smart graphics artwork. The acceptance rate for full papers was 30%.

We would like to thank all authors and speakers for making this year's event such a success, the reviewers for their careful work, and the Program Committee for selecting and ordering contributions for the final program. We are grateful to the Vice-rectorate for Technological Innovation of the University of Salamanca, to the local organizers of the event and, especially, to Guy Martini, director of

the International Arts Festival of Castilla y León, for giving us the opportunity to move part of the Smart Graphics symposium out of academia and to become a cultural event.

For these reasons Smart Graphics 2009 was not only a big scientific success but also a completely new experience in art and sciences which will inspire future Smart Graphics enterprises.

March 2009

Andreas Butz
Marc Christie
Brian Fisher
Antonio Krüger
Patrick Olivier
Roberto Therón

Organization

Organizing Committee

Andreas Butz	University of Munich, Germany
Marc Christie	INRIA Rennes, France
Brian Fisher	University of British Columbia, Canada
Antonio Krüger	University of Münster, Germany
Patrick Olivier	Newcastle University, UK
Roberto Therón	University of Salamanca, Spain

Program Committee

Elisabeth André	University of Augsburg
William Bares	Millsaps College
Marc Cavazza	Teeside University
Luca Chittaro	University of Udine
Sarah Diamond	Ontario College of Art and Design
Steven Feiner	Columbia University
David S. Ebert	Purdue University
Knut Hartmann	Flensburg University of Applied Sciences
Hiroshi Hosobe	National Institute of Informatics, Tokyo
Christian Jacquemin	LIMSI/CNRS
Tsvi Kuflik	University of Haifa
Rainer Malaka	University of Bremen
Shigeru Owada	Sony CSL
W. Bradford Paley	Digital Image Design
Bernhard Preim	University of Magdeburg
Thomas Rist	University of Applied Sciences, Augsburg
Shigeo Takahashi	University of Tokyo
Mateu Sbert	University of Girona
Lucia Terrenghi	University of Munich
Massimo Zancanaro	ITC-irst Trento

Supporting Institutions

The Smart Graphics Symposium 2009 was held in cooperation with Eurographics, AAAI, ACM Siggraph, ACM Siggart and ACM Sigchi. It was supported by the Vice-rectorate for Technological Innovation, University of Salamanca, 5th International Arts Festival of Castilla y León and Obra social de Caja Duero.

Table of Contents

Part-IV: Computer Graphics and Artificial Intelligence

Part-V: Virtual and Mixed Reality

Part-VI: Short Presentations

Part-VII: Art Exhibition and Demos

Part-I
Visual Analytics and Infovis

Visual Evaluation of Clustered Molecules in the Process of New Drugs Design

Carlos Armando García[1], Roberto Therón[1], Rafael Peláez[2],
José Luis López-Pérez[2], and Gustavo Santos-Garcia[2]

[1]Departamento de Informática y Automática, Facultad de Ciencias
[2]Departamento de Química Farmacéutica, Facultad de Farmacia
Universidad de Salamanca, Spain
CarlosGarcia@usal.es

Abstract. Drug design is very complex and expensive. Finding new active chemical structures is a very important goal. Both experimental and virtual (in silico) screenings can be used to explore chemical space [11][12]. With virtual screening it is possible to reduce the amount of compounds for experimental evaluations. Moreover, when the 3D structure of the target is known, candidate molecules can be put to fit in the target hole in different positions and later cluster these positions in order to find the best to fit. Therefore, we propose a visual tool that couples with Jmol[21] viewer, provides together with a means of visually exploring clustered molecules, an overview of the majority of the data, supporting thus the decision making in the process of new drugs design.

Keywords: visual analysis, information visualization, clustering, drug design, virtual screening, tubulin.

1 Introduction

Visualization is a centuries-old field. Visual analytics is relatively new. What distinguishes visual analytics from ordinary visualization is the active role played by the computer in the presentation of information to the viewer [1]. Furthermore, visual analytics has been applied in the Pharmaceutical Industry [2], and can be applied in the drug design. Keeping this in mind, our approach was such as to develop a tool to synthesize and derive insight from massive data, therein detecting the best results in the process of drug design, utilizing appropriate information visualization techniques [3][4].

1.1 Drug Design Process

The process in the design is very complex and demands cooperative interdisciplinary efforts [5]. Regardless of the great and steady methodological advances achieved throughout the years and the huge efforts invested in this enterprise, the results are frequently disappointing. The recent achievement of the human genome project has not only unearthed a number of new possible drug targets

A. Butz et al. (Eds.): SG 2009, LNCS 5531, pp. 3–14, 2009.

but also highlighted the need for better tools and techniques for the discovery and improvement of new drug candidates [6][7]. Today, there are experimental and computational approaches accessible in the different stages of the drug design and development processes [8][9][10].

In the early stages of drug discovery, finding new active chemical structures is a very important goal. Both experimental and virtual (in silico) screenings can be used to explore chemical space, and often both strategies are combined [11][12]. Virtual screening (VS) is an in silico high-throughput screening (HTS) procedure which attempts to rank candidate molecules in descending order of likelihood of biological activity, hence reducing the number of compounds for which very costly experimental evaluations are needed [13].

Docking is one conceivable choice when the 3D structure of the target is known. It consists of the positioning of the compounds in the target site (posing) and a ranking of the resulting complexes (scoring) [14]. The strategy is functional even when the binding site is unknown or ill-defined, and there have been many successful cases realized. Nevertheless, docking simulations model multiple complex phenomena with a minimal time investment, thus resulting in an inconsistent performance. Attempts to alleviate the inherent limitations of the method, such as the use of different scoring functions to compensate for their simplicity, the incorporation of ligand flexibility, or the simulation of protein flexibility, have met with different degrees of success [15][16]. During the final stages, the best ranked compounds are clustered and classified and have to be visually inspected by experienced chemists in order to confirm their goodness. This visual filtering is time consuming, expensive, and difficult to reproduce, as chemists with different backgrounds make different determinations. New chemoinformatic tools which can help the chemist in the selection of candidates are thus welcome. However, they are difficult to develop, as they have to somehow reproduce chemical insight.

The following sections will discuss a method to cluster different molecule structures in order to compare them for the process of new drug design. In section 2, we explain a manual clustering in which is based our method. In Section 3, we talk about the clustering results of a cluster algorithm based on manual clustering. Section 3 also presents our contribution to compare different molecule structures. Sections 4 and 5 show the results obtained and the conclusions of our current work.

2 Manual Clustering

[17] proposes a method to cluster molecule structures. This was taken as a model of the colchicine binding site of tubulin, an important anticancer target. The dataset of hypothetical ligands docked consisted of virtual compounds from three different sources: a subset of 700.000 lead-like [18] molecules from the ZINC free electronic database [19], a subset of 990 nonreactive organic molecules from the ACD molecules employed by A. N. Jain in Surflex docking validation [20], and a collection of more than 300 compounds synthesized in the laboratory and tested against tubulin.

The clustering problem was divided into two parts: an initial clustering of the different poses (conformations, translations and rotations) of each ligand and a subsequent clustering of the selected poses of each ligand. The clustering results were classified by comparing them with a chemical classification produced by a chemist who compared dataset and the compounds from the ACD, with the reference ligands: podophyllotoxin and DAMA-colchicine.

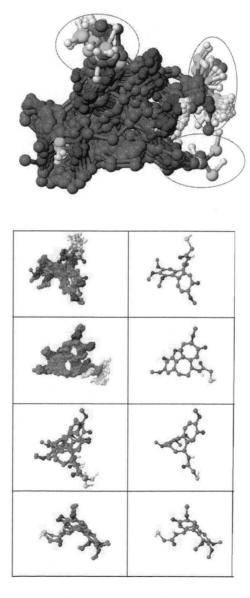

Fig. 1. Dataset and the possible clusters in it. All the clusters are made by hand.

A manual clustering of the top ranked poses yielded [21] eight distinct clusters of different sizes. According to chemical intuition, the docking programs generated a large number of top scoring poses. These poses grouped together in three different clusters, one of which was particularly enriched in compounds of the in house dataset that presented activity in tubulin polymerization essays. These results were in agreement with known structure activity relationships for this family of compounds, which pinpoint moiety as an essential structural requirement. The remaining two clusters place the second aromatic ring in quite different dispositions, suggesting that it is not possible to simultaneously occupy the two pharmacophoric points occupied by rings B and E of podophyllotoxin. Accordingly, and based on chemical intuition, these two clusters should correspond to less potent ligands. The remaining clusters place the ligands in dispositions that bear no resemblance to those of the model ligands, and therefore their interpretation is not as straightforward.

Figure 1 on the top of the manually selected clusters, the complete dataset; the possible clusters in the dataset are marked by blue circles. Below, the four clusters that the chemist manually selected are shown, along with the representative molecule from each cluster. In order to do this it was necessary that survey the entire dataset. From there we have to compare the molecules visually, one by one, deciding which molecules were similar and separating them to form a cluster. Then would have search in the main file for the representative molecule from the cluster, based on the value on the file. Understandably, this process is time-consuming for just one molecule. Therein, it becomes out of the question when dealing with hundreds of molecules.

3 Clustering

Upon obtaining unpleasant results, it was decided to follow an interactive methodology which allows the chemist to cast knowledge onto the clustering results. Integrating the two clustering steps (clustering the poses for each ligand and clustering the ligands) as a single step.

The first step helps the chemist rationalize the docking results for each ligand and is in itself an important act in the process of clustering by hand, as it is a means of data reduction. Comparing different poses of the same ligand is often used in molecular modeling studies and is usually based on rmsd (root mean square deviation) calculations of the atomic coordinates in Cartesian space. In addition to conformational differences, rotation and translation have to be considered in docking experiments, as opposed to other normal molecular modeling applications, such as conformational searching, where the conformations are superimposed by minimizing the rmsd, thus eliminating these contributions to the differences. Once again, it is very convenient to analyze a stepwise protocol in which a conformational comparison is first performed, prior to a comparison of the rotations and translations of the poses.

Fig. 2. Results of the cluster algorithm. Compared with figure 1 the results are actually the same.

As previously mentioned, comparison of chemical entities with different numbers and types of atoms is a challenging task, and often chemists with different backgrounds make substantially different choices. A general procedure which automatically selects the important features of a drug - ligand complex to be considered in the pairwise comparison of ligands is thus difficult to implement. In order to carry the second step of clustering, it was therefore decided to proceed with a clustering algorithm which could be later modified by the chemist.

In order to cluster the molecules decisions were made to select which regions of binding site are more important to the recognition process. This allows reduction of the data size without a loss of three dimensional resolutions. Therefore it was decided to start with the knowledge provided by the docking programs and select the highest rated (maxima) of the interaction energies. In order to do so, a docking program which operates based on a grid approximation was selected: AutoDock [22].

From the map files generated by AutoDock, zones of maximal and minimal contribution to the binding energy can be calculated. The occupation patterns of these privileged zones by the different poses of each ligand provided the initial guesses for the clustering.

As explained in the previous section, making clusters manually is a time consuming task. However, with a cluster algorithm time consumption is considerably reduced and the results are very similar, as evidenced in figure 1 and figure 2.

3.1 Our Approach

The process of drug design could be compared to painting; a scheme of the image is drawn several times until a final image is decided upon , then the appropriate colors are selected, and lastly it is put in a frame. The design of new drugs for a particular disease follows a similar pipeline: a large number of tests in the

laboratory have to be performed before the drug can be tested on animals, which is expensive and consumes a considerable amount of time. That is why a cluster algorithm is used to cluster the dataset and with the results obtained now we would be able to compare different structures from different files and see the results in visual software for 3D molecule structures. The real challenging task is when we have different types of structures; i.e., with different number of atoms per molecule or atoms in the molecule (for example oxygen instead of nitrogen) or the positions of the molecule in the space. An example of three very different groups of molecules that must be inter-compared is shown in figure 3.

3.2 Steps towards Visual Analysis

It is obvious that the structures shown in figure 3 are very different from one other, and if a clustering algorithm were applied, it would yield unsatisfactory results for all the problems previously mentioned. Therefore, it is necessary to standardize all the structures in order to compare them.

Not all of the structures from the dataset are necessary, as there are molecules present as copies that occupy different positions in the space, allowing clustering the dataset and obtaining the representative structure from each cluster. It proceeds similarly with all the files containing the dataset structures, in order to reduce the amount of data to be analyzed by the chemist.

Therefore, the first step is to cluster each dataset file separately and obtain the most representative molecule from each cluster. We apply a clustering algorithm that will attempt to classify the structures from the dataset. In this particular classification we are clustering by the type of atom in the molecule and the position in the space (x, y, z), producing fifteen clusters for each dataset file. Next it is necessary to read the Free Energy of Binding from the dataset file and save that structure (the cluster's representative) for a later comparison with a different molecule.

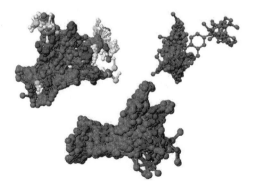

Fig. 3. Three datasets with different structures of molecules. All these molecules have to be compared in order to produce new drugs.

Once this step is completed for each dataset file, comes the challenging part of comparing and clustering all representative molecule structures. Thus, the second step is to make all the structures homogeneous, i.e., all molecules must have the same number of atoms to be clustered by the algorithm. The question is which atoms should be considered and which should not. The question is solved using chemist heuristics: the best atoms to be considered are the ones with the most negative values in the map files. Moreover, all the binding energy from the datasets files are calculated using those map files. In this manner it is possible to customize the number of atoms to the best needs of the chemist, thereby producing the best results. Once the number and type of atoms have been selected, a new uniform dataset is ready to be clustered for a further analysis, and a new pdb file is written (The Protein Data Bank is an archive of experimentally determined three-dimensional structures of biological macromolecules that serves a global community of researchers, educators, and students [23]).

3.3 Visual Analysis

The final step is to cluster this new dataset (pdb file). With the selected atoms from the dataset a new structure is built and then treated as a single vector of data, then compared with the rest of the molecules. Therefore, the position in space (x, y, z) and the calculated values from the map files of such structures are used as input for the clustering algorithm. The clusters are examined with Jmol, which is an open source molecule viewer [21]. Jmol has been modified to visually analize the results from the cluster algorithm, as shown in figure 4. Thus, the proposed tool includes:

a) Clustering Algorithm: As a part of the visualization window the clustering process is launched.
b) Cluster Visualization: Shown in figure 4. It is on the right side of the visualization window, consists of rectangles for each cluster under analysis (marked within a circle and labeled as Clustering). Each cluster is colored differently.
c) Models in cluster: On the left side of the visualization window (marked with an arrow and labeled as "Models in Cluster"; shows the models per cluster). With a minimum of one structure per cluster.
d) Comparison of clusters: By selecting the desired clusters (rectangles on the right), one can visually compare the clusters (see figure 6) that are colored differently. In conjunction with the filter feature it is possible to explore with more detail each cluster.
e) Cluster Filters: Through this feature the models of the cluster are brushed, changing the color of the models to cyan and making them translucent. This is used with the comparison cluster function.
f) Names of the files used for the clustering: In the upper portion of the visualization window.

JMOL VIEWER

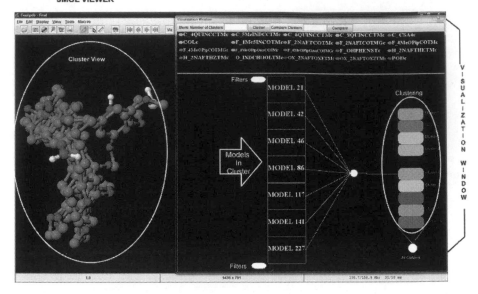

Fig. 4. General view of the visualization window inside of Jmol. The user is inspecting models of cluster 6. While in Jmol all the molecules structure (models) are shown. In the upper portion of the visualization window the names of the files containing the models are also available.

4 Results

For the present research we used twenty different dataset files, each with different numbers and types of atoms, in order to compare the map files:

* TUB1HH.A.map,
* TUB1HH.C.map,
* TUB1HH.e.map,
* TUB1HH.H.map,
* TUB1HH.N.map,
* TUB1HH.O.ma,
* TUB1HH.S.map.

Each map file has the same center defined in Cartesian coordinates at: $x = -17.504$, $y = -21.268$, $z = -27.343$; the same number of elements: 60 x 60 x 60; and the same spacing in Armstrong: 0.375.

The first step was selecting the number of clusters for each dataset file (all files have the TUB1HH suffix), the cluster algorithm was the k-means, we chose the k-means algorithm. Based on the expertise of the chemist it was decided to make fifteen clusters per dataset, from there the most representative clusters were

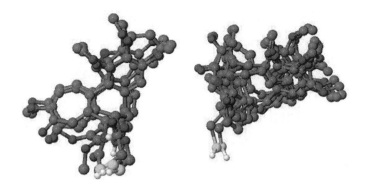

Fig. 5. A dataset of two molecules and the result with the k-means algorithm

selected, as mentioned previously. Some values of the Free Energy of Binding were: -5.67 kcal/mol from F-4MeOPipCOTMc, -8.87 kcal/mol H-2NAFTHETMc, -7.92 kcal/mol OX-2NAFTOXETMc, -10.65 kcal/mol PODc. Then we selected twenty atoms from these molecules in order to cluster and compare them, taking the five most negative from e.map, the five most negative randomly from the rest of the maps, and ten atoms from the rest of the molecules. With the new information the vector was made taking into consideration the position in space (x, y, z) and the values of the atoms in the e.map. The input to the k-means was: a) The number of columns per the number of atoms, in this case (20 * 4); b) The number of clusters to made was 10; c) The maximum number of rows in the dataset was 300; d) And the number of stages to run was 2000.

Were compared two molecules, first the C-4QUINCCTMc and COLc. In figure 5 the dataset from these two molecules is seen. Due to space allowances, only two of the ten clusters are shown. The yellow spheres are well clustered in figure 5 and the same occurs with the blue spheres. Between them we can see that their structures are similar, a trend which continues with three and more molecules.

Figure 6 displays a comparison of three clusters, each one in the colors of cyan, dark green and dark khaki. With the comparison cluster tool it is possible to determine if the algorithm has clustered well. Also making it a validation tool. Moreover, it can readjust the clustered items according to the knowledge of the chemist. Additionally, the dark khaki cluster has coinciding positions of atoms in space it is evidenced with the dark green cluster. In order to go further in depth, a filter can be applied in the cluster comparison, as seen in figure 7. By brushing the items of the cluster with the comparison method, one of them becomes translucent; allowing the visualization of which atoms correspond in the same position of other clusters. Moreover it is possible to see through the translucent color structures the ones that are solid, in order to contrast the shapes of the structures.

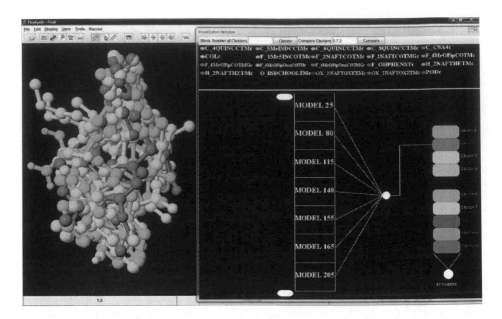

Fig. 6. Visual comparison of three clusters, cluster 5, 7 and 2

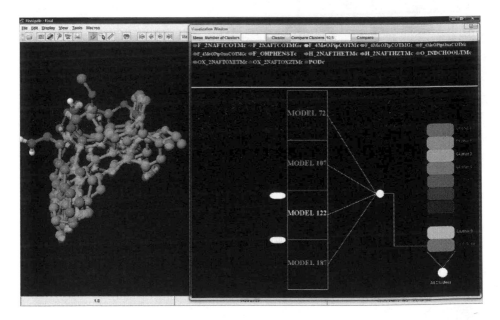

Fig. 7. Filtering two clusters. The brushed element is turned into a translucent color, while the rest of them kept the color original (green the filtered and cpk color the compared one).

5 Conclusions

The development in new drug design is more suitable and efficient with the employment of a clustering algorithm because it allows the use of different molecules in the process. Moreover, the time consumed in the comparison of different molecules is reduced to a few minutes instead of hours or days. Besides, the results are very satisfactory for the chemists because the methodology practically reproduces the expertise of the chemists when they attempt to cluster manually. This tool will be extremely useful in the selection of molecules as targets for chemical synthesis and essays.

5.1 Future Work

As to future work, there is the possibility of introducing a treemap in the element of cluster visualization. This would allow for the possibility of knowing how many structures of the files (dlg files) are involved per cluster result (i.e., how many Colchicine structures are in cluster one, or cluster two, if they are present, etc.).

Acknowledgement. This work was partially supported by the Ministerio de Educación y Ciencia (project GRACCIE (CONSOLIDER-INGENIO, CSD 2007-00067)) and by the Junta de Castilla y León (projects GR47, GR34 and SAO30A06).

References

1. Wilkinson, L., Anushka, A., Grossman, R.: High-Dimensional Visual Analytics: Interactive Exploration Guided by Pairwise Views of Point Distributions. IEEE Transactions on Visualization and Computer Graphics 12, 1363–1372 (2006)
2. Saffer, J.D., Burnett, V.L., Chen, G., van der Spek, P.: Visual Analytics in the Pharmaceutical Industry. IEEE Computer Graphics and Applications 24, 10–15 (2004)
3. Keim, D., Andrienko, G., Fekete, J.D., Kohlhammer Jörn, G., Guy, M.: Visual Analytics: Definition, Process, and Challenges. In: Kerren, A., Stasko, J.T., Fekete, J.-D., North, C. (eds.) Information Visualization. LNCS, vol. 4950, pp. 154–175. Springer, Heidelberg (2008)
4. Thomas, J.J., Cook, K.A.: A Visual Analytics Agenda. IEEE Comput. Graph. Appl. 26, 10–13 (2006)
5. Abraham, D.J.: Burgers Medicinal Chemistry and Drug Discovery, 6th edn. John Wiley & Sons/ Wiley-VCH Verlag GmbH & Co. (2003)
6. Lauss, M., Kriegner, A., Vierlinger, K., Noebammer, C.: Characterization of the drugged human genome. Pharmacogenomics 8, 1063–1073 (2007)
7. Paolini, G.V., Shapland, R.H.B., van Hoorn, W.P., Mason, J.S., Hopkins, A.L.: Global mapping of pharmacological space. Nat. Biotechnol. 24, 805–815 (2006)
8. Ojima, I.: Modern Molecular Approaches to Drug Design and Discovery. Acc. Chem. Res. 41, 2–3 (2008)
9. Baxendale, I.R., Hayward, J.J., Ley, S.V., Tranmer, G.K.: Pharmaceutical Strategy and Innovation: An Academics Perspective. Chem. Med. Chem. 2, 268–288 (2007)

10. Kubinyi, H.: Drug research: myths, hype and reality. Nat. Rev. Drug Disc. 2, 665–669 (2003)
11. Ling, X.F.B.: High throughput screening informatics. Comb. Chem. High Throughput Screen 11, 249–257 (2008)
12. Diller, D.: The synergy between combinatorial chemistry and high-throughput screening. Curr. Opin. Drug Discov. Devel 11, 346–355 (2008)
13. Soichet, B.K.: Virtual screening of chemical libraries. Nature 432, 862–865 (2004)
14. Leach, A.R., Shoichet, B.K., Peishoff, C.E.: Prediction of Protein-Ligand Interactions. Docking and Scoring: Successes and Gaps. J. Med. Chem. 49, 5851–5855 (2006)
15. Warren, G.L., Andrews, C.W., Capelli, A.-M., Clarke, B., LaLonde, J., Lambert, M.H., Lindvall, M., Nevins, N., Semus, S.F., Senger, S., Tedesco, G., Wall, I.D., Woolven, J.M., Peishoff, C.E., Head, M.: A Critical Assessment of Docking Programs and Scoring Functions. J. Med. Chem. 49, 5912–5931 (2006)
16. Sotriffer, C.A., Dramburg, I.: Situ Cross-Docking, To Simultaneously Address Multiple Targets. J. Med. Chem. 48, 3122–3123 (2005)
17. Peláez, R., Therón, R., García, C.A., López, J.L., Medarde, M.: Design of New Chemoinformatic Tools for the Analysis of Virtual Screening Studies: Application to Tubulin Inhibitors Advances in Soft Computing. In: 2nd International Workshop on Practical Applications of Computational Biology and Bioinformatics (IW-PACBB 2008), vol. 49(1), pp. 189–196 (2008)
18. Carr, R.A.E., Congreve, M., Murray, C.W., Rees, D.C.: Fragment-based lead discovery: leads by design. Drug Disc. Dev. 14, 987–992 (2005)
19. Irwin, J.J., Shoichet, B.K.: ZINC - A Free Database of Commercially Available Compounds for Virtual Screening. J. Chem. Inf. Model 45, 177–182 (2005)
20. Jain, A.N.: Surflex: Fully Automatic Flexible Molecular Docking Using a Molecular Similarity-Based Search Engine. J. Med. Chem. 46, 499–511 (2003)
21. Visualization of the superposed complexes was done with Jmol (2006), http://www.jmol.org and with MarvinBeans 4.1.2, ChemAxon, http://www.chemaxon.com
22. Morris, G.M., Goodsell, D.S., Halliday, R.S., Huey, R., Hart, W.E., Belew, R.K., Olson, A.J.: Automated docking using a Lamarckian genetic algorithm and an empirical binding free energy function. J. Comp. Chem. 19, 1639–1662 (1998)
23. Documentation describing the PDB file format, http://www.wwpdb.org/docs.html

Large Image Collections – Comprehension and Familiarization by Interactive Visual Analysis

Krešimir Matković[1], Denis Gračanin[2], Wolfgang Freiler[1], Jana Banova[3], and Helwig Hauser[4]

[1] VRVis Research Center in Vienna, Austria
{Matkovic,Freiler}@VRVis.at
[2] Virginia Tech
gracanin@vt.edu
[3] PRIP, Vienna University of Technology, Austria
banovaja@prip.tuwien.ac.at
[4] University of Bergen, Norway
helwig.hauser@uib.no

Abstract. Large size and complex multi-dimensional characteristics of image collections demand a multifaceted approach to exploration and analysis providing better comprehension and appreciation. We explore large and complex data-sets composed of images and parameters describing the images. We describe a novel approach providing new and exciting opportunities for the exploration and understanding of such data-sets. We utilize coordinated, multiple views for interactive visual analysis of all parameters. Besides iterative refinement and drill-down in the image parameters space, exploring such data-sets requires a different approach since visual content cannot be completely parameterized. We simultaneously brush the visual content and the image parameter values. The user provides a visual hint (using an image) for brushing in addition to providing a complete image parameters specification. We illustrate our approach on a data-set of more than 26,000 images from *Flickr*. The developed approach can be used in many application areas, including sociology, marketing, or everyday use.

Keywords: Interactive Visual Analysis, Coordinated Multiple Views, Large Image Collections.

1 Introduction

The popularity of digital photography and the exponential growth of Internet resulted in the emergence of a new phenomenon — very large Internet image collections. They offer new and interesting opportunities to share images with friends, relatives, or public. Image collections can be used in a number of ways.

Sociologists can investigate the available data about the users uploading images, the number of comments an image initiated, details about the people who commented, etc. Marketing professionals can analyze preferences and characteristics of a specific target group. For example, they could determine that men

A. Butz et al. (Eds.): SG 2009, LNCS 5531, pp. 15–26, 2009.

between 25 and 30 prefer blue, highly saturated images with flowers (this is just a fictitious example). After identifying a preference, they can fine-tune marketing campaigns, e.g., for personal marketing. Individual users can also profit from exploring such image collections. We are fascinated by "new and unknown worlds" captured in images and related information (e.g. Google Earth). We can establish social contacts with other users through such online sites. There is a lot of, still mostly unused, information in Internet image collections.

Due to sheer size and complexity of image collections it is impossible to understand them by only viewing images or by only investigating abstract image parameters. We use multiple, coordinated views to simultaneously explore images and related parameters and introduce innovative ways of parameter selection. The user can also use images in the selection process. This is not an image query system, or a tool for browsing of image collections. The main idea is in understanding hidden characteristics of images and collections. The user can intuitively and in an almost effortless way interact and alternate between images and their parameters to perform various types of exploration (e.g. multivariate parameter analysis). We propose a manifold integration of proven approaches (with a couple of new aspects) to make it possible (for the first time — to the best of our knowledge) to comprehend and familiarize large image collections.

The user can start with an overview of image parameters, focus only on a subgroup of users (e.g. female users), spot an interesting image and use it as a target. All similar images are selected and their parameters are highlighted. The user spots an outlier with respect to the averaged image hue (e.g. a green image) and discovers, for example, that images with similar color distributions are usually uploaded by male users. Using images and strict parameter specifications together as a filter offers unlimited possibilities to comprehend large image collections.

2 Related Work

Image collections grow rapidly — *Flickr* [4] exceeded 3 billions of images (Nov. 2008) with 5,000+ images uploaded every minute. There are other attempts to exploit large Internet image collections [12] but as far as we know we use a novel approach making it possible to comprehend and familiarize with such collections.

Roberts[11] provides an extensive report on the current state of the art of coordinated multiple views in exploratory visualization. Various techniques were developed to analyze series of numeric values. Hochheiser et al. [6] developed the *TimeSearcher* tool for visual analysis of time-dependent series of numerical values by displaying multiple graphs in the same display window. These graphs can be filtered by drawing *timeboxes*. Only graphs passing through all timeboxes are displayed. Konyha et al. [9] proposed the segmented curve view as another approach to analyze time series data. The series of values are represented by bars that are divided into multiple blocks. The color of each block becomes more saturated with the number of virtual graph lines passing through it.

Ahlberg and Shneiderman [1] describe the *Filmfinder* tool for exploring a large film database by interactive filtering using various criteria. By applying

the dynamic queries approach to information filtering, a continuous starfield display of the films, and tight coupling among the components of the display, the *FilmFinder* encourages incremental and exploratory search.

Hyunmo and Shneiderman [8] developed *PhotoFinder*, a picture management application for flexible filtering of images by dynamic queries and previews. Bederson [2] described another tool, *PhotoMesa*, that uses quantum treemaps to arrange thumbnail pictures on the screen. Quantum treemaps improve the aspect ratio and reduce the waste of screen space.

Hu et al. [7] used Bregman Bubble Clustering for an algorithm to find dense clusters in image search results. They tested the algorithm using an image collection from *Flickr* [4] and made comparison with the *Flickr* search algorithm. When searching for common names, their clustering method has better results than the *Flickr* image search. Yang et al. [14] use semantic image segmentation in order to browse the image collections.

While all these approaches proved useful with respect to selected aspects of the here addressed (larger) challenge, we know of no approach which allows to utilize a multifaceted analysis, considering the images, image similarities, and image parameters altogether.

3 Image Collection Description

Conventionally, data analysis approaches, such as traditional statistics or OLAP techniques, assume the data to be of a relatively simple multi-dimensional model (simple with respect to the separate data dimensions). For complex data sets like image collections, it is necessary to provide an adequate data model. Each image is associated with a data point so the data set representing the image collection consists of data points (tuple values) of n dimensions. Each dimension represents a parameter describing an image. Parameter values can be categorical, numerical, and data series. The image itself is also a dimension in the data item.

There are several categories of parameters like external parameters (image caption/title; name, age or gender of the author, time the image is created, etc.), environmental parameters (file name, file size, file creation time, file modification time, etc.), content parameters (image format, pixels, etc.), and derived parameters. The derived parameters are derived (calculated) from the raw pixel data for example, hue, saturation, contrast, etc.

We analyze an image collection from *Flickr*. There are two groups of external parameters. The first group of six external parameters (flickr parameters) relates to the "use of an image" on the *flickr* site and includes *date taken* (the date when the image was taken), *number of comments*, *number of favorites*, *number of views*, *number of tags*, and *title*. The second group of ten external parameters (user parameters) relate to the user (image "owner") and includes *user name*, *gender*, *singleness*, *home town*, *location*, *occupation*, *image count per user*, *contact count*, *pro* (i.e. if the user has a pro account on Flickr), and *first date*.

We have more than 60 derived parameters. Averaged image hue, saturation, lightness, and contrast are computed for each image. In order to gain deeper

insight into such collections we subdivide images also into cells of a regular grid and compute average hue, saturation, lightness, and contrast values for each cell in this grid (Figure 1b). Those parameter values constitute data series in the data tuple. We subdivide images in four different resolutions (rectangular grid): 2×2 (four cells) 3×3 (nine cells), 4×4 (16 cells), and 5×5 (25 cells).

In order to allow a more semantically based approach to color features we introduce color names based on the work by Van de Weijer et al. [13]. In English, eleven basic color terms have been defined based on a linguistic study. The normalized amount of pixels of each color is individually computed for each image. To additionally explore the colors in images colorfulness is measured by computing the Earth Mover's Distance [3] between an "ideal uniform colorful" distribution and the measured color distribution of the image. Simple average hue can be problematic, especially for images with a high amount of various red tones (the simple average of hue will suggest that the image is blue) or with low saturation (black, white and grey tones will have almost random hue values). Therefore a vector-based, saturation weighted formula is used to compute the average hue [5]. Further, we explore the texture and graininess in the images by computing the three-level decomposition of the Daubechies wavelet transform for each color channel (H/S/L). We have also calculated depth of field indicator [3]. The Viole-Jones face detector is used to locate frontal faces on the images.

Each of the 26,000 images we used (downloaded from Flickr using the publicly available Flickr API) corresponds to a tuple which contains the described parameters and the image itself. We can, through interactive visual analysis, analyze relationships among various parameters and get insight into image collections.

4 An Iterative and Integrated Approach to Comprehension an Familiarization of Image Collections

Conventional but yet very effective views such as histograms, scatterplots, or parallel coordinates are used for numeric or categorical data such as the average contrast, average hue/saturation, or photographers' gender and marital status. Figure 1a shows a histogram of average lightness values. The lightness range is divided into 16 bins and each bar shows how many images have an average lightness of a particular range. The sum of all values is the total sum of all images in the collection. We can clearly see that the images with medium average lightness are the most frequent in our dataset. We could easily depict all other parameters using the same view. Such views give us an overview of the image collection but often they are not enough to reveal fine-grained details or to visualize values that are averaged over the entire image.

4.1 Segmented Curve View

Besides numerical parameters we also have data series parameters. Average hue, e.g., for subrectangles can be observed as a series of numbers, each representing the hue of a subrectangle. There are many ways of visualizing series data, but

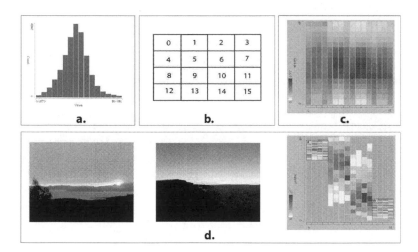

Fig. 1. a. A histogram showing the distribution of lightness values for an image collection consisting of more than 26,000 images. **b.** Subdivision of an image in 16 segments for partial parameter computation and corresponding cell numbering. **c.** A segmented curve view of lightness distributions in segments of all images in the collection. The x axis of the segmented curve view has 16 segments (16 subrectangles in b.) and each vertical bar is divided into 16 segments (bins). Bins are colored dependent on number of images having lightness in a particular segment in the range defined by a particular bin. **d.** A segmented curve view of lightness distributions. The first four bars represent the upper quarter of all images, the last four the lower quarter. We select images that are bright in the upper and dark in the lower part at the same time. Two images in the left illustrate typical images for such a selection.

most visualization methods were designed for continuous data (mostly for time series). The segmented curve view [9] is one of the exceptions. Due to the discrete nature of the mapping domain (number of rectangles), the segmented curve view seems to be more appropriate here. It provides a comprehensive view of a large family of data series. It depicts the distribution of a dependent variable (e.g. lightness) for each value of an independent variable (subrectangle in our case) for every data point (image in the collection). For each discrete value of an independent variable (subrectangle) there is one vertical bar in the segmented curve view. This bar is subdivided into segments (bins) and the number of items (images) passing through a bin is depicted using a color scale. The total number of items in a bar equals the total number of images in the collection. Each image in the collection is subdivided into rectangles.

The segmented curve view for lightness ('V' in HSV color system) shows lightness in all subrectangles for all the images (Figure 1c). For example, the first bar in the segmented curve view depicts distribution of lightness in subrectangle 0 (upper-left corner) for the whole image collection.

The leftmost bar in the segmented curve view shows a relatively uniform distribution across the entire range of lightness in our data set. This is apparent from very similar shades of blue for all 16 segments of the bar. This shows that the

number of images with light, dark and medium light segment 0 is approximately equal in our collection. Segments 1 and 2 have slightly less frequent dark values. Segment 3 is similar to segment 0. Segments 5, 6, 9, and 10 (center of the images) have significantly less light or dark colors than other segments.

Figure 1d shows another example. The upper parts of the first four bars represent the images that are bright in the upper quarter. The lower parts of the last four bars represent the images with the dark lower quarter. Figure 1d shows the selection of images that are bright in the upper quarter and dark in lower quarter at the same time. The selection was done interactively by the user. The view shows distribution in the selected parts of the bins only, and the rest is shown in gray. Two images from such a selection are shown in Figure 1d on the left.

Although the segmented curve view and the approach with several subrectangles might seem complex at the first sight, the gained additional information is significantly larger than the information from simple overall average histograms, as illustrated in Figure 1a. If we would have only overall average values per image, we could not observe and analyze distributions of parameters across images in the collection as demonstrated in Figure 1d.

4.2 Forms of Interaction

Interaction is the core of interactive visual analysis and plays the most important role in coordinated, multiple views systems. The basic idea of linking and brushing makes it possible to select a range of parameters in one view (e.g., specific lightness values) and to see which parameters the selected items have. The selection is traditionally called brushing in interactive visualization. Figure 2 illustrates linking and brushing.

The histogram on the left (Figure 2 top row) shows a user's selection (made by a mouse) of highly saturated images. A linked parallel coordinates view of eight further parameters is shown as well. The selected images are depicted in red and the context (all other images) is gray. Figure 2 shows the lightness distribution for 16 segments of the selected images on the right of the top row. The distribution has all bins covered. Figure 1c shows a different distribution in the segmented curve view for all images in the collection. Note many images with dark corners (dark blue lowest segments in bars 0, 3, 12, and 15).

The user is not limited to a single brush but can combine many brushes and use Boolean operations on them. Let us refine the previous selection now. If we add another histogram and additionally select only single users and only taken users (taken is Flickr terminology used for non-single users) we can explore the difference in lightness distribution of highly saturated images for these two groups (Figure 2 bottom row). Note how singles tend to have much darker corners!

Image as a Brush. The nature of images, their complexity and our difficulty to visualize images from parameters require additional interaction. Even though we get deeper insights by utilizing subrectangle values and advanced linking and brushing, it is still not enough. It is impossible to correctly mentally visualize an image only from the parameters. The user still prefers the image itself. We have to include the original images in the analysis. The ability to treat image in the

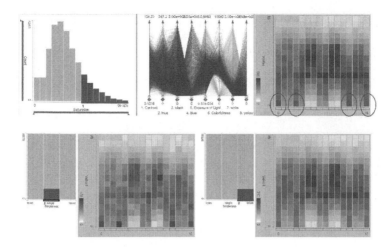

Fig. 2. Top Row: User brushes images with high average saturation selecting only the right hand side bins in the saturation histogram shown on the left. We can see the distribution of eight other parameters for the selected images in the parallel co-ordinates view in the middle. Finally, the segmented curve view on the right shows a more detailed view on lightness of selected images. Note the differences between this view and Figure 1c. Note also, many images with dark corners (bins in red ellipsis) for images with high saturation. Bottom row: If we refine selection now differentiating between single and taken users (Flickr terminology) we can see the difference in lightness distribution. The dark corners are more probable by single users.

same way we treat other parameters (brushing and linking) provides a unique opportunity to analyze large image collections. We provide a linked picture view showing the original images. Now the user can see not only the parameters of selected images, but the images themselves. When we see the selected images together, some similarity which can not be seen in the parameter space might become visible. The picture view is not only passively linked, it can be used for brushing, too.

The idea is to let the user select an image, the system then finds similar images, and images that are similar enough define a brush now. Since all views are linked, the user can see the parameters of the selection in the parameters views. This is a completely new way of brushing. The user does not select the exact parameters but a target image. Refining the search with additional parameter brushes, image brushes, and their combinations provides unlimited possibilities.

In order to realize such a system we needed a definition of image similarity. There are many content based image retrieval systems, techniques and similarity measures that can be used. We have used the Visual Image Query [10] based on color layout similarity. It serves as a tool to allow us brushing by image selection and can be easily replaced or enhanced with any other available technique. The query algorithm is only a tool for us, it is not a topic of this paper.

When we select an image as a target image, the underlying algorithm is too complex for us to predict which images will be selected. In contrast to conventional

brushing in the parameter space where the exact parameter limits are specified, using an image as a brush represents a fuzzy form of brushing. The user hints a color layout by image selection and the system responds with a new selection. This adds a different quality to this way of brushing, and makes it particulary convenient for image collections analysis. The interplay between brushing in the parameter space, and brushing by the selection of a target image creates a unique system for analysis and exploration of large image collections.

Selections can contain a lot of images so it may not be possible to display them all using a limited display space. We display as many thumbnails as possible in the view and allow the user to see the next and previous page with thumbnails. The user can specify the criterion for image sorting and influence the order of the resulting images (e.g., display highly saturated images first). Any of the available parameters can be used for sorting. In this way some hidden relations can be discovered, and image collections can be understood better.

5 Demonstration

We illustrate interaction possibilities (parameters, images, sorting) of our approach using a general purpose interactive visualization tool enhanced with the image view and image brushing capabilities.

First we investigate if there is a pattern in parameters of popular images, and if there is a difference between popular images of single and taken photographs. If we find that there is a difference this information can be used in, e.g., a marketing campaign. If target customers are single, one could use images with parameters that appeal singles.

We use parallel coordinates to select parameters and see the results. Parallel axes are used and the values belonging to one image are connected with a polyline, depending on image parameters. There is a polyline for each image in the collection. Figure 3 top left shows parallel coordinates with multiple selections.

We select images with a large number of comments, views and tags. We also select taken users (left set of images) and single users (right set of images). There is a large difference in the lightness and saturation distribution between these two groups. Popular images of taken users are much more saturated. There is a large number of unsaturated images in the singles' group (dark rectangles at the bottom of the segmented curve view in the right hand side set.) The lightness distribution in the taken users' images is also more regular. There are many images with medium lightness. The parameters depicted in lower parallel coordinates are similar, and finally the picture view shows 25 images form each groups with most comments. The saturation characteristic can be clearly seen in the images. The interpretation of the results, i.e. why popular images of single users tend to have low saturation is out of scope of this paper. We intend to analyze these results with sociologists in order to interpret the results.

We now restrict our selection in Figure 4 to those images that are favorites of many users. We examine the histograms to find a correlation between the popularity of images and the author's gender. We also examine if the images of

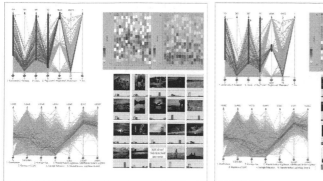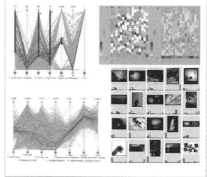

Fig. 3. Images with many comments, views, and tags are selected using parallel coordinates (numbers next to the selections are used to identify various brushes only.)Left images show additional selection of taken users, and images of single users are shown on the right. The distribution of lightness and saturation is shown in segmented curve views. The 25 images with most comments from each group are shown in the picture view. Different saturation distribution and different mood in the images.

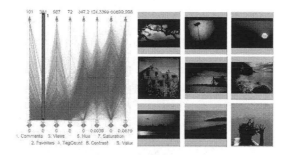

Fig. 4. Left: In a parallel coordinates view we can brush pictures, that have been selected by many users as their favorites. This way we can concentrate on popular images. **Right:** The most popular pictures of the result set.

singles or taken authors are more popular. The histogram shows the exact values of popular images in relation to all images, so we can conclude, that about 7% of all pictures taken by women are popular, whereas only 5% of pictures taken by men are popular. That means pictures taken by women in this case have 38% higher chance of becoming favorites. The influence of an author's singleness is smaller, but still measurable. The single users' pictures have about 4.9% chance to become popular. If the image author is in a relationship, the chance is 6.3% or about 29% more. Figure 4 shows the most popular pictures from our collection.

If we restrict our selection to even more popular images (Figure 5), the differences between male and female authors further increase, while the differences between single and taken users decrease a little bit. We can view images taken by female and male authors separately, and look for differences. Figure 5 shows

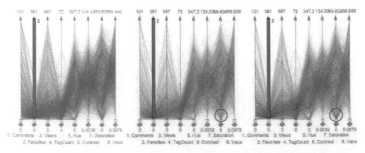

Fig. 5. Left: We can resize our brush and cut away some of the pictures that are less often chosen as favorites. **Middle:** Popular images from female authors. **Right:** Popular images from male authors. The blue circles emphasize pictures with very low saturation. These are greyscale images which are more often taken by male authors.

a comparison of the parallel coordinates view of female and male authors. The blue circle indicates an obvious difference in the saturation axis. Male authors seem to prefer low saturated photos, that are favorites of other users.

After applying a brush to the saturation axis, we view the resulting images and check if the trends we found before are still valid. Both trends are now reversed. For greyscale images (low saturation), photos taken by men have 30% higher chance to become favorites. Single authors outperform taken ones by 22%.

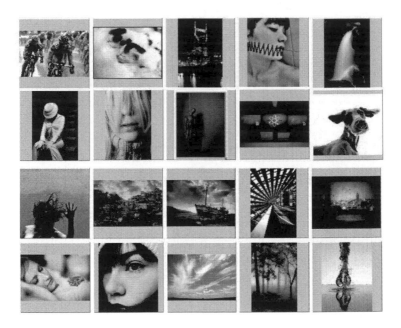

Fig. 6. Top: These greyscale pictures have been selected as favorites by many users. **Bottom:** These popular images (subset shown) have a medium saturation and are more often taken by female authors.

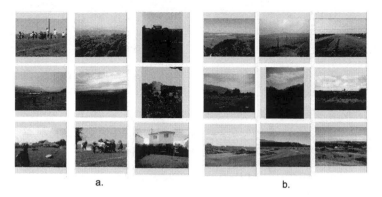

a. b.

Fig. 7. The user provided a landscape image as brush. The selection was further narrowed to male and female users, and interestingly, in our image collection, female users (a.) tend to upload landscapes with some additional objects in the image.

When selecting medium saturated pictures however, we can reproduce the trends we found in the beginning. Pictures taken by female authors now have a 66% higher chance to become popular. The chances of pictures taken by the users in a relationship is more than 42% higher than for the singles. The most popular pictures with a medium saturation can be seen in Figure 6 bottom.

Finally, we show an example with a target image. A landscape image is used to look for landscape images. The resulting pictures are shown in Figure 7. As expected, we got a lot of landscape images. Some of them were pure landscapes and some of them included people, houses, or other objects. We now easily refine the search in the parameter space to see if this difference is related to some parameters. After short exploration we found out that in our collection landscape images uploaded by female users (Figure 7a) often contain some additional objects and those by males usually do not (Figure 7b).

The described examples show various possibilities of proposed approach. Interplay of image space and parameter space and possibility to iterative drill down to the wanted information using various interaction represent a novel and exciting way of understanding large image collections.

6 Summary and Conclusions

We describe a novel approach to analysis of large image collections that provides additional insights about image collection parameters, such as metadata or derived parameters. We can explore image collections and find patterns in image parameters while maintaining the focus on visual impression. It adds new qualities to image collection analysis and understanding and facilitates better comprehension and familiarization. It can be used in numerous scenarios for marketing research, sociology research, etc., or just by common users to get insight into image collections. The process is fun, fascinating and intuitive, both for domain experts or researchers, as well as for regular users "navigating on the

sea of images." We have introduced a novel concept of image brush for interactive visual analysis. Future work will focus on increasing the scalability of the implementation and new input (e.g. multi-touch) and output (high-resolution) technologies.

References

1. Ahlberg, C., Shneiderman, B.: Visual information seeking using the FilmFinder. In: ACM CHI 1994 Conference Companion, pp. 433–434 (April 1994)
2. Bederson, B.: Quantum treemaps and bubblemaps for a zoomable image browser (2001)
3. Datta, R., Joshi, D., Li, J., Wang, J.: Studying aesthetics in photographic images using a computational approach. In: Leonardis, A., Bischof, H., Pinz, A. (eds.) ECCV 2006. LNCS, vol. 3953, pp. 288–301. Springer, Heidelberg (2006)
4. Flickr photo sharing community (2007), http://www.flickr.com
5. Hanbury, A., Kropatsch, W.G.: Colour statistics for matching in image databases. In: Vision in a Dynamical World 27th AGM Workshop, pp. 221–228. Österr, Arbeitsgemeinschaft für Mustererkennung (2003)
6. Hochheiser, H., Shneiderman, B.: Dynamic query tools for time series data sets: timebox widgets for interactive exploration. Information Visualization 3(1) (2004)
7. Hu, Y., Yu, N., Li, Z., Li, M.: Image search result clustering and re-ranking via partial grouping. In: IEEE Inter. Conf. on Multimedia and Expo (2007)
8. Kang, H., Shneiderman, B.: Visualization methods for personal photo collections: Browsing and searching in the photofinder. In: IEEE International Conf. on Multimedia and Expo (III), pp. 1539–1542 (2000)
9. Konyha, Z., Matkovic, K., Gracanin, D., Duras, M.: Interactive visual analysis of a timing chain drive using segmented curve view and other coordinated views. In: Coordinated and Multiple Views in Exploratory Visualization, Zurich (2007)
10. Matković, K., Neumann, L., Siglaer, J., Kompast, M., Purgathofer, W.: Visual image query. In: SMARTGRAPH 2002: Proceedings of the 2nd international symposium on Smart graphics, pp. 116–123. ACM Press, New York (2002)
11. Roberts, J.C.: State of the art: Coord. & multiple views in exploratory visualization. In: Coord. and Multiple Views in Exploratory Visualization, Zurich (2007)
12. Snavely, N., Seitz, S.M., Szeliski, R.: Photo tourism: exploring photo collections in 3d. ACM Trans. Graph. 25(3), 835–846 (2006)
13. van de Weijer, J., Schmid, C., Verbeek, J.: Learning color names from real-world images. In: Proceedings of IEEE Computer Vision and Pattern Recognition (2007)
14. Yang, J., Fan, J., Hubball, D., Gao, Y., Luo, H., Ribarsky, W., Ward, M.: Semantic image browser: Bridging information visualization with automated intelligent image analysis. In: IEEE Visual Analytics Science And Technology (2006)

Towards the Big Picture: Enriching 3D Models with Information Visualisation and Vice Versa

Michael Sedlmair[1], Kerstin Ruhland[2,4], Fabian Hennecke[1], Andreas Butz[2], Susan Bioletti[4], and Carol O'Sullivan[3]

[1] BMW Group Research and Technology, Munich, Germany
[2] Media Informatics Group, University of Munich, Germany
[3] Preservation and Conservation Department, Trinity College Dublin, Ireland
[4] Graphics Vision and Visualisation Group, Trinity College Dublin, Ireland
{michael.sedlmair,fabian.hennecke}@bmw.de, andreas.butz@ifi.lmu.de,
{ruhlandk,carol.osullivan,bioletts}@tcd.ie

Abstract. Most information visualisation methods are based on abstract visual representations without any concrete manifestation in the "real world". However, a variety of abstract datasets can indeed be related to, and hence enriched by, real-world aspects. In these cases an additional virtual representation of the 3D object can help to gain a better insight into the connection between abstract and real-world issues. We demonstrate this approach with two prototype systems that combine information visualisation with 3D models in multiple coordinated views. The first prototype involves the visualisation of in-car communication traces. The 3D model of the car serves as one view among several and provides the user with information about the car's activities. LibViz, our second prototype, is based on a full screen 3D representation of a library building. Measured data is visualised in overlaid, semi-transparent windows to allow the user interpretation of the data in its spatial context of the library's 3D model. Based on the two prototypes, we identify the benefits and drawbacks of the approach, investigate aspects of coordination between the 3D model and the abstract visualisations, and discuss principals for a general approach.

Keywords: Information Visualisation, 3D Models, Multiple Coordinated Views.

1 Introduction

While we were applying Information Visualisation methods to real-world scenarios in our earlier projects [17,18,19], we observed that in many cases relevant data does not exist in a purely abstract form, as assumed by many information visualisation approaches. In addition to the abstract data, there is often some connection to real-world entities such as cars or buildings. We refer to such data as *hybrid, multivariate data* because it consists of an abstract part as well as a direct reference to some real-world behaviour or entity. We postulate that this

A. Butz et al. (Eds.): SG 2009, LNCS 5531, pp. 27–39, 2009.

type of data is available for large number of real-world scenarios and therefore merits further investigation.

Traditional approaches are mostly designed for either abstract or real-world data and can be categorised as being either Information (InfoVis) or Scientific (SciVis) Visualisation. While SciVis basically deals with the representation of measured data with the help of virtual 3D objects [20], InfoVis concentrates on abstract data and representations [3,20]. However, the boundary between these two areas is not always easy to identify, as demonstrated by our own experience with real-world applications. Therefore, comprehensive solutions and combined approaches are usually required.

In fact, there are already some existing systems that visualise such hybrid information. For instance, many InfoVis applications are based on a combination of abstract representations together with colour coded and coordinated 2D maps to clarify the correlation of geospatial and abstract information. In SciVis, on the other hand, virtual 3D representations of real-world objects are enhanced by descriptive, often simply textual information. These concepts have proven helpful in gaining insights into the correlations between abstract and object-related information.

In this paper, starting from an InfoVis point of view, we focus on situations where abstract data is also related to a specific, self-contained representation of the real world. For such cases, we propose the enrichment of abstract visualisations with virtual 3D representations of the underlying real-world entity, by visualising them simultaneously in a multiple coordinated view (MCV) system.

We propose two different approaches and demonstrate them with prototypical applications. First, we present *CarComViz*, a visualisation system for in-car communication data. CarComViz extends a previously implemented, abstract MCV visualisation [19] with an additional 3D model of the car and combines both approaches in parallel displayed views. CarComViz supports automotive engineers and diagnostic experts in navigating and getting insight into highly complex and abstract traced data from in-car networks. Up to 15K messages per second are distributed over 13 bus systems in one car, and the size and complexity of this dataset requires multivariate visualisation support. The network data has an inherent relationship to the car itself, as it is the technical cause or effect of activities within the vehicle.

We also present *LibViz*, a visualisation of multivariate measured data from the Old Library in Trinity College Dublin, introduced in [17]. In LibViz, a user can navigate through the virtual library, while visualising additional information about measured, location dependent data, such as dust levels, humidity information or window conditions. The application combines a wide variety of data sources to provide preservation specialists with a general overview and to allow insight into complex aggregate information. Unlike CarComViz, the representation of the library is displayed in full screen mode and presents the central view of the application. Additional abstract visualisations are overlaid in semi-transparent windows and are dynamically coordinated with the 3D model. This approach is common in 3D gaming, for instance.

2 Related Work

Multiple Coordinated Views (MCV) are commonly used to visualise highly complex, multivariate and multidimensional data [11]. Many InfoVis applications use this technique to combine abstract visualisations such as scatter plots, parallel coordinates visualisation or treemaps. One major benefit of MCV is the potential to reveal relationships within the data [1]. Therefore, many tools elucidate relationships between the abstract part of the data and its reference to real-world entities by integrating 2D representations of these entities within an MCV system. Such applications typically depict medical data [12] or geospatial information [16,7]. In contrast, SciVis systems focus more on technical artefacts and the direct mapping of measured data onto a 3D representation of the artefact. Additional 2D Views are used to display legends and additional textual information.

In recent years, the trend has been towards abolishing the somewhat artificial boundary between InfoVis and SciVis [14,15]. While the "separate but equal" approach was appropriate in some cases, it has become increasingly clear that SciVis and InfoVis approaches must converge in order to gain deeper insights into interrelated, complex areas. Kosara et al. presented a MCV framework linking SciVis and InfoVis, using 2D scatter plots for abstract data and 3D scatter plots for artefact representation [9]. Similar approaches can be found in the *Weave* [5] and *VizCraft* [4] systems. Such spatial data can also be represented by solid 3D representations. Husoy and Skourup [6] presented an approach using a 3D model of an industrial plant as the user interface for a control system. Within the plant's 3D model, the user has direct access to data and information integrated in the model. Butkiewicz et al. [2] developed an interactive MCV analysis tool that combines two 3D views with a heat map for chronological visualisation of changes to an urban environment. One major benefit of their tool is that it can demonstrate relationships between the multivariate data and real urban model by using the 3D presentation of the landscape together with the 2D heat map.

Last but not least, our approach is also inspired by 3D game technology. The enrichment of virtual 3D worlds with additional 2D data is very common in this community. Textual and graphical 2D overlays are used to show additional information such as game status, avatar behaviour or maps, and support navigation and orientation [10]. However, there is one fundamental difference between using 2D overlays in 3D games and in task driven visualisation approaches like ours. For gaming, 2D elements are viewed only as a necessary evil, decreasing immersion in order to show additional information. However, for visualisation purposes, the 2D elements are an essential contribution towards the goal of gaining greater insights.

3 Goal and Requirements

As discussed above, 3D representations of real-world entities enriched with abstract information have been proposed before. However, in this paper we do not focus on a direct mapping of information onto a 3D model, as commonly applied in SciVis applications. Rather, we investigate how 3D models can be integrated

into MVC systems in order to improve the understanding of semantic connections between abstract data and real-world entities. In doing so, the 3D model serves less as a carrier of complex information, but more as a visual connection of the data to reality.

To use the proposed combination of abstract visualisation and 3D models, it is necessary that the underlying data set fulfils some basic criteria - it must be: *multivariate* (it consists of several variables) and *hybrid* (it is abstract in one variable and connected to the real world in another). Obviously, for purely abstract data without any connection to real-world entities, or real-world data alone, our approach is not appropriate.

In reality, multivariate, hybrid datasets are often complex and hard to understand. Representing the information in a MCV system allows the complexity to be divided [1]. The abstract part of the data can be visualised via established or novel approaches from InfoVis, while one or more additional views can show the real-world aspects of the data using a virtual 3D representation. Thus, visual correlations between the views can provide insight into the connections between abstract and real-world information.

4 Two Example Prototypes

Below, we will present two of our prototype systems, each showing a different MVC approach to combining 3D models with information visualisations. Car-ComViz (an extension of [19]) is based on an equitable side-by-side presentation of views, whereas LibViz [17] uses a centralised full-screen 3D model with overlaid information windows.

4.1 CarComViz

CarComViz is an application to visualise in-car communication traces. Such recorded data from in-car communication networks is a good example of multivariate, hybrid data. The core data is of an abstract nature and represents, in simple terms, signals and messages sent between functions. However, these functions in turn are implemented in so-called electronic control units (ECUs), which are the hardware components containing the function. Hence, they are obviously related to the real-world vehicle by the position in which they are installed. Furthermore, certain signals cause physical effects such as moving a window or switching on the light. Automotive diagnostic experts record the data directly from the vehicle via a hardware interface and specific recording tools. The traces contain a sequence of up to 15K messages per second, and therefore become very large. The messages include information about the sending functional blocks (which in turn implies the sending ECUs), various encapsulated signals and further detailed information such as timestamps.

Currently used analysis software such as Canalyzer[1] or Tracerunner[2] are very powerful, but mostly text based tools. However, the lack of visualisation makes

[1] www.canalyzer.de

[2] www.tracerunner.de

it hard to understand the correlations within the data. To achieve a deeper understanding of the bus communication, it is necessary to gain more insight into the timing and causal connections between messages and real behaviour. Therefore, we designed a tool in which the user can visually browse traces and see detailed information about messages, while monitoring activities and the current physical state of the vehicle.

Design. CarComViz is designed to support visual analysis during offline data diagnosis. It is based on three views (cf. Fig. 1):

The *Autobahn View* is the central, abstract view of this application. It can be seen as an offspring from the scatter plot. It is a customized method built on a metaphor of a crowded motorway. A bus system is visualised as separate superior blocks, the motorway. Every bus transports messages from different ECUs. This transportation is represented by a horizontal bar, which would be a lane according to the motorway comparison. The lane contains black rectangles, which represent every message sent by the ECU through the bus to another ECU. Instead of showing the sent messages, this view can also be used to visualise sent signals. Interaction within the view is based on zooming and panning. Starting with an overview, the user can zoom into interesting parts of the trace and can horizontally as well as vertically pan around at each zoom level.

A traditional *List View* represents detailed information about the data in a textual line-up. The user can interactively select items from the Autobahn View and show the corresponding detailed information in this view, which can be additional information about exact timing, encapsulated signals or the hexadecimal raw data. We found that the classical textual representation was still the best way to show this detailed information.

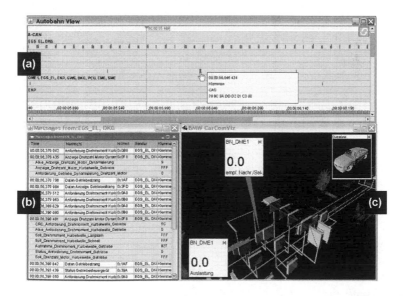

Fig. 1. CarComViz: (a) Autobahn View, (b) List View, (c) 3D Model View

In addition to these abstract views (cf. [19]), a novel *3D Model View* depicts a virtual model of the vehicle of interest. Real behaviour, such as moving the windows, turning on the lights or accelerating wheels, is presented by animation. Navigating through time in the Autobahn View causes resulting activities to occur in the 3D model, depending on the particular message content. Additionally, the user can configure different perspectives of the car and view them in a "picture within a picture" style. By dynamically adjusting the transparency of the car's components, the focus of the different perspectives can be set to be very flexible. The perspective views can be freely repositioned within the window and dynamically toggled by clicking on them. The selected perspective view is then swapped into the main stage where it can be configured and navigated. Furthermore, the user can initialise supplemental 2D overlays, which are directly connected to a specific component of the car via a semitransparent arrow. Both mechanical components, e.g., a wheel, and electronic components, such as ECUs or bus systems, can be thus enhanced. The 2D overlay can show a specific user defined value of interest, such as the actual speed or bus load that changes over time. Interface configuration tasks (creating perspective views or 2D overlays, adjusting transparency) are set manually in a detached settings dialogue.

Evaluation. We conducted a qualitative user study with five automotive domain experts, focusing on the additional 3D View. The participants were confronted with tasks of differing complexity. The tasks dealt with the recognition of car states and the identification of causal relationships between a 3D model and abstract network information, such as "which message caused the door to open?" With our user study, we did not aim to benchmark ourselves with respect to existing industrial analysis tools. Our goal was to clearly focus on evaluating the specific effects of integrating a virtual 3D model into the analysis process.

All participants acknowledged the overall benefit of using the 3D model in the combined and correlated representation with the abstract 2D visualisations, which is encouraging. Exclusively abstract representations were not effective in linking the information to real-world behaviour, while the exclusively 3D representation was less useful for analysing in-car communication traces. The expertise of the user, however, has a significant effect, in that the more expert (s)he is, the less 3D model visualisation is necessary. The visual correlations between the views were understood very well. Also, obvious state transitions such as opening a door were easily identified, with only small scale changes such as activating the indicator being difficult to detect. For such subtle effects, other techniques and solutions for 3D highlighting should be investigated.

4.2 LibViz

LibViz [17] is a tool to assist the Preservation and Conservation Department in preserving the collection of the Old Library in Trinity College Dublin. The application visualises a variety of data recorded in the Library. So far, it provides information about windows, dust, temperature and relative humidity, along with additional data about visitor statistics and external weather data. This multivariate, hybrid data is visualised using appropriate types of information

visualisation methods and can be explored using a 3D virtual reconstruction of the Old Library. This representation serves to elucidate structural and environmental correlations and allows the user to compare and assess the relationships between the various datasets in a spatial context.

Design. In LibViz, semi-transparent 2D widgets overlay a 3D virtual reconstruction of the Old Library. Since the main use of the application is the visualisation of recorded data, the 3D model of the Library is kept reasonably simple. The user can navigate freely inside the model by using either virtual buttons provided in the interface, or mouse/keyboard navigation similar to computer game controls.

Two initial 2D widgets contain *global functions* such as navigation controls, a clipping slider and a list of feature buttons to activate the various data visualisations. The purpose of the other widgets is to show the actual data in the form of abstract information visualisations. To exemplify the interaction between the 3D model and the 2D widgets, we describe the temperature and relative humidity feature (cf. Fig. 2). Activating this feature draws neutrally coloured cubes at the position where the sensors are located inside the library. These sensors can be inspected by navigating inside the 3D environment or by using the clipping slider from the global function widget to remove layers of the building. Furthermore, an opened widget lists all available sensor names. To select a specific sensor, the user chooses one from the list or by clicking on the 3D representation of the sensor. Both activities open the *detail widget* and the *extra data widget*. Furthermore the sensor cubes are coloured depending on the average data over the selected time frame for temperature (in the lower half of the cube) and relative

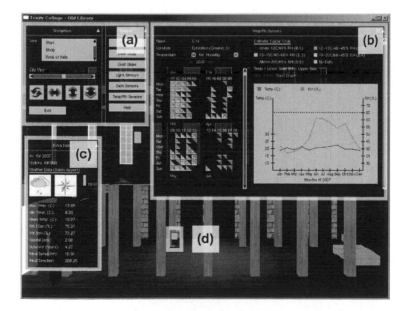

Fig. 2. LibViz: (a) Widget for global functions, (b) Detail widget, (c) Extra data widget, (d) Sensor within the 3D model

humidity (in the upper half). By choosing a sensor, the date is set to the year of the last recorded sensor dataset.

The detail widget holds a *Calendar View* [21] and a *Graph View*. The average temperature of each calendar day defines the colour code of the initial Calendar View. Using check boxes, the user can decide if the calendar and the graph should show temperature, relative humidity or both. This view allows the user to identify patterns and thereby possibly hazardous situations. The second view of this widget contains a time graph. In addition to the internal environmental conditions, the extra data widget contains visitor numbers and external weather data. A bar graph of the percentage of visitors and weather icons allows an overview of the available data to be visualised. The time graph of the detail widget, the extra data widget and the coloured sensor cubes in the 3D environment are linked to the Calendar View. Selecting a specific year, month, week or day changes the representation and content of these three components. This enables the user to examine the data from different points of view and to compare the various influencing factors. The data can be set in connection with the sensor position inside the building and the external weather data. Different sensors can be directly compared with each other inside the 3D environment.

The time component is suited to the dust accumulation feature as well. Dust sensors are distributed in the Library's Long Room and are visualised as spheres that are assigned the colour code of the last measurement. The detail widget of this feature provides a time slider over the measurement dates. Sliding through time changes the sensor's colour and removes or adds sensors according to their appearance.

Evaluation. A user study was conducted to determine a) whether the design of the application met the needs of its target users and b) how effectively the users were at completing assigned tasks using the system. There were eleven participants, of whom five were library employees and six were computer graphic scientists. In the first trial, the users had to complete four tasks, followed by a questionnaire and a final trial with slightly modified tasks. The given tasks were designed to test users' ability to find the information they were asked for and to direct their attention to specific details in the application. Using the example of the temperature and relative humidity feature, the user was instructed to locate a specific sensor and to record its colour code and internal and external temperature on a specific day. The usage questionnaire focused on extracting the correct information using the application. The users found it easy to work with the 2D representation such as the Calendar View or time graphs. While the majority of the users had no problems selecting the correct sensor from the 3D environment, they nevertheless preferred selecting the sensor from a list. Overall, feedback was very positive.

5 Towards a General Understanding

During the successful implementation and evaluation of these two prototype systems, some general underpinning principles began to emerge. The combination of

3D visualisation with 2D abstract InfoVis elements clearly combines the benefits of both worlds without sacrificing too much of either. We now develop these ideas further and propose some general principles for hybrid visualisation applications.

5.1 Combining the Views

We proposed two different approaches to combine 3D models with information visualisation in a MCV system: *Equal Views* and *3D Model with Overlays*. These approaches illustrate the trade-off between allocating screen space and accepting overlaps. CarComViz, for instance, is based on the approach of Equal Views. One or more views of the 3D model serve as parallel views within a MCV system. The views are more or less equal and dynamically divide the screen space without overlaying each other. The technique is commonly used in the area of MCV applications. LibViz, on the other hand, uses the approach of a central 3D model with overlays. This approach is more common in 3D gaming. The approach can be seen as a mixture of sequential and parallel representation of views. The 3D model of the entity forms the centre of the visualisation and is shown in the entire application window or in full screen. While this was not necessary for CarComViz, LibViz benefits from a full screen representation of the 3D model because it allows an adequate and parallel presentation of all sensors within their spatial context. This improves the overall comprehension of correlations between the high number of sensors. A smaller representation would either cause a loss of presentable sensors, if zoomed in, or a loss of information perceptibility, if zoomed to an entire view. To show the abstract information, additional 2D visualisations are overlaid on demand and are dynamically linked to the 3D model. In LibViz, we accepted the drawback of overlapping because of the reason mentioned above. To counteract the effects we did two things: Firstly, the overlaid windows were set semitransparent so that a certain degree of context is retained. Secondly, the windows can be dynamically minimised to show the entire, non-overlapped 3D model view on demand.

To summarise, both approaches are equally valid, but a full screen representation should only be used when the application truly justifies it. It may be the case that the problem of overlapping can only be partially addressed using interaction and transparency. Furthermore, the decision about which approach to take depends on where the user's focus should be. A 3D Model with Overlay representations will draw the main attention to the 3D model and relegate the abstract visualisations to the status of additional information sources. On the other hand, the Equal View approach does not make any inherent prediction of where the focus should be concentrated. The user can decide whether to start with abstract visualisations and use the 3D model view for context, or vice versa.

5.2 Linking the Views

There are several different approaches to linking views in MCV applications. We identify two general ways that are usable for our target applications:

Item Linking. Brushing and Linking is a common interaction technique in the area of MCV [8]. Usually it is used to highlight identical data items in different

views. Also, elements that reveal a clear relationship, e.g., messages sent by a certain ECU and the ECU itself, can be graphically bonded. Combining 3D models with abstract visualisations provides one aspect of linking and brushing that goes beyond the conventional use of highlighting identical elements. In addition to connecting equal elements over view boundaries, it allows *spatial (3D-)positions* to be highlighted according to a selected abstract item. Spatial awareness can be achieved due to the fact that one (or more) representations of the items are shown in their real-world entities' context. In CarComViz, for instance, hovering over a message element in the Autobahn view will cause the bounding box of its encapsulating ECU to be highlighted in the 3D model view. The highlighting colours in both views are the same and the user can immediately make the connection.

Semantic Linking. Semantic Linking refers to the fact that an interaction, e.g., a selection or navigation, in an abstract view causes some actual behaviour in the 3D model. CarComViz, in particular, used this specific form of linking the views. Navigating over time in the Autobahn view initiates a sequence of activities in the car's 3D model. For instance, the vehicle's front door opens, it closes again and the wheels begin to move. This would correspond to a forward navigation in a situation where the driver enters the car, starts the engine and moves off. The equivalent backwards navigation would cause a reset of actions so that the status of the vehicle stays correct. In general, this yields two novel forms of coordinating views:

1. *Showing activities*: A specific data chunk causes some real-world activity of the entity. The behaviour can be visualised via animation and the user can reproduce the connection between the activity and abstract information.
2. *Status of entity*: In the case of time dependent data, the 3D model of the entity allows the user to see the actual state of the entity at each point in time. Navigating over the time line updates the status of the 3D model.

Both aspects can help the user to get a broader insight into complex, multivariate, hybrid data by clarifying the entity's real-world context.

5.3 Navigating the Views

During our user studies we observed that some users experienced difficulties with navigating within the 3D models. Such problems only occurred with novice users, unlike expert users who had some 3D gaming experience. In LibViz, we therefore integrated two different 3D navigation variants to counteract this. It turned out that the button controls were especially helpful for novice users, whereas the mouse/keyboard navigation mode was preferred by more expert users. Initially, this problem is a generic 3D issue. By combing 2D and 3D elements we additionally impose the need to mentally switch between different control modes in 3D and 2D. However, we did not observe that users had a particular problem with this.

6 Discussion

There is a high user demand for 3D model based visualisations. That is a fundamental insight gained during our user-centred development approaches to LibViz and CarComViz. Some of the most common statements were: "3D models just look good", "That's fun to use and really intuitive" or "With the model I can easily communicate things, even to my boss...". It would be disingenuous to state that such subjective considerations were not a major motivating factor for our work. However, we do temper this enthusiasm with a disclaimer: *3D model based visualisation is appealing, but in order to make it truly useful in practical applications, it should be easy to control and enriched with additional 2D representations to visualise multivariate, hybrid data.*

Initially, there should be a clear spatial aspect to the data, which is meaningful for the user. Otherwise, a 3D model visualisation may look nice but provide no beneficial insights. A simple 2D representation, even though it is not as graphically attractive for the user, will provide better performance. Conversely, once the added value of using 3D has been proven, it is not sufficient in most cases to simply enrich the 3D models with complex abstract information. The abstract dimensions of the data cannot be directly mapped into the 3D real-world space, as the amount of data will exceed the user's perceptual capacity. For example, showing all messages in a vehicle running over all buses in real time would lead to cognitive overload.

However, if these prerequisites are satisfied, there are several benefits of using 3D models in combination with information visualisation tools. As we can see above, the basic benefit of our approach is that we can combine abstract information with real entities or put it in its real spatial context. Additionally, the virtual 3D model provides capabilities that real-world objects do not. For example, we can easily turn a car around to see its bottom side, or take slices off a library to show its interior. This also enables us to directly support pre-attentive perception to focus and highlight elements or activities of interest.

7 Conclusion and Future Work

This paper documents our experience with combining approaches of InfoVis and 3D model representations by means of two example desktop applications. After describing the design of these two systems, we then took a step back in order to identify common underlying principles and proposed guidelines for the design of future systems.

The main difference between the two approaches taken in our two examples is the way in which they combine 3D and InfoVis elements, and how the user can navigate between 2D and 3D respectively. Both approaches are justifiable for their respective applications. They each have relative benefits and drawbacks, and therefore we have provided guidelines about when to use them. The main commonality between both approaches is the fact that they both manage to establish a real-world reference of abstract data quite clearly. They allow, for

example, to navigate a time line in the abstract view and thereby essentially add a 4th (temporal) dimension to the (coordinated) 3D view as an additional freely controllable parameter (in contrast to just playback). Events in the data can clearly be linked to physical motions in the 3D model (and vice versa), and data elements can be related to 3D positions in the real world. Both of these connections would be impossible to draw without the combination of abstract 2D and realistic 3D visualisations.

There are still challenges and questions which need to be examined, for instance: "How can elements be suitably highlighted in the 3D model and what are the relative benefits of various techniques?", "How can we apply useful, approach-specific automatic changes in the 3D view, e.g., automatically set transparencies or support automatic camera navigation?", "Which is the most appropriate form of 3D navigation for novice users?", or "Are there any specific effects of context switching between abstract 2D and modelled 3D?". Another major challenge will be to evaluate our systems further. It is particularly difficult to objectively measure the enhancement of understanding that our visualisations deliver (in fact, this is a challenge faced in general for InfoVis, cf. [13]).

We hope that with these insights, we have stimulated a systematic approach to combining 2D visualisations of abstract data with realistic 3D visualisations. Combining these methods, as described in this paper, can allow the user to understand the bigger picture more easily, without sacrificing the strengths of the respective techniques used - a clear case of the sum being greater than the parts. In our future work, we will generate more examples of this combination and hope to be able to achieve an even tighter coupling and eventually provide a quantitative evaluation of the benefits.

References

1. Baldonado, M., Woodruff, A., Kuchinsky, A.: Guidelines for using multiple views in information visualization. In: Proceedings of the working conference on Advanced visual interfaces, pp. 110–119. ACM Press, New York (2000)
2. Butkiewicz, T., Chang, R., Wartell, Z., Ribarsky, W.: Visual Analysis and Semantic Exploration of Urban LIDAR Change Detection. In: Computer Graphics Forum, vol. 27, pp. 903–910. Blackwell Publishing, Malden (2008)
3. Card, S., Shneiderman, B., Mackinlay, J.: Readings in information visualization. Morgan Kaufmann Publishers, San Francisco (1999)
4. Goel, A., Baker, C., Shaffer, C., Grossman, B., Mason, W., Watson, L., Haftka, R.: VizCraft: A Problem-Solving Environment for Aircraft Configuration Design. Computing in Science and Engineering, 56–66 (2001)
5. Gresh, D., Rogowitz, B., Winslow, R., Scollan, D., Yung, C.: WEAVE: a system for visually linking 3-D and statistical visualizations, applied to cardiac simulation and measurement data. In: Proceedings of the conference on Visualization 2000, pp. 489–492. IEEE Computer Society Press, Los Alamitos (2000)
6. Husøy, K., Skourup, C.: 3d visualization of integrated process information. In: NordiCHI, pp. 497–498 (2006)
7. Jern, M., Johansson, S., Johansson, J., Franzen, J.: The GAV Toolkit for Multiple Linked Views. In: Fifth International Conference on Coordinated and Multiple Views in Exploratory Visualization, 2007. CMV 2007, pp. 85–97 (2007)

8. Keim, D.: Information Visualization and Visual Data Mining. IEEE Transactions on Visualization and Computer Graphics, 1–8 (2002)
9. Kosara, R., Sahling, G., Hauser, H.: Linking scientific and information visualization with interactive 3D scatterplots. In: Proc. WSCG Short Communication Papers, pp. 133–140 (2004)
10. Maple, C., Manton, R., Jacobs, H.: The use of multiple co-ordinated views in three-dimensional virtual environments, vol. IV, pp. 778–784 (2004)
11. North, C., Shneiderman, B.: Snap-together visualization: a user interface for co-ordinating visualizations via relational schemata. In: Proceedings of the working conference on Advanced visual interfaces, pp. 128–135. ACM, New York (2000)
12. North, C., Shneiderman, B., Plaisant, C.: Visual Information Seeking in Digital Image Libraries: The Visible Human Explorer. Information in Images (1997)
13. Plaisant, C.: The challenge of information visualization evaluation. In: Proceedings of the working conference on Advanced visual interfaces, pp. 109–116. ACM, New York (2004)
14. Rhyne, T.: Does the Difference between Information and Scientific Visualization Really Matter? IEEE Computer Graphics and Aplications, 6–8 (2003)
15. Rhyne, T., Tory, M., Munzner, T., Ward, M., Johnson, C., Laidlaw, D.: Information and Scientific Visualization: Separate but Equal or Happy Together at Last. In: Proceedings of the 14th IEEE Visualization 2003 (VIS 2003). IEEE Computer Society, Washington (2003)
16. Roth, S., Lucas, P., Senn, J., Gomberg, C., Burks, M., Stroffolino, P., Kolojejchick, J., Dunmire, C.: Visage: a user interface environment for exploring information. In: Proceedings of Information Visualization, pp. 3–12 (1996)
17. Ruhland, K., Bioletti, S., Sedlmair, M., O'Sullivan, C.: Libviz: Data visualisation of the old library. In: Proceedings of the 14th International Conference on Virtual Systems and Multimedia dedicated on Digital Heritage (October 2008)
18. Sedlmair, M., Hintermaier, W., Stocker, K., Büring, T., Butz, A.: A dual-view visualization of in-car communication processes. In: Proceedings of the 12th International Conference on Information Visualization (July 2008)
19. Sedlmair, M., Kunze, B., Hintermaier, W., Butz, A.: User-centered Development of a Visual Exploration System for In-Car Communication. In: 9th International Symposium on Smart Graphics, SG 2009, Proceedings, Salamanca, Spain, May 28-30 (2009)
20. Tory, M., Möller, T.: Human factors in visualization research. IEEE Transactions on Visualization and Computer Graphics 10, 72–84 (2004)
21. van Wijk, J., van Selow, E.: Cluster and calendar based visualization of time series data. In: Proceedings of the 1999 IEEE Symposium on Information Visualization, p. 4. IEEE Computer Society, Washington (1999)

Part-II
User Studies

Evaluation of Alternative Label Placement Techniques in Dynamic Virtual Environments

Stephen D. Peterson[1], Magnus Axholt[1], Matthew Cooper[1],
and Stephen R. Ellis[2]

[1] Linköping University, SE-601 74 Norrköping, Sweden
{stepe,magax,matco}@itn.liu.se
[2] NASA Ames Research Center, Moffett Field, CA 94035-1000, USA
sellis@mail.arc.nasa.gov

Abstract. This paper reports on an experiment comparing label placement techniques in a dynamic virtual environment rendered on a stereoscopic display. The labeled objects are in motion, and thus labels need to continuously maintain separation for legibility. The results from our user study show that traditional label placement algorithms, which always strive for full label separation in the 2D view plane, produce motion that disturbs the user in a visual search task. Alternative algorithms maintaining separation in only one spatial dimension are rated less disturbing, even though several modifications are made to traditional algorithms for reducing the amount and salience of label motion. Maintaining depth separation of labels through stereoscopic disparity adjustments is judged the least disturbing, while such separation yields similar user performance to traditional algorithms. These results are important in the design of future 3D user interfaces, where disturbing or distracting motion due to object labeling should be avoided.

Keywords: Label placement, user interfaces, stereoscopic displays, virtual reality, visual clutter.

1 Introduction

Label placement is a well-known problem within the field of cartography [4]. One of the primary design principles in static map labeling is to minimize the amount of overlap between text labels and graphical features, including other labels [17]. This principle prevails also for real-time label placement algorithms in 3D environments such as Augmented and Virtual Reality (AR/VR); each label's 3D placement is adjusted so that its 2D projection on the view plane does not overlap other labels and features [2,3,14,15].

Such view plane-based algorithms (hereafter named "planar" algorithms) are often successful in finding label placements without overlap. However, since the label placement around each object is arbitrary, spatial correlation of labels and objects they designate can become contradictory and confusing [11]. Moreover, labels in a scene with moving objects will constantly rearrange, producing potentially disturbing motion in the view plane.

A. Butz et al. (Eds.): SG 2009, LNCS 5531, pp. 43–55, 2009.

An alternative approach to external labeling is to restrict label motion to one dimension, for example in height along the display's y-axis [5,10]. If labels undergo vertical motion only, the spatial correlation between labels and objects improve since they always share the same x-coordinate. View plane motion is not eliminated however, just limited to the vertical domain; furthermore, this approach cannot prevent labels from overlapping other label lines.

Yet another approach using one-dimensional motion is to move labels in stereoscopic depth only. In this way, label motion in the view plane is avoided entirely. Labels will overlap as objects move; however, the difficulty of reading such overlapping labels is alleviated by separating the labels in stereoscopic depth [12,13], utilizing the clutter-breaking characteristics of stereography [8].

A previous user study found that planar label placement, in contrast to depth placement, may impair spatial judgment in a static virtual environment [11]. The experiment reported in this paper extends those results by evaluating how label motion affects performance in a dynamic virtual environment. We instantiate this label placement problem in an air traffic control (ATC) application, where the user, acting as an air traffic controller, observes simulated airport traffic from a control tower viewpoint. Label placement is one of the key problems when applying AR and VR technologies to ATC operations or training. Aircraft must be unambiguously and continuously labeled, while they move around in complex traffic patterns; furthermore, label motion must not be disturbing, distracting or break existing workflows [1].

2 Related Work

Label placement algorithms have previously been evaluated for AR environments. Azuma evaluated three planar label placement algorithms against a control condition, with random label placements, and a non-interactive algorithm which would generally produce optimal placements [2]. The algorithms were evaluated both numerically and in terms of user performance. One of the three real-time algorithms, a novel cluster-based algorithm, was found to yield the best average placement at low computation cost. However, it produced slightly more frequent label movements and erroneous responses than the other two algorithms. A relationship between motion frequency and error rates could not be established in that study: The non-interactive algorithm, adaptive simulated annealing, produced much more frequent label movements than all other algorithms, yet did not lead to degraded user performance.

The perceptual effects of text motion on computer monitors received much research attention when personal computers became commonplace in the early 80's. For unidirectional text motion (scrolling), large jump sizes were found to improve comprehension compared to small (one or two character) jumps [6]. Later experiments showed that continuous (pixel-by-pixel) movement was better than jumps of one or more characters, producing comprehension similar to static text [9]. This early research does indicate that frame-to-frame coherence of moving text is important for legibility.

3 Label Placement Algorithms

This section describes the label placement algorithms used in this experiment: two algorithms utilizing the planar separation technique, one using height separation, and one using depth separation. Figure 1 shows examples of these algorithms in the experimental environment.

The default label placement was, for all label placement algorithms, 1.7 degrees of visual angle above each object on the screen. The labels were by default placed in one depth layer at 25 m distance from the user, corresponding to the distance to the background objects in the virtual environment.

3.1 Planar Separation

With planar label separation, a label may be placed in any direction in the view plane around the object it designates, with a label line connecting the object and label. In this experiment we implemented two algorithms using planar label placement from [2]: the greedy depth-first algorithm, because it was found to produce the least motion in that experiment, and the clustered algorithm, because it produced the least amount of label overlap.

The clustered algorithm identifies groups of labels, clusters, of transitively overlapping labels. These clusters are treated in order of descending size, and a

(a) Planar separation

(b) Height separation

(c) No separation

Fig. 1. Examples of (a) planar and (b) height separation, along with the (c) control condition without separation. Depth separation is no different from (c) in this 2D paper medium, but in a stereoscopic display these overlapping labels are separable due to their placement in distinct depth layers.

fixed maximum (50 in our implementation) number of random label placements are evaluated for each cluster. By using a fixed number of random placements in this way, the algorithm escapes certain local minima common to other algorithms that optimize label placements without stochastic processing; furthermore it is guaranteed to complete within a certain computation time.

The greedy algorithm iterates all labels in a priority order which is randomized for each iteration. If a label is in an overlap situation, new label positions with $10°$ separation are evaluated. When all 36 positions have been evaluated, the best is chosen. If a position with zero cost is found, it is immediately accepted and the next label processed. Our implementation differs slightly from Azuma's implementation in that the search alternates in the clockwise and counter-clockwise directions from 0 to $±180$, instead of only searching clockwise from 0 to $350°$. In this way, the algorithm checks the farthest position ($±180°$) last; it is thus more likely to find a new zero-cost placement closer to the original position, minimizing label motion.

Our implementations of these algorithms use the same overlap computation, cluster identification and cost metrics as detailed in [2]. However, we implemented a slightly different technique for label rendering. Azuma renders a label line of constant length, and places the label to the right or left of the label line, depending on the angle. This causes labels to jump between right and left positions when the label line passes the extreme vertical positions, directly above or below the object. Since our current evaluation also compares animated and instantaneous motion (see the section on Independent Variables) we need to guarantee that animated label motion never produces such jumps at any label position. We therefore make the label center follow an elliptical path (semi-major axis = 1.20, semi-minor axis = 0.72) when moving around the object in the view plane; furthermore we allow label line connections on the center of any label edge, not only the right or left. In this way, a label can move around its object with constant label-object spacing and without text jumps; only less salient label line jumps can occur.

3.2 Height Separation

In the implemented height separation algorithm the label line length is variable and may overlap other labels; however, the label and the object always share the same x-coordinate. The height placement algorithm iterates all labels in an order based on the objects' distance in the environment, from closest to farthest. If a label is in an overlap situation with another label, the one corresponding to the farthest object is raised in increments of half a label height (0.5 degrees of visual angle) until a placement without overlap is found. In this way, the farthest objects will be annotated with the topmost labels, minimizing the overall label line length and label-label line overlaps in the scene. The end result is comparable to the label stacking method in [5], as well as interval-slot view management [10].

3.3 Depth Separation

A label placement algorithm that manages label separation in stereoscopic depth was implemented. The algorithm, fully described in [11], places overlapping labels in distinct depth layers between the observer and the observed objects. The layers are separated by 5 arcminutes of stereoscopic disparity, which was found optimal for our viewing conditions [12]. The depth placement algorithm iterates all labels in an order based on the objects' distance in the environment, from farthest to closest. If the labels of two objects overlap, the label of the closest object is moved to the next depth layer where no overlapping label is found. Such overlap relationships are managed in overlap chains, detailed in [11]. Labels of closer objects in the virtual environment are placed in closer depth layers, to avoid potentially confusing contradiction of depth cues [13].

4 Experiment

4.1 Task and Procedure

The task of each experimental trial was to count the number of target objects in a designated target area within the virtual environment. The target area was defined in the experiment instructions as the part of the environment located behind a horizontal blue line rendered on the ground plane (depicted in figure 1). The target objects were defined by a three letter identifier: An object would be considered a target if the first three letters in its label matched the identifier. Target objects outside the target area were excluded from the count, as were non-target objects within the target area.

Each trial was initialized with only the target identifier being displayed on the screen. The trial was subsequently started by pressing any key on the keyboard: the virtual environment was rendered on the display, and the objects started moving according to the recorded traffic pattern. In the same instant the objects and labels appeared, a timer was initialized. When counting was completed, the virtual environment was removed and the timer stopped by pressing any key on the keyboard. The response was entered by pressing the arrow keys until the correct number was displayed on the screen. By pressing any key again, the response and timer data was recorded and the next trial was started.

The scenarios used for the trials were randomly selected from a set of nine scenarios of similar characteristics: In each scenario there were 14-19 objects present, out of which 7-11 were located in the target area. The objects in the target area were assigned as targets randomly. The average number of target objects recorded was 3.1 (SD=1.4), and the maximum number was 8.

Each label consisted of six characters, a three-letter identifier {AIB, AFR, AFL} followed by three randomized numbers making each label unique. Because of randomization of label-target assignment, the participants could not recall labels and their location from a previous trial, thereby minimizing training effects due to scenario familiarity.

The objects on the ground plane followed a simulated airport traffic pattern. Only a few objects were in motion at any given point in time, typically 3-6, and the fastest objects moved with a speed of 0.4 degrees of visual angle per second. Each of the nine scenarios contained 20 seconds of simulated data. During this time the total number of objects in the target area remained constant, to preserve a single correct response within a trial.

Each participant was given written instructions before the experiment. The stereoscopic display was calibrated for each participant using the measured inter-pupillary distance from an Essilor digital pupilometer. Before the experimental trials, ten test trials were given during which participants were accustomed to the task and screened for stereoscopic depth perception. Each participant completed 90 trials divided into two blocks, with a break in between. After completing the trials, a written questionnaire was given. The total time including preparations, experimental trials and questionnaire was approximately 45 minutes per participant.

4.2 Participants

Twelve voluntary participants were recruited for this experiment, nine male and three female. Ages ranged from 28 to 61, with median age 38. We used balanced age subgroups, since visual accommodation has substantially degraded after age 40: six subjects were 28-39 years old, and six 40 or above.

All participants completed the Randot stereo acuity test, with a required retinal disparity of 1 arcmin or better.

4.3 Hardware Setup

Two 6500 ANSI lumen projectors equipped with linear polarization filters provided passive stereo imagery in XGA resolution on a 1.00×0.78 m projection screen. Each participant was seated on a stool 2.0 m in front of the screen, yielding a pixel size of 1.6 arcmin and a $28.1° \times 21.9°$ field-of-view. The room was darkened, and the windows covered with opaque plastic film. The projectors were driven by an NVIDIA Quadro FX 4500 graphics card on a dual Intel Xeon workstation running Ubuntu Linux.

The experimental code was written in C++ using OpenSceneGraph for scenario construction and VR Juggler for configuring the virtual environment. No head tracking was implemented since the participants remained stationary and relatively distant from the screen.

4.4 Independent Variables

Label Placement Algorithm. In addition to the four algorithms previously described, we included a control condition where labels stayed fixed in the default position.

Frequency. The label placement algorithms were running at $1/2$, 1 or 2 Hz.

Motion Type. Labels would either relocate to new positions instantly, with one single jump, or using an animated motion for a gradual transition.

In the case of animated motion, the labels had to reach their new positions before the next run of the placement algorithm. Thus, the time during which labels were transitioning between positions was 2, 1 and 0.5 seconds, respectively, for the frequencies $1/2$, 1 and 2 Hz. Intermediate label positions for animated motions were linearly interpolated; however, the speed followed a cosine function $(-\pi \leq t \leq \pi)$, which yielded smooth transitions with slow initial and final stages of motion.

4.5 Dependent Variables

We measured the duration from the instant each trial was started, until a response was given. As mentioned in the Task section, the scenarios were 20 seconds long. If no response was given within this time period, the trial timed out and the response time was capped at 20 seconds.

We also measured the response error, i.e. the absolute difference between the actual number of target objects in the scene and the provided response.

4.6 Experimental Design

Each participant saw all combinations of the independent variables in a repeated measures within-subjects design, where each combination was repeated three times. In total 1080 recordings of response time and response error were made, 90 per subject (5 label placement algorithms × 3 frequencies × 2 motion types × 3 repetitions).

5 Results

5.1 Response Time

We treated timeouts as correct responses, since the participants would likely have responded correctly had more time been given. Erroneous responses were however excluded from the analyses of response time.

Using analysis of variance (ANOVA) we found that the main effect of label placement algorithm on response time was significant $(F(4, 44) = 13.4, p < 0.001)$. Post-hoc Scheffé comparisons showed that all label placement algorithms were significantly faster than the control condition; however, the means of the different label placement algorithms were not found to be significantly different $(\alpha = 0.1)$. The bar chart in figure 2 shows the mean response times for each label placement algorithm.

In addition, our analysis showed a significant main effect of motion type on response time $(F(1, 10) = 9.83, p < 0.05)$. Instantaneous movements were only moderately faster than animated, 0.44 s or 4.8% on average, although this difference was found to be statistically different.

Our analysis showed no other main or interaction effects on response time.

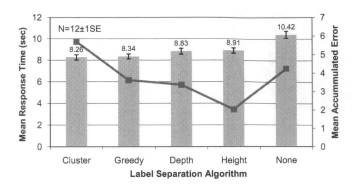

Fig. 2. The bar chart (primary y-axis) shows the mean response times. The line (secondary y-axis) shows mean accumulated error per experimental run.

5.2 Response Error

The mean error rate, the ratio of erroneous judgments, was 17.1%. For the erroneous trials the mean error magnitude, the absolute difference between the correct and given response, was 1.22.

Six timeouts were recorded during the 1080 trials, four of these in the control condition. This grouping could not be statistically confirmed using a contingency table. Indeed, the low timeout rate, 0.6%, confirms that 20 seconds was an appropriate upper time limit for each trial.

A non-parametric Friedman test showed a significant main effect of label placement algorithm on response error ($\chi^2(4) = 15.3, p < 0.01$). Using the Wilcoxon signed rank test for pairwise comparisons of conditions, we found that the algorithm for clustered planar separation generated greater error than greedy planar separation (Wilcoxon statistic $= 4.0, p < 0.05$), depth separation (Wilcoxon statistic $= 61.0, p < 0.05$), and height separation (Wilcoxon statistic $= 0.0, p < 0.001$). Height separation also generated significantly reduced error compared to the control condition without label separation (Wilcoxon statistic $= 2.0, p < 0.05$). The greedy planar, depth, and height separation algorithms were statistically indistinguishable from each other. The line in figure 2 shows, per label placement algorithm, the mean accumulated error. That is, the amount of error generated by each subject, on average, over the course of the experiment.

Update rate showed no significant main effect on response error ($\chi^2(2) = 1.17, ns$), neither did motion type (Wilcoxon statistic $= 31.0, ns$).

5.3 Impact of Label Motion

As described in the Independent Variables section, the time during which labels were in motion between old and new positions is 2, 1 or 0.5 s respectively. We are interested in the actual speed reached by labels on the display, since motion

Table 1. Average speed of a label in motion at the maximum and minimum label movement distance for each label separation technique. For planar and height separation, the values are in degrees of visual angle on the screen as seen by the participants. For depth separation, the values are in arcminutes of stereoscopic disparity between left and right eye images.

| | Planar (any type) | | Height | | Depth | |
	$10°$	$180°$	1 height layer	10 height layers	1 depth layer	5 depth layers
$1/2$ Hz	$0.15°/s$	$2.78°/s$	$0.21°/s$	$2.10°/s$	2.50 arcmin/s	12.5 arcmin/s
2 Hz	$0.62°/s$	$11.1°/s$	$0.82°/s$	$8.20°/s$	10.0 arcmin/s	50.0 arcmin/s

of higher speed could be more disturbing. Since time is given, we get the label speed by calculating the path length for each label movement.

The smallest label movement with a planar separation algorithm, $10°$, corresponds to $0.31°$ of visual angle on the screen. The corresponding value for one height layer is $0.41°$ of visual angle. The smallest depth motion is between two adjacent depth layers, 5 arcminutes. Table 1 shows the average speed of label motion for the shortest and longest recorded movement distance, grouped by the lowest and highest frequency, for each label separation technique.

In order to make analyses on how label motion affected performance, we computed the total label motion per second for the labels in each trial. Using χ^2 contingency tables we calculated how the errors were distributed among trials with moderate and intense label motion, with the median speed serving as threshold. Table 2(a) presents the contingency tables for each label placement algorithm, based on motion data from all labels present in the display. Our subsequent analysis showed that only the clustered planar label placement was significantly affected by motion (see table for χ^2 value); trials with little motion generated significantly less erroneous responses.

Table 2. χ^2 contingency tables showing the number of trials with correct and erroneous responses, grouped by motion magnitude, for each label separation method. All labels are included in the motion calculation in (a), while only target labels are included in (b). Significant effects are denoted with (*).

(a) All labels

| | Clustered * | | Greedy | | Depth | | Height | |
	Corr	Err	Corr	Err	Corr	Err	Corr	Err
Moderate	86	18	88	14	89	17	93	10
Intense	73	30	82	19	85	21	94	9
$\chi^2(1)$	4.06 ($p < 0.05$)		0.96 (ns)		0.51 (ns)		0.06 (ns)	

(b) Target labels only

| | Clustered * | | Greedy * | | Depth | | Height * | |
	Corr	Err	Corr	Err	Corr	Err	Corr	Err
Moderate	87	16	92	9	91	14	99	4
Intense	72	32	78	24	83	24	88	15
$\chi^2(1)$	6.74 ($p < 0.01$)		7.97 ($p < 0.01$)		2.98 (ns)		7.02 ($p < 0.01$)	

Further analysis only looking at target label motion (table 2(b)) showed that motion had a significant impact on user performance for all label placement algorithms with view plane components (clustered/greedy planar and height separation). The depth placement algorithm is thus the only one where no significant correlation between label motion intensity and task difficulty could be found, both when looking at the entire visual scene and the specific target labels.

5.4 Questionnaire

In the post-exercise questionnaire the participants responded to questions using a five-point Likert scale. First, each participant rated a number of factors that might have adversely affected the overall performance (figure 3(a)). None of the factors received a median severity rating above 2 on the five-point scale, indicating that our experimental setup and task were not excessively straining or uncomfortable.

Reading labels with depth separation was judged slightly more difficult than with planar and height separation (figure 3(b)), but the differences were not statistically significant (Wilcoxon statistic $= 10.5, ns$).

The motion produced by the depth separation algorithm was judged significantly less disturbing than both height (Wilcoxon statistic $= 33.5, p < 0.05$) and planar separation algorithms (Wilcoxon statistic $= 45.0, p < 0.01$); median values were 1 and 2 points lower, respectively, on the five-point scale (figure 3(c)). Furthermore, height separation was judged significantly less disturbing than planar (Wilcoxon statistic $= 42.5, p < 0.05$).

When asked about the preferred motion type, all participants except one preferred animated motion over instantaneous. This preference was found to be significant ($\chi^2(1) = 3.94, p < 0.05$).

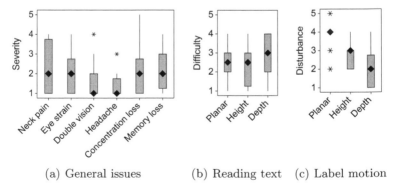

(a) General issues (b) Reading text (c) Label motion

Fig. 3. Post-exercise questionnaire ratings. In these Tukey [16] boxplots the median value for each factor is indicated with a diamond, the interquartile range is represented by a grey box, outliers are indicated with asterisks, and the largest non-outlier observations are indicated through whiskers.

6 Discussion

Figure 4 shows that the average number of labels moved per second is, depending on its running frequency, 2.5 to 4.3 for the clustered planar algorithm, 2.1 to 2.9 for the greedy planar algorithm, 1.9 to 2.2 for the height algorithm, and 1.0 to 1.2 for the depth algorithm. The relatively high values for the clustered algorithm may be due to the fact that labels are moved in clusters, which sometimes will produce movement of labels not originally in overlap [2]. When comparing the average cost (the amount of overlap produced) per iteration, the greedy planar algorithm yields 1.04 while the clustered yields 0.84. The lower average cost and the larger average number of labels moved per second indicates that the clustered algorithm can more often produce a better overall label placement, at the cost of a larger number of label movements.

Out of the evaluated label placement algorithms, the clustered planar algorithm yielded significantly more errors overall; furthermore it was the only algorithm where intense motion of both target and non-target objects produced significantly higher error rates. We therefore believe that the clustered planar algorithm is better suited for interfaces with less background motion, and that, even though producing slightly more overlap, the greedy algorithm is a better planar label placement algorithm for highly dynamic scenes. We employed many measures to reduce the motion amount and saliency of the planar label placement algorithms, namely i) eliminating label jumps at extreme top/bottom positions, ii) smoothening motion using acceleration scheme and iii) making the greedy algorithm prioritize smaller movements. Nevertheless, depth movements in particular, but also height movements, were judged much less disturbing in the post-exercise questionnaire. The depth and height separation algorithms could therefore be better options for highly dynamic scenes, where the user must not be unnecessarily disturbed or distracted.

Initially we theorized that animated label motion would yield better performance than instantaneous. However, the response time data analysis revealed the opposite; instantaneous label motion produced significantly faster response times than animated. We believe this may be due to the fact that labels are difficult to read while moving, and if they relocate instantly they can be immediately read

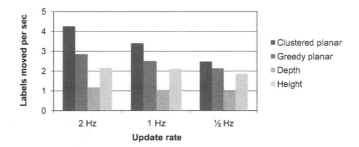

Fig. 4. Labels moved per second for each label placement algorithm and frequency

in the new location. Response errors were in general not significantly different for the two motion types. Interestingly, while instantaneous motion produced slightly faster responses, participants rated animated motion significantly less disturbing.

7 Conclusion and Future Work

This study has compared four different label placement algorithms in a virtual environment with many moving objects. We have found that a label placement algorithm that maintains depth separation of overlapping labels produces significantly less disturbing motion than traditional algorithms separating labels in the view plane. It does so while providing similar performance improvement in terms of response time over the control condition in a visually demanding search task. While the depth separation algorithm produced slightly more errors than the height separation algorithm, the difference was not found to be significant. Interestingly, depth separation was the only technique not statistically affected by the intensity of motion; the algorithms separating labels in the view plane produced significantly larger error during trials with intense label motion.

These results provide empirical evidence that an algorithm that maintains depth separation of labels is an alternative to traditional label placement algorithms in stereoscopic display environments; it may even be the better option in visually cluttered scenes with many moving objects.

Future extensions to this work could include different types of tasks; while the visual search and counting task used here is appropriate for measuring readability and disturbance during motion, an observation and monitoring or detection task could be envisioned for measuring distraction and effects on visual attention. Such a study could be aimed at establishing thresholds for motion, so that label rearrangement in the view plane can be performed without distraction. One may wish to study depth motion as well; however, as seen in the current study, the intensity of depth motion did not affect performance and depth motion was not judged to be disturbing. This result indicates that depth motion, at least at the rates required for label separation, is not functionally distracting. Indeed, previous work has shown that such motion, albeit only using a very small visual feature, does not "pop out" from disparity noise [7].

A future study could also record eye tracking data, for analysis of search strategies and more in-depth studies of which types of label motion disrupts the user in a monitoring task.

References

1. Allendoerfer, K.R., Galushka, J., Mogford, R.H.: Display system replacement baseline research report. Technical Report DOT/FAA/CT-TN00/31, William J. Hughes Technical Center, Atlantic City International Airport, NJ (2000)
2. Azuma, R., Furmanski, C.: Evaluating label placement for augmented reality view management. In: Proceedings of IEEE/ACM International Symposium on Mixed and Augmented Reality (ISMAR 2003), Tokyo, Japan, pp. 55–75 (October 2003)

3. Bell, B., Feiner, S., Höllerer, T.: View management for virtual and augmented reality. In: Proceedings of the symposium on User Interface Software and Technology (UIST 2001), Orlando, Florida, pp. 101–110 (2001)
4. Christensen, J., Marks, J., Shieber, S.: An empirical study of algorithms for point-feature label placement. ACM Trans. Graph. 14(3), 203–232 (1995)
5. Cooper, M., Lange, M.: Interactive and immersive 3d visualization for atc. In: Proceedings of the 3rd Eurocontrol Innovative Research Workshop, Paris, France (2004)
6. Granaas, M.M., McKay, T.D., Lanham, R.D., Hurt, L.D., Juola, J.F.: Reading moving text on a crt screen. Human Factors 26, 97–104 (1984)
7. Harris, J.M., McKee, S.P., Watamaniuk, S.N.J.: Visual search for motion-in-depth: stereomotion does not pop-out from disparity noise. Nature Neuroscience 1, 165–168 (1998)
8. Holbrook, M.B.: Breaking camouflage: stereography as the cure for confusion, clutter, crowding, and complexity - three-dimensional photography. Photographic Society of America Journal 8 (1998)
9. Kang, T.J., Muter, P.: Reading dynamically displayed text. Behaviour & Information Technology 8(1), 33–42 (1989)
10. Maass, S., Döllner, J.: Efficient view management for dynamic annotation placement in virtual landscapes. In: Butz, A., Fisher, B., Krüger, A., Olivier, P. (eds.) SG 2006. LNCS, vol. 4073, pp. 1–12. Springer, Heidelberg (2006)
11. Peterson, S.D., Axholt, M., Cooper, M., Ellis, S.R.: Visual clutter management in augmented reality: Effects of three label separation methods on spatial judgments. In: Proceedings of the IEEE Symposium on 3D User Interfaces, Lafayette (LA), USA (March 2009)
12. Peterson, S.D., Axholt, M., Ellis, S.R.: Label segregation by remapping stereoscopic depth in far-field augmented reality. In: Proceedings of IEEE/ACM International Symposium of Mixed and Augmented Reality (ISMAR 2008), Cambridge, UK (September 2008)
13. Peterson, S.D., Axholt, M., Ellis, S.R.: Objective and subjective assessment of stereoscopically separated labels in augmented reality. Computers & Graphics 33(1), 23–33 (2009)
14. Rose, E., Breen, D., Ahlers, K.H., Crampton, C., Tuceryan, M., Whitaker, R., Greer, D.: Annotating real-world objects using augmented reality. In: Computer Graphics: Developments in Virtual Environments (Proceedings of CG International 1995 Conference), Leeds, UK, pp. 357–370 (June 1995)
15. Rosten, E., Reitmayr, G., Drummond, T.: Real-time video annotations for augmented reality. In: Bebis, G., Boyle, R., Koracin, D., Parvin, B. (eds.) ISVC 2005. LNCS, vol. 3804, pp. 294–302. Springer, Heidelberg (2005)
16. Tukey, J.W.: Exploratory Data Analysis. Addison-Wesley, Reading (1977)
17. Yoeli, P.: The logic of automated map lettering. The Cartographic Journal 9(2), 99–108 (1972)

TagClusters: Semantic Aggregation of Collaborative Tags beyond TagClouds

Ya-Xi Chen[1], Rodrigo Santamaría[2], Andreas Butz[1], and Roberto Therón[2]

[1] Media Informatics, University of Munich
Amalienstr. 17, 80333 Munich, Germany
{yaxi.chen,andreas.butz}@ifi.lmu.de
[2] Department of Informatics and Automatics, University of Salamanca
Pz. de los Caídos, S/N, CP 37008, Salamanca, Spain
{rodri,theron}@usal.es

Abstract. TagClouds is a popular visualization for the collaborative tags. However it has some instinct problems such as linguistic issues, high semantic density and poor understanding of hierarchical structure and semantic relation between tags. In this paper we investigate the ways to support semantic understanding of collaborative tags and propose an improved visualization named TagClusters. Based on the semantic analysis of the collaborative tags in Last.fm, the semantic similar tags are clustered into different groups and the visual distance represents the semantic similarity between tags, and thus the visualization offers a better semantic understanding of collaborative tags. A comparative evaluation is conducted with TagClouds and TagClusters based on the same tags collection. The results indicate that TagClusters has advantages in supporting efficient browsing, searching, impression formation and matching. In the future work, we will explore the possibilities of supporting tag recommendation and tag-based Music Retrieval based on TagClusters.

Keywords: Improvement of TagClouds, collaborative tagging, visualization of tags, semantic analysis, tag recommendation, music retrieval.

1 Introduction

With the rapid growth of the next-generation Web, many websites allow the normal users to make contributions by tagging the digital items. This collaborative tagging has become a fashion in many websites and the most representative ones are the social bookmarking site Del.icio.us (http://delicious.com/), the photo sharing site Flickr (http://www.flickr.com/) and the music community Last.fm (http://www.last.fm). Their low technical barrier and easy usage of tagging have attracted more than millions of users. The user-contributed tags are not only an effective way to facilitate personal organization but also provide a possibility for the users to search for information or discover new things.

Currently, there are two ways for Music Retrieval based on tags. The first category is the keyword-based search, which is the most common way to seek information on

A. Butz et al. (Eds.): SG 2009, LNCS 5531, pp. 56–67, 2009.

the Web. The system will return all the information related to the keyword. The second one is a visualization-based method called TagClouds (as figure 1 shows). Due to its easy understandability and aesthetical presentation, TagClouds has become a fashion in many websites. However, it still has some intrinsic disadvantages and many researchers have been dedicated to improve its aesthetical presentation or better semantic understanding. In this paper, we explored how to improve the visualization of tags in Last.fm and to support the semantic understanding of structures and relations between tags which might lead to more success tag recommendation and visualization-based Music Retrieval.

In the remaining sections of this paper, TagClouds and its related works will be first discussed, and then the possibilities to improve semantic understanding of collaborative tags beyond TagClouds will be explored. A prototype named TagClusters and its evaluation will be presented. The discussions on the evaluation results and future work will conclude the paper.

2 TagClouds

TagClouds is a visual presentation of the most popular tags, in which tags are usually displayed in alphabetical order and attributes of the text such as font size, weight or color are used to represent features, for example, font size for prevalence and color brightness for recentness. As a result of collaborative tagging, the popular tags shown in TagClouds have more accurate meaning than that assigned by a single person. TagClouds draws attention to more important items and thus provides an overall impression and reflect the general interests among broad demography [5, 6]. With TagClouds a keyword-based search can be conducted with one selected tag as input.

There are a lot of works focusing on the factors influencing the visualization quality of TagClouds. Halvey *et al.* [1] assessed tag presentation by evaluating different factors which ease the finding of tags. They discovered that font size,

Fig. 1. TagClouds in Last.fm.

position and alphabetization can aid to find information more easily and quickly. Similar conclusions could be found in [2, 15]. Rivadeneira *et al.* [3] also stated the interesting discovery that large fonts are not definitely to be found easily.

2.1 Disadvantages of TagClouds

As revealed in [24], after 100 users indexed the same resource, each tag's frequency is a nearly fixed proportion of the total frequency of all tags assigned to the resource. This stability was also verified in [25, 26]. Although there is a relative stability among collaborative tagging, because of the free nature of tagging, the intrinsic problem with uncontrolled tags is that there are inevitable noise and redundancies [8, 9].

Linguistic problems with free tagging

Nielsen [7] found that different educational and cultural background might lead to the tag inconsistency which was also mentioned in [27]. Specifically, there are two common problems with free tagging systems which are difficult to avoid from the user's side: synonymy and ambiguity. Synonymy is also defined as "inter-indexer inconsistency" [7] and it happens when different indexers use different terms to describe the same item. Ambiguity means one term may have several meanings [10], which will generate noise in retrieval results. Although the social collaborative tagging could alleviate the problems of synonymy and ambiguity, as pointed out in [11], such problems still exist, for example, *hip hop* and *hip-hop* in figure 1.

High semantic density

As discussed in [9, 12], if all the visible tags are selected only by the usage frequency, there might be a problem of high semantic density which means very few topics and related prominent tags tend to dominate the whole cloud and the less important items fade out [6]. Therefore, a more reasonable selection method should be improved.

Poor understandability of structure and relation

Hassan and Herrero [9] claimed that the alphabetical arrangements neither facilitate visual scanning nor infer semantic relation between tags. In the evaluation of Hearst *et al.* [6] a significant proportion of interviewees did not realize that tag clouds are regularly organized alphabetically. They discovered that the users have difficulty to compare tags with small size and to derive semantic relations. There might be wrong relation interpretation with items placed near to each other. Therefore TagClouds is not suitable for understanding of structure and relation.

2.2 Improvements

There are abundant works focusing on the improvements of TagClouds to support better aesthetic visualization and semantic understanding.

Enhancements of TagClouds

Regarding the aesthetic issue, since some factors might influent the effectiveness of visualization, some systems have already allowed the user to adjust these parameters and the representative systems are PubCloud [13] and ZoomClouds [14].

Tight coupling [16] addressed in improving the quality of TagClouds by introduction of spatial algorithms to pack the text in the visualization tighter. Kaser and Lemire [17] used electronic design automation (EDA) to improve the display of tag clouds to avoid large white space. Seifert *et al.* [18] proposed a series of algorithms which can display tags into arbitrary convex polygons with dynamical adaptive font size.

The clustering algorithms were applied to gather semantic similar tags. In [9] the k-means algorithm was applied to group semantic similar tags into different clusters. Similar work can be found in [19]. Li *et al.* [8] supported browsing of large scale social annotations based on analysis of semantic and hierarchical relations. The user profile and time factor can be integrated for personalized or time-related browsing [7].

Different visualizations for tags
Bielenberg and Zacher [20] proposed a circular layout in which the font size and the distance to the center represent the tag importance. Shaw [21] visualized the tags as a graph where edge represents the similarity. TagOrbitals [23] presented tags with relations and summary information in an atom metaphor where each primary tag is placed in the center and other related tags are placed in surrounding bands. The main problem with this visualization is the orientation of texts.

Most the methods discussed above are static visualizations and lack of interactions. Furthermore, the low level sub-structures are still needed to be deeper explored which will help to form a better understanding of hierarchical structure and relations.

3 TagClusters: Support Semantic Understanding of Tags

As we discussed above, TagClouds has instinct linguistic problems and it is difficult to understand the relation and structure between tags. In this paper, we have choosen the tags in Last.fm as the experimental source. We explore the problems with TagClouds in Last.fm and investigate the possibilities to improve the semantic understanding of tags.

3.1 Research Issues

The key issues in our research are the semantic aggregation to support efficient hierarchical browsing and relation understanding. We believe that if all the tags are organized in a more understandable semantic way, it will be more helpful for tag recommendation and tag-based Music Retrieval.

Semantic aggregation
Based on the text analysis, the synonym issue can be controlled by grouping semantic similar tags into one cluster, for example, *favorite* and *favorites*, *rock and roll* and *rock n roll*. The semantic aggregation also helps to alleviate the problem of ambiguity. For example, fewer users know that "electronic" and "IDM" present roughly the same genre. Within the visualization of TagClusters, the user can see these two tags are grouped into the same cluster which means they have same meaning. This is also an efficient way to help the users gain some music knowledge.

Hierarchy exploration and relation visualization
We explore the implicit hierarchical structure hidden inside the free input tags. With such structure, the user can have a better understanding of tags, especially genre-related categories. Following the top-down fashion, the user can search more specifically with less ambiguity problems. With the highlighting of the overlapped part, the user can tell the relation between tags in a high semantic level.

Possible applications based on TagClusters
Based on the hierarchical structure of TagClusters, there might be potential usages such as tag recommendation and tag-based music retrieval. Once the hierarchical structure of tags is derived, the user can get useful tag suggestions while avoiding spelling error and redundancy effectively. Genre is one of the most common criteria for music organization and retrieval [29], however, there is no standard definition of genre. For the tag recommendation, the system should offer possible suggestions for the user instead of generating them automatically. For example, if the user types in "electronic", the system should prompt possible tags such as "IDM". When the semantic similar tags are grouped hierarchically, it facilitates tag-based searching and the system can return richer relevant retrieval results.

3.2 TagClusters User Interface

TagClusters is implemented based on Overlapper [28], a visualization tool focused on the connections and overlappings in data. TagClusters is an interactive interface where tags are drawn as labels with different sizes like in TagClouds, and tag groups are drawn as transparent colored areas (see figure 2). TagClusters uses the underlying structure of Overlapper, based on a Force-Directed Layout that does not use a typical node-link approach, but a Venn-diagram approach in order to represent groups and group relationships. The initial placement and label size of tags are not random, but coherent with tag co-occurrence (see section 4.2). Therefore, TagClusters can be described as a TagClouds where position is semantic relevant and the visualization is reinforced by group wrappers. These characteristics exploit the user perception abilities for traceability and group detection, improving the visual analysis.

In addition, the interface offers several options to the user: pan and zoom without losing context, hide/show tags and groups, modify label sizes, search tags by text, modify underlying forces, export the visualization, etc. The system also offers multiple options for tag selection which might facilitate the tag-based Music Retrieval. For example, the user can choose multiple tags or groups by combination of keyboard and mouse. He/she can also draw a shape manually and all the tags included in this shape will be selected.

Since most of the popular tags are genre-related and the relevant groups are overlapped with each other, the genre-related groups are placed in the center and other less semantic related tags and groups are scattered in the non-central space. Within a group, related tags will be further grouped into sub-groups. Groups are represented as transparent colored areas, so the overlapped groups (groups that share one or more tags) will have intersecting, more-opaque areas, thus highlighting overlapping tags. With such visualization, the user can have a better understanding of structure and

relation between tags. For example, in Figure 2, we can see that *rock* is the most relevant category and related to several others, such as *pop* and *punk*. Also we find several genres that relate to *metal* and *rock* at the bottom of the figure.

Fig. 2. TagClusters visualization with the same tag collections in figure 1

4 Underground Semantic Analysis

The organization of tags in TagClusters is based on a semantic analysis which determines the structure and position for each tag. Firstly we applied text analysis to create the hierarchical structure while excluding redundancy. Then we determine the initial position for each tag based on the semantic similarity calculation.

4.1 Text Analysis Based Clustering

After observation of TagClouds shown in figure 1, we found that synonymy is the most prominent problem with the texts which might be caused by single/plural such as "female vocalist" and "female vocalists". The different spelling habits always lead to redundancy, for example, "favorite" and "favourite". Besides, people tend to add different separations between the same words, for example, "post-rock" and "post rock", "rock and roll" and "rock n roll".

In Last.fm, all the tags especially the genre-related tags have a characteristic feature: the tag in lower semantic level always contains the tag in the higher level and the length of tag is proportional with its semantic level, for example, "death metal" and "brutal death metal". This feature helps to derive the hierarchical structure.

In our system, after removal of different separators, such as "_" and "&", the Porter algorithm [30] is applied to detect the stem for each tag. Tags with the same stemmed

words will be clustered in the same group. Within one group, tags with similar semantic meanings will be further clustered into sub-groups. For example, all the tags containing "metal" will be grouped in the Metal group and related tags such as "death metal" and "brutal death metal" will be placed in a sub-group (see figure 3); all the tags related to gender will be clustered in a vocal group and similar for the time-related tags, such as "80s" and "00s" (see left part of figure 2). After the text analysis, most of the tags can be effectively grouped into the relevant cluster. We also found that this basic technique should be further enhanced to solve the literal similar but actually irrelevant tags such as *classic* and *classic rock*.

Fig. 3. Examples of text analysis results

4.2 Calculation of Semantic Similarity

After deriving the hierarchical structure of tags, the semantic similarity is calculated based on the co-occurrence. Co-occurrence is widely used in the field of Music Retrieval to determine the semantic relation between information items [7, 27]. In the tag case, this semantic similarity equals to the division between the number of resources in which tags co-occur and the number of resources in which any of the two tags appears [7, 9], as equation 1 shows.

$$RC(A,B) = |A \cap B| / |A \cup B| \tag{1}$$

With the semantic analysis all the tags will be well organized: the initial location of each tag is assigned by means of a 2D projection based on a multidimensional scaling of co-occurrences. The genre-related tags, which might be the most useful category for tag-based searching, become prominent in the visualization. Other categories such as time- or emotional-related categories are scattered because of the less semantic relationship with the genre category. Instead of exclude them from the visualization,

these categories still remain in the visualization and can be inspected by browsing or keyword-based searching.

5 Evaluation

To evaluate TagClusters, we recruited 12 participants at the University of Munich, 7 German from the Media Informatics Group and 5 foreigners from other groups, 4 female and 8 male with a mean age of 27 years. All participants are generally experienced with computers. We conducted a comparative evaluation of TagClouds and TagClusters. The evaluation was task-oriented and the participants were required to conduct 6 tasks concerning searching, browsing, impression formation and matching. Each task is consisted of two similar sub-tasks and the following is a brief description of the representative tasks.

Task 1: Locate one single item: Find a tag named "german".
Task 2: Tag sorting: list the top 5 popular tags.
Task 3: Tag comparison and filtering: list the top 5 genre-related tags.
Task 4: Derive group structure: give a hierarchical structure for the Metal-related tags.
Task 5: Find relation between tags: is there overlap between Indie and Classic?
Task 6: Judge the tag similarity: is Alternative more similar to Rock or Electro?

5.1 Quantitative Analysis

The complete time and the answer precision for both systems are shown in figure 4.

For task 1, although the tags in TagClouds can be located by the alphabetical order, locating the first character still needed some time. Furthermore, 25% of the participants did not realize that TagClouds are ordered alphabetically thus they spend more time to locate one tag. The participants claimed that the searching functionality in TagClusters helped to locate the item quickly.

TagClouds performed better with task 2 and 3. It contains all the tags in a small graph and it is easier to scan and locate tags without panning or zooming. To present all the tags as the concept of group and describe the similarity between tags as spatial distance, TagClusers needs more space and thus creates a larger graph in which the participant had to keep panning and zooming to get a complete overall impression. To form the correct impression, the participant also needed to mentally compare and memorize the relevant information which might slow down the response time and answered with lower precision.

TagClusters worked significantly better with task 4. Since the tags are hierarchically organized and semantic similar groups are placed near to each other, it is easy to find the structure. With TagClouds, the semantic similar tags might be placed scattered all over the graph, the participants had to scan all the tags and to form a structure mentally which spend much more time and led to lower precision. To derive the complex structure for Metal-related tags (as figure 4 shows), the participants spent much more time with TagClouds while received lower precision with the answers.

Since the semantic similar tags are hierarchically grouped and the overlapped part is visually highlighted, it is easier to determine the relation between tags. TagClusters worked better with task 5 and 6 which need understanding of semantic relation of tags.

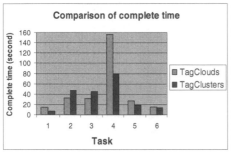
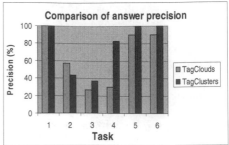

Fig. 4. Comparison of complete time and correctness

After completed each task, the participants were asked to score the easiness of each task and the usefulness of both systems. The result is shown in figure 5.

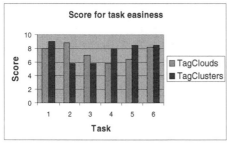
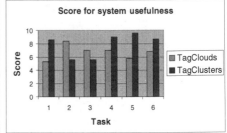

Fig. 5. Comparison of task easiness and system usefulness

The participants scored higher for TagClusters except for task 2 and 3, which is consistent with the result in figure 5. It implies that we should take better usage of the space in TagCluster in order to create a smaller and more efficient visualization.

After completing all the tasks, the participants filled out a post-questionnaire which concerns the overall impression of both systems in the aspects of enjoyment, understandability, helpfulness and aesthetical beauty. TagClusters was scored better with all the criteria (as figure 6 shows).

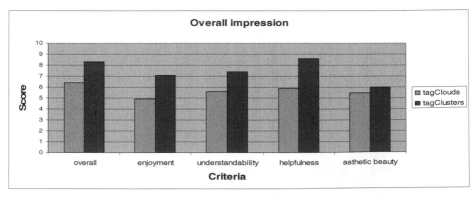

Fig. 6. Overall impression of both systems

5.2 Qualitative Analysis

Visualization issue

For TagClouds, the alphabetical order is useful when the user has an specific tag in mind. However, the user who is unfamiliar with this visualization tends to ignore this feature. Although the tags with bigger font size are easier to be noticed which is helpful to get the information of popular tags, the tags with smaller size might be ignored. The position is also a crucial factor to draw the user's visual attention. Some user claimed that top half part of TagClouds seems to be more prominent and they tend to ignore the bottom half. In order to get a compact view and take usage of space effectively, the system truncated the tag with long length into separate lines which might lead to misunderstanding. For example, in the first line of figure 1, alternative rock is placed into 2 lines and some participants were confused.

By grouping semantic similar tags, TagClusters helps to discover tags with small font size. For example, the rock-related tags with small font size might be ignored in figure 1 while still remaining relevance in figure 2 since they are clustered into the same group with the prominent Rock tag.

Semantic understanding

Without indication of semantic relation in TagClouds, some participants wrongly interpreted the semantic similarity as near position or similar font size. There is no semantic organization and sometimes the user has to scan all the tags line by line and might have problems with locating multiple tags in one time. Some participants even used mouse to locate viewed tag or staring at the screen while writing down the answers. Another problem is that the user who has less music knowledge might meet difficulties with judging the relation between some uncommon tags and it was a prominent problem with majority of the foreigner participants. With illustration of semantic structures in TagClusters they could conduct the same tasks easier.

For TagClusters, the participants also came up with some suggestions for the aesthetical issues in TagClusters, such as stronger highlighted effect, color coding for different tag categories and the desire for a more compact graph.

6 Conclusion

In this paper we investigate the ways to support semantic understanding of collaborative tags and propose a new visualization named TagClusters. We compare the performance of traditional TagClouds and our system and the results imply that our system has advantage in supporting semantic browsing and better understanding of hierarchical structure and relation between tags. The semantic organization of tags can exclude redundancy effectively and might facilitate the tag recommendation and tag-based music retrieval which will be explored in our future work.

Acknowledgement

This research was funded by the Chinese Scholarship Council (CSC), the German state of Bavaria and the Spanish Ministerio de Educación y Ciencia (project CSD 2007-00067). We would like to thank the participants of our user study.

References

1. Halvey, M.J., Keane, M.T.: An assessment of tag presentation techniques. In: Proc. of the 16th international conference on World Wide Web, WWW 2007, New York, USA (2007)
2. Golder, S., Huberman, B.A.: The structure of collaborative tagging systems. Journal of Information Science 32(2), 198–208 (2006)
3. Rivadeneira, A.W., Gruen, D.M., Muller, M.J., Millen, D.R.: Getting our head in the clouds: toward evaluation studies of tagclouds. In: Proc. of the SIGCHI conference on Human factors in computing systems, CHI 2007, New York, USA (2007)
4. Viégas, F.B., Wattenberg, M.: Tag Clouds and the Case for Vernacular Visualization. Interactions 15(4), 49–52 (2008)
5. Hearst, M.A.: What's up with Tag Clouds? (May 2008), http://www.perceptualedge.com/articles/guests/whats_up_with_tag_clouds.pdf (accessed December 30, 2008)
6. Hearst, M.A., Rosner, D.: Tag Clouds: Data Analysis Tool or Social Signaller? In: Proc. of the International Conference on System Sciences, Waikoloa, HI (2008)
7. Nielsen, M.: Functionality in a second generation tag cloud. Master thesis, Department of Computer Science and Media Technology, Gjøvik University College (2007)
8. Li, R., Bao, S., Yu, Y., Fei, B., Su, Z.: Towards effective browsing of large scale social annotations. In: Proc. of the 16th international conference on World Wide Web, WWW 2007, New York, USA (2007)
9. Hassan, M.Y., Herrero, S.V.: Improving tag-clouds as visual Music Retrieval interfaces. In: Proc. of the International Conference on Multidisciplinary Information Sciences & Technologies, INSCIT 2006, Merida, Mexico (2006)
10. Mathes, A.: Folksonomies - cooperative classification and communication through shared metadata, http://www.adammathes.com/academic/computer-mediated-communication/folksonomies.html (accessed December 30, 2008)
11. Wu, X., Zhang, L., Yu, Y.: Exploring social annotations for the semantic web. In: Proc. of the international conference on World Wide Web, WWW 2006, Edinburgh, Scotland (2006)
12. Begelman, G., Keller, P., Smadja, F.: Automatic tag clustering: improving search and exploration in the tag space. In: Proc. of the 15th international conference on World Wide Web, WWW 2006, Edinburgh, Scotland (2006)
13. Kuo, B.Y.-L., Hentrich, T., Good, B.M., Wilkinson, M.D.: Tag clouds for summarizing web search results. In: Proc. of the 16th international conference on World Wide Web, WWW 2007, New York, USA (2007)
14. Zoomclouds, http://zoomclouds.egrupos.net/ (accessed December 30, 2008)
15. Bateman, S., Gutwin, C., Nacenta, M.: Seeing things in the clouds: the effect of visual features on tag cloud selections. In: Proc. of the nineteenth ACM conference on Hypertext and hypermedia, HT 2008, Pittsburgh, USA (2008)
16. Ahlberg, C., Shneiderman, B.: Visual information seeking: tight coupling of dynamic query filters with starfield displays. In: Proc. of the SIGCHI conference on Human factors in computing systems, CHI 1994, New York, USA (1994)
17. Kaser, O., Lemire, D.: Tag-cloud drawing: algorithms for cloud visualization. In: Proc. of the international conference on World Wide Web, WWW 2007, New York, USA (2007)
18. Seifert, C., Kump, B., Kienreich, W.: On the beauty and usability of tag clouds. In: Proc. of the 12th international conference on Information Visualization, IV 2008, London, UK (2008)

19. Provost, J.: Improved document summarization and tag clouds via singular value decomposition. Master thesis, Queen's University, Kingston, Canada (September 2008)
20. Bielenberg, K., Zacher, M.: Groups in social software: Utilizing tagging to integrate individual contexts for social navigation. Master's thesis, Program of Digital Media, University of Bremen (2005)
21. Shaw, B.: Utilizing folksonomy: Similarity metadata from the del.icio.us system, http://www.metablake.com/webfolk/web-project.pdf (accessed December 30, 2008)
22. Westerman, S.J., Cribbin, T.: Mapping semantic information in virtual space: dimensions, variance and individual differences. International Journal of Human-Computer Studies 53(5), 765–787 (2000)
23. Kerr, B.: TagOrbitals: tag index visualization. IBM research report, http://domino.research.ibm.com/library/cyberdig.nsf/1e4115aea78b6e7c85256b360066f0d4/8e1905dc8b000673852571d800558654?OpenDocument (accessed December 30, 2008)
24. Golder, B., Huberman, B.A.: Usage Patterns of Collaborative Tagging Systems. Journal of Information Science, 32 (2), 198–208
25. Golder, S., Huberman, B.A.: The structure of collaborative tagging systems. Journal of Information Science 32(2), 198–208 (2006)
26. Halpin, H., Robu, V., Shepherd, H.: The complex dynamics of collaborative tagging. In: Proc. of the 16th international conference on World Wide Web, WWW 2007, New York, USA (2007)
27. Begelman, G., Keller, P., Smadja, F.: Automated tag clustering: Improving search and exploration in the tag space. In: Proc. of the 16th international conference on World Wide Web, WWW 2006, Edinburgh, Scotland (2006)
28. Santamaría, R., Therón, R.: Overlapping Clustered Graphs: Co-authorship Networks visualization. In: Proc. of the 9th international Symposium on Smart Graphics, SG 2008, Rennes, France (2008)
29. Cunningham, S.J., Bainbridge, D., Falconer, A.: More of an Art than a Science': Supporting the Creation of Playlists and Mixes. In: Proc. of the 7th International Conference on Music Music Retrieval, ISMIR 2006, Victoria, Canada (2006)
30. Porter, M.F.: An algorithm for suffix stripping. Program 14(3), 130–137 (1980)

An Interface for Assisting the Design and Production of Pop-Up Card

Sosuke Okamura[1] and Takeo Igarashi[2]

[1] Department of Computer Science, The University of Tokyo,
Bunkyo-ku, Tokyo, Japan
okamura@ui.is.s.u-tokyo.ac.jp
[2] Department of Computer Science, The University of Tokyo / ERATO, JST
takeo@acm.org

Abstract. This paper describes an interface for assisting the design and production of pop-Up cards by using a computer. A pop-up card is a piece of a folded paper from which a three-dimensional structure pops up when it is opened and can be folded flatly again. People enjoy its interesting mechanism in pop-up books and greeting cards. However, it is difficult for non-professional people to design pop-up cards because of various geometric constraints to fold flatwise. We therefore propose an interface to help people to design and make pop-up cards easily. We deal with pop-up cards that fully opens at 180-degrees in this paper.

We implement a prototype that allows the user to design a pop-up card by setting new parts on the fold lines and editing their position and shape afterwards. At the same time, the system examines whether the parts protrude from the card or whether the parts collide with each other when the card is closed. The result is continuously shown to the user as a feedback. This enables the user to concentrate on the design activity.

We created a couple of pop-up cards using our system and performed an informal preliminary user study to demonstrate the usability of our system.

1 Introduction

A pop-up card is a piece of a folded paper from witch a three-dimensional paper structure pops up when it is opened. The card can be folded flatly again. People enjoy its interesting mechanism in pop-up books [1] [2] [3] and greeting cards. Fig. 1 is an example of pop-up book "Alice's Adventures in Wonderland". It pleases persons of all ages to make, receive, and look at a pop-up card.

It is relatively easy to physically construct a pop-up card. If one has templates, he or she can simply cut and glue them to construct a pop-up card. However it is unfortunately much harder for non-professional people to design a pop-up card. First, it is difficult to correctly understand the mechanisms of a pop-up card. Second, it is difficult for them to find the positions where all pop-up parts don't collide with, requiring repetitive trial and error during design. They cut out the parts from paper, paste them on the card, and check whether they collide or not

A. Butz et al. (Eds.): SG 2009, LNCS 5531, pp. 68–78, 2009.
© Springer-Verlag Berlin Heidelberg 2009

Fig. 1. The example of pop-up book "Alice's Adventures in Wonderland"[1]

again and again. Once an error is found, they must consider all the position once more and redo from the beginning. This process requires a lot of time, energy, and paper. Design and simulation in a computer can relieve us of the boring repetition and save our time.

Glassner proposed methods to design a pop-up card in [4] [5] [6]. His papers introduced several simple pop-up mechanisms. They also described how to use these mechanisms, how to simulate position of vertices as an intersecting point of three spheres, how to check whether the structure sticks out beyond the cover or a collision occurs during opening, and how to generate templates. It is useful for designing simple pop-up card.

Our work builds on his pioneering work and presents several new materials. First, we add two new mechanisms based on V-fold to our system, box and cube. Second, we give detailed description of the user interface, which was not elaborated in his original papers. Third, our system provides real-time feedback to the user during the user's editing operations by examining whether parts protrude from the card when closed or whether they collide with each other during opening and closing. Finally, we report on our informal preliminary user study in which we have asked two novice users try our system and get some feedback.

2 Related Work

Glassner described a stable analytic solution for the location of important points for the three important pop-up techniques (single-slit, asymmetric single-slit, and V-fold mechanisms) when the pop-up card folds and unfolds in Interactive Pop-Up Card Design [4] [5] [6]. He also implemented his solution in a small design program. However, he did not describe the detail of the interactive behavior of the program, nor did he report any user experience.

Mitani and Suzuki proposed a method to create 180-degree flat fold Origamic Architecture with lattice-type cross sections [7]. This system makes pieces from a three-dimensional (3D) model. Those pieces can be used in our system because its base mechanism is same as an angle fold open box mechanism described in

the following section. However, 3D model is not always available. Furthermore, the structure is set only on the center fold line and can't be combined with other multiple pieces.

Lee et al. described calculations and geometric constraints for modeling and simulating multiple V-fold pieces [8]. However, their system is limited to V-fold mechanisms and it is not designed as an interactive system.

Several interactive interfaces were proposed for 90-degree pop-up cards. Mitani et al. proposed a method to design Origamic Architecture [9] models with a computer by using voxel model representation [10] [11]. Using this method, the system can store 90-degree pop-up card models and display them in computer graphics. The user's operations are interactive addition and deletion of voxels. They used this system for graphics science education [12]. They also proposed a method to design Origamic Architecture models with a computer by a model using a set of planar polygons [13]. Their system computes and keeps the constraint to guarantee that the model can be made with single sheet of paper. Thus, it enables the user to make more complex 90-degree pop-up cards interactively from beginning to printing patterns. Hendrix and Eisenberg proposed a system "Popup Workshop" [14] [15]. Their system enables the user to design pop-up cards by making a cut in 2-dimensional. Its result in 3D can be opened and closed in the Viewer window. They showed that children can design pop-up cards utilizing their system [16]. However, their interfaces aren't available for 180-degree pop-up card. 90-degree pop-up cards are made with single sheet of paper and their systems work well by using this constraint. It is difficult to design 180-degree pop-up cards by using voxel model or planar polygon model. Moreover, it is hard for people to edit 3D structures in 2D because they can't imagine the resulting 3D shape.

3 Assisted Pop-Up Card Design

The screen snapshot of our prototype system is shown in Fig. 2.

Our system allows the user to design pop-up card by using a mouse and a key-board. It consists of one window for design and simulation of the pop-up card. Fig. 3 shows the functions of our system. The user sets parts, adjusts their properties (length, angle, position and pattern), and generates templates. The system always examines whether parts protrude from the card or whether they collide with each other during interactive editing.

The user can use five mechanisms in our system. The V-fold mechanism, the even-tent mechanism, and the uneven-tent mechanism are introduced in [4]. The angle fold open box mechanism and the angle fold cube mechanism [17] based on V-fold one are new. The former makes a box which is an empty rectangular parallelepiped without the top and the bottom (Fig. 4 (a)). The latter makes an angle fold open box added a lid (Fig. 4 (b)). The lid is folded toward inside of the box when the card is closed.

Fig. 2. The screen snapshot of our system

Fig. 3. Functions of our prototype system

Fig. 4. (a) The angle fold open box mechanism. (b) The angle fold cube mechanism.

3.1 Constrained Editing

Setting Parts. The user first selects a desired mechanism and moves the mouse cursor to a fold line. The black point then appears on the fold line. If the user

Fig. 5. User interface to set parts. (a) If the user clicks on a fold line, (b) the system generates new part there.

Fig. 6. User interface to edit shapes. The user can (a)(b)(c)(d)(e) change lengths, (f)(g) change open angles, (h)(i) change gradient angles, and (j)(k) put textures.

clicks the mouse button, the system automatically generates the new part on that position. Its lengths and angles are set to a default value, which can be adjusted later.

Editing Shapes. The user drags the vertices of a part in order to edit its shape (Fig. 6). When the user selects a part, its vertices are highlighted. The user drags one of them. In editing lengths, the user can maintain the parallelogram shape by pressing shift-key during dragging (Fig. 6 (c)). The user can also extend a panel of a part (Fig. 6 (d)(e)). The user can change the angle between two planes and the inclination of the part (Fig. 6 (f)(g)(h)(i)).

Deleting Parts. The user clicks the part to delete a part. If other parts exist on the part, they are also deleted.

Mapping Textures. The user prepares images in advance and can use them as textures. In order to put a texture on a part, the user selects a panel of a part and an image (Fig. 6 (j)(k)).

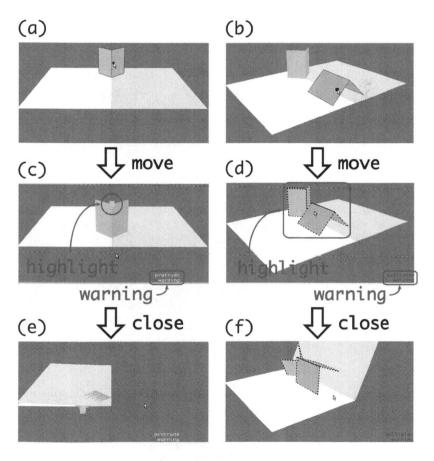

Fig. 7. User interface when the system detects errors. (a)(b) The user moves a part. (c)(d) If the system detects errors, it draws the warning message and highlights the part. (e) If the card is closed, the part protrude from the card. (f) If the card is closed, the parts collide each other.

Generating Templates. The system automatically generates 2D templates from the 3D model designed by the user. The system also makes tabs to glue the parts and guidelines to tell the user where to glue them on.

3.2 Realtime Error Detection

The system examines during interactive editing whether the parts protrude from the card when closed or whether the parts collide with each during closing and opening. When the system detects such a protrusion or a collision, it displays the message on the lower right window and highlights the parts that cause the error (Fig. 7 (c) (d)). Those are executed in real time. If the error is resolved, the message and the highlights disappear immediately.

4 Implementation

We implemented our prototype system based on Glassner's work [4] [5] [6] using Microsoft Visual C++ with MFC platform. We also used OpenGL to render the scene and OpenCV to read images. Implemented functions are shown in Fig. 3. Note that undo function isn't implemented in our system yet. A pop-up card is represented as a tree data structure. Each node of the tree corresponds to a part and contains its relative position on the parent part and various parameters. The system firstly computes the card position by its open angle and updates its center fold line information. Next, the 3D coordinates of the parts on the fold line are updated. The system repeats above procedure recursively to determine the 3D coordinates of all parts.

The system checks a protrusion error and a collision error each time while dragging and when setting a part. The system checks the collision at every 10 degree. This might miss minor collision, but it is not an issue thanks to the inherent flexibility of a paper. We also tried checking at every 1 degree, but it became too slow when the number of parts increases.

5 Results

Fig. 8 shows example pop-up cards designed using our system. We designed it referring to a pop-up book titled "The Wonderful Wizard of OZ" [2]. We designed this piece in our system in approximately two hours (Fig. 8 (b)). It was easy to decide their heights and position thanks to the error detection mechanism. Templates generated by our system are shown in Fig. 8 (d)(e)(f). It took approximately two hours to actually construct the card (Fig. 8 (c)). Fig. 8 (g) shows another example. We designed it in approximately two hours and construct in approximately two and half hours (Fig. 8 (h)). These results show that our system can handle reasonably complicated pop-up structure.

We also conducted an informal preliminary user study. The test was conducted using a typical notebook personal computer with a key-board and a mouse. We prepared two tasks. One is to create a pop-up card of a building without using

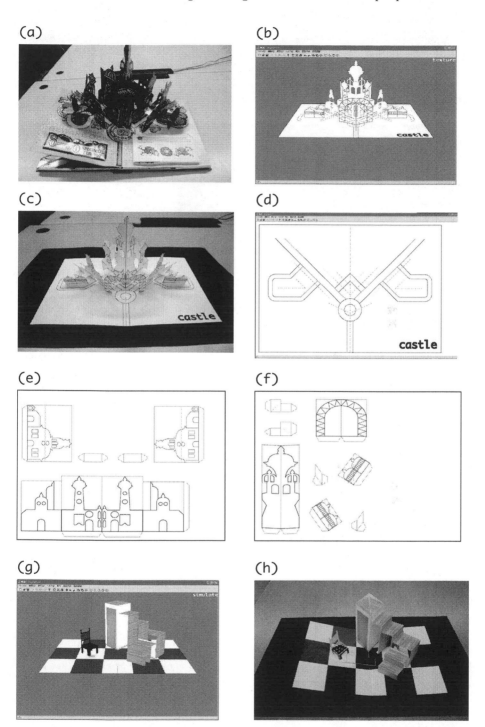

Fig. 8. Results : pop-up cards designed in our system

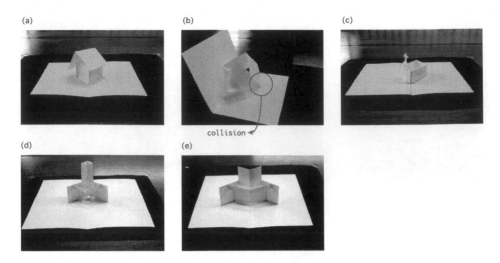

Fig. 9. Results of preliminary user study. (a) the piece of the first subject in task 1. (b) collision occurs when (a) is closed. (c) the piece of the first subject in task 2. (d) the piece of the second subject in task 1. (e) the piece of the second subject in task 2.

our system (task 1). The other is to do the same task but using our system (task 2). Two test users participated the study. They first completed the task 1. We then explained out system to them and had them practice it for approximately 5 minutes. Finally, they worked on the task 2. After they finished all tasks, we had a brief interview session to hear their feedback.

The first test user had never created pop-up cards, and had no knowledge of them. His piece in the task 1 is shown in Fig. 9 (a). It looks good, but it is difficult to close it because of a collision (Fig. 9 (b)). His piece in the task 2 is shown in Fig. 9 (c). It is simple, but it can be closed correctly. It took him thirty minutes to create the former (fifteen minutes to design and fifteen minutes to make), and twenty minutes to create the latter (ten minutes to design and ten minutes to make).

The second test user also had never created pop-up cards before, and had little knowledge about them. His pieces are shown in Fig. 9 (d) (task 1) and Fig. 9 (e) (task 2). They have mostly the same structure and can be closed correctly. However, it took him seventy minutes to create the former (forty minutes to design and thirty minutes to construct) while it took only forty minutes to create the latter (twenty minutes to design and twenty minutes to construct).

From this preliminary user study and their feedbacks, we found the following advantages of our system. First, it is easy to design a pop-up card using our system than doing so using papers, a pair of scissors, and a glue. Second, the pop-up cards designed using our system can be closed correctly without protrusion and collision. This is due to the protrusion detection and the collision detection. The second subject spent less time in design because it was easy to adjust the height of the pop-up part not to protrude the card. He spent long time adjusting the

height in the task 1. The first subject failed to make a correct pop-up structure, but succeeded in our system.

On the other hand, there are a couple of limitations in our system. First, a symmetrical design is frequently used in pop-up cards but symmetric editing is not directly supported in our current implementation. Second, as our system uses displacement in two dimensional (on window) to edit, the direction that the user wants to move and one that the user must move may be different.

6 Conclusion and Future Work

We proposed an interface to help people to design and create pop-up cards. Our system examines whether the parts protrude from the card or whether they collide with each other during interactive editing and the result is continuously shown to the user as a feedback. This helps the user to concentrate on the design activity. We showed sample pop-up cards created by using our system and we reported on the preliminary user study. The preliminary user study showed that the protrusion detection and collision detection are very effective.

In the future, we plan to add new functions to the system. First, we want to make a mirror editing system. If the user edits a part, the system changes values to maintain symmetry. Second, we would like to make a function that the user can change lengths and angles by entering numerical values. Third, we want to make a constraint mechanism. When the user marks a pair of edges, those two edges are always same lengths.

We use textures to add detailed appearance to a part, but it is a pain to prepare a texture in advance by using other software. We would like to let the user paint them directly on the part directly in our system.

We implemented five mechanisms. However, there are a lot of other mechanisms. One of the most interesting mechanisms we want to implement is curved surfaces. Curved surfaces deform non-linearly unlike a simple planar surafces and we plan to apply some soft of physical simulation.

Acknowledgements

We would like to thank Jun Mitani for his helpful comments. We also appreciate the members of Igarashi Laboratory for their useful discussions.

References

1. Sabuda, R., Carroll, L.: Alice's Adventures in Wonderland. Little Simon (2003)
2. Baum, L.F.: The Wonderful Wizard of OZ. Elibron Classics (2000)
3. Sabuda, R., Reinhart, M.: Encyclopedia Prehistorica: Dinosaurs. Candlewick Press (2005)
4. Glassner, A.: Interactive pop-up card design. Miscrosoft Technical Report (1998)
5. Glassner, A.: Interactive pop-up card design, part i. IEEE Computer Graphics and Applications 22(1), 79–86 (2002)

6. Glassner, A.: Interactive pop-up card design, part 2. IEEE Computer Graphics and Applications 22(2), 74–85 (2002)
7. Mitani, J., Suzuki, H.: Computer aided design for 180-degree flat fold origamic architecture with lattice-type cross sections. Journal of graphic science of Japan 37(3), 3–8, 20030901 (2003)
8. Lee, Y., Tor, S., Soo, E.: Mathematical modelling and simulation of pop-up books. Computers graphics 20(1), 21–31 (1996)
9. Chatani, M.: Origamic Archtecture Toranomaki (1985)
10. Mitani, J., Suzuki, H., Uno, H.: Computer Aided Design for Origamic Architecture Models with Voxel Data Structure. Transactions of Information Processing Society of Japan 44(5), 1372–1379 (2003)
11. Pop-up Card Designer PRO,
 http://www.tamasoft.co.jp/craft/popupcard-pro/
12. Mitani, J., Suzuki, H.: Making use of a cg based pop-up card design system for graphics science education. Journal of graphic science of Japan 38(3), 3–8, 20040901 (2004)
13. Mitani, J., Suzuki, H.: Computer aided design for origamic architecture models with polygonal representation. In: Computer Graphics International, 2004. Proceedings, pp. 93–99 (June 2004)
14. Hendrix, S.L.: Popup Workshop: Supporting and Observing Children's Pop-up Design
15. Popup Workshop, http://l3d.cs.colorado.edu/~ctg/projects/popups/
16. Hendrix, S.L., Eisenberg, M.A.: Computer-assisted pop-up design for children: computationally enriched paper engineering. Adv. Technol. Learn. 3(2), 119–127 (2006)
17. Carter, D.A., Diaz, J.: The Elements of Pop-up: A Pop-up Book for Aspiring Paper Engineers. Little Simon (1999)

Part-III
Human Computer Interaction

Whole Body Interaction with Geospatial Data

Florian Daiber, Johannes Schöning, and Antonio Krüger

Institute for Geoinformatics, University of Münster,
Weseler Str. 253, 48151 Münster, Germany
{flowdie,j.schoening,kruegera}@uni-muenster.de

Abstract. Common Geographic Information Systems (GIS) require a
high degree of expertise from its users, making them difficult to be oper-
ated by laymen. This paper describes novel approaches to easily perform
typical basic spatial tasks within a GIS: e.g. pan-, zoom- and selection-
operations by using multi-touch gestures in combination with foot
gestures. We are interested in understanding how non-expert users in-
teract with such multi-touch surfaces. We provide a categorization and a
framework of multi-touch hand gestures for interacting with a GIS. This
framework is based on an initial evaluation. We present results of a more
detailed in situ-study mainly focusing on multi-user multi-touch interac-
tion with geospatial data. Furthermore we extend our framework using
a combination of multi-touch gestures with a small set of foot gestures
to solve geospatial tasks.

1 Introduction and Motivation

Multi-touch has great potential for exploring complex content in an easy and
natural manner and multi-touch interaction with computationally enhanced sur-
faces has received considerable attention in the last few years. Some designers
make use of the geospatial domain to highlight the viability of their approaches.
This domain provides a rich testbed for multi-touch applications because the
command and control of geographic space (at different scales) as well as the
selection, modification and annotation of geospatial data are complicated tasks
and have a high potential to benefit from novel interaction paradigms [1]. One
important observation of previous studies [2] with multi-touch Geographic In-
formation Systems (GIS) is that users initially preferred simple gestures, which
they know from Windows-Icons-Menus-Pointer (WIMP) systems with mouse in-
put. After experiencing the potential of multi-touch, users tended towards more
advanced physical gestures [3] to solve spatial tasks, but these gestures were
often single hand gestures or gestures, where the non-dominant hand just sets
a frame of reference that determines the navigation mode, while the dominant
hand specifies the amount of movement. So far the combination of hand and
foot input has gained only little attention [4]. This combination has a couple
of advantages and helps to rethink the use of the dominant and non-dominant
hand. Foot gestures can be used to provide continues input for a spatial navi-
gation task, which is more difficult to operate with the hands in a natural way.

A. Butz et al. (Eds.): SG 2009, LNCS 5531, pp. 81–92, 2009.

Hand gestures are good for precise input regarding punctual and regional information. It is however difficult to input continuous data with one or two hands for a longer period of time. For example, panning a map on a multi-touch wall is usually performed by a "wiping"-gesture. This can cause problems if the panning is required for larger distances, since the hand moves over the surface and when it reaches the physical border it has to be replaced and then moved again. In contrast foot interaction can provide continuous input by just pushing the body weight over the respective foot. Since the feet are used to navigate in real space such a foot gesture has the potential advantage of being more intuitive since it borrows from a striking metaphor.

In this paper, we present a framework for multi-touch interaction with GIS, an initial evaluation of that framework, a larger study with non-expert users and the extension of the multi-touch framework for the combination of foot and hand input. The following section places this paper in the context of the related work in the variety of fields that provide the basis for this research. In the third section the three key parts of a conceptual framework for multi-touch interaction with spatial data is proposed. Afterwards in section four, the framework is extended with foot gestures. A first evaluation of the multi-touch framework and a second study about multi-user interaction is presented in section five. Section six gives a short overview about the implementation of the system. The paper concludes with a discussion of the results and ideas for future work.

2 Related Work

Until today mice and keyboards are still used by most GIS users to navigate, explore and interact with a GIS even though they are not optimal devices for this purpose. Since 1999 several hardware solutions exist that allow for the realization of GIS with multi-touch input on surfaces of different sizes. The webpage[1] of Buxton is giving a good and complete overview on the current technologies as well as the history of multi-touch surfaces and interaction. With today's technology [5] it is now possible to apply the basic advantages of bi-manual interaction [6],[7] to the domain of spatial data interaction. Also the selection of relevant data, the configuration of adequate data presentation techniques, and the input or manipulation of data are central tasks in a GIS (as in any interactive system)[8]. For the study of our multi-touch GIS system with multiply users we installed an interactive surface in a pedestrian underway. Large interactive screens installed in public space are not so far from fiction [9]. Jeff Han's YouTube demonstration[2] captured the imagination of researchers and users alike. Technologies that allow the low-cost implementation of robust multi-touch interaction, such as Frustrated Total Internal Reflection (FTIR) [10] and Diffused Illumination (DI) [5], have allowed the low-cost development of such surfaces and have led to a number of technological and application innovations. From an HCI perspective it is interesting to investigate how these large interactive screens can support

[1] http://www.billbuxton.com/multitouchOverview.html
[2] http://www.youtube.com/watch?v=QKh1RvOPlOQ

different kinds of collaborative interactions. To our knowledge this is the second attempt to analyze the interaction at a large multi-touch display in (or in our case under) a city centre.

Peltonen et al. [11] presented detailed observations from their own large multi-touch display, called CityWall, in the city of Helsinki, Finland. On the DI multi-touch display a photo explorer was presented. They observed various interaction patterns relating to how people used the CityWall installation, and how they collaborated and interacted with each other at the display. Prante et al. [12] proposed different interaction zones (Cell Interaction Zone, Notification Zone, and Ambient Zone) for the interaction with a large public display. This work was followed up by Vogel et al. [13] with their work on an interaction framework for sharable, interactive public ambient displays. Vogel defined four interaction phases, facilitating transitions from implicit to explicit interaction and from public to personal interaction (personal interaction zone, subtle interaction zone, implicit interaction zone and ambient zone). In a former study [2] the focus lies on investigating the usage and user needs of virtual globes. The main result of that study was that the main motivation of around half of the users (53.4% - 11.6%) was to use a virtual globe for either looking at their own house or other individual places (e.g. a neighbor's house, their hotel from their last vacation, the city center). Even though multi-touch interaction gained a lot of attention in the last few years the interaction possibilities of feet were not considered as much, not even in the geospatial domain.

Various researchers did relevant work in the area of foot input for interactive systems. Pearson and Weiser identify appropriate topologies for foot movement and present several designs for realising them in [14]. In an exploratory study [15] they assessed a foot-operated device against a mouse in a target-selection task. The study showed that novices could learn to select fairly small targets using a mole. Pakkanen and Raisamo [16] highlight alternative methods for manipulating graphical user interfaces with a foot and show the appropriateness of foot interaction for non-accurate spatial tasks. In his research on 3D-input devices Zhai established the distinction in rate controlled and position controlled forms of input. While position controlled input depends on where the user directly maps to, rate controlled input means that the user's input is related to the speed of the cursor movement [17]. Following Zhai's classification the multi-touch input is predominantly position controlled while foot input is rate controlled.

3 Multi-touch Interaction with Spatial Data

In contrast to the more general work of Wu [18], a conceptual framework for interaction with spatial data on a multi-touch enabled surface using physical gestures is presented in the following section. This section describes the three key parts of our conceptual framework. Starting by deriving a set of physical interactions, followed by describing the interaction that is needed to manipulate spatial data. Finally, the commands and controls that are needed to manipulate the geographic interaction space (at different scales) are discussed.

3.1 Physical Multi-touch Interactions

As a first step towards developing a framework for multi-touch and foot interaction, a set of simple physical interaction patterns for multi-touch input is derived (see figure 1 inspired by [3] and [18]). For multi-touch input there are three classes of these patterns: simple fingertip, palm-of-the-hand and edge-of-the-hand input. Gestures with the suffix "1" and "2" are simple one hand gestures, whereas "3"–"5" are bimanual gestures. "1"s and "2"s can be combined to make more complex two-handed gestures. Gestures "F1"–"F5" are based on one or two single-finger touches. These gestures are derived from pointing motions. Interacting via one or two whole hands is described with gestures "H1"–"H5". The main idea behind the "F" and "H" interaction classes is the direct manipulation of region shaped objects. To interact with line-like objects and to frame or cut objects, the edge of the hand provides another class of gestures. These are the gestures with the prefix "EH". Each interaction class contains the following gestures: Single pointing touch (1), Single moving touch (2) (not only limited to linear movement), Two touches moving in the same direction (3), Two touches moving in opposite directions (4), Moving of two touches in a rotational manner (5) (Physical multi-touch interactions are highlighted with orange in Table 1).

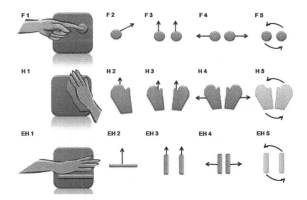

Fig. 1. Set of physical multi-touch gestures

Table 1. Framework for multi-touch interaction with geospatial objects (derived physical gestures)

	World		(Geo-) Objects			Symbols		
	Globe	Plain	Point	Line	Polygon	Point-Symbols	Labels	Layer
POINT	F1	F1	F1	EH1	H1	F1	F1	F1
ZOOM	F4	F4	-	F4	F4	F4	F4	(F4)
PAN	H2	F2	F2	EH2	H2	F2	F2	-
ROTATE	F5	F5	-	F5	F5	F5	F5	-
TILT	H1+F2, H1+H2	H1+H2	-	-	-	F6	-	-
CUT				EH1, EH3	EH1, EH3			-

3.2 Interaction Primitives

In addition to the aforementioned physical multi-touch and foot gestures classes, a set of interaction primitives for interaction with geospatial data is proposed (see Table 1 yellow sidebar). These primitives allow interaction tasks for basic geospatial data, such as pointing or zooming [1], and are commands and controls that are needed to manipulate the geographic interaction space (at different scales) as well as to select, modify and annotate geo-objects. The tasks are point, zoom, pan, rotate, tilt and cut as described in [1].

3.3 Interaction Space

The interaction space is a simple set of graphical views and representations for spatial objects. Interaction primitives are used to modify the (graphical) view, e.g. zooming, panning, and rotating the globe (sphere) or plain (map view). It also contains feature manipulation, feature symbolization (simple symbol changes), feature filtering (hide a layer or feature, show another) and management of background images (see Table 1 green header).

3.4 Multi-touch Gestures for Spatial Tasks

To understand the relationship between gestures and geospatial operations, we have asked 12 participants (five female and seven male) to fill out the matrix with one or more physical interaction primitives or combination of primitives of their choice. All eight participants assigned physical gestures for the interaction primitives in the spatial interaction space at different scales. If three participants agreed on the same interaction primitive, we inserted the proposed interaction styles for various selection and manipulation tasks in Table 1. This table is organized as follows: The rows represent the most common commands that are needed for geospatial tasks: point, zoom, pan, rotate, tilt (i.e. to control the parameters of a geographical view), and cut (as a representative for a topological operation such as dividing an area). We are aware that there might be other commands which could be explored but at this stage of the work we wanted to concentrate on some of the most common ones. The columns of the table represent the geographic space and objects that can be subjects of the various commands. The interaction (selection and manipulation) with geo-objects can be distinguished according to their geometric properties: point, line, and polygon. Finally, in geospatial applications one often finds interaction patterns with symbolic representations (such as a point-of-interest, in the table denoted as point-symbols), or their annotations, which we refer to as labels. Similar symbols are often organized in layers, which can themselves be subject of manipulation. Interestingly, the geometric property of the interaction is reflected in the physical nature of the proposed multi-touch interaction. For example, single point-like objects are referred to with a single pointing gesture (F1), while rotation of a globe or panning of a 2D map is more likely to be performed by a wiping-style gesture (H2). The selection of geo-objects can be improved by referencing their

geometric properties. For example, the selection of a street on a map could be more precisely performed by moving a finger along that street (F2) instead of just pointing to it. This helps to reduce the ambiguity of the gesture as pointed out in [19]. Please note that not all of the primitive gestures of Fig. 1 are listed in Table 1. For example the two-hand gesture (EH4 and H4) seems of no use. However we believe that if we look at more complex operations, such as intersecting two polygons, these operations will be useful. Of course, this has to be investigated further in future work.

4 Multi-touch and Foot Interaction with Spatial Data

Even though multi-touch interaction gained a lot of attention in the last few years the interaction possibilities of feet were not considered as much. In [4] we try to make a contribution in that direction of how physical multi-touch gestures in combination with other modalities can be used in spatial applications. What is still lacking is a better understanding of how physical multi-touch gestures in combination with other modalities can be used in spatial applications. This work tries to make a contribution in this respect. This section describes the extension of the multi-touch framework presented above. Multi-touch is now combined with foot interaction to improve the overall interaction with spatial data.

4.1 Physical Foot Interactions

A set of simple physical foot interaction patterns that can be performed by the user standing on a Wii Balance Board (see Figure 2 (a)) are derived. Up to now five different patterns (named with lower case letters) can be investigated: "fb" = "stand on ball of feet", "ft" = "stand on tippy-toes", "fr" = "balance center on the right", "fl" = "balance center on the left", "fs" = "stand on sides of feet". Most of the gestures are self-explaining. For example "ft" means that the user is moving the balance point forward and just stands on tiptoes. "fs" denotes an action (user standing on sidefeets) people often perform while they are waiting (the physical foot interactions are highlighted with blue in Fig. 2 (b)).

| | World | | (Geo-) Objects | | | Symbols | | |
	Globe	Plain	Point	Line	Polygon	Point-Symbols	Labels	Layer
POINT	F1	F1	F1	EH1	H1	F1	F1	F1
ZOOM	F4	F4	-	F4	F4	F4	F4	(F4)
PAN	H2 , fr, fl	H2 , fr, fl	F2, fr, fl	EH2, fr, fl	H2, fr, fl	F2	F2	-
ROTATE	F5	F5	-	F5	F5	F5	F5	-
TILT	ft, fb	ft, fb	-	-	-	-	-	-
CUT				EH1, EH3	EH1, EH3			-

Fig. 2. Set of physical foot gestures (a) and framework of multi-touch and foot interaction for geospatial objects (b)

4.2 Interaction Primitives and Interaction Space

The interaction primitives and the interaction space are nearly the same. Some interaction primitive are now controlled by the feet (see Fig. 2 (b) yellow sidebar). The proposed interaction styles for various selection and manipulation tasks are summarized in a table (see Fig. 2 (b)). The table is organized as described in section 3.4 but now filled up with physical hand and/or foot gestures to interact with-geo-objects. For example "panning" can be accomplished by using the physical multi-touch interaction "H2" or the foot interactions "fr", "fl".

5 Results and Evaluation

The presented framework was evaluated in different stages and in different studies. The results of an initial user study and a broader study in an exhibition are presented in the following.

5.1 Multi-touch Interaction

An initial user study was carried out to test the multi-touch interaction framework. The study was conducted with 9 participants, 3 female and 6 male, with a mean age of 26.8 years (ages 23–38). The test setup was the following: The subjects had to solve simple geospatial tasks to get information about certain places in the world. For example, they had to navigate (with pan, zoom, rotate and tilt) to Washington, D.C., find the Washington Monument and gather information about the monument, the Lincoln Memorial and the Capitol. Another task was to measure distances on the globe. During the test the users were asked to "think aloud". After the actual test users rated the map navigation techniques by filling out a questionnaire based on ISO 9241-110 (five-point rating; lower scores denote a better rating) and inspired by [20]. The total time of the experiment took about 60 minutes for each participant. In general users gave good rates (between 1 and 2) with small confidence intervals (see Fig. 3). The only outlier was the error tolerance because the tilting gestures caused problems for some users.

5.2 Multi-user Interaction

The multi-touch framework proposed in Sect. 3 was also evaluated in a multi-user scenario. A sample application on a large-scale multi-touch screen based on the framework was installed during a technology exhibit called "Germany 'Land of ideas' " in a pedestrian underway in the city of Münster for one week. In the following first insights gained from this deployment are provided. The focus of this study lies on the observation of spontaneous and group interaction patterns. The video[3] presents the short impression of the installation. The ambient nature

[3] Hightech-Underground on youtube:
http://www.youtube.com/watch?v=27oSoDdU2fk

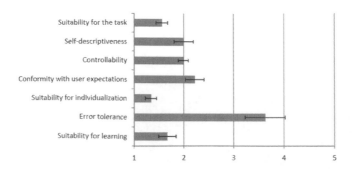

Fig. 3. Results of the user interface evaluation questionnaire

Fig. 4. User interacting at a large-scale multi-touch displays in a pedestrian underway in the city of Münster, Germany, during a hightech exhibition in Oct. 08

of this wall setup does not attract users by itself. Users watching other people interacting with the application before they interact seem to be less shy and more experimental [21]. Users rarely performed the proposed interaction scheme as depicted in Fig. 4:1–3. Instead of navigating to a POI (see Fig. 4:1) and open the detailed information (see Fig. 4:2) and closing it again (see Fig. 4:3). Users had fun performing various gestures: rotating, flipping, scaling the digital globe. This "fun-factor" played an important role. Most users were not so interested in the presented information that was intended for this exhibition but rather interacting with the globe in order to look for their house, vacation houses and tennis court (see Fig. 5:7). Although designed for single users, the application was mainly used by groups of 2–8 people. An exemplary group of elderly men reveal this highly interactive group communication in Figs. 5:5–5:8. After reaching the wall the first user (with a cap) starts to interact with the globe (see Fig. 5:5). Immediately a discussion about the map begins ("Where is our tennis court?"). A second user (with a red jacket) looks over the shoulder of the first one (see Figs. 5:6 and 5:7), leans forward and takes over the interaction part (see Fig. 5:8) [22]. Thus, user groups of different sizes are able to collaboratively interact with the single-user application. The formerly described "Teacher-apprentice setting" [11] also plays a role in this study. Examples for this are shown in Fig. 6. In many cases one person (teacher) shows or explains something to "the student" (see Figue 5:8). Another collaborative interaction is shown in Fig. 6:12. A team of users performs parallel zoom-gestures. Our preliminary investigation of the

Fig. 5. User interacting at a large-scale multi-touch displays in a pedestrian underway in the city of Münster, Germany

Fig. 6. User interacting at a large-scale multi-touch displays in a pedestrian underway in the city of Münster, Germany

data we have collected, largely verifies findings from literature. We could find similar interaction patterns as Peltonen [11] namely: "huge amount of team-work" (consider Figs.5:5–7), "Pondering grip vs. grandiose gestures" (consider Figs.5:8), "Leaving a mark" and "Teacher-apprentice setting" (consider Fig.5:8).

In accordance with a survey we conducted in previous work [2], we observed that in practice most people seem to use digital globes to answer simple questions, like: "where is my house?", "how does the vicinity of a particular area look like?", "where is our tennis court?" and so on. We also recognized the interaction zones already identified by Prante and Vogel. However, here we have observed a much finer and dynamic distinction between different zones when multiple users are involved. Since the closest zone has enough space to accommodate multiple users, we could observe different types of interaction ranging from synchronous and asynchronous interaction in time and space. It often happened that users where switching zones, for example the user with the red coat in Fig. 5:5–7, first observes at a certain distance and then suddenly moves towards the wall to interact in the same space as the user in front of him at the same time. Synchronous interaction in time but not in space can be observed in Fig. 6:9: here both users have their "own" area of the wall were they interact. What is very interesting is that the size of the wall and the type of application seems to afford these different interaction patterns. Being designed with a single user in mind, the application would not support these types of interactions. Still our users naturally appropriated the application and tried to overcome the deficits of the interface design. This could point designers of user interfaces of large multi-touch surfaces in two directions, to take an expensive or a cheap approach: it could mean to carefully design interaction methods that take care of time and space and allow for both asynchronous and synchronous interaction in space and time, or to just ignore this and design a simple but useful single-user application that people

enjoy (and then appropriate for group usage). Of course the latter case makes only sense in settings such as the one presented in this paper: a playful virtual globe application, which aims at interaction spans of minutes rather than hours.

6 Implementation

We used a low-cost, large-scale (1.8m x 2.2m) multi-touch surface that utilizes the principles of Frustrated Total Internal Reflection (FTIR) [10] as display and touch input device. The Wii Balance Board[4] as foot input device is wirelessly connected via Bluetooth and GlovePie[5] and is used to stream the sensor data from the Wii Balance Board to the application. The image processing and blob tracking is done by the Java multi-touch library[6], developed at the *Deutsche Telekom Laboratories*. The library provides the touches as a server using the TUIO-protocol [23]. The application is based on NASA World Wind[7] using the Java-based SDK. The exhibition setup was nearly the same, but without the Wii-Board and the associated components. The exhibition took place for one week in an old pedestrian underway in the city on Münster. This underway is normally closed due to construction defects, but was reopened for the event from 10 am to 6 pm every day. Nearly 1200 people attended the exhibit. We installed a video camera to record the user and group interactions and this was clearly identified by the visitors. In addition in the "semi-wild" exhibition environment there were many other technical challenges to tackle (lightning, seeping water, vandalism etc.).

7 Conclusion and Outlook

In this paper, two steps of a framework for geospatial operations are presented. In the first step multi-touch gestures to navigate and manipulate spatial data are derived from a usability inspection test. Based on the results of the multi-touch framework a first concept and implementation of the combination of multi-touch hand and foot interaction is provided. The combination of direct, position controlled (hand) with indirect, rate controlled (feet) input is proposed and evaluated in an initial user study. While hand gestures are well suited for rather precise input foot interactions have a couple of advantages over hand interactions on a surface: (a) it provides an intuitive means to input continuous input data for navigation purposes, such as panning or tilting the viewpoint, (b) foot gestures can be more economic in the sense that pushing once weight over from one foot to another is less exhausting than using one or both hands to directly manipulate the application on the surface, e.g. when trying to pan a map over a longer distances, (c) it provides additional mappings for iconic gestures, for

[4] e3nin.nintendo.com/wii_fit.html

[5] http://carl.kenner.googlepages.com/glovepie

[6] http://code.google.com/p/multitouch

[7] http://worldwind.arc.nasa.gov/java/

single commands. In a more general way foot interaction provides an orthogonal horizontal interaction plane to the vertical multi-touch hand service and can be useful to improve the interaction with large scale interaction multi-touch surfaces. In a second study the pure multi-touch approach was used to analyse multi-user interaction with geospatial data. The first results are that geospatial like virtual globes highly support group communication and interaction with the wall on one side and more hierarchical structure like the "Teacher-apprentice setting" on the other side. The different interactions have to be investigated more in detail.

In future there is a need for exploring the combination of interaction both planes for spatial tasks further, but this certainly has a huge potential for interaction with spatial data or even for more abstract visualization that uses a 3D-space to organize data. This paper presents first steps how additional modalities can overcome navigation problems with virtual globes and let users interact more intuitively and presumably even faster with virtual globes on multi-touch surfaces.

Acknowledgements

We would like thanks Thore Fechner for developing the application and Markus Löchtefeld, Raimund Schnürer, Alexander Walkowski, Oliver Paczkowski and Christoph Stasch for installing and demounting the interactive multi-touch displays six feet under Münster and Keith Cheverst, Brent Hecht and Ramona Weber for providing many comments.

References

1. UNIGIS. Guidelines for Best Practice in User Interface for GIS: ESPRIT/ESSI project no. 21580 (1998)
2. Schöning, J., Hecht, B., Raubal, M., Krüger, A., Marsh, M., Rohs, M.: Improving Interaction with Virtual Globes through Spatial Thinking: Helping users Ask "Why?". In: IUI 2008: Proceedings of the 13th annual ACM conference on Intelligent User Interfaces. ACM, USA (2008)
3. Wilson, A., Izadi, S., Hilliges, O., Garcia-Mendoza, A., Kirk, D.: Bringing physics to the surface. In: UIST 2008: Proceedings of the 21st annual ACM symposium on User interface software and technology. ACM, New York (to be appear) (2008)
4. Schöning, J., Daiber, F., Rohs, M., Krüger, A.: Using hands and feet to navigate and manipulate spatial data. In: CHI 2009: CHI 2009 extended abstracts on Human factors in computing systems. ACM, New York (2009)
5. Schöning, J., Brandl, P., Daiber, F., Echtler, F., Hilliges, O., Hook, J., Löchtefeld, M., Motamedi, N., Muller, L., Olivier, P., Roth, T., von Zadow, U.: Multi-touch surfaces: A technical guide. Technical report, Technical University of Munich (2008)
6. Buxton, W., Myers, B.: A study in two-handed input. In: Proceedings of the SIGCHI conference on Human factors in computing systems, pp. 321–326 (1986)
7. Hinckley, K., Pausch, R., Proffitt, D., Kassell, N.F.: Two-Handed Virtual Manipulation. ACM Transactions on Computer-Human Interaction 5(3), 260–302 (1998)

8. Maceachren, A., Brewer, I.: Developing a conceptual framework for visually-enabled geocollaboration. International Journal of Geographical Information Science 18(1), 1–34 (2004)
9. Schöning, J., Krüger, A., Olivier, P.: Multi-touch is dead, long live multi-touch. In: CHI 2009: Workshop on Multi-touch and Surface Computing (2009)
10. Han, J.Y.: Low-cost multi-touch sensing through frustrated total internal reflection. In: UIST 2005: Proceedings of the 18th annual ACM symposium on User interface software and technology, pp. 115–118. ACM, USA (2005)
11. Peltonen, P., Kurvinen, E., Salovaara, A., Jacucci, G., Ilmonen, T., Evans, J., Oulasvirta, A., Saarikko, P.: It's mine, don't touch!: interactions at a large multi-touch display in a city centre. In: CHI 2008: Proceeding of the twenty-sixth annual SIGCHI conference on Human factors in computing systems, pp. 1285–1294. ACM, New York (2008)
12. Prante, T., Röcker, C., Streitz, N., Stenzel, R., Magerkurth, C.: Hello.wall – beyond ambient displays. In: Adjunct Proceedings of Ubicomp, pp. 277–278 (2003)
13. Vogel, D., Balakrishnan, R.: Interactive public ambient displays: transitioning from implicit to explicit, public to personal, interaction with multiple users. In: UIST 2004: Proceedings of the 17th annual ACM symposium on User interface software and technology, pp. 137–146. ACM, New York (2004)
14. Pearson, G., Weiser, M.: Of moles and men: the design of foot controls for workstations. ACM SIGCHI Bulletin 17(4), 333–339 (1986)
15. Pearson, G., Weiser, M.: Exploratory evaluation of a planar foot-operated cursor-positioning device. In: CHI 1988: Proceedings of the SIGCHI conference on Human factors in computing systems, pp. 13–18. ACM, USA (1988)
16. Pakkanen, T., Raisamo, R.: Appropriateness of foot interaction for non-accurate spatial tasks. In: Conference on Human Factors in Computing Systems, pp. 1123–1126 (2004)
17. Zhai, S.: Human Performance in Six Degree of Freedom Input Control. PhD thesis, University of Toronto (1995)
18. Wu, M., Balakrishnan, R.: Multi-finger and whole hand gestural interaction techniques for multi-user tabletop displays. In: Proceedings of the 16th annual ACM symposium on User interface software and technology, pp. 193–202 (2003)
19. Wasinger, R., Stahl, C., Krüger, A.: M3I in a Pedestrian Navigation & Exploration System. In: Human-Computer Interaction With Mobile Devices and Services: 5th International Symposium, Mobile Hci 2003. Proceedings, Udine, Italy, September 8-11 (2003)
20. Gediga, G., Hamborg, K.C.: Isometrics: An usability inventory supporting summative and formative evaluation of software systems. In: HCI (1), pp. 1018–1022 (1999)
21. Brignall, H., Rogers, Y.: Enticing people to interact with large public displays in public spaces. In: Proceedings of INTERACT 2003, pp. 17–24 (2003)
22. Twidale, M.B.: Over the shoulder learning: Supporting brief informal learning. Comput. Supported Coop. Work 14(6), 505–547 (2005)
23. Kaltenbrunner, M., Bovermann, T., Bencina, R., Costanza, E.: Tuio: A protocol for table-top tangible user interfaces. In: Proc. of the The 6th International Workshop on Gesture in Human-Computer Interaction and Simulation (2005)

The Pie Slider:
Combining Advantages of the Real and the Virtual Space

Alexander Kulik, André Kunert, Christopher Lux, and Bernd Fröhlich

Bauhaus-Universität Weimar
{alexander.kulik,andre.kunert,bernd.froehlich}@medien.uni-weimar.de
http://www.uni-weimar.de/medien/vr

Abstract. The Pie Segment Slider is a novel parameter control inter-
face combining the advantages of tangible input with the customizability
of a graphical interface representation. The physical part of the interface
consists of a round touchpad, which serves as an appropriate sensor for
manipulating ring-shaped sliders arranged around a virtual object. The
novel interface concept allows to shift a substantial amount of interaction
task time from task preparation to its exploratory execution. Our user
study compared the task performance of the novel interface to a com-
mon touchpad-operated GUI and examined the task sequences of both
solutions. The results confirm the benefits of exploiting tangible input
and proprioception for operating graphical user interface elements.

Keywords: Menu Interaction, Circular Menu, Continuous Values.

1 Introduction

A tangible representation of digital information can help users to understand and
operate complex systems. Many such interfaces deal with the spatial manipu-
lation of virtual objects, which are directly and intuitively controlled through
physical representations (e. g. [22], [21], [7], [10], [8]). However, if it comes to
the control of abstract parameters (e. g. sound, colors or system parameters) ex-
ploiting the benefits of tangible interaction techniques is not as straightforward.
For abstract parameters, users find it often difficult to directly specify a desired
value on a scale without adjusting it and perceiving the result. We argue that
appropriate control interfaces should therefore emphasize on direct manipulation
of a parameter value rather than on targeted selection.

We developed the Pie Slider interface (fig 1) to combine the benefits of tan-
gible interaction (namely tactile constraints and proprioception) with those of
graphical representations (namely customizability and definable range) for effi-
cient manipulation of varying parameter sets. The design of our novel interfaces
is strongly influenced by the observation that workflows in complex applications
do not only involve the manipulation of parameters, but an important amount
of time is also spent on preparations (e. g. tool selection). With the development

A. Butz et al. (Eds.): SG 2009, LNCS 5531, pp. 93–104, 2009.

Fig. 1. The Pie Slider for color adjustments

of the Pie Slider we aimed at reducing the required time for the selection of parameters and emphasize on the actual manipulation of their respective values.

The design is based on two major principles:

1. The design of the graphical interface and the tangible input sensor resemble each other as such that the user can control the system without looking at the input device.
2. The starting point for input on the device's surface defines the parameter to adjust, while the relative motion of the finger on the surface changes its value.

Our work contributes to research regarding the exploitation of tangible constraints for supporting the user's input as well as circular menu systems and sliders. To evaluate the usability of the Pie Slider interface we performed a controlled user study. The results confirm the benefits of exploiting real world references such as tangible devices and proprioception for operating graphical user interface elements.

2 Tangible Constraints

Ullmer et al. [20] introduced the concept of core tangibles to facilitate menu interaction and parameter adjustments using tangible interfaces for various applications. They use physical menu cards (t-menus) for the association of digital content with interaction trays, which contain sensor electronics for the selection and manipulation of items and parameters depicted on the t-menus. Labels for tangible interaction devices may also dynamically change. Kok and van Liere [13] used an augmented reality setup to analyze the impact of passive tactile feedback as well as the co-location of input action and visual representation on interaction performance. They demonstrate significant benefits for both independent variables in experimental tasks consisting of menu selection and slider adjustments. TUISTER [2] and DataTiles [18] are two other examples of a tangible user interfaces that allow to dynamically exchange the data reference of

the tangible device. The concept of data tiles also includes specific parameter tiles for a visual representation of linear or circular sliders. They carry tactile grooves for providing passive tactile feedback for the constraints of the respective interface.

Parameter adjustment by circular sliders in combination with passive haptic feedback provided by a physical input device can be also found in the watch computer interaction system of Blaskó and Feiner [1] as well as in some commodity computer devices like the iPod™ scroll wheel. Empirical comparison of such touch-based interfaces with tactile guidance to physical scroll wheels [24] and jog dials [15] revealed that the semi-tangible approach is not necessarily worse in terms of task performance. The touch sensitive scroll ring even showed advantages over the physical scroll wheel in a document scrolling task, since clutching was not required and thus large distances were covered more efficiently [24].

3 Selection and Adjustments

PieMenus [11] and marking menus [14] are prominent examples of circular selection layouts and their advantages with respect to certain workflows in human computer interfaces have been demonstrated [3]. Circular gestures allow for continuous position-controlled input without requiring clutching [19], [16] and they provide a very intuitive and efficient way to adjust the motion velocity. FlowMenus, introduced by Guimbretière et al. [9], incorporate an attempt to combine circular menu layouts with rotational adjustments of parameters. They allow the user to select a parameter from a circular menu, which can then be adjusted with circular motion input in a fluent gesture. Such a combination of parameter selection and adjustment can also be found in control menus [17], where the parameter's value is not adjusted with circular, but with linear motion input. However, McGuffin et al. reported that users were having difficulties in adjusting continuous parameters with both techniques, which did not make use of the tangible qualities of the employed input devices. The authors propose another integration of circular parameter selection and subsequent adjustments, which they call FaST sliders. Here users adjust linear sliders that appear after the selection of a parameter from a circular marking menu.

4 The Pie Slider

Previous research has demonstrated the efficiency of circular touchwheels for scrolling tasks [24], [15]. This interaction method may also be applied for the adjustment of other, more abstract parameter sets influencing e. g. image or sound characteristics and thus be employed for the design of remote controls for media commodities or public displays. Adjusting the appearance of an image may require modifications in contrast, brightness and saturation. Tuning sound may involve the adjustment of volume and stereo balance or the manipulation of several bandwidth-dependent parameters. Obviously the parameters in each

Fig. 2. Specifying a shadow effect with the Pie Slider

set should be displayed together to support adjustments of all relevant factors in a concerted fashion.

Touchwheels provide relative isotonic input. It is therefore not relevant where the user starts the circling input motion. In contrast, touch sensors report the absolute finger contact position. We propose to exploit this information for pie menu-like parameter selection. We segment the circle into as many sections as there are parameters belonging to a specific set. For example, for color manipulations in HSV color space we segment the circle into three segments (fig 1). Using a touch-sensitive device instead of a mechanical jog dial or knob allows for various segmentation configurations. Circular-shaped input devices such as a touch wheel or a circular touchpad serve as a prop for circular layouts of graphical user interfaces. To select one of the presented parameters the user simply taps into the corresponding zone of the touch device and starts adjusting its value with continuous input motions along the rim (fig 2). During the continuous finger motion the areas of the other parameters can be passed without changing the selection. Thus the parameter range can be mapped to a full 360 degrees circular motion or even to multiple physical rotations if more precision is required.

We decided to use a circular touchpad instead of a touchwheel because touchpads are often built into handheld devices and mobile computers for cursor control. Furthermore, the touchpad provides two degrees of freedom instead of only one available with the touchwheel. We use a polar coordinate system for operating the pie slider with a circular touchpad. The angular value controls a parameter value. The radius can be used to switch rapidly between the initial and the newly set value. Moving the fingertip back to the touchpad's center resets to the initial value, moving back to the circular border sets it again to the recent adjustment (fig 3). Thus the user can rapidly switch back and forth between both values to evaluate the effect of the recent parameter change. Lifting off the finger at the circular border confirms the newly set value while the value remains unchanged otherwise.

The basic motivation for the Pie Slider is to preserve the adaptability of virtual representations while providing just enough tangibility to facilitate efficient and precise interaction without forcing the user to visually control input actions. The circular touchpad acts as an appropriate tangible prop for operating the Pie Slider. Interaction thus benefits from proprioceptive and passive tactile feedback

Fig. 3. Undo, redo and confirmation with the Pie Slider

both for tapping on discrete selection items and for the relative circular slider adjustment by the motion of the finger along the touchpad's rim.

Circular arrangements do not only have advantages regarding the accessibility of items and the option of continuous motion, but also they can be placed around an object of interest without obscuring it (fig 1). Thus the user's focus can be kept on the object being modified rather than on a menu placed somewhere else on the screen. Webb and Kerne [23] developed the concept of in-context sliders and demonstrated the benefits of placing a slider interface within the respective object area on the screen without occluding it like pop-up menus often do. Instead of positioning the slider in an overlapping fashion within the respective object, a similar effect can be achieved with circular menus and sets of rotational sliders framing the object of interest.

5 User Study on a Color Adjustment Task

We implemented an hue-saturation-value (HSV) color adjustment task to analyze the usability and performance of the pie slider (circular condition) and compared it to the commonly used linear sliders (linear condition). The goal of the task was to match the color of a displayed square to a given color shown in an adjacent square (fig 4). The color of the upper square was directly manipulated by the user while the lower square displayed the target color. Once the color had been set correctly, the task was completed and the next trial automatically started. Only one parameter had to be adjusted at a time to minimize the influence of individual color adjustment skills. The respective slider was highlighted by a white outline. The other two parameter sliders remained operational, but in case of mis-activation, the input was reset after lifting up the finger.

During the circular condition the screen displayed the three HSV controls as equally distributed ring segments with hue at the top, saturation at the lower right and value assigned to the lower left sector (fig 4a). For the linear condition, the controls were horizontally stacked with hue on top, saturation in the middle and value at the bottom (fig 4b). All sliders incorporated a wiper or handle, indicating the current setting.

We assured that the related variables including the size and appearance of the visual interface and the tolerance of setting were comparable across both input

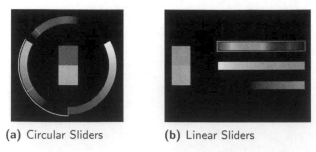

(a) Circular Sliders (b) Linear Sliders

Fig. 4. Slider Menu for HSV Color Adjustment

conditions. With respect to the input motion requirements, this was not always possible, but we tried to balance them by adjusting lengths and distances for the linear slider condition to corresponding length and distances along the circular perimeter for the circular condition.

The Pie Slider enabled direct parameter selection through finger contact in the corresponding zone of the touch device. After selection, this parameter could be manipulated by circular motion. Lifting the finger off from the touchpad completed an adjustment. The linear condition provided the same functionalities, but in a different way. Common linear sliders had to be manipulated by a cursor. The wiper could be selected using the cursor and dragged to the target position. Moving the pointer off the slider area did not result in losing the connection to the wiper.

As a shortcut method in the linear condition, the slider could be selected at a specific position by directly pointing at it, which caused the wiper to jump to the selected value. Since the slider controls in the experimental application visually represented their parameter space, the users could directly aim at the desired value and then drag the wiper only if fine adjustments were necessary. This interaction method may be more efficient in cases where the target value is known beforehand as in our test scenario. In many real world applications this approach is not as helpful, since adjusting values is more often an exploratory task in which users actually want to visually track the continuous changes between a sequence of values.

Besides the control technique, we included further independent variables in the studies, namely the type of color parameter that had to be adjusted and the distance between the starting and the target value. We expected differences in the cognitive effort to adjust hue, saturation or value resulting in an impact on task completion times. For the variable *distance*, we defined five conditions based on a linear relation to the index of difficulty as defined by Fitts' Law[6].

5.1 Task Modeling

We modeled the color adjustment task for the linear and circular condition using the Keystroke Level Model [4] to predict task execution times for common

desktop interfaces. We expected mental operations for task initialization as well as for visual attention shifts.

For the Pie Slider we identified the following sequence of operations:

1. M_{init}: Mental operation to initialize the task
2. K_{select}: Segment selection as an equivalent to a Keystroke
3. A_{adjust}: Circular dragging operation for adjustment
4. $B_{confirm}$: Button or touchpad release for confirmation

This leads to the following equation:

$$T_{circular} = T_M + T_K + T_A + T_B \qquad (1)$$

For the linear slider condition we identified the following sequence:

1. M_{init}: Mental operation to initialize the task
2. M_{search}: Mental operation to identify the pointing target
3. P_{select}: Coarse pointing to the desired value
4. B_{pick}: Press button to drag wiper
5. A_{drag}: Linear dragging operation for adjustment
6. $B_{release}$: Button release to confirm action

Leading to the following equation:

$$T_{linear} = T_M + T_M + T_P + T_B + T_A + T_B \qquad (2)$$

Based on this model we assumed that using the Pie Slider would be more efficient due to simplified parameter selection. We wanted to evaluate this model and get insights into the influence of the apparatus used to perform the modeled task sequences. To compare the recorded execution times of our study with the predicted task sequences, we distinguished the selection phase and the adjustment phase of the task. We used touchpad or button contact events as a trigger to distinguish the two phases. Note that within the linear condition the color adjustment could be partially or fully achieved during the *selection* phase by directly pointing into the proximity of the target value. Selection and adjustment operations of incorrect parameter controls were logged separately in order to compare the likelihood of making errors with each interface and to get more accurate data on the time distribution among task sequences.

5.2 User Study

Experimental Setup. The study was conducted on a desktop set-up using a 30" LCD graphics display for visual stimuli. The visual control interfaces of both *techniques* stretched over 30 cm (in length or diameter) on the screen. The participants were seated at approximately 1m distance to the screen and we asked them to place the input device on the table such that they felt comfortable. Both conditions were based on touchpad-based input. The employed sensor device provided an active area of 62.5mm x 46.5mm. In the linear condition the

touchpad operated the cursor, while in the circular condition, the device served as a tangible reference to the displayed parameter set. Here the touch-sensitive area was covered by a 2mm strong plastic plate leaving a circular area of 44mm in diameter unmasked for touch input. Thus the linear condition was operated with relative motion input for selection as well as slider adjustments, whereas the circular condition exploited absolute position input for selection and relative motion input for adjustments. To balance precision and rapidity, a non-linear transfer function as known from pointer acceleration in operating systems was applied to motion input in both conditions.

Participants. Six female and ten male users aged between 20 and 33 years participated in this study. All of them were students in engineering, fine arts or humanities. None of them reported to have issues with color perception.

Design and Procedure. First, our participants were introduced to the devices and interaction techniques used in the study. Then they were given a training session to learn procedures of the color adjustment task in both menu conditions. After a short break 75 color adjustment tasks were recorded for the first menu type, followed by another 75 with the other one. The order of the *technique* conditions was balanced between users. To minimize fatigue every 15 subsequent trials short breaks were detained. One sequence included each of the three color parameters combined with five distance conditions respectively. To assure that color differences could easily be distinguished we applied a tolerance level of 4% and conducted pilot studies to specify color values for start and target that are perceptionally easy to identify. The predefined values were listed in a database and randomly presented to the participants, while assuring that no specific color adjustment task was repeated.

Hypothesis. We estimated the average time required for task execution with the pie slider (3) and the linear sliders (4) by using the execution time predictions (in seconds) provided by Card et al. [5] as well as John and Kieras [12]:

$$T = 1.35 + 0.28 + T_A + 0.1 = 1.73 + T_A \tag{3}$$

$$T = 1.35 + 1.35 + 1.1 + 0.1 + T_A + 0.1 = 4.00 + T_A \tag{4}$$

The required time for color adjustment (T_A) could not be obtained from the literature. Even though on the motor level it is a simple dragging operation, we expect longer execution times due to cognitive load. In both conditions slider adjustments were controlled with relative motion input and a comparable control display gain. But while the distance between start and target value could only be covered with slider motion (T_A) in the circular condition, the linear condition enabled to shorten this distance by pointing close to the respective target value on the slider. In this case T_A can become zero if the user points very accurately. However, we assumed that cognitive processes of comparing two colors have a higher impact on operation times than the distance. Hence we based our hypotheses on the assumption that adjustment operations will require a comparable amount of time in both conditions.

- H1: The time required for the selection operation will be significantly longer for the linear condition.
- H2: The times for the selection subtask will contribute the main differences in task completion times.
- H3: The Pie Slider will perform significantly faster for the color adjustment task than the linear sliders.
- H4: *Distance* will have a stronger impact on task completion times for the circular condition.

5.3 Results and Discussion

Data was collapsed and entered into a 2 (technique) x 3 (parameter) x 5 (distance) analysis of variance with the order of techniques as between-subjects factor. Order of techniques showed no main or interaction effect. Bonferroni adjustment of α was used for post-hoc comparisons. We found significant main effects on task completion times for the factors *technique* ($F(1, 14) = 5.26$, $p < .05$) and *parameter* ($F(2, 28) = 4.02$, $p < .05$) as well as a significant interaction between *technique* and *distance* ($F_{(4,56)} = 3.46$, $p < .05$).

Task completion times were significantly shorter for the circular condition (5.12 s) than for the stack of linear sliders (5.74 s), which confirms H3. A closer examination of the task phases (fig 5) shows that parameter selection took 75% less time in the circular condition (0.67 s) than in the linear condition (2.75 s), which confirms H1. In both cases the selection time is much shorter than expected. We suggest that the task did not require the expected time for initialization, because the users were repeatedly performing it. When subtracting the expected 1.35 s for this mental operation, the predicted values get close to the recorded data. The average time for the adjustment operation was 3.34 s in the circular and 2.84 s in the linear condition. The time advantage of the linear condition may result from differences in the involved motor operations. However, since users were provided with information on the target value, it is more likely that it stems from the described possibility of pointing close to the target value during the selection phase.

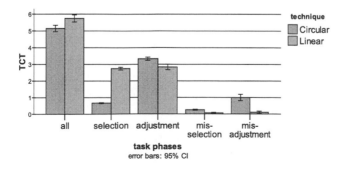

Fig. 5. Task phases per menu type

The results indicate that the performance advantages of the circular condition mainly stem from the facilitated selection process, but we cannot see the huge advantage (summing up to 1.58 s) in the overall task completion times. This is due to the differences in the errors. The sum of incorrect selection and adjustment time is much higher for the circular condition than for the slider condition (1.26 s vs. 0.17 s). We observed that the benefit of a facilitated selection process comes with the drawback of a higher likelihood of incorrect selections.

The task completion times for hue, saturation and value are 5.72 s, 5.43 s and 5.14 s, respectively. Post-hoc comparisons showed a significant difference ($p < .05$) only between hue and value, which indicates a higher cognitive effort to adjust hue. The parameter hue consisted of several color ramps between the primary colors, whereas the control of value can be intuitively mapped to the one-dimensional ("more or less") scale of a slider.

A closer analysis of the interaction of *technique* with *distance* does not support H4. Task completion times for the circular condition does not consistently increase over the five distance values (5.03 s, 4.92 s, 5 s, 5.07 s, 5.59 s - from short to long distances), but only with the largest distance. However, the task completion times recorded in the linear condition expose a variation that seems to have even less correlation with distance (5.45 s, 6.08 s, 6.02 s, 5.48 s, 5.69 s – from short to long distances).

In summary we found that the participants of our study rapidly became proficient in operating our novel parameter control interface. The performance of the Pie Slider interface was significantly better than the performance of the commonly used interaction technique for manipulating virtual controls on the screen. We observed that direct pointing on a tangible device is more efficient than screen-based interaction with virtual tools - even though the on-screen targets were much larger in our study than in common graphical user interfaces.

6 Conclusions and Future Work

The Pie Slider facilitates the rapid selection of the parameter to be adjusted and allows users to spend most of the interaction time on its actual parameter adjustment. Our approach combines advantages of tangible control devices such as proprioception and tactile guidance with those of graphical user interfaces including scalability and dynamic labeling. The comparison of the Pie Slider to the common linear slider interface showed the overall usability of the developed approach for the adjustment of parameter sets. We observed that users rapidly become proficient with the hybrid interaction technique consisting of absolute point selection and relative motion input. Significant performance benefits were found for absolute pointing within the tangible reference frame of the circular touchpad. However, we also observed that such accelerated interaction techniques do not only facilitate intended operations, but also unintented ones.

Our aim to shift interaction time from the preparation of the task to its operation could be achieved with the design of the Pie Slider. Our results prove that even in tasks where the target value is known beforehand the novel interface is competitive to common approaches providing the possibility for directly

selecting a target value. We suggest that in cases, where the desired value is not known beforehand, but needs to be explored through continuous manipulation, the Pie Slider would show even stronger performance advantages.

We believe that the presented interaction technique is beneficial for many applications that require the adjustment of abstract parameters. The inherent adaptability of the interface suggests a generic implementation for indirect interaction on various display systems including home entertainment and presentation displays for advertisement or data visualization. Besides integrating the novel parameter control technique into such applications, we will further develop and analyze interaction techniques that facilitate task preparation and emphasize on the exploratory adjustment of parameter values.

References

1. Blasko, G., Feiner, S.: An interaction system for watch computers using tactile guidance and bidirectional segmented strokes. In: ISWC 2004: Proceedings of the Eighth International Symposium on Wearable Computers, pp. 120–123. IEEE Computer Society, Washington (2004)
2. Butz, A., Groß, M., Krüger, A.: Tuister: a tangible ui for hierarchical structures. In: IUI 2004: Proceedings of the 9th international conference on Intelligent user interfaces, pp. 223–225. ACM, New York (2004)
3. Callahan, J., Hopkins, D., Weiser, M., Shneiderman, B.: An empirical comparison of pie vs. linear menus. In: CHI 1988: Proceedings of the SIGCHI conference on Human factors in computing systems, pp. 95–100. ACM, New York (1988)
4. Card, S.K., Moran, T.P., Newell, A.: The keystroke-level model for user performance time with interactive systems. Commun. ACM 23(7), 396 410 (1980)
5. Card, S.K., Newell, A., Moran, T.P.: The Psychology of Human-Computer Interaction. L. Erlbaum Associates Inc., Hillsdale (1983)
6. Fitts, P.: The Information Capacity of the Human Motor System in Controlling the Amplitude of Movement. Journal of Experimental Psychology 47, 381–391 (1954)
7. Fitzmaurice, G.W., Ishii, H., Buxton, W.: Bricks: Laying the foundations for graspable user interfaces. In: CHI, pp. 442–449 (1995)
8. Göttel, T.: Probono: transferring knowledge of virtual environments to real world situations. In: IDC 2007: Proceedings of the 6th international conference on Interaction design and children, pp. 81–88. ACM, New York (2007)
9. Guimbretiére, F., Winograd, T.: Flowmenu: combining command, text, and data entry. In: UIST 2000: Proceedings of the 13th annual ACM symposium on User interface software and technology, pp. 213–216. ACM, New York (2000)
10. Hinckley, K., Pausch, R., Goble, J.C., Kassell, N.F.: Passive real-world interface props for neurosurgical visualization. In: CHI 1994: Conference companion on Human factors in computing systems, p. 232. ACM, New York (1994)
11. Hopkins, D.: The design and implementation of pie menus. Dr. Dobb's J. 16(12), 16–26 (1991)
12. John, B.E., Kieras, D.E.: The goms family of user interface analysis techniques: comparison and contrast. ACM Trans. Comput.-Hum. Interact. 3(4), 320–351 (1996)
13. Kok, A.J.F., van Liere, R.: Co-location and tactile feedback for 2d widget manipulation. In: VR 2004: Proceedings of the IEEE Virtual Reality 2004, p. 233. IEEE Computer Society, Washington (2004)

14. Kurtenbach, G.: Some articulatory and cognitive aspects of marking menus: an empirical study. Human Computer Interaction 8(2), 1–23 (1993)
15. Lee, E.: Towards a quantitative analysis of audio scrolling interfaces. In: CHI 2007: CHI 2007 extended abstracts on Human factors in computing systems, pp. 2213–2218. ACM, New York (2007)
16. Moscovich, T., Hughes, J.F.: Navigating documents with the virtual scroll ring. In: UIST 2004: Proceedings of the 17th annual ACM symposium on User interface software and technology, pp. 57–60. ACM, New York (2004)
17. Pook, S., Lecolinet, E., Vaysseix, G., Barillot, E.: Control menus: excecution and control in a single interactor. In: CHI 2000: CHI 2000 extended abstracts on Human factors in computing systems, pp. 263–264. ACM, New York (2000)
18. Rekimoto, J., Ullmer, B., Oba, H.: Datatiles: a modular platform for mixed physical and graphical interactions. In: CHI 2001: Proceedings of the SIGCHI conference on Human factors in computing systems, pp. 269–276. ACM, New York (2001)
19. Smith, G.M., Schraefel, M.C.: The radial scroll tool: scrolling support for stylus- or touch-based document navigation. In: UIST 2004: Proceedings of the 17th annual ACM symposium on User interface software and technology, pp. 53–56. ACM, New York (2004)
20. Ullmer, B., Sankaran, R., Jandhyala, S., Tregre, B., Toole, C., Kallakuri, K., Laan, C., Hess, M., Harhad, F., Wiggins, U., Sun, S.: Tangible menus and interaction trays: core tangibles for common physical/digital activities. In: TEI 2008: Proceedings of the 2nd international conference on Tangible and embedded interaction, pp. 209–212. ACM, New York (2008)
21. Underkoffler, J., Ishii, H.: Illuminating light: an optical design tool with a luminous-tangible interface. In: CHI 1998: Proceedings of the SIGCHI conference on Human factors in computing systems, pp. 542–549. ACM Press/Addison-Wesley Publishing Co., New York (1998)
22. Underkoffler, J., Ishii, H.: Urp: a luminous-tangible workbench for urban planning and design. In: CHI 1999: Proceedings of the SIGCHI conference on Human factors in computing systems, pp. 386–393. ACM, New York (1999)
23. Webb, A., Kerne, A.: The in-context slider: a fluid interface component for visualization and adjustment of values while authoring. In: AVI 2008: Proceedings of the working conference on Advanced visual interfaces, pp. 91–99. ACM, New York (2008)
24. Wherry, E.: Scroll ring performance evaluation. In: CHI 2003 extended abstracts on Human factors in computing systems, pp. 758–759. ACM, New York (2003)

User-Centered Development of a Visual Exploration System for In-Car Communication

Michael Sedlmair[1], Benjamin Kunze[1], Wolfgang Hintermaier[1],
and Andreas Butz[2]

[1] BMW Group Research and Technology, Munich, Germany
{michael.sedlmair,benjamin.kunze,wolfgang.hintermaier}@bmw.de
[2] Media Informatics Group, University of Munich, Germany
andreas.butz@ifi.lmu.de

Abstract. Modern premium automobiles are equipped with an increasing number of Electronic Control Units (ECUs). These ECUs are interconnected and form a complex network to provide a wide range of advanced vehicle functionality. Analyzing the flow of messages in this network and tracking down problems has become a major challenge for automotive engineers. By observing their working practices, we found that the tools they currently use are mostly text-based and largely fail to provide correlations among the enormous amount of data. We established requirements for a more appropriate (visual) tool set. We followed a user-centered approach to design several visualizations for in-car communication processes, each with a clear purpose and application scenario. Then we used low-fidelity prototypes to evaluate our ideas and to identify the "working" designs. Based on this selection, we finally implemented a prototype and conducted an expert evaluation which revealed the emergence of a novel mental model for thinking about and discussing in-car communication processes.

Keywords: Information Visualization, User-centered design, In-Car Communication Networks.

1 Introduction

An increasing variety of functionality is provided in premium automobiles to enable more efficient, enjoyable, and safer driving. This has led to an increasing amount of hardware in the form of Electronic Control Units (ECUs), as well as new software components in these ECUs. In the last several years, many innovations and new functions were realized by interconnecting ECUs to share information within the vehicle in new ways. The tremendously increased complexity of today's in-car communication networks is the consequence. Modern premium automobiles currently contain up to 70 ECUs, interconnected by four major bus technologies (CAN, MOST, FlexRay, LIN). Some of these ECUs are even connected to all of these bus technologies, and a massive amount of information is distributed by exchanging messages. Current in-car communication networks have to deal with up to one million messages per minute, and each message in

A. Butz et al. (Eds.): SG 2009, LNCS 5531, pp. 105–116, 2009.
© Springer-Verlag Berlin Heidelberg 2009

turn transports a certain amount of signals representing sensor measurements and status information.

With this increasing complexity, engineers are more and more challenged in terms of analyzing errors and diagnosing faulty vehicle behavior. They are persistently confronted with an enormous amount of data generated by bus traffic scans and network simulation systems. To address this problem, specific tools were developed to support analysis experts in comprehending in-car communication processes. However, the tools that are currently available are mainly based on textual descriptions and lack presentation of cause and effect relations. However, to gain a deeper understanding of the bus communication, it is necessary to clearly see the temporal (or even causal) relation between messages.

To support this communication analysis, we propose a graphical representation of the temporal relation between messages. We describe our three-phase, user-centered design process and the experience with applying our tool in a real, industrial environment for the diagnosis of in-car communication. The fact that this is a true expert domain requires close cooperation with users to clearly understand their working practices and to fine-tune solutions to their needs. Tools which do not adhere to this design strategy will most probably turn out to be inappropriate [17]. In this paper we present a working example how a user-centered approach can be applied to design information visualization in an industrial environment, namely the automotive industry, and how this led to an novel, appropriate visualization concept. A central point of our approach is to involve domain experts - the rarely available automotive analysis experts - closely in every stage of the design process. According to the specific requirements of each phase we used different human-computer interaction (HCI) methods to obtain a suitable, comprehensive visualization design. We used user observations and guided interviews in the analysis phase, evaluated a number of designs by means of low-fidelity prototypes and conducted an expert user study with a fully implemented prototype in the evaluation phase.

2 Related Work

In HCI, many people have investigated user-centered design approaches [8,11,12]. However, in the field of information visualization designers often neglect these HCI principles and develop inappropriate system designs. In the recent past, things have started to change and the fundamental relevance of a user-centered approach for the success of information visualization systems is recognized in [3,6,14,17,19]. Wijk [17] for instance ascribes the fact of many poor designs to a gap between the visualization researcher and the domain experts. The design often suffers from the fact that these two parties have an entirely different background and expertise. Wijk therefore proposes a user-centered design approach to clearly understand the end users' needs and limitations. Wassnik et al. [19] also discuss the adaption of user-centered design approaches from HCI and their transfer to interactive visualization systems. They propose a highly iterative design process with prototypes of different fidelities and their evaluation. Particularly, a detailed analysis of the users, their tasks and environments

is strongly recommended to solicit actual needs. A few existing projects have already applied a user-centered approach to develop information visualization systems. Goodall, et al. [4] for instance designed a visualization system to support network traffic analysis for intrusion detection. To get insight into the users' needs they used contextual interviews [7] and derived system requirements for this specific application area.

In the analysis of current working practices, we found several expert tools used by automotive engineers to analyze in-car communication data. These tools are directly related to our work because they represent the current practices, which we want to improve by extended use of information visualization concepts. Canalyzer[1] is one of the most frequently used software tools. It is an expert analysis tool integrated into a tool chain to work with automotive bus systems and communication networks and the de-facto standard tool for error diagnostics and network analysis. The user interface of Canalyzer has shaped the way in which engineers think and work right now. It provides a variety of modules to textually represent data in lists and also supports some basic, non-interactive visualization, such as line and bar charts, gauges, status bars, or a topology view of the ECU network. While on the technical realization side, this tool provides a wide functionality and professional way to support the engineers' needs, there is a high potential for improvement by providing interactive information visualization. Several other tools are available and used for analyzing in-car communication processes. One relatively new tool is Tracerunner[2], which differs from the rest by a stronger use of color coding and the occasional use of relatively sophisticated visualization techniques. In addition to the textual information, for instance a map can represent GPS data, a compass can show the current orientation or a speedometer can be displayed. Furthermore, there are several in-house tools from automotive companies which have roughly the same use case mapping and functionality range as Canalyzer or Tracerunner. These tools are mostly directly adapted to product specific requirements. One common observation was that none of these tools really supports the user with interactive information visualization techniques.

3 Analysis: Current Working Practices and Users' Needs

Studying the User. In order to design a system for such a special target group, it is very important to clearly understand their current practices and needs [19]. We conducted two different kinds of user studies for this. First, we used a mixture of a user observation and a guided interview to get direct insight into the daily routines of the experts. Two observers sat next to one analysis expert, observing his/her daily work, taking notes and asking questions about unclear points. Then, we enriched these observational studies with guided expert interviews to directly focus on our interests - the current use of visualization and the expected added value of visualization in this area. The interviews were conducted after

[1] http://www.canalyzer.de
[2] http://www.tracerunner.de

the user observations. In doing so, we avoided distorting the results of the observational studies by prematurely informing the user about our interests. We conducted these studies with eight experts, all working in the analysis and diagnosis of in-car communication processes. Each study took 1-2 hours depending on the amount of time the experts were willing to contribute. In a second step, we designed an online questionnaire to contact a wider range of analysis experts and to directly address our findings from the observations and interviews. The focus was mainly on currently used tools for diagnosis, the variety of use cases they have to deal with, and the current usage of visualization. In this process, we received feedback from 23 more experts and confirmed our previous findings.

Results of the Studies. Not surprisingly, we encountered a very *high degree of specialization* in the underlying domain. When watching an engineer browse through an in-car communication network data trace, a layman would not be able to follow the quick and complex thoughts and conclusions which are made within seconds, mostly because of the complex and very specific way in which engineers read and interpret the data shown in hexadecimal code. Every engineer has her/his expertise in one particular field of the network, for instance in two motor management ECUs. All codes used there are familiar to the engineer and easy to interpret. But if the expert wants to explore data beyond the usual, well-known scope, s/he has to browse through unknown, non-interpreted hexadecimal code and mapping the functions soon becomes a tenacious and time-intense activity. The most important software tools were Canalyzer and a number of in-house tools. Which tools the engineers preferred, mostly depended on personal preferences, usage by colleagues within the same department, capabilities of the tool and license fees. The tools are mostly based on textual description of communication data with long lists of raw communication data. This *raw data is very important* for the engineers to exactly understand the details in the communication process and to identify the precise point of failure. However, for understanding coherences, dependencies, and trends this form of data presentation is useless. The tools also support some basic visual descriptions, for instance a line graph or progress bars for signal values. However, in the interviews and questionnaire we learnt that these visualizations did not match the experts' needs. All subjects strongly demanded a higher degree of visual support in the analysis process. Furthermore, we found that users frequently worked with *multiple parallel and sequential views* to provide different perspectives of the same dataset (e.g., a line chart and a hexadecimal information list), for simultaneously looking at different timestamps (e.g., looking for similar or cyclic settings), or for comparing different datasets. Although these multiple views were often used, the current tools poorly support a proper coordination between them.

Derived Requirements. From our formative studies we derived the following common requirements for improving the current practice:

Enhance Visual Support and Interaction. Novel visualization methods have to be considered and evaluated regarding their usefulness and adequacy for human

perception. While the detailed representation in current tools is sufficient for parts of the task, visualization techniques must be used to gain more insight into correlations, dependencies and overview aspects. Additionally, the subjects of the studies demanded those visualizations to be highly interactive and to support direct manipulation [13] to allow usable and extensive exploration techniques.

Support Preattentive Processing. Human perception is neither efficiently used by browsing endless data tables nor by recognizing small hexadecimal changes within them. However, the users we observed spent plenty of time searching and navigating these lists. The effect of preattentive processing [15] of certain graphical features, such as color or shape, can reduce the perception time for the existence, absence or number of graphical items on the stage. Including this consideration into the design process means keeping the colors and shapes of any visual vocabulary as simple and subtle as possible, whereas any important point of interest should pop out of the surroundings [18,16].

Quick Access to Raw Information. Any piece of raw data from signals, messages and values must be reachable at any time. An abstraction of the data can be helpful, but is not preferred for showing hard facts. Hence, the classical List View with its rich level of detail will remain a central point in the user interface.

Enhance Temporal Structure and Navigation. In-car communication traces have a strong inherent temporal structure. Message after message is recorded and written into the trace file sorted by time stamp. However, navigation and orientation in time is poorly supported by the current analysis tools. They just put all the information in scrollable, ordered lists. As the lists get very large, this requires a lot of scrolling effort, and - even worse - reduces data to its causal order and actually hides exact time differences (which can only be found by looking into the detailed information). However, to better understand all temporal relations, both coarse and fine time information is relevant.

Multiple Coordinated Views. Observing the connection between different visual data representations can increase the understanding of complex relations in the datasets. We therefore propose the explicit support of multiple coordinated views (MCV, [9]). While current tools make extensive use of multiple views, these are poorly coordinated. A clear and usable coordination concept should support the user in browsing the data and allow easy switching between views.

4 Design: Creating and Evaluating Novel Approaches

Generation of Ideas. In the idea generation phase, a visualization catalog was collected, which contained existing views, newly developed visualization concepts and adaptations of traditional solutions. The proposed concepts were:

- *Textual List View:* The traditional List or Table View is the most familiar way to show detailed data and it is extensively used in current tools.
- *Classic Visualization Methods*: Line and bar charts are frequently used visualization methods. They are easy to understand and therefore have a huge

potential for representing time-dependent data sets. They have represented the way people use and think about information visualization for the past couple of decades (cf. fig. 1 (a) and (b)).

- *Themeriver:* The Themeriver [5] visualization uses a "river" metaphor with different "currents" varying in width to represent data values. The purpose of the Themeriver is to give a general overview of trends within time periods of datasets. (cf. fig. 1 (c)).
- *Bubble View:* The Bubble View was based on scale-free networks [1] used in bioinformatics. It visualizes different points within an in-car network, for instance ECUs or functions implemented in the ECUs drawn as bubbles and directed graphs with arrows between them. Whenever the activity of such a component increases, the corresponding bubble starts to grow. This was meant to present a current state of the system and show the "big players" at a certain time. (cf. fig 1 (d)).
- *Autobahn View:* The Autobahn View is a novel visualization concept which we designed according to the outcomes of our analysis phase (cf. section 3). The Autobahn View is based on the metaphor of a crowded highway and on the fundamentals of a scatter plot. Each bus system is visualized as a separate group of lanes - the highway. Every bus transports messages from different ECUs represented by an incorporated horizontal bar - a lane of the highway. The lanes in turn contain black rectangles - the cars - which each represent a message sent by the ECU through the bus to another ECU, ordered horizontally by time. A slightly different view was defined as the Signal-Autobahn View. This view inherits all principles of the Autobahn View, but represents transported signals instead of messages (cf. fig. 1 (e)).

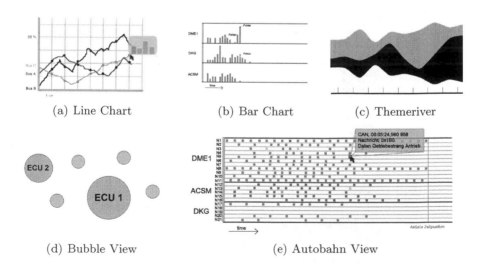

(a) Line Chart (b) Bar Chart (c) Themeriver

(d) Bubble View (e) Autobahn View

Fig. 1. Visualization catalog

Low-Fidelity Prototypes and Evaluation. To evaluate our design ideas, we discussed printed versions (cf. fig. 1 (a)-(e)) with the same 8 experts we had observed in the analysis phase. Their input narrowed the visualization concepts down very quickly and led to a short list of pragmatic design solutions. We asked them to assign use cases to the visualization concepts and to imagine and illustrate in each case an example how it can be used to visualize the underlying data, e.g.,: "In my opinion the Autobahn View could be used to show message bursts and to investigate frequencies in sending actions". Based on this evaluation, we classified the visualization concepts into three categories: Strongly requested, optional, or not requested. The results of this classification as well as the reasons and the mapped use cases can be found in table 1.

Table 1. Results of visualization catalog evaluation

View	Figure	Desire	Reasons	Mapped use cases
Textual List View	-/-	Strongly requested	The list view is irreplaceable to show the detailed data in tabulated format (cf. Current Working Practices)	- Showing precise detailed information - Exploring data - Monitoring data - Analyze data
Classic Visualization Methods	1 (a) 1 (b)	Optionally requested	These visualization forms are well known and easy to understand. Experts like using them but demand a higher degree of interactivity.	- Showing state of the components - Showing activity history of components - Showing traffic volume - Finding transition states
Themeriver	1 (c)	Not requested	High abstraction level with less level of detail was assessed to be not applicable to the in-car communication domain.	- Showing combined trends
Bubble View	1 (d)	Optionally requested	Although this view had no direct use case mapping it was extremely well liked in discussions because of its innovative character.	No use cases found
Autobahn View	1 (e)	Strongly requested	This visualization reached a wide acceptance by the expert users because it supported a common mental model with a simple and pleasant visual vocabulary.	- Finding Errors - Monitoring Cyclic Traffic - Monitoring the In-Car Communication - Getting familiar with the car network domain - Explore Cause-Effect relations

5 Evaluation: Building and Evaluating a Prototype

Final Concept. In order to turn the basic concepts into a well-designed tool, we took the most requested visualization concepts, namely the Autobahn View and the List View, applied established design guidelines, worked out an appropriate interaction concept and integrated several features to support the users' working practices. These two visualization concepts form the basis of an MCV application, allowing the user to work with an arbitrary number of Autobahn Views and List Views, which can be interactively created. The two concepts each emphasize different kinds of information. The Autobahn View is used to visualize messages or signals, both based on their ECU affiliation. A List View can display detailed information about messages, for instance exact time stamps, included signals, long name, etc., or, alternatively, about signals, such as the signal's raw data. All input from the experts was used to design a coherent interaction concept

Fig. 2. Screenshot of the application with (a) Message-Autobahn, (b) Signal-Autobahn and (c) Message-List / Additional arrows show a POI (left) and Sync Button (right)

within the views and a coordination concept between the views. Figure 2 shows a screenshot of the implemented system.

As an implication of our design requirements, the final concept adheres to Shneiderman's visualization mantra *Overview first, zoom and filter, details on demand* [13]. The Message-Autobahn View forms the central part and window of our application. It is the only view restricted to a single instance and makes all messages of a given data trace accessible. In general, the Autobahn View is based on the zoomable interface paradigm (ZUIs, [2]). Two-dimensional panning is accomplished by grabbing the view, and zooming by the mouse's scroll wheel. Navigating along the x-axis, therefore, enables the user to go back and forth in time in a convenient and familiar way. At the lowest zoom level, the Autobahn View accommodates a coarse-grained representation, showing many messages without fine-grained timing information (*Overview*). The entire representation is arranged on a horizontal timeline and can show up to 5000 message items in a time frame of up to 3 seconds on one screen.

By an animated zoom, which takes not more than 300 msecs, the user can easily get to a higher level of detail (*Zoom*). Fig. 3 shows a sequence of inter-actions to zoom in to a specific area within the trace. Finding the right levels of time granularity for each of the four zoom levels was challenging. The car-system stores time stamps in microseconds. As our observation and interviews showed, engineers work mostly with milliseconds. The problem, that messages from the same millisecond, but different microseconds would be shown as par-allel, was discarded by engineers non-critical. Nevertheless a compromise was implemented in the form of a user-selected switch between steps of 100 micro- and 1 milliseconds. In addition, to emphasize the aspect of overlapping messages in the milliseconds view, a subtle number was set up next to the highest item which contains the number of messages within this cluster of parallel messages.

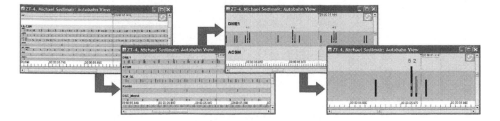

Fig. 3. Zooming stepwise into the Autobahn View

Since not every message or ECU is necessary for a particular use case, a filter functionality lets the user switch ECUs, messages, signals, or even entire bus systems off or on (*Filter*). As all the users had a technical background, a Boolean syntax was used in a textual filter dialog, e.g., "NOT message-name1 AND NOT message-name2".

To support the required quick access to non-abstract data, our application provides three ways to reach this kind of raw data (*Details on Demand*):

- *Selection:* Every message or signal on the Autobahn View is clickable. This single selection opens the List View with all available detail of that particular message or signal. Besides the single selection, the user can select multiple items by pressing CTRL and drawing a rectangle over the area for which more information is desired.
- *Preview:* Every message or signal item on the stage provides a mouseover preview showing the name, the hexadecimal code and the time of this message.
- *Context Menu:* In order to show all listed details from one ECU or message, the user can issue commands such as "List all details" via a rightclick menu.

To support orientation within the mass of time-based data, we integrated a marking concept to *support preattentive popout effects.* We used visual markers in the form of circles filled with exaggerated, saturated colors to emphasize certain messages or signals - points of interest (POIs) - within the Autobahn View. The circles are positioned directly over the associated item in the view and pop out from the pale background. For differently colored POIs inter-POI preattentive distinction is not supported. In addition, they are shown in a so-called overview bar. This allows direct navigation between POIs along the entire timeline (cf. fig. 2). The concept of POI highlighting is used for:

- *Anchors:* These are user-defined marks, which can be interactively added to the stage and filled with explanatory text.
- *Search:* Search queries can be created through a separate component in which the user selects certain messages or signals and the system highlights all matching items. Query parameters are the highlighted color, the name of the message or signal and an optional value range for signals. A typical search query would look like "Signal xy>10".

Time synchronization between Autobahn Views is achieved by a variant of synchronous scrolling [9]. Every Autobahn View has a timedrop component, on which the local time of the view is shown by a text field and a dotted line. Next to the local time we show the global time which is used to synchronize the views. In order to synchronize a view to the global time the user has to push the synchronize icon placed in the upper right corner (cf. fig. 2). In doing so, the user adds this particular view to the list of already synchronized views. Browsing through the data in one of these views then triggers a time update and navigational action in all other views.

Implementation of a High Fidelity Prototype. Our prototype is implemented with java and uses the piccolo[3] framework for zoomable interfaces. The prototype is connected to real data sets recorded from in-car communication networks and can handle datasets of up to 200 000 messages. In the longer run, a more complex and portable system environment has to be implemented, which, however, was clearly not the focus of our research.

Evaluation of the Prototype. We conducted a qualitative expert user study to assess the understandability and the usability of our visualization. The subjects were five experts with long experience in automotive diagnostics and analysis and each study took 1-2 hours. The study was divided into three parts. First, we gave a short introduction to our tool with a concept video and a five minute testing phase. Then, the subjects had to solve several tasks to evaluate the tool's usability and to get familiar with the tool's paradigms. The tasks ranged from very elementary, tool-based to more sophisticated, domain-based ones, e.g.,: "Open a new view and synchronize the views", "Find a specific message", or "Find abnormalities in the communication of the ECU LRR". In this phase we used the think aloud protocol to capture the subjects' opinions, criticisms and ideas. Finally, a guided interview was used for general feedback and to evaluate the understanding and insight provided by our novel visualization.

The overall feedback from the domain experts was very positive. During the studies we observed, that the Autobahn View provided a novel mental model for thinking and discussing in-car communication data. It is hard to measure this kind of insight [10] but it was very interesting to see four of five domain experts starting to explain things directly by means of the novel Autobahn metaphor, e.g.,: "As you can see, we have lots of traffic on this ECU's lane", "Oh, what does that burst of message rectangles mean?" or "On the road you can perfectly track cyclic messages". Another hint in this direction was an observation we made during a presentation with a live demo of our concept in a meeting of analysis experts. During the live demo, the attendees suddenly started to discuss a known problem of a specific ECU by means of the Autobahn representation. The problem was about the ECUs "spamming" activities on the bus and the engineers started arguing: "Does anyone know why the LRR ECU sends message bursts in this compressed cycle?", "In my opinion that has to be the reason for the bus spam.", "No, the other ECUs seem to work normally", etc. The most

[3] http://www.cs.umd.edu/hcil/jazz/

appropriate use cases for our concept were the direct perception of message bursts and activity centers as well as the detection of frequencies and cycles within the communication data. Also, the fast availability of detailed information was very helpful for a more detailed exploration in these situations. The feedback on usability was also very positive. All subjects were able to use the interface fast and without major problems.

The final evaluation also showed problems and revealed room for improvement of our visualization concept. Most importantly, the stacking of nearly simultaneous messages was initially misunderstood by three of five of our subjects. It was interpreted as a length coding of information and guessed to be the messages' byte length. Enquiring this in detail, however, showed that coding the messages' length would not be beneficial for the engineers at all. After resolving the misconception, they had no further problems in understanding. Nevertheless, the initial misunderstanding must be taken seriously and considered in future work. Additionally, we detected an incompatibility in understanding the panning and zooming interaction concept with two of our subjects. They noted that they would prefer zooming via drawing a rectangle, which conflicted with our interaction concept for selecting a group of items. After several minutes of using the interface, this usability problem seemed to have disappeared and the subjects used the tool fluently. While this could be investigated further to avoid potential conflicts with established ways of interaction, it can also be argued that our target group consists of expert users, and hence an initial problem might be less severe than for one time users. Another point of criticism was the understanding of the coordination feature. Two of our subjects wondered that they had to select more than one view to start the synchronization action. Their current mental model matched more an "all-or-none" synchronization feature and the synchronization of sub-groups of views was not self-explanatory. In future work it has to be clarified whether the more powerful and dynamic group synchronization is worth the additional learning effort or whether a global synchronization for all views would perform better.

6 Conclusion and Future Work

We have presented a user-centered approach to designing a new, visually and cognitively well-founded tool set for automotive engineers to deal with complex in-car communication processes. Based on a detailed observation of our target group, we established a number of requirements for the design of this tool set. In the following design phase, we developed different visualizations, each with a clear application scenario in mind, and evaluated these designs with our target group. Based on these findings we implemented a prototype and conducted an expert user study which revealed the emergence of a novel mental model, called Autobahn View. After further iterative refinement (cf. section 5 - Evaluation) and enhancement of scalability (cf. section 5 - Implementation), we are planning to integrate our designs tightly with the existing tools and provide a stable working environment for day-to-day use.

References

1. Barabasi, A., Oltvai, Z.: Network biology: understanding the cell's functional organization. Nature Reviews Genetics 5(2), 101–113 (2004)
2. Bederson, B., Meyer, J., Good, L.: Jazz: an extensible zoomable user interface graphics toolkit in Java. In: Proceedings of the 13th annual ACM symposium on User interface software and technology, pp. 171–180. ACM, New York (2000)
3. Boyd, D., Gallop, J., Pahnen, K., Platon, R., Seelig, C.: VIVRE: User-Centred Visualization. LNCS, pp. 807–816 (1999)
4. Goodall, J., Ozok, A., Lutters, W., Komlodi, A.: A user-centered approach to visualizing network traffic for intrusion detection. In: Conference on Human Factors in Computing Systems, pp. 1403–1406. ACM, New York (2005)
5. Havre, S., Hetzler, E., Whitney, P., Nowell, L.: ThemeRiver: Visualizing Thematic Changes in Large Document Collections. IEEE Transactions on Visualization and Computer Graphics, 9–20 (2002)
6. Johnson, C., Moorehead, R., Munzner, T., Pfister, H., Rheingans, P., Yoo, T.: NIH-NSF Visualization Research Challenges Report (2006)
7. Komlodi, A., Goodall, J., Lutters, W.: An Information Visualization Framework for Intrusion Detection. In: Conference on Human Factors in Computing Systems. ACM, New York (2004)
8. Norman, D., Draper, S.: User Centered System Design; New Perspectives on Human-Computer Interaction. Lawrence Erlbaum Associates, Inc., Mahwah (1986)
9. North, C., Shneiderman, B.: M. U. of Maryland. In: A Taxonomy of Multiple Window Coordinations. Human-Computer Interaction Laboratory, Institute for Advanced Computer Studies, College Park, H. I. Laboratory (1997)
10. Plaisant, C.: The challenge of information visualization evaluation. In: Proceedings of the working conference on Advanced visual interfaces, pp. 109–116. ACM, New York (2004)
11. Preece, J., Rogers, Y., Sharp, H.: Beyond Interaction Design: Beyond Human-Computer Interaction. John Wiley & Sons, Inc., New York (2001)
12. Shneiderman, B.: Designing the user interface. MIT Press, Cambridge (1989)
13. Shneiderman, B.: The eyes have it: a task by data type taxonomy for information-visualizations. In: IEEE Symposium on Visual Languages, 1996. Proceedings, pp. 336–343 (1996)
14. Thomas, J., Cook, K.: Illuminating the path The research and development agenda for visual analytics. IEEE, Los Alamitos (2005)
15. Treisman, A.: Preattentive processing in vision. Computer Vision, Graphics, and Image Processing 31(2), 156–177 (1985)
16. Tufte, E.: Envisioning Information. Optometry and Vision Science 68(4), 322 (1991)
17. van Wijk, J.: Bridging the Gaps. In: IEEE Computer Graphics and Applications, pp. 6–9 (2006)
18. Ware, C.: Information Visualization: Perception for Design. Morgan Kaufmann, San Francisco (2004)
19. Wassink, I., Kulyk, O., van Dijk, E., van der Veer, G., van der Vet, P.: Applying a User-Centered Approach to Interactive Visualisation Design. Trends in Interactive Visualisation (2008)

Part-IV
Computer Graphics and Artificial Intelligence

A Spatio-temporal Reasoning System for Virtual Camera Planning

Marc Christie[1], Fabrice Lamarche[1], and Frédéric Benhamou[2]

[1] The BUNRAKU Team
INRIA Rennes Bretagne Atlantique
Campus de Bealieu
F-35042 Rennes, France
marc.christie@irisa.fr, fabrice.lamarche@irisa.fr
[2] University of Nantes, LINA CNRS UMR 6241
2, Rue de la Houssinière
F-44322 Nantes, France
frederic.benhamou@lina.univ-nantes.fr

Abstract. The problem of virtual camera planning consists in comput-
ing camera paths in virtual environments that satisfy given cinemato-
graphic properties. In this article, we present a spatio-temporal query
system for reasoning over the cinematographic expressiveness of a dy-
namic 3D scene. We offer a declarative language with quantifiers based
on a first order logic representation. Prior to any query, we fully charac-
terize each spatial and temporal region of the search-space according to
a broad set of properties. We rely on interval-based constraint techniques
to guarantee the completeness of the characterization. Then in order to
answer a query, we build a digraph that connects over space and time
the areas satisfying the request. The exploration of this digraph together
with its connectivity properties provide the user with the identification
of distinct classes of solutions as well as the full set of camera paths
with their temporal validity. Applications are found in film prototyping,
e.g. when a director needs to explore the staging, shot and editing pos-
sibilities in real world, by using virtual environments, or in automated
and semi-automated editing.

1 Introduction

An increasing number of filmmakers rely on 3D tools as prototyping environ-
ments to evaluate the cinematographic possibilities of a scene[1]. For this purpose,
a rough 3D modelling of the environment is made together with the specifica-
tion of the actor staging. In this environment, the filmmaker explores the pos-
sible camera shots and editing combinations by relying on low-level interaction
possibilities offered by classical 3D modelers. This exploration generally follows

[1] Steven Spielberg employed Unreal Tournament as a framework to evaluate some
camera shots of his film A.I. Other filmmakers such as Enki Bilal and Luc Besson
rely on similar approaches.

A. Butz et al. (Eds.): SG 2009, LNCS 5531, pp. 119–127, 2009.
© Springer-Verlag Berlin Heidelberg 2009

a tedious generate and test process as little to no tools assist the user in his interactive exploration.

In this paper we propose a system that aims at improving the exploration process when assessing the cinematographic expressiveness of a virtual 3D scene. We propose a high level cinematographic language able to query the environment and answer such questions as: 'Does there exist a camera path such that we can see all three objects without occlusion for the duration of the scene?' or 'Where are the different camera locations for which moving objects A and B are seen from the front with a wide shot, and do not overlap on the screen?'. We propose to operationalize this language in a way that enables the complete exploration of the search space and generate multiple camera path solutions. The formal aspect of the queries (first order logic) is not intended to be used directly by the filmakers, but as a basis on which to build evolved user interfaces. Thus, the contribution in this paper is related to the expressive power of this language and its interval-based operationalization.

The idea underlying our approach is illustrated in Figure 1 with a simple example. As displayed, the conjunction of two properties is obviously characterized by the intersection of their underlying spatial and temporal relations. Such an intersection provides both the location and the duration for which the properties are verified. A solution to the problem is a path inside the intersected region.

Since the exact representation and manipulation of relations in high dimensional spaces is critical (a camera has seven degrees of freedom, and one for its temporal evolution), in this work we rely on approximate representations and space partitioning techniques. To perform an exhaustive characterization of every area with relation to each cinematographic property, we use interval constraint-based techniques [5] that partition the search space into 8-dimensional boxes to evaluate them. Based on this partitioning, a digraph is built by connecting adjacent boxes that enjoy the same properties (see Fig. 3). In this directed graph an

Fig. 1. Evolution of two sets of camera configurations over time (in purple and blue) that satisfy distinct cinematographic properties. Their intersection (in red) characterizes both the range of camera configurations (q) and the duration (d) for which both properties are satisfied. Camera paths and camera configurations can then be searched for inside the intersected region.

interval box is a node, and an arc the adjacency between boxes. An arc represents either a connection in space (*i.e.* the camera can freely be moved between the two boxes) or a connection in time (*i.e.* the camera can lay within these boxes for a duration that is the union of the durations).

In the following section, we position our work *w.r.t.* the state of the art. The query language is then described in detail and the following chapters present the interval-based techniques employed to characterize the search space and to construct the adjacency graph. Results are finally presented within average complex scenes.

2 State of the Art

In the task of querying the cinematographic expressiveness of virtual environments, requested properties are expressed on the desired shot (either by a user with a high-level language, or through the use of graphical interfaces that generate the properties), and different search techniques explore completely or partially the space for solutions. Good examples are found in [1,11,4]. The first applies a sampling of the search space by performing a uniform discretization of the camera parameters over position, orientation and focal distance (time is not considered). Each configuration is evaluated with respect to the specification, and the best result is returned as an aggregation of the individual fulfilment of each property. The approach is restricted to queries in static environements only and computes a unique solution of the problem.

The second contribution [11] follows a similar principle in addressing the visual composition problem (*i.e.* static camera positioning) as a pure optimization process. A fitness function is defined as a linear weighted combination of the fulfilment of the shot properties. The seven parameters of the camera are encoded in an allele and random crossovers and mutations are utilized to roam the search space with a generic algorithm. A preliminary extension to dynamic cameras is proposed that is restricted in its expressiveness (quadratic spline paths with with fixed *look-at* point and fixed start and end positions) [8].

In [4], the authors propose a semantic characterization of the different classes of solutions by computing a carving of the search space from a given a description. The constraints are represented as *semantic volumes*, *i.e.* volumes that encompass regions of the space that fulfil a cinematographic property. This work can be considered as an extension of *visual aspects* [9] and closely related to *viewpoint space partitioning* [13] for object recognition in computer vision. In *visual aspects* all the viewpoints of a single polyhedron that share similar topological characteristics in the image are enumerated. A change of appearance of the polyhedron, with changing viewpoint, partitions the search space. Computing all the partitions enables the construction of regions of constant aspect (*viewpoint space partitions*). Christie *et al.* extend viewpoint space partitions to multiple objects and replace the topological characteristics of a polyhedron with properties such as occlusion, relative viewing angle, distance and relative object location. A *semantic volume* is defined as a volume of possible camera locations that give

rise to qualitatively equivalent shots with respect to cinematographic properties. Since a problem is described as a conjunction of properties, the volumes can be intersected to yield a single volume or a set of disconnected volumes. The contribution is restricted both in its expressiveness by only handling a conjunction of properties, and by not considering dynamic scenes and temporal requests.

In most contributions, temporal aspects are neglected. Indeed, the intrinsic complexity of the techniques prevent them to be applicable in the case of evolving scenes. Though some declarative solving techniques have been explored to manage temporally indexed properties for time intervals (see [2,3]), the expressiveness in the querying is restricted (time intervals need to be fixed in advance), camera paths are restrained to basic camera movements, and no classification is proposed.

In this approach, we make the best of the previous approaches by allowing queries on temporally evolving 3D scenes, and ensuring that properties are satisfied in the path over time. We compute and propose the whole set of solutions with their full characterization. We perform reasoning to distinguish classes in the solution sets.

3 A Spatio-temporal Query Language

Following previous work related to spatial and temporal reasoning [7,6,12], we establish an expressive query language as a first order logic formalism which predicates are cinematographic primitives. The predicates we consider cover a large number of properties explored in previous work (see Table 1 and [4]) and can be classified as :

- related to the screen properties;
- related to the orientation of the camera;
- related to the movements of the camera.

Table 1. A representative set of properties available in our cinematographic query system. Properties are related to the motion of the camera, the shot and the content of the screen. κ represents a camera path.

Properties	Description
LeftOf(A,B,κ)	enforces A to be left of B in the screen
OnScreen(A,κ)	enforces A to be in the screen
InFrame(A, f, κ)	enforces A to lie in rectangular frame f
InFrontOf(A, B, κ)	enforces A to be located in front of B on screen
Occluded(A,B, κ)	enforces A to occlude B
Orientation(A, view,κ)	enforces the view shot on A (front, rear, top...)
LowAngleShot(A, κ)	enforces a low-angle shot of A
CloseUpShot(A, κ)	enforces a close-up shot of A
StaticCam(κ)	enforces a static shot (no path)
Travelling(κ)	enforces a linear motion of the camera path
Panoramic(κ)	enforces a panoramic motion of the camera path

A request is expressed as a logic statement: *e.g.* looking for a static camera configuration such that objects A and B are on the screen, viewed from the front, and do not occlude each other is written as a binary predicate:

$$shot1(A, B) \equiv \exists \kappa : StaticCam(\kappa) \wedge OnScreen(A, \kappa) \wedge OnScreen(B, \kappa) \wedge$$
$$Orientation(A, front, \kappa) \wedge Orientation(B, front, \kappa) \wedge$$
$$\neg Occluded(A, B, \kappa) \wedge \neg Occluded(B, A, \kappa)$$

If the semantics of negation is obvious for some of the primitives (for example $\neg OnScreen(A, \kappa)$ means the object should not appear on the screen), others require either more complex answers ($\neg CloseUpShot(A, \kappa)$ means accepting the whole set of shots ranges but this one, that is Establishing shot, Long shot, ... up to Extreme closeup shot) or cannot be expressed at all (*e.g.* there is no meaning to $\neg Travelling(\kappa)$).

The expressiveness of this language is augmented by using universal and existential quantifiers. The quantifiers operate on enumerated sets (such as viewing angles or shots distances) or on continuous sets such as the time parameters. For example, to express a static shot (*i.e.* looking for a camera configuration and not a camera path), such that object A is not occluded by object B, whatever the time in a given interval is written as:

$$shot2(A, B) \equiv \exists q, \forall t \in [0..5] : StaticCam((q, t)) \wedge \neg Occlusion(A, B, (q, t))$$

A more complex example is given by:

$$shot3(A) \equiv \quad \exists a \in \{Front, Left, Right\}, \forall t \in [0..5],$$
$$\exists q : Travelling((q, t)), \forall o \in \{B, C, D\} \wedge$$
$$Orientation(A, a, (q, t)) \wedge LeftOf(A, o, (q, t))$$

which queries a camera travelling motion such that a is either viewed from the front, left or right and that A must be on the left of objects B, C and E on the screen for time interval $[0..5]$.

4 Operationalization

Rather than relying on straightforward discrete sampling techniques that only partially represent the search space (*e.g.* by selecting a uniformly distributed sampling of point configurations and evaluating them with respect to the properties [1]), our technique builds upon an interval-based evaluation of box configurations. Each region represented as an $8-$dimensional box (camera parameters and time) is evaluated *w.r.t.* the temporal satisfaction of each property. Due to this interval representation, a property is either fully satisfied, partially satisfied or not satisfied.

4.1 Interval Constraint-Based Search

Interval arithmetic has been initially introduced by R. Moore [10] to over-come the limitations due to rounding errors and floating point representation. Each real r is enclosed by two floating point values in an interval I such that $I = [a, b] = \{r \in \mathcal{R} \mid a \leq r \leq b\}$, with $a, b \in \mathcal{F}$ (\mathcal{F} represents the set of float-ing point values). The classical operators over \mathcal{R} can be redefined by enforcing the fundamental property of containment. Let X and Y belong to \mathcal{I} (the set of intervals), and let \square be a binary operator on \mathcal{R}. The interval extension of \square is given by $X\square Y = Hull(\{x\square y | x \in X \text{ and } y \in Y\})$ where $Hull(S)$ computes the smallest floating-point interval enclosing the set of reals S. Functions and con-straints are extended to intervals in a similar way by replacing the real operators by their interval counterparts.

The introduction of interval-based constraint techniques [5] fairly improve the exploration of the search space by using contracting operators that effi-ciently prune areas not satisfying given constraints. In our approach, for each property, we apply a constraint propagation scheme over the search space to remove the inconsistent areas. Since the properties need to be evaluated over a time interval, we rely on an extension of propagation techniques that manage temporally indexed constraints [2]. Each resulting box is then tagged by the property it satisfies, and a merging process is operated for all the properties to fully characterize the search space (see Figure 2).

Given a query, we then select the appropriate boxes. Let c represent a con-straint (*i.e.* a property) and \mathcal{B} the powerset of boxes, this selecting operator S is defined as:

$$S(c) = \{b \in \mathcal{B} | c(b) holds\}$$
$$S(\neg c) = \{b \in \mathcal{B} | \neg c(b) holds\}$$
$$S(c_1 \wedge c_2) = S(c_1) \cap S(c_2)$$
$$S(c_1 \vee c_2) = S(c_1) \cup S(c_2)$$
$$S(\forall x \in D, c(x)) = \bigcap_{i \in D} S(c(i))$$
$$S(\exists x \in D, c(x)) = \bigcup_{i \in D} S(c(i))$$

Boxes related to p_1 property Boxes related to p_2 property Merge of boxes

Fig. 2. The merging process. Two initial pavings are computed by interval-based con-straint propagation over properties p_1 and p_2 and merged together. Each area is then fully characterized *w.r.t.* both properties ($p_1 \wedge p_2$, $p_1 \wedge \neg p_2$, $\neg p1 \wedge p_2$ and $\neg p_1 \wedge \neg p_2$).

4.2 Adjacency Graph

After partitioning and characterizing the search space, the answer to a query is solved by selecting the set of appropriate interval boxes, and constructing an adjacency digraph from the boxes spatial and temporal adjacency. Each node in the graph represents a box, and each arc either a spatial bound (s−arc) between two boxes that share a common face in space, or a temporal bound t−arc that share a connection in time. The graph is a digraph as t−arcs are directed (*i.e.* the camera does not reverse in time). An example of such a graph is given in Figure 3. A solution to the query is represented by a (possibly disconnected) path in the graph. Given the desired nature of the camera path (either a static shot, a free shot, or a constrained move such as panoramic or travelling), different explorations of the graph can be performed. For example the computation of the set of distinct paths in the graph offers a good overview of the shot possibilities.

Fig. 3. A display of a space-and-time graphs: adjacency of boxes in space (vertical axis) create s−arcs in blue, and adjacency in time (horizontal axis) create t−arcs in red inside a graph where the nodes represent the boxes. Camera paths (in green) are built by exploring the disjoint subgraphs. Classification is done by studying overlaps.

Furthermore the graph representation offers a convenient way to cluster different classes of solutions. The analysis of the relative locations of connected subgraphs in the graph leads to multiple configurations:

- obviously if the graph is empty, the description is inconsistent and one needs to remove some properties;
- if the graph is connected, there exists only one class of solutions (however there exist multiple camera configurations/paths in this graph);
- if the graph is composed of multiple connected components (disjoint subgraphs), one needs to reflect the relative locations of their projections over space and time:
 - if the projections of two disjoint connected subgraphs overlap in time but not in space, these represent different alternatives for a shot;
 - if the projections of two disjoint connected subgraphs overlap in space and not in time, these represent different camera sequences in time from similar view points;

- if the projections of two disjoint connected subgraphs do not overlap in space and time, they characterize different viewpoints both in space and time.

This reasoning is generalized for all disjoint connected subgraphs and provides a straightforward way to explore different shots and edits.

5 Implementation and Results

Implementation has been achieved in C++, with Elisa interval solving library[2]. 3D data and environments are provided by Ogre3D engine[3]. The preprocessing cost of the scene is important both in space and time; for the average complex scenes presented in figure 4, handling 20 objects of interest with an average of 100 divisions on all dimensions, computation time is over 2 hours, and required space is above 3.6 Gb. In regard, the computation of an answer to a query is performed in less than a second for most queries.

Fig. 4. Successive intersections over the search space that illustrate the query $shot3(p)$. The boxes represents the areas for feasible camera configurations in space only.

6 Conclusion

In this article, we have proposed a spatio-temporal system for reasoning on the cinematographic expressiveness of a virtual 3D environment. A logic-based formalism is proposed that enables universally and existentially quantified requests

[2] http://sourceforge.net/projects/elisa/
[3] http://www.ogre3d.org/

on possible positions and paths of a virtual camera in a 3D scene where locations and movements of entities are known. This declarative process is illustrated on a number of examples in a reasonable complex environment, and the process lays the groundwork for a powerfull and expressive way to access the cinematographic power of a dynamic 3D environment. This is the first time such a spatio-temporal query system is proposed for virtual camera control. Possible applications are found in film prototyping and semi-automated editing.

References

1. Bares, W., Thainimit, S., McDermott, S., Boudreaux, C.: A model for constraint-based camera planning. In: Smart Graphics AAAI 2000 Spring Symposium, Stanford, California, pp. 84–91 (March 2000)
2. Benhamou, F., Goualard, F., Languénou, E., Christie, M.: Interval constraint solving for camera control and motion planning. In: ACM Transactions on Computational Logic, pp. 732–767 (October 2004)
3. Christie, M., Languénou, É., Granvilliers, L.: Modeling camera control with constrained hypertubes. In: Van Hentenryck, P. (ed.) CP 2002. LNCS, vol. 2470, pp. 618–632. Springer, Heidelberg (2002)
4. Christie, M., Normand, J.-M.: A semantic space partitioning approach to virtual camera control. In: Proceedings of the Eurographics Conference (EG 2005), Computer Graphics Forum, vol. 24, pp. 247–256 (2005)
5. Cleary, J.G.: Logical arithmetic. Future Generation Computing Systems 2(2), 125–149 (1987)
6. Erwig, M., Schneider, M.: Developments in spatio-temporal query languages. In: DEXA 1999: Proceedings of the 10th International Workshop on Database & Expert Systems Applications, p. 441. IEEE Computer Society, Washington (1999)
7. Haarslev, V.: A logic-based formalism for reasoning about visual representations. J. Vis. Lang. Comput. 10(4), 421–445 (1999)
8. Halper, N., Olivier, P.: CAMPLAN: A Camera Planning Agent. In: Smart Graphics 2000 AAAI Spring Symposium, pp. 92–100 (March 2000)
9. Koenderink, J.J., van Doorn, J.: The internal representation of solid shape with respect to vision. Biological Cybernetics 32, 211–216 (1979)
10. Moore, R.: Interval Analysis. Prentice-Hall, Englewood Cliffs (1966)
11. Olivier, P., Halper, N., Pickering, J., Luna, P.: Visual Composition as Optimisation. In: AISB Symposium on AI and Creativity in Entertainment and Visual Art, pp. 22–30 (1999)
12. Pfoser, D., Jensen, C.S., Theodoridis, Y.: Novel approaches in query processing for moving object trajectories. In: VLDB 2000: Proceedings of the 26th International Conference on Very Large Data Bases, pp. 395–406. Morgan Kaufmann Publishers Inc., San Francisco (2000)
13. Plantinga, H., Dyer, C.R.: Visibility, Occlusion, and the aspect graph. International Journal of Computer Vision 5(2), 137–160 (1990)

Heuristic-Search-Based Light Positioning According to Irradiance Intervals

Francesc Castro, Esteve del Acebo, and Mateu Sbert

Institut d'Informàtica i Aplicacions, Universitat de Girona, Spain
{castro,acebo,mateu}@ima.udg.edu

Abstract. We present a strategy to solve the problem of light positioning in a closed environment. We aim at obtaining, for a global illumination radiosity solution, the position and emission power for a given number of lights that provide a desired illumination at a minimum total emission power. Such a desired illumination is expressed using minimum and/or maximum values of irradiance allowed. A pre-process is needed in which irradiance is computed for a pre-established set of light positions by means of a random walk. The reuse of paths makes this pre-process reasonably cheap. Different heuristic-search strategies are explored and compared in our work, which, combined to linear programming, make it possible to efficiently visit the search space and, in most cases, obtain a good solution at a reasonable cost.

Keywords: Light positioning, heuristic search, irradiance, reuse of paths, random walk.

1 Introduction

Inverse problems in lighting consist in deciding the lighting setting (number of lights, emission power, light position, light shape, etc.) that allows to obtain a desired lighting, having application in interior design, urban modeling, etc. In many cases, the importance of indirect illumination (light interreflections between the objects) in such problems makes it necessary to use a global illumination model rather than a local one. Global illumination models, such as radiosity, consider both direct and indirect illumination, in order not to miss realism.

We focus on the problem of light positioning in real environments composed by diffuse objects, aiming at finding the position and emission power of the lights which illuminate the environment at a minimum total emission power, satisfying some given lighting requirements given in terms of *validity intervals* of irradiance. Dealing with these simplified diffuse environments, a radiosity solution is appropriate to simulate the lighting. Since the lighting has to be computed for many different light positions, we take advantage of the reuse of paths in random walk radiosity.

The resulting constrained optimization problem is divided into 2 subproblems. First, choosing the subset of light positions to be considered from a wide set of authorized light locations. Second, for a given subset of positions, computing the optimal emission power for each of them. The first subproblem is tackled via

A. Butz et al. (Eds.): SG 2009, LNCS 5531, pp. 128–139, 2009.

different optimization approaches, while the second subproblem is easily dealt with using linear programming.

This article is structured as follows. Section 2 introduces previous work in reuse of shooting paths and light positioning. The optimization problem is defined in section 3. Section 4 describes how this problem is solved, while the performed experiments are described in section 5. Finally, section 6 provides the conclusions of our work, and some future research.

2 Previous Work

2.1 Reuse of Paths for Several Light-Source Positions in Radiosity

Radiosity [CW93] is a global illumination technique that simulates the multiple reflections of light in a scene. Radiosity algorithms assume that the exiting radiance of a point is direction independent, and, given a discretization of the scene in patches, compute their *irradiance*. The irradiance of a patch is defined as its incoming light power divided by its area. Monte Carlo shooting random walk [Bek99] can be used to estimate the irradiances. Shooting paths are generated from light sources, carrying each of the paths an equal amount of light power which is distributed to the patches visited by the path.

From the idea of reusing paths in random walks applied to the solution of linear equation systems [Hal94], the reuse of shooting paths in radiosity was introduced for moving lights in [SCH04]: shooting paths generated in a light position could be used for the rest of positions, in a sort of each-for-all strategy. Details about how this strategy works can be found in [CSH08], where it was applied to light positioning by allowing the user to visually decide which was the best location for a light.

2.2 Light Positioning

Kawai et al. [KPC93] presented a framework for designing the illumination in an environment using optimization techniques applied to a radiosity-based system. Their algorithm was flexible and fast, and considered light-source emission, reflectivities, and light direction as optimization variables, but not light positions, which had to be fixed. The user was allowed to modify the constraints and objective function at each iteration of the algorithm. Inequality constraints setting lower and upper bounds for the radiosity of a patch were allowed.

Elorza et al. [ER97] used standard genetic algorithms to search for the best combination of number, position, and intensities of lights. Objective function, which took into account the minimization of energy, was defined with respect to the difference between the proposed solution and a desired user-defined illumination. A radiosity-based image synthesis system was used.

Marks et al. [MAB+97] dealt with light selection and placement for image rendering, both standard and image-based. They allowed the user to intuitively browse in order to select light positions and test the results.

Jolivet et al. [JPP02] applied a Monte Carlo approach to the inverse lighting problem, considering only direct lighting. Once defined the lighting wishes of the designer via declarative modeling, they estimated using ray tracing the most appropriate light positions in order to illuminate the desired areas.

Gumhold [Gum02] tackled the problem of light positioning in the context of visualization, in order to maximize the information introduced by the illumination. They used histogram Shannon entropy together with global maximization algorithms to compute the optimal light locations, considering only direct illumination.

Ha et al. [HO06] created a tool which allowed the design of objective functions and the application of several optimization techniques, including stochastic optimization. The same authors presented in [HO07] an example-based design system for local illumination lighting. Such a system allowed both declarative and natural specification of lighting. Users were allowed to choose a desired lighting from exemplar 2D images.

Some of the most recent work on light positioning has been applied to agronomy and botany. Ferentinos et al. [FA05] used genetic algorithms for lighting design applied to greenhouses. They took into account only direct illumination. Optimization was done considering number of point lights and power consumption, and looking for a uniform distribution of the light. Delepoulle et al. [DRC08] also used genetic algorithms for light positioning, taking into account direct and indirect illumination and including the coordinates of the light positions in the solution codification. They aimed at obtaining uniform incoming light over the plants in a grown chamber.

Finally, Pellacini et al. [PBMF07] presented an interactive system, with applications to computer cinematography, that allowed the desired lighting effects to be easily painted in the scene. The system computed the parameters to achieve the desired lighting via nonlinear user-guided optimization.

3 Problem Definition

3.1 Our Approach to the Inverse Illumination Problem

Most approaches to the inverse illumination problems listed in section 2.2 share a common trait: they use heuristic search methods in order to try to find the feasible illumination which minimizes some distance function to the desired final illumination. In our opinion, these approaches present several shortcomings:

- The search space includes both light positions and light intensities, being very costly to do an effective search in such a huge search space.
- The use of a simple distance function like, for example, the mean quadratic distance between the illumination obtained for each patch and the desired one, raises problems like the impossibility of specifying maximal or minimal illuminations for a patch or set of patches, the difficulty of minimizing the total cost of the illumination or even the obtention of negative values of emission power for one or more lights. The attempt to fix these problems modifying the distance function and introducing constraints produces complex search spaces with plenty of local minima.

- The heuristic search processes need continuous illumination simulations to evaluate the goodness of the successive proposed solutions. These simulations are very costly if the illumination has to be computed from scratch, and very inexact if only direct illumination is taken into account.

To tackle these problems, our proposal presents two novelties:

- A new formulation of the problem that substitutes the distance function to be minimized by a set of constraints on the maximal and minimal illumination allowed for each patch and the maximal and minimal emission power permitted to each light. Once fixed a set of light positions, the problem of finding their emission powers observing all the constraints can be solved by a linear optimization method. Moreover, the use of these methods allows us to define a linear cost function to be minimized (total illumination cost, for example). Thus, heuristic search is done only over the set of lights and positions, not taking into account emission powers.
- Economical pre-calculation, thanks to path reuse (see [CSH08]), of a basis of values representing, for each patch, light, and position, the total power arriving, directly or indirectly, to this patch for one power unit emitted by this light located at this position.

3.2 Mathematical Definition of the Problem

According to our formulation, an instance of the inverse illumination problem is given by the following:

- A scene S described as a set $P = \{p_1, \cdots, p_p\}$ of p patches. For each patch p_i, we define I_i, the irradiance of p_i, as the total amount of power arriving to p_i divided by its area A_i.
- A set of lights $L = \{l_1, \cdots, l_m\}$, each of them having characteristics as prize, maximum emission power, or consumption. For each light l_i, w_i represents its emission power, while $cost_i$ represents its cost per emitted watt.
- A set $X = \{x_1, \cdots, x_q\}$ of authorized light positions within S.
- A 3D-array \mathcal{F} of $p \cdot m \cdot q$ real non-negative values in the interval $[0\ldots1]$. For each $p_i \in P$, $l_j \in L$ and $x_k \in X$, $\mathcal{F}_{i,j,k}$ represents the contribution to the irradiance of patch p_i of each unit of light power emitted by light l_j at location x_k. Thus, given a subset $L^K = \{l_{u_1}, \ldots, l_{u_K}\}$ of K lights located respectively at positions x_{v_1}, \ldots, x_{v_K}, we can express the irradiance of p_i as:

$$I_i = \sum_{j=1}^{k} \mathcal{F}_{i,u_j,v_j} \cdot w_{u_j}. \tag{1}$$

- A set $C = \{c_1, \ldots, c_q\}$ of constraints. Part of them are used to describe the desired illumination for the set of patches P (or a subset of it), having the form $\alpha_i \leq I_i \leq \beta_i$, α_i, β_i being non-negative bounds. Additionally, there will also be constraints limiting the power emitted by the lights, having the form $\chi_i \leq w_i \leq \delta_i$, χ_i, δ_i being non-negative bounds.

The problem can be stated as follows: given the sets P, L, X and C, the 3D-array \mathcal{F}, and given a positive integer K (the maximum number of active lights allowed, which is given by the user), find a subset $L^K = \{l_{u_1}, \ldots, l_{u_K}\} \subset L$ of exactly K lights, their respective positions in X and their respective emission powers w_{u_1}, \ldots, w_{u_K} in such a way that all the constraints in C are satisfied and the total illumination cost T (objective function) (2) is minimized. Note that some of the emission powers w_{u_i} could be 0, so, in practice, the best solution can have less than K active lights.

$$T = \sum_{j=1}^{k} w_{u_j} \cdot cost_{u_j}. \tag{2}$$

4 Solving the Problem – Approaches and Implementation

Diagram in Fig. 1 describes the whole process of light positioning described in this article. We will apply heuristic-search algorithms together with linear programming in order to solve our optimization problem, which will be split into 2 subproblems:

- For a given position subset, computing the optimal emission power for each position in the subset.
- Exploring the search space.

Computing optimal emission powers. Given a subset s of light positions (a *state*), we aim at knowing if we can assign an emission power to each position observing the problem constraints. If such a power configuration exists (if s is a *valid* state), we aim at obtaining the emission powers which minimize function T, being such optimal emission powers and T recorded in s. Since this is a linear inequality system with an objective function to be minimized, linear programming techniques, like simplex algorithm, can give us such optimal emission powers (if existing). Moreover, since our problem always has "greater or equal" inequalities, given by the minimum irradiance bounds, we can discard as non-valid the states in which the irradiances corresponding to the maximum emission power allowed for each position do not reach the minimum bound for some of the patches. This

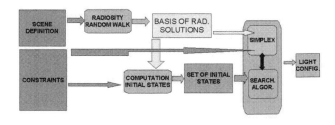

Fig. 1. The light positioning process

strategy permits to avoid to run simplex on such states, resulting in a reduction of the cost.

Choosing subsets of light positions. Let q be the number of authorized light positions, and let K be the (maximum) number of lights allowed, this gives a number of $\binom{q}{K}$ subsets of K light positions (search space). It is not difficult to see that the full exploration of the search space is unfeasible even for a moderate value of q and a small value of K. Different heuristic-search algorithms can be applied in order to explore the search space in a reasonable time. Next we describe the main approaches used in the work presented in this article.

We have used a hash map of states to avoid to deal with the same state more than once. Repeated states are simply ignored by our search algorithms, involving a noticeable reduction of the cost.

4.1 Local-Search Algorithms – Hill Climbing

Local search algorithms (LS) are used in problems formulated in terms of finding a solution maximizing (or minimizing) a criterion among a number of candidate solutions in the search space. *Hill climbing* algorithms (HC) are a relatively simple kind of LS based on starting by a valid state chosen at random and moving in the search space by slightly mutating the actual state to a better one. The process stops when no mutation of the actual state is possible. Hill climbing always finds a local minimum of the objective function, but such a value can be far of the optimal. Fig. 2 outlines the basic HC algorithm. Next we will focus on the 2 main parts in the algorithm above.

> *Choose initial valid state s*
> **while** *s \neq null* **do**
> *best=s*
> *s= s.bestSuccessor()*
> **endWhile**

Fig. 2. Basic hill climbing algorithm

Choosing the initial valid state. A naive strategy to obtain the initial valid state consists in just generating combinations of K light positions at random and taking the first of such combinations that observes the constraints. Since HC uses to perform better the closer the initial state to the optimal, we can easily improve the performance of the algorithm by generating at random a number of candidate valid states and taking as initial state the best of them (the one with minimum emission power). It is worth to mention that, in order not to allow, if the problem has no solution, infinite searches of the initial valid state, the process is forced to abort after exploring a given number of light combinations without obtaining a valid solution.

Choosing the best successor. Given a valid state s, we choose the best successor between a set $S(s)$ of successors of s (or neighborhood of s). Such successors are generated by applying mutations to s. A mutation of s is added to $S(s)$ if

it is a valid state with lower objective function than s. We mutate a state s by replacing one of its positions by positions out of s. Two matters have to be taken into account in the mutation:

- Which light position x_i is to be replaced.
- Which light positions are to be considered to replace x_i.

Regarding to the first issue, we have considered several heuristics, such as taking the position with higher value of optimal emission power, the one with lower optimal emission power, and a position at random. The results obtained in our experiments show lower average value of the objective function when replacing the position with a higher emission power. Thus, this is the heuristic we have applied along this article.

Regarding to the second issue, we consider all the positions whose distance to the replaced position is lower or equal than a given radius r expressed in grid cell units. In section 5 we experiment different values of r and try to find which values are the most appropriate.

Once the set $S(s)$ has been determined, one of its elements has to be chosen as the best successor of s. Two different ways of choosing such a best successor have been considered:

- Choosing the successor with minimum value of the objective function. This strategy is known as *steepest ascent* hill climbing (SAHC).
- Choosing the successor using a probability distribution on $S(s)$. Reasonably, the probability of a successor to be chosen is established proportionally to the inverse of its objective function value. We refer to this strategy as *stochastic* hill climbing (StHC).

In order to make HC more efficient, *random restart* is a commonly used strategy. It consists in running HC n times, each from a different initial state (different seed). We first generate and store a number N ($N \geq n$) of candidate valid states (chosen at random), and then we choose as seeds the best n of them (the ones with lower value of the objective function). We have used random restart hill climbing (RRHC) in the experiments presented in next section.

4.2 Beam Search

Beam search (BS) is a heuristic search algorithm based on breadth-first search. The initial level of the search tree is a set of n valid states chosen at random, n being a preestablished value called the beam width. Successive levels of the tree are generated by obtaining all the successors of the states in the current level, sorting them by the value of the objective function, and taking only the best n of them. The process ends up when the current level is empty. Since the optimal state can be pruned, BS does not always find the optimal solution. Fig. 3 outlines the basic beam search algorithm.

The initial set of valid states is chosen by generating (at random) N candidate valid states ($N \geq n$) and picking up the best n of them. The process is forced to

Choose initial set R of n valid states
best=R.best() (S.best() is the state of R having minimum T)
do
 set $Q = \emptyset$ *// Q set of successors of states in R*
 for each *state s_i in R* **do**
 $Q = Q \cup S(s_i)$
 endFor
 R =best j states in Q (j =min(n, Q.size()))
 if *R not empty* \land *R.best() improves best* **then** *best=R.best()*
while *R not empty*
endWhile

Fig. 3. Basic beam search algorithm

abort after exploring a given number of states without obtaining a valid solution. $S(s_i)$ stands for the set of successors of state s_i. Successors are obtained in the way described in section 4.1.

5 Results

We consider undistinguished light sources, that is, all the lights will have the same maximum and minimum emission power, and the same cost per watt. Moreover, we have set the minimum emission power to 0. Given such simplifications, objective function T reduces to the sum of emission powers, while \mathcal{F} becomes a $2D$-array. The 3 approaches seen in section 4 have been tested:

- Steepest ascent hill climbing with random restart (SAHC)
- Stochastic hill climbing with random restart (StHC)
- Beam search (BS)

3 parameters have been considered in our tests:

- N, the number of states that are candidate to be the seeds of our searches.
- n, the number of seeds taken in both hill climbing and beam search.
- r, the maximum distance (in grid-cell units), when mutating states, from the position i leaving a state to the positions allowed to replace i.

5.1 Experiments

Two different scenes, described next, have been used in our experiments.

 In **scene** 1 (Fig. 6 (left)) we aim at having a minimum irradiance of $15W/m^2$ on the top of the tables (resulting in 512 constraints) using up to 4 lights of $500W$ at most. 164 positions for the lights have been considered, placed in a regular grid on the ceiling and the upper part of the walls. This gives a total of $\binom{164}{4} \approx 29M$ states in the search space.

 In **scene** 2 (Fig. 6 (right)) we aim at having a minimum irradiance of $15W/m^2$ on the top of the desks and a maximum irradiance of $15W/m^2$ on the top of the shelves (resulting in 576 constraints) using up to 4 lights of $500W$ at most. 384

light positions have been considered, placed in a regular grid on the ceiling and the upper part of the walls, giving a total of $\binom{384}{4} \approx 892M$ states.

In order to evaluate the obtained results, objective function T, time for obtaining the N candidate states (t_{ini}), and time for the search process (t_s) have been considered. Since a random factor is involved in the experiments (due basically to the generation of the initial states), we have done 3 runs at each experiment, and average values for the objective function and the running time have been displayed. All the runs have been done in a Pentium IV at $3GHz$ with $2GB$ of RAM.

Experiment 1: solution neighborhood. This experiment, on scene 1, aims at finding the most appropriate values of parameter r. We have fixed $n = 10$, taken a set of $N = 200$ initial solutions, and run the methods for $r = (1, 2, 3, 4)$. Table 1 shows the results. The time for generating the initial solutions does not depend on r, so we have omitted such a value. We see that in SAHC and BS the best performance is obtained with $r = 3$. $r = 4$ gives the same value of T, but at a higher search cost. StHC behaves different, since the lowest values of T are obtained with $r = 1$. This fact can be due to the stochastic nature of the search process in StHC. We conclude that a value of $r = 3$ is appropriate for scene 1. Moreover, we see that StHC has a worse performance than SAHC. So, we decide to dispense with StHC approach in the following experiments.

Table 1. Scene 1. Testing the performance for different values of the radius r. Second, fourth, and sixth columns stand for time in the search processes for the 3 methods, while third, fifth, and seventh columns stand for the corresponding values of T. These results correspond to $N = 200, n = 10$.

	t_s SAHC	T SAHC	t_s StHC	T StHC	t_s BS	T BS
$r = 1$	26 sec.	749.2	30 sec.	767.3	29 sec.	754.4
$r = 2$	52 sec.	749.2	65 sec.	767.3	89 sec.	746.6
$r = 3$	85 sec.	744	85 sec.	784	191 sec.	742.8
$r = 4$	106 sec.	744	108 sec.	784.6	221 sec.	742.8

Experiment 2: number of seeds. We have tested SAHC and BS for different values of n and N, taking $r = 3$ in all cases. On scene 1, graph in Fig. 4 (left) shows, for SAHC, the behavior of T as n grows for 3 different values of N. We note that SAHC works better the higher the value of n, but this behavior is less pronounced when the initial states are very carefully selected (that is, with high values of N). In such a case (see $N = 200$), T does not practically change for the different values of n. This fact seems to point out that the performance of SAHC strongly depends on the initial states of the search process. A similar behavior can be observed for BS in graph in Fig. 4 (right).

An important issue to be considered is the relative effort we should devote, with respect to the search stage, to generate the initial candidate solutions. Graph in Fig. 5 (left) shows how the search stage reduces T (regarding to the best initial solution) for different values of N in both SAHC and BS, taking $n = 13$. Although T reduces less as N grows, such a reduction is significant in

Fig. 4. (left) SAHC: number of seeds (x-axis) vs. T (y-axis) for different values of *N*.(right) BS: beam width (x-axis) vs. T (y-axis) for different values of *N*.

Fig. 5. (left) Reduction of T (y-axis) due to the search process for different values of N (x-axis). (right) Running time (y-axis) for different values of N (x-axis).

all cases. Graph in Fig. 5 (right) shows, also for $n = 13$, how computational time varies as N increases. This graph shows that in SAHC t_s grows slowly than t_{ini} (which grows linearly with N), while in BS t_s can decrease in some cases as N grows (note that t_{ini} is the same for both BS and SAHC). We can extrapolate that from moderate values of N on, t_{ini} will be greater than t_s for both approaches. We conclude that both the generation of initial solutions and the search stage are important and cannot be missed in any case, and parameters N and n have to be carefully adjusted for each problem. Fig. 6 (left) shows the best solution found for scene 1, where the minimum cost to arrive at such a solution has been obtained by using BS with $N = 100$ and $n = 13$.

Similar results have been obtained experimenting with scene 2, in which the higher number of authorized positions increases the cost with respect to scene 1. Fig. 6 (right) shows the best solution found for this scene, obtained by using BS with $N = 45$ and $n = 12$.

Fig. 6. (left) Best light-source placement found for scene 1 involving 4 lights. 164 authorized positions have been considered. $T = 744.0W$ (global minimum is $742.8W$, according to the full exploration of the search space, which has taken several days of running time). Beam search algorithm has been used for the search, with $r = 3$, $N = 100$, and $n = 13$. $t_{ini} = 54$ sec. $t_s = 204$ sec. Time for computing the radiosity solutions= 738 sec. (right) Best light-source placement found for scene 2 involving 4 lights. 384 authorized positions have been considered. $T = 742.9W$ (no full exploration has been done because of the magnitude of the search space). Beam search algorithm has been used for the search, with $r = 3$, $N = 45$, and $n = 12$. $t_{ini} = 722$ sec. $t_s = 336$ sec. Time for computing the radiosity solutions= 2616 sec. Lights have been represented in all cases with a size proportional to their emission power.

6 Conclusions and Future Research

We present a new formulation of the problem of light positioning. We establish irradiance intervals for the patches in the scene, aiming at minimizing the total emission power. Light positioning problem is solved by dividing each iteration step into 2 subproblems: using linear programming to obtain optimal emission powers, and using heuristic search over the authorized positions for the lights. The lighting simulation preprocess has been done using radiosity random walk with reuse of paths. Such a reuse allows to drastically reduce the cost for the computation of the radiosity solutions for each of the light positions considered.

The search algorithms developed allow, at a reduced cost, to significantly reduce the value of the objective function with respect to the solution obtained by simply selecting the best of a number of initial solutions obtained at random. Different experiments in order to establish good values for the parameters involved in the searches have been done, although optimal parameter values probably depend on the features of the input data (scene description and constraints). Establishing the relation between the scene chosen and the optimal values of the parameters deserves future research. Regarding to the search approaches used in our work, beam search seems to be slightly superior to hill climbing, arriving at the best solutions in less time.

Next we enumerate some points to be taken account in the future. First, we will elaborate on the obtaining of the initial solutions for the searches, even considering constraint relaxation or distances to constraint satisfaction. Second, we plan to use other heuristic search algorithms, such as genetic algorithms or particle swarm optimization. Third, not only position but also orientation of the

lights will be taken into account. Finally, we will consider generalization to more sophisticated environments, including complex-geometry objects and variable lighting conditions as sun movement along the day.

Acknowledgments

This project has been funded in part with grant number TIN2007-68066-C04-01 from the Spanish Government.

References

[Bek99] Bekaert, P.: Hierarchical and stochastic algorithms for radiosity. Ph.D. Thesis. Catholic Univ. of Leuven (1999)

[CSH08] Castro, F., Sbert, M., Halton, J.H.: Efficient reuse of paths for random walk radiosity. Computers and Graphics 32(1), 65–81 (2008)

[CW93] Cohen, M., Wallace, J.: Radiosity and Realistic Image Synthesis. Academic Press Professional, London (1993)

[DRC08] Delepoulle, S., Renaud, C., Chelle, M.: Improving light position in a growth chamber through the use of a genetic algorithm. In: Artificial Intelligence Techniques for Computer Graphics, vol. 159, pp. 67–82 (2008)

[ER97] Elorza, J., Rudomin, I.: An interactive system for solving inverse illumination problems using genetic algorithms. Computation Visual (1997)

[FA05] Ferentinos, K.P., Albright, L.D.: Optimal design of plant lighting system by genetic algorithms. Eng. Applications of Artificial Intelligence (2005)

[Gum02] Gumhold, S.: Maximum entropy light souce placement. IEEE Visual (2002)

[Hal94] Halton, J.H.: Sequential monte carlo techniques for the solution of linear systems. Journal of Scientific Computing 9(2), 213–257 (1994)

[HO06] Ha, H.-N., Olivier, P.: Explorations in declarative lighting design. In: Butz, A., Fisher, B., Krüger, A., Olivier, P. (eds.) SG 2006. LNCS, vol. 4073, pp. 160–171. Springer, Heidelberg (2006)

[HO07] Ha, H.-N., Olivier, P.: Lighting-by-example with wavelets. In: Butz, A., Fisher, B., Krüger, A., Olivier, P., Owada, S. (eds.) SG 2007. LNCS, vol. 4569, pp. 110–123. Springer, Heidelberg (2007)

[JPP02] Jolivet, V., Plemenos, D., Poulingeas, P.: Inverse direct lighting with a monte carlo method and declarative modelling. In: Sloot, P.M.A., Tan, C.J.K., Dongarra, J., Hoekstra, A.G. (eds.) ICCS-ComputSci 2002. LNCS, vol. 2330, pp. 3–12. Springer, Heidelberg (2002)

[KPC93] Kawai, J.K., Painter, J.S., Cohen, M.F.: Radioptimization: goal based rendering. Computer Graphics 27, 147–154 (1993) (Annual Conf. Series)

[MAB+97] Marks, J., Andalman, B., Beardsley, P.A., Freeman, W., Gibson, S., Hodgins, J., Kang, T., Mirtich, B., Pfister, H., Ruml, W., Ryall, K., Seims, J., Shieber, S.: Design galleries: A general approach to setting parameters for cg and animation. In: Proc. of SIGGRAPH 1997, pp. 389–400 (1997)

[PBMF07] Pellacini, F., Battaglia, F., Morley, K., Finkelstein, A.: Lighting with paint. ACM Transactions on Graphics 26(2), Article 9 (June 2007)

[SCH04] Sbert, M., Castro, F., Halton, J.H.: Reuse of paths in light source animation. In: Proceedings of CGI 2004, Crete, Greece (2004)

Interactive Generation and Modification of Cutaway Illustrations for Polygonal Models

Sebastian Knödel, Martin Hachet, and Pascal Guitton

INRIA - Université de Bordeaux, France
{knoedel,hachet,guitton}@labri.fr

Abstract. We present a system for creating appealing illustrative cutaway renderings. This system bases on simple sketch-based interfaces and stylized rendering techniques for the study of elaborate 3D models. Since interactive visualization technology found its way to the general public, there is a demand for novel interaction techniques that allow easy exploration of the displayed illustrations. Hence, our system lets users create individual cutaway views to focus on hidden objects. At the same time, important contextual information is emphasized by illustrative rendering techniques.

Keywords: Cutaway, Sketch-based Interaction, Illustrative Visualization.

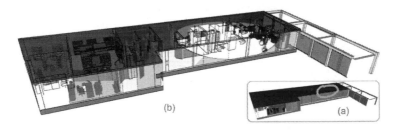

Fig. 1. Exploration of an office building (a) sketching a circular cutaway (b) final composite illustrative rendering including cutaways, transparency and ghostviews

1 Introduction

The advances of 3D interactive technology as well as novel rendering techniques have enhanced the real time creation of detailed and appealing imagery of elaborate 3D models for a large audience. At the same time, the emergence of direct touch-based interface technology has led to the creation of new interaction metaphors. Consequently, new perspectives appear that involve users in the process of content creation and modification. However, there is still a lack of suitable user interfaces that make these technological achievements accessible to a general public with little experience in 3D interaction.

A. Butz et al. (Eds.): SG 2009, LNCS 5531, pp. 140–151, 2009.

In recent years a wide variety of complex 3D models have become available. At the same time grew a demand for interactive techniques that let users inspect these 3D models in an interactive manner, in order to understand their structure. In this case, exploration represents the opportunity to have a closer look into the interior of the model. From our point of view, one major key element to accomplish such an exploration is the possibility for users to cut away parts of the 3D model. Secondly, the system must also be able to present and preserve contextual information that underlines special characteristics and structures.

Such 3D models often consist of so many parts that the exploration can become cumbersome. In order to examine the interior of a 3D model, users need be able to expose hidden parts. One example is the study of a 3D model of an office building that contains extensive details, like detailed pieces of furniture, as illustrated in Figure 1(a). Without having further information about the inner structure, users need intuitive and simple interfaces to be able to "open" the 3D model and to modify the resulting cutaway.

The purpose of our approach is to develop a system that allows regular users to create and interact with appealing illustrations of divers virtual 3D models. Our focus lies on the development of cutaway techniques that allow users to explore the interior of a 3D model in a simple and efficient way. To achieve this goal, we introduce novel sketch-based interfaces and smart widgets. In particular, users generate such cutaways using simple gestures and refine the shape of the cut afterward by means of repositioning and resizing operations.

To better convey, the resulting imagery is displayed using stylized rendering techniques to permit users to focus on important properties, while preserving the surrounding context information, as shown in the final rendering in Figure 1(b). To create such a vivid rendering we use transparent representations and highlight important contours of the modified 3D model.

In the following, we present in section 2 related work. In section 3 we explain our general approach, whereas in section 4 we show in detail the generation of the cutaway and we present the widget that is used to modify them. After that, in section 5 we describe visualization techniques and we conclude in section 6.

2 Related Work

2.1 Illustrative Visualization and Sketch-Based Interaction

Various research has been conducted on the creation of interactive technical illustrations of complex 3D models. Gooch et al. [1] created appealing technical illustrations by enhancing functional characteristics of shape and structure though drawing of silhouette curves. Silhouette curves and contours play an important role in shape recognition as Isenberg et al. [2] pointed out. We share this argument and perform a contour extraction as well. Another important role in technical illustration plays transparency. Diepstraten et al. [3] created technical illustrations containing opaque and non-opaque objects using depth ordered transparency. Nienhaus et al. [4] went further and created non-photorealistic

blueprint renderings using the so called depth peeling technique. Our depth-ordered transparency rendering approach has similarities with the depth peeling technique. In the contrary, we do not slice the object but rather reorder the structure of the 3D model in a view dependent visibility graph, which we present in section 5.1.

Sketch-based interfaces became popular in the area of freeform modeling. Zeleznik et al. [5] and Igarashi et al. [6] showed that simple gestures and curves are useful tools for creating and manipulating 3D geometry. We use a similar approach to let the user specify regions on the surface that are meant to be cut away. Apart from freeform modeling research, Schmidt et al. [7] proposed a sketch-based interface that allows the user to compose widgets for 3D object manipulation. We propose a widget with essential manipulation functionalities as a graphical user interface for users during the modification of the cutaway. This widget is located in proximity to the mouse cursor adopting the Marking Menus approach by Kurtenbach [8].

2.2 Cutaways in 3D Data

A cutaway illustration is a popular and powerful method that allows users to expose hidden objects of a complex geometry. There exist several different approaches that allow the generation of cutaways with polygonal and volumetric models. However, a lot of existing research proposes interface solutions for interactive cutaways in volumetric data sets. In the contrary, there exist only a few works that propose user interfaces for cutaways in polygonal 3D models.

Cutaways in Volumetric Data. McGuffin et al. [9] presented an interactive system for volumetric objects, where users can create and manipulate cuts inside a volumetric object using additional interfaces and widgets. We use in our approach similar cut shapes as proposed in their system, but unlike to our approach, they positioned the interface widget inside the 3D model. In another approach McInerney et al. [10] used 3D slice plane widgets as a 3D interaction model for exploring volume image data. Chen et al. [11] proposes a variety of complex volume manipulation tools that allow drilling, lasering, peeling, as well as cut and past operations. However, we want to provide simple interfaces, whose functionalities are easy to understand.

Brückner et al.[12][13], Viola et al. [14] and Wang et al. [15] discus related approaches to enhance the focus and guard context of an illustration. They combined cutaways and non-photorealistic visualization techniques to smartly uncover the most important information and to let the user interactively inspect the interior of a volumetric data set. In our system, the aspect of context preservation plays an important role as well as the use of transparency and contour rendering techniques.

Cutaways in Polygonal Data. Basically, the creation of cutaways in volumetric data sets is different from polygonal ones, since voxels have to be removed. There exists several approaches that allow cutaway creation in polygonal data sets. Often they use Constructive Solid Geometry (CSG) algorithms to create such cutaways.

One early approach of cutaway creation by Viega et al. [16], the *3D Magic Lenses*, proposed a multi pass algorithm using clipping planes with *flat* lenses embedded in a 3D environment. Another work by Coffin et al. [17] proposes so called perspective *cut-away views* that define a cutout shape or choose a standard shape and sweep it over the occluding wall segments to reveal what lies behind the surface. Diepstraten et al. [18] presented different methods to create cutaways in polygonal data, including the *Cutout* and the *Breakout* techniques. However, we use image-based CSG rendering techniques to create cutaways in polygonal data, as Li et al. [19] and Burns et al. [20] presented in their approaches. We present our implementation in more detail in section 4.3. In their work, Li et al. [19] presented a system for authoring and viewing interactive cutaway illustrations of complex 3D models that uses sophisticated data structures and animations. They propose to create the cutaways in a automatic or semi-automatic interactive process and provide very convincing results that limits users to predefined viewpoints, which we want to avoid. Another method for automatically generating cutaway renderings of polygonal scenes at interactive frame rates was presented by Burns et al. [20]. They use illustrative and non-photorealistic rendering cues as well, but do not propose direct interfaces to users.

3 General Approach

The level of interactivity in traditional cutaway applications is usually reduced. The possibilities to modify the resulting cutaway are often restricted. Most of the time, users choose the part to be revealed from a list. Then, the system creates automatically the cutaway from a meaningful point of view. In contrast our approach enables users to proceed and modify cutaways by themselves. We decided to use a sketch-based approach as an interface for the creation of a cut.

Performing a sketch allows users to cut the surface of an object. We think that there is a strong semantic link between the drawing of a sketch and the cutting of an object. We propose four different essential gestures, which we present in detail in section 4.1.

After the initial cutting phase, the modification of a cutaway can be performed via a smart widget that provides an essential variety of functionalities. The tools, provided by the widget, follow the mouse cursor and are consequently easily accessible. Users choose whether such a modification may influence only a local cutaway or all the cutaways in the 3D model. If necessary, size and structure of the global cutaway is adapted to avoid obstructions during editing.

In our approach, we focus on the creation of cutaway illustrations for polygonal data, since it is the most common data representation of 3D information. A lot of existing research about cutaways tend to work with volumetric data. Nowadays powerful tools that allow the creation of highly complex 3D models are available to the general public. Consequently, we need a sophisticated data management to be able to create and modify cutaways in such 3D models, while maintaining interactive frame rates. The reader will find more details about our implementation in section 4.3.

To explore, to analyze, and to understand the functionality of a complex 3D model, it is not sufficient to only allow users to create a cutaway. At the same time, illustrative and instructive visualization techniques are necessary to preserve the general context, especially if whole parts are cut away or other parts are still occluded. Therefore, we additionally use visualization techniques, like transparency, contour shading, and ghostlines to emphasize invisible structures.

4 Interactive Cutaways

4.1 Sketch Gestures

Users create a cutaway using a simple sketch gesture. The system evaluates the gesture and generates the corresponding cut. To conduct the cutting interaction, users only need to know four basic gestures, which are the *line*, *circle*, *corner* and the *ribbon* gesture. In the following, we present the different gestures and the corresponding cutaways.

Line Gesture. The most simple gesture to cut through the surface of a 3D model is a stroke of a straight line. It is similar to cutting a surface with a knife, which is a common everyday life task. In that case the system creates a narrow window cut aligned to the length and direction of the stroke, as shown in Figure 2(a). Since the resulting cutaway might not reveal enough underlying parts, users may edit it afterward using the tools presented in section 4.4.

Corner Gesture. Certainly users might want to create bigger cutaways right away. To do so, they draw a vertical stroke followed by a horizontal stroke. As a result the system creates a window cut, whose dimensions are relative to the length of the vertical and horizontal stroke. The cutaway is positioned at the center of the approximated rectangle, which is defined by the vertical and horizontal stroke length, as we show in Figure 2(b).

Circular Gesture. Another simple gesture consists of spherical-shaped sketch line. The sketch can also be elliptic- or egg-shaped. The position of the spherical cutaway is derived from the center of the circle sketch. The size of the circular cut is determined by the vertical and horizontal dimensions of the spherical-sketch, which we illustrate in Figure 2(c).

Ribbon Gesture. We want to let users also create wedge type cutaways. The main characteristic of the wedge cut is its sharp edge that breaks into the object and creates an opening with a certain angle. Therefor, we decided to represent this cutaway as a ribbon shaped sketch. Furthermore the ribbon sketch unifies the two parameters in one coherent movement, as one can observe in Figure 2(d). The vertical sketch line determines position and size of the edge, whereas the horizontal one is used to calculate the opening angle of the wedge.

Additional cutaways could be imagined. However, the multiplication of possible gestures would make the interface more complex and would require a longer learning phase for users.

Fig. 2. (a) Line sketch with resulting narrow window cut, (b) corner sketch with resulting window cut, (c) spherical sketch with resulting spherical cut, (d) ribbon sketch with resulting wedge cut

Automatic Cutaways. We offer also the possibility to create automatic cutaways, as presented by Li et al. [19]. Of course, users may manipulate these cutaways afterward. The system provides a preview list of all parts of the 3D model. Users select the part they are interested in, thus the system creates automatically all necessary cuts to expose the object.

4.2 Cut Shapes

Depending on the detected gesture and their position as well as their dimensions, our system determines the resulting shape of the cutaway. Due to traditional geometric illustration conventions, as denoted by Li et al. [19] and McGuffin et al. [9], we focus on four basic shapes to create a cut; the spherical shaped cut, the cubic shaped cut, the wedge shaped cut, and the tube shaped cut. Figure 3 presents the different cut shapes with the resulting cutaway. All four cut shapes can be effected using simple sketch-based gestures that are connatural to the resulting cutaway. The tube shaped cut, presented in Figure 3(d), is used for automatic cutaways.

The previously described cuts for polygonal geometry, are generated using image-based *Constructive Solid Geometry* algorithms, provided by the OpenCSG library [21]. These algorithms basically combine two shapes by taking the union of them, by intersecting them, or by subtracting one shape of the other.

Initially we have to adjust the depth of the cutaway to a default value that corresponds to the depth of the bounding box. This might be considered as an arbitrary choice, but it turned out that the resulting size represents an good compromise. Users may change the depth of the cut at anytime using the widget, which is presented in section 4.4. Furthermore, we provide continuous and smooth animations to visualize the opening of a cutaway, which makes it easier for users to follow the cutting procedure and to understand the spatial relations.

Fig. 3. Cut shapes and their resulting cutaway, (a) cubic cut shape, (b) spherical cut shape, (c) wedge cut shape, (d) tube cut shape

4.3 Cutaway Generation

To be able to create correct cutaways including geometric constraints that allow a modification, the data of the 3D model has to be reorganized in a so called visibility graph. The view dependent visibility graph, introduced by Li et al. [19], organizes the parts of the 3D model in structured layers. This is realized by determining their visibility from the current viewpoint using multiple occlusion tests.

Fig. 4. Example of the creation of a Visibility Graph

To create the graph, the relative and absolute visibility of an object is compared in an iterative process. If one object is completely visible, it is added to the current layer. If parts are occluded by another object and the relative visibility is consequently lower than the absolute one, the object is not added to the current layer. The complete procedure is presented in scheme 4.

4.4 Modifying the Cutaway

The possibility to manipulate the cutaway is important since solely automatic creation leads often to unsatisfying results. Indeed, the system can hardly estimate what users exactly want to see, since various kinds of cutaways are imaginable. However, we think that giving more control to the user may promote a better understanding of the structure of the 3D model. Thus, good interaction metaphors and interfaces are very important, such that users are able to easily customize the cutaway to meet their needs. In our approach, we want to let users directly modify the cutaways. More precisely, users should be able to reposition and to resize the cutaways freely using simple interfaces.

We propose a smart widget as the graphical user interface (GUI). It appears next to the cursor like the *Marking Menus*, which were introduced by

Kurtenbach et al.[8]. This way it is always easily accessible. This widget provides three basic selectable functionalities, which are illustrated in Figure 5(a). The first function allows translation of the cutaway in the x-y plane. The second functionality resizes the cut in the x-y plane and the third option increases the size in the z axis. To guaranty that the cut remains always visible to users, we do not provide translation in the z axis. Instead users can increase the scale of the cutaway in direction of the z axis.

(a) (b) (c)

Fig. 5. (a) Widget representation in cutaway, (b) Multiple cutaways of a complex 3D model containing various parts, (c) Corresponding ID buffer

We allow the global modification of multiple cutaways as well as the local modification of a selected one. Since for every part of the 3D model one particular cutaway object is created, every cut for every part can be modified independently. Users select the part they want to modify with a simple mouse click. Subsequently, they can modify the cutaway of this part using the widget as previously explained.

Fig. 6. From left to right, resizing the cutaway of the red box consequently modifies the size of the cutaway of the green and brown box

We want to provide simple selection mechanisms, so that every visible part of the 3D model is selectable. Hence users modify the cutaway of one part independently from other cutaways. To allow the cutaway selection we assign to every part of the 3D model one unique ID. After that, the 3D model is rendered using its assigned ID as a color, as shown in Figure 5(b) and (c). After picking on one part with the mouse, the system can retrieve the color at the pixel and consequently the ID of the selected part. With that ID the system can immediately refer to the proper data in the visibility graph and adjust position and size of the selected cutaway.

When users modify one local cutaway the position and size of surrounding cutaways are adapted due to constraints given by the visibility graph, which is illustrated in Figure 6. For example, if one local cutaway is resized by users other

cutaways will also be resized, but only in the case where the boundaries of the local cutaway intersect boundaries of another cutaway. As already stated, the necessary information about surrounding parts, which have to be affected by the modification, is provided by the layered visibility graph. The resulting transformations for surrounding cuts can be calculated easily, since our cut shapes are represented though basic geometrical objects, as spheres, cubes and cylinders.

5 Illustrative Context Visualization

In the previous section we have shown that users can create and modify cutaways of elaborate 3D models. However, they often need more information about invisible parts, to better understand the relationships between them. We divide such occluded parts into two groups. The first group contains parts that are not visible since they were removed by the cutaway. Parts of the second group are still hidden by other geometry. Since these parts represent important contextual information we want to visualize them in a way that the objects of interest in the cutaway remain in focus. We use two basic rendering techniques. First of all, the ghostview visualization displays parts that were cut away. Secondly, a transparent rendering with contour enhancement depicts parts that are still covered. Both techniques rely on the visibility graph structure to perform layer dependent blending of all scene parts.

5.1 Layered Transparency and Contours

To create a transparent visualization of the 3D model we make use of the view dependent visibility graph. Since all parts are organized in layers, depending on their distance to the viewpoint, we consequently have information about the visibility and the depth. We adapt the blending procedure to create a transparent visualization. This is done by rendering each layer of the graph from back to front and blending it with the previously accumulated layers. As a result, farther parts appear more transparent than parts in layers closer to the viewpoint. This procedure is illustrated in Figure 7. This process also increases rendering times depending on the number of layers. However, the advantage is that all parts in one layer appear similar, since they obtain the same level of transparency. We illustrate this effect in Figure 8(a).

One purpose of our approach is to create blueprint-like renderings that illustrate parts of a 3D model in such a way that users can infer their function and relation to other parts. Therefore, we benefit again from the visibility graph structure and apply edge detection on each layer separately. To detect the contours we use a standard Sobel filter on the diffuse Lambertian visualization. After that, the system blends the resulting contours from back to front into the final image. This blending approach is similar to the procedure we use to blend the transparent layers (see Figure 7). Since we use the visibility graph, we are able to obtain correct contours for all parts in each layer. Furthermore, the parts in one layer do not occlude themselves, hence they do not hide important information. As a result, the contours of closer parts appear stronger in the final

image than the contours of parts that are located more distant to the viewpoint. Parts from the same layer appear with equal contours.

To enhance rendering quality, we add contour information to the final blended transparent image, which makes it easier for the user to differentiate between different parts, as shown in Figure 8(c).

Fig. 7. Rendering pipeline to create transparent illustrations using the layered visibility graph

Fig. 8. Final renderings with (a) transparency, (b) illustration only with contours (blueprint) and (c) adding contours information to the transparent rendering

5.2 Composite Visualization

After users created a cutaway to reveal hidden parts, as shown in the Figures 9(a) and (b), our system provides additional information about the context inside and around the cutaway. Our system combines the result with a ghostview rendering that reveals the structures inside the cut, as illustrated in Figure 9(c). Then, we use transparent rendering to display parts of the 3D model that are

still covered. The final technical illustration presents multiple information about different parts of the 3D model. It also provides at the same time contextual information about the overall structure, as illustrated in in Figure 9(d).

(a) (b) (c) (d)

Fig. 9. (a) Sketching the rectangular cutaway, (b) modifying the resulting cutaway, (c) visualizing cut parts with ghostview, (d) final composite illustrative rendering of an engine including cutaways, with transparent and ghostview rendering

6 Conclusion and Future Work

We presented new interaction and rendering techniques to create appealing illustrative renderings for elaborate polygonal 3D models. First, users create cutaways in a novel and simple way using our sketch-based interaction technique. Then, they modify the resulting cutaway using the smart widget. Finally, the system enhances rendering to show more contextual information by representing invisible parts with transparency effects and ghostviews. With our approach users easily explore a complex 3D model with simple interaction techniques and obtain rich illustrative visualizations at the same time.

In the future we want to identify other simple gestures to provide more distinct manipulation of a cutaway. Furthermore we have to evaluate the usability of our approach in a comprehensive user-study. We consider also to examine different visualization techniques that enhance the visibility of a bigger variety of characteristics of the 3D model, as for example the depth cue.

Such a system provides rich visualizations via simple interaction and facilitates the access to elaborate 3D content especially for non experienced users. Regarding the long-term goal, our system opens new perspectives for 3D interaction by providing simple interface solutions for the general public.

References

1. Gooch, B., Peter, G.A., Shirley, P., Riesenfeld, R.: Interactive technical illustration. In: Proceedings of symposium on Interactive 3D graphics. ACM Press. New York (1999)
2. Isenberg, T., Freudenberg, B., Halper, N., Schlechtweg, S., Strothotte, T.: A developer's guide to silhouette algorithms for polygonal models. IEEE Computer Graphics and Applications 23(4), 28–37 (2003)

3. Diepstraten, J., Weiskopf, D., Ertl, T.: Transparency in interactive technical illustrations. Computer Graphics Forum 21 (2002)
4. Nienhaus, M., Döllner, J.: Blueprints: illustrating architecture and technical parts using hardware-accelerated non-photorealistic rendering. In: Proc. GI (2004)
5. Zeleznik, R.C., Herndon, K.P., Hughes, J.F.: Sketch: an interface for sketching 3d scenes. In: SIGGRAPH 1996, pp. 163–170. ACM, New York (1996)
6. Igarashi, T., Matsuoka, S., Tanaka, H.: Teddy: a sketching interface for 3d freeform design. In: SIGGRAPH 1999 (1999)
7. Schmidt, R., Singh, K., Balakrishnan, R.: Sketching and composing widgets for 3d manipulation. Computer Graphics Forum 27(2) (April 2008)
8. Kurtenbach, G.P.: The design and evaluation of marking menus. PhD thesis, Toronto, Ont., Canada, Canada (1993)
9. McGuffin, M.J., Tancau, L., Balakrishnan, R.: Using deformations for browsing volumetric data. In: VIS 2003: IEEE Visualization. IEEE Computer Society, Los Alamitos (2003)
10. McInerney, T., Broughton, S.: Hingeslicer: interactive exploration of volume images using extended 3d slice plane widgets. In: GI 2006: Graphics Interface 2006 (2006)
11. Chen, H.L., Samavati, F., Sousa, M.: Gpu-based point radiation for interactive volume sculpting and segmentation. The Visual Computer 24 (July 2008)
12. Brückner, S., Gröller, E.M.: Volumeshop: An interactive system for direct volume illustration (2005)
13. Brückner, S., Grimm, S., Kanitsar, A., Gröller, E.M.: Illustrative context-preserving volume rendering. In: Proceedings of EuroVis 2005, pp. 69–76 (2005)
14. Viola, I., Sousa, M.C.: Focus of attention+context and smart visibility in visualization. In: SIGGRAPH 2006: ACM SIGGRAPH 2006 Courses. ACM Press, New York (2006)
15. Wang, L., Zhao, Y., Mueller, K., Kaufman, A.: The magic volume lens: an interactive focus+context technique for volume rendering. In: IEEE Visualization (2005)
16. Viega, J., Conway, M.J., Williams, G., Pausch, R.: 3d magic lenses. In: UIST 1996: Proceedings of the 9th annual ACM symposium on User interface software and technology, pp. 51–58. ACM, New York (1996)
17. Coffin, C., Hollerer, T.: Interactive perspective cut-away views for general 3d scenes. In: IEEE Symposium on 3D User Interfaces, pp. 25–28 (2006)
18. Diepstraten, J., Weiskopf, D., Ertl, T.: Interactive cutaway illustrations. Computer Graphics Forum, 523–532 (2003)
19. Li, W., Ritter, L., Agrawala, M., Curless, B., Salesin, D.: Interactive cutaway illustrations of complex 3d models. ACM Trans. Graph. 26(3) (July 2007)
20. Burns, M., Finkelstein, A.: Adaptive cutaways for comprehensible rendering of polygonal scenes. In: SIGGRAPH Asia 2008. ACM, New York (2008)
21. Kirsch, F., Döllner, J.: Opencsg: a library for image-based csg rendering. In: ATEC 2005: Proceedings of the annual conference on USENIX Annual Technical Conference, Berkeley, CA, USA, USENIX Association, p. 49 (2005)

Part-V
Virtual and Mixed Reality

Complexity and Occlusion Management for the World-in-Miniature Metaphor

Ramón Trueba, Carlos Andujar, and Ferran Argelaguet

MOVING Group, Universitat Politècnica de Catalunya, Barcelona, Spain
{rtrueba,andujar,fargelag}@lsi.upc.edu

Abstract. The World in Miniature (WIM) metaphor allows users to interact and travel efficiently in virtual environments. In addition to the first-person perspective offered by typical VR applications, the WIM offers a second dynamic viewpoint through a hand-held miniature copy of the environment. In the original WIM paper the miniature was a scaled down replica of the whole scene, thus limiting its application to simple models being manipulated at a single level of scale. Several WIM extensions have been proposed where the replica shows only a part of the environment. In this paper we present a new approach to handle complexity and occlusion in the WIM. We discuss algorithms for selecting the region of the scene which will be covered by the miniature copy and for handling occlusion from an exocentric viewpoint. We also present the results of a user-study showing that our technique can greatly improve user performance on spatial tasks in densely-occluded scenes.

1 Introduction

The World in Miniature (WIM) metaphor [1] complements the first-person perspective offered by typical VR applications with a second dynamic view of a miniature copy of the virtual world. This second exocentric view of the world helps users to understand the spatial relationships of the objects and themselves inside the virtual world. Furthermore, because the WIM is hand-held, it can be quickly explored from different viewpoints without destroying the larger, immersive point of view.

The WIM has been used as a unifying metaphor to accomplish many user tasks including object selection and manipulation, navigation and path planning. Object selection can be accomplished either by pointing directly at the object or by pointing at its proxy on the WIM. By rotating the hand-held replica, users can even view and pick objects that are obscured from the immersive camera viewpoint. Once selected, objects can be manipulated either at the scale offered by the WIM or at the one-to-one scale offered by the immersive environment. The WIM can also include an avatar of the user that can be moved to change the user location in the environment, providing camera control from an exocentric point of view. Furthermore, since the WIM provides the user with an additional scale at which to operate, the user can choose the most appropriate scale for any given navigation or manipulation task.

A. Butz et al. (Eds.): SG 2009, LNCS 5531, pp. 155–166, 2009.

Any WIM implementation has to address two key problems. On the one hand, one must decide which region of the environment should be included in the miniature copy. Early implementations put a replica of the whole environment in the miniature, thus limiting its application to simple models like a single room. A few extensions of the WIM have been proposed to handle more complex models [2,3,4]. These approaches use a miniature copy which includes only those objects inside a region of interest, which can be scaled and moved either manually or automatically. These techniques allow the accomplishment of user tasks at different levels of scale. However, current approaches either provide adhoc solutions valid for a limited class of models, or assume the input scene already provides some information about its logical structure, such as the subdivision of a building into floors. On the other hand, WIM implementations have to provide some way to handle 3D occlusion. Regardless of the size and shape of the region included in the miniature copy, bounding geometry such as walls must be conveniently culled away to make interior objects visible. Early implementations relied solely on backface culling techniques [1], but these are suitable only for very simple models; general 3D models require the application of more sophisticated techniques for handling 3D occlusion such as cut-away views [5].

In this paper we present Dynamic Worlds in Miniature (DWIM), a new approach to handle complexity and occlusion in the WIM so that it can be used in arbitrarily-complex, densely-occluded scenes. First, we propose to select the region to be included in the miniature copy using a semantic subdivision of the scene into logical structures such as rooms, floors and buildings computed automatically from the input scene during preprocessing. The rationale here is that matching the miniature copies with logical entities of the environment will help the user to accomplish interaction tasks on the WIM. A logical decomposition provides additional cues to better understand the spatial relationships among parts of the scene, in addition to a more intuitive and clear view of the nearby environment suitable for precise object selection and manipulation. Second, we propose a simple algorithm to provide a cut-away view of the miniature copy, so that interior geometry is not obscured by the enclosing geometry (Figure 1).

Fig. 1. Two examples of our improved WIM visualization. The miniature replica provides a cut-away view of a part of the model according to the user's position.

The main contributions of the paper to the WIM metaphor are (a) an algorithm to automatically compute which region of the scene must be included in the miniature copy which takes into account a logical decomposition of the scene, and (b) an algorithm for providing a cut-away view of the selected region so that interior geometry is revealed. These improvements expand the application of WIM to arbitrarily-complex, densely-occluded scenes, and allows for the accomplishment of interaction tasks at different levels of scales. The rest of the paper is organized as follows. Section 2 reviews related work on WIM extensions, cell decomposition and 3D occlusion. Section 3 provides an overview of the three main components of our extension to the WIM, which are detailed in Sections 3.2, 3.3 and 3.4. Results of a user-study are discussed in Section 4. Finally, we provide concluding remarks and future work in Section 5.

2 Previous Work

In this section we briefly review previous work related to the problem being addressed (enhancements to the WIM metaphor) and to our adopted solution (cell decomposition and occlusion management).

2.1 Worlds in Miniature

The WIM was proposed originally by Stoakley, Conway and Pausch [1] who discussed their application to selection, manipulation and travelling tasks. They found that users easily understood the mapping between virtual world objects and the proxy WIM objects. Unfortunately, using a replica of the whole environment in the miniature limits its application to simple models like a single room, due to occlusion and level-of-scale problems. Several WIM extensions have been proposed to overcome this limitations. The STEP WIM proposed by La Viola et al. [3], puts the miniature replica on the floor screen so that it can be interacted with the feet. The main advantage is the freeing of the hands for other tasks. The method provides several methods for panning and scaling the part of the scene covered by the miniature. The Scaled and Scrolling WIM (SSWIM) [4] supports interaction at multiple levels of scale trough scaling and scrolling functions. SSWIM adds functionally and hence complexity because the user has to scale the model manually. The scrolling is automatic though when the user moves to a position outside of a dead zone. This dead zone is a box centered at the SSWIM. Chittaro et al. [2] propose an extension of the WIM to support user navigation through virtual buildings, allowing users to explore any floor of a building without having necessary to navigate. Unfortunately, it requires an explicit identification of all the polygons on the different floors, which can be a time-consuming task for complex models. Unlike previous WIM extensions, we select the region covered by the miniature using an automatically-computed decomposition of the model into cells.

2.2 Cell and Portal Decompositions

A cell-and-portal graph (CPG) is a structure that encodes the visibility of the scene, where nodes are cells, usually rooms, and edges are portals which represent the openings (doors or windows) that connect the cells. There are few papers that refer to the automatic determination of CPGs, and most of them work under important restrictions [6]. Teller and Squin [7] have developed a visibility preprocessing suitable for axis-aligned architectural models. Hong et al. [8] take advantage of the tubular nature of the colon to automatically build a cell graph by using a simple subdivision method based on the center-line (or skeleton) of the colon. To determine the center-line, they use the distance field from the colonic surface. Very few works provide a solution for general, arbitrarily-oriented models with complex, non-planar walls. Notable exceptions are those approaches based on a distance-field representation of the scene [9,10]. Our approach for cell detection also relies on a distance field and it is based on the scene decomposition presented in [10].

2.3 Management of 3D Occlusion

Complex geometric models composed of many distinct parts arise in many different applications such as architecture, engineering and industrial manufacturing. Three-dimensional occlusion management techniques are often essential for helping viewers understand the spatial relationships between the constituent parts that make up these datasets. Elmqvist and Tsigas [11] analyze a broad range of techniques for occlusion management and identify five main design patterns: Multiple Viewports (using two or more separate views of the scene), Virtual X-Ray (turn occluded objects visible), Tour Planners (a precomputed camera animation reveals the otherwise occluded geometry), Interactive Exploders (adopted for the WIM in [2] through a floor sliding mechanism) and Projection Distorter (nonlinear projections are used to integrate two or more views into a single view).

Virtual X-Ray techniques are particularly relevant to our approach as they make the discovery task trivial and facilitate access to the potential targets by selectively removing distractors. Distractors can be removed by turning them semi-transparent or invisible [12]. Using transparency is particularly simple to implement as it eliminates the need for identifying distracting objects, but rendering semi-transparent objects increases the visual complexity of the scene and the cognitive load to the user. Distractor removal techniques can be view-independent [13] or view-dependent [2,14]. Here we only discuss view-dependent techniques as they are more appropriate to reveal geometry on a hand-held miniature. A number of algorithms for generating cut-away views are proposed by Diepstraten et al. [5]. The proposed algorithms are both efficient and easy to implement, although two important assumptions are made: they assume that the classification of objects as interior or exterior is provided by an outside mechanism, and that the cut-out geometry is convex. Fortunately, our decomposition of the scene into cells with approximately constant visibility allows the application of very simple algorithms to generate cut-away views.

3 Our Approach

3.1 Overview

We aim at improving the WIM metaphor by addressing three problems:

- **WIM delimitation:** given the current viewpoint location, we compute the part of the scene to be included in the miniature copy and thus presented to the user as a hand-held miniature. We use a polyhedron to represent the region of the space covered by the WIM.
- **WIM clipping:** once the region to be included has been computed, we must cull away the portions of the scene outside the selected region.
- **WIM revealing:** we provide a cut-away view of the selected region so that interior geometry is revealed.

The algorithm for WIM delimitation proceeds through two main preprocessing steps (described in detail in Section 3.2): *cell detection*, where the scene is discretized into a voxelization and then voxels are grouped into cells with approximately constant visibility, and *polyhedral approximation*, where a low-polygon approximation of the cell's boundary is extracted. Our decomposition scheme produces cells which roughly approximate structural elements of the scene such as rooms and corridors.

At runtime, the user will be presented with a WIM comprising only the scene objects inside the current cell (the one containing the current viewpoint). Since regions are detected during preprocessing, the clipping can be performed either during preprocessing or at runtime. In the former case, we could clip the scene geometry to each cell and store the resulting geometry. However, this approach would add complexity to the integration with already existing applications using their own scene graph. Therefore, we have adopted a runtime approach for clipping the scene geometry to a polyhedral region. Our solution (described in Section 3.3) can be seen as a particular case of CSG rendering (we must render the intersection of the scene with the polygonal region) which can be implemented easily on a GPU [15]. Finally, we apply a view-dependent cut-away technique for removing the frontmost geometry of the cell so that internal objects are visible (WIM revealing). An important benefit of using cells with approximately constant visibility is that they greatly simplify the WIM revealing problem: removing the enclosing geometry will be enough to reveal interior objects. Note that the presence of interior walls inside the miniature would complicate significantly the algorithm for providing cut-away views. We describe a simple solution (Section 3.4) with no extra cost which gives good results on the class of cells produced by our decomposition algorithm.

3.2 WIM Delimitation

Cell Detection. Our approach for cell detection operates on a discrete representation of the input scene. Thus we first convert the input model into a voxelization encoded as a 3D array of real values. This conversion can be performed

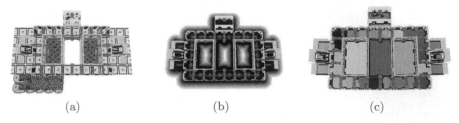

(a)	(b)	(c)

Fig. 2. Cell detection on the test building: (a) original model (only one floor is shown for clarity); (b) discrete distance field; (c) cell decomposition

in the GPU [16]. Voxels traversed by geometry are assigned a zero value whereas empty voxels are assigned a one value. Then we compute a discrete distance field (Figure 2(b)). Distance fields have been used for generating cell-and-portal graph decompositions [9,10] as the valleys of the distance field approximately correspond to the portals of the scene. We approximate the distance field using a 5x5x5 Chamfer distance matrix [17] which requires only two passes through each voxel.

The grouping of voxels into cells is accomplished by a region-growing process starting from the voxel having the maximum distance value. During this process, all conquered voxels are assigned the same cell ID. We use negative values for cell IDs to distinguish visited voxels from unvisited ones. The propagation of the cell ID continues until the whole cell is bounded by voxels having either negative distance (meaning already-visited voxels), zero distance (non-empty voxels) or positive distance greater than the voxels at the cell boundary. When the growth of one cell stops we simply choose a new unvisited maximum and repeat the previous steps until all voxels belong to some cell (see Figure 2(c)). Lastly, we filter out small cells produced by geometric noise [10].

Polyhedral Approximation. We approximate each cell (consisting of a collection of voxels) with a polyhedron using the surface extraction algorithm proposed in [18]. Before the extraction, a dilation operation is performed for each cell to include adjacent non-empty voxels. This step is required to include the geometry enclosing the cell, such as walls (see Figures 3(c) and 3(f)).

3.3 WIM Clipping

At runtime, the user will be presented with a WIM comprising only the scene objects inside the current region (the region containing the current viewpoint). This can be seen as a particular case of CSG rendering, as we must render the intersection of the scene with a polyhedral approximation of the current cell. A coarse-level, CPU-based culling to the region's bounding box can be used to quickly discard geometry not to be included in the miniature. However, this coarse-level clipping must be combined with a fine-level clipping to the polyhedral cell. Fortunately, there are efficient algorithms for rendering CSG models using the GPU [19,15], whose implementation can be greatly simplified when the CSG tree consists of a single boolean operation. The algorithm we propose

is based on building a Layered Depth Image [20] of the polyhedral approximation from the current WIM viewpoint. Layered Depth Images (LDIs) can be efficiently constructed using depth-peeling [21]. We use OpenGL framebuffer objects (FBOs) to render each layer directly into a depth texture. Since the WIM delimitation algorithm tends to produce regions with very low depth complexity, these regions can be encoded with just a few LDI layers and one rendering pass for each layer (note that the LDI is build from a low-polygon description of the cell's boundary, which is geometrically simpler than the part of the scene inside the cell). Once the LDI has been computed, the coarsely-culled scene is rendered using a fragment shader that checks the fragment's depth against the LDI and discards outside fragments.

3.4 WIM Revealing

Note that our WIM clipping strategy does not solve the occlusion problem due to enclosing geometry such as walls. Fortunately, it can be trivially extended to keep enclosing geometry from occluding interior objects. The only modification required is to offset frontface faces of the polyhedral region in the opposite direction of their normals (i.e. increasing the d coefficient of the implicit plane equation). In our implementation the offset was set to roughly the length of a voxel. The resulting effect is that the frontmost geometry will be culled away by the fragment shader, without sacrificing the outer context entirely (Figure 3(f)). Due to the simple nature of the cells detected in the first step, this simple approach yields very good results at no extra cost.

4 Results and Discussion

We conducted a user-study to evaluate potential advantages of our *WIM delimitation* and *WIM revealing* strategies in comparison with competing approaches. We focused on selection and manipulation tasks performed in spatially-immersive displays such as CAVEs. The test model was a three-story building with about 60 rooms and 150k polygons. Figure 2(c) shows the results of the cell decomposition step on the test model, using a 128^3 voxelization. The running time for the cell decomposition was 6 seconds, including the voxelization, distance transform and polyhedral approximation steps.

Concerning WIM delimitation, we compared our approach (based on automatic cell detection) with a *user-adjustable cube* defining the part of the scene to be included in the replica. Our adjustable-cube implementation is inspired in SSWIM [4] with some modifications to match our VR system. At the beginning of the task, the cube was centered in the user's position and covered a fraction of the model (in the experiments the cube covered about a 10% of the model). Users were able to manually scale up and down the cube at constant speed (2.5 m/s for the experiments), using two Wanda buttons. Similar to [4], the cube center was updated when the user navigated to a location farther away from the initial position (we set the distance threshold to a 60% of the cube size). The adjustment of the cube size and position only affected the WIM coverage;

the apparent size of the WIM remained constant during the experiment (about 30 cm^3). Regarding WIM revealing, we considered two options for distractor removal: turning them invisible (using our *z-offset* approach) or semi-transparent (using unsorted alpha blending with depthbuffer write operations disabled).

Given that our WIM delimitation strategy automatically matches the WIM extents to the current cell, in the best case scenario one could expect DWIM delimitation to have a positive impact on selection performance. In practice, however, this may not be the case. On the one hand, DWIM's lack of manual adjustment can keep the user from finding a suitable level of scale for performing the spatial task. On the other hand, DWIM's cells include enclosing geometry which might distract the user unless efficiently removed. We also expected the WIM revealing strategy to have a varying impact depending on the WIM delimitation strategy and the amount of intervening distractors. In any case, rendering semi-transparent objects increases the visual complexity so we expected the transparency option to have a negative impact on selection performance.

Apparatus. All the experiments were conducted on a four-sided CAVE with active-stereo projectors at 1280x1280 resolution. The input device was a 6-DOF Ascension Wanda and a tracking system with 2 receivers providing 60 updates/s with 4 ms latency. The experiment was driven by a cluster of 2.66GHz QuadCore PCs with Nvidia Quadro 5500 cards.

Participants. Eleven volunteers (1 female, 10 male), aged from 24 to 35, participated in the experiment. Some participants (4) had no experience with VE applications; 5 had some experience and 2 were experienced users.

Procedure. The task was to select some objects and move them to a target destination represented by a sphere. Target destinations were chosen to be more than 4 meters away from the initial position so that the task could be accomplished more efficiently using the WIM proxies rather than the actual objects. Selection and manipulation in the WIM was accomplished using the virtual hand metaphor. Users were requested to complete the task as quickly as possible. Users were allowed to navigate at 2m/s constant speed using the wanda's joystick.

Design. A repeated-measures within-subjects design was used. The independent variables were WIM delimitation (adjustable cube, current cell) and WIM revealing (transparency, z-offset), resulting in four combinations. Each participant performed the experiment in one session lasting approximately 15 min. The session was divided into four blocks, one for each technique. Before each block users were provided with a short training session which required them to complete practice trials. We measured the time to complete the task, distinguishing between selection, manipulation and navigation times (some users decided to navigate to find a better view to accomplish the task).

Various options for WIM delimitation and rendering are shown in Figure 3. Figure 3(d) shows the replica covering the whole model. Note that this WIM is not suitable for object manipulation due to occlusion and level-of-scale problems. Rendering the WIM with alpha blending (Figure 3(a)) does not provide

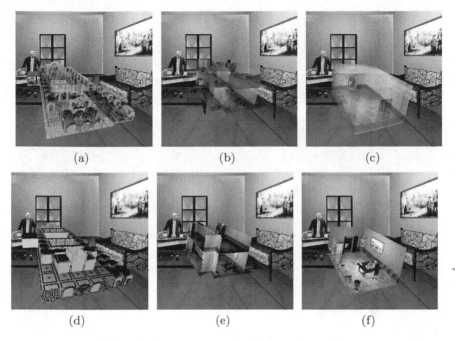

(a) (b) (c)

(d) (e) (f)

Fig. 3. Different strategies for WIM rendering

a sufficiently clear view of the model and still provides a scale unsuitable for object manipulation. Figures 3(b) and 3(e) show sample renderings with the adjustable cube. The result of our clipping algorithm (with transparency instead of z-offset revealing) is shown in Figure 3(c). Now the miniature includes only the geometry inside the automatically-detected cell, providing a better scale for accurate selection and manipulation tasks. Finally, Figure 3(f)shows the final output of our algorithm. The quality of the results can also be observed in the accompanying videos (further results can be found in [22]).

Results. Results of the experiment are shown in Figure 4(a). The two-way ANOVA showed a significant effect ($p < 0.01$) for the WIM delimitation factor, users performing much better (30% less time) with the WIM delimited automatically to the current cell rather than manually with the cube. This result was expected as our approach eliminates the need to manually adapt the WIM extent to the task. We also found a significant effect ($p = 0.04$) for the WIM revealing factor, and a clear interaction effect ($p < 0.01$) between delimitation and revealing. When the WIM was delimited automatically to the current cell, the choice of the revealing strategy had a significant effect, users performing much better when removing occluding walls with the z-offset approach. This seems to confirm our hypothesis on the limitations of the transparency option for performing spatial tasks (see Figures 3(c) and 3(f)). However, when delimiting the WIM with the adjustable cube, the revealing strategy had little impact on overall user performance. Our explanation for this is that rendering the WIM

with transparency resulted in higher visual complexity of the resulting images, but this was compensated by the fact that users were not forced to perform a fine adjustment of the cube to avoid occluding walls (see Figures 3(b) and 3(e)).

It can be argued that the chosen task favors our approach against the adjustable cube option because the initial user position was located in the same room as the object to be manipulated. Therefore we conducted a second experiment with identical setup except for the object to be manipulated, which was moved to an adjacent room. This change implied that, when using our approach, users were required to navigate to the target room, whereas for the adjustable cube users were able to decide whether to navigate or to scale-up the cube. We also chose a target room with less occluding objects to favor transparency against our z-offset approach. Figure 4(b) shows the results of the second experiment. Despite being a worst-case scenario for our approach, we still found a significant effect for WIM delimitation ($p = 0.01$), users performing better with DWIM. Our explanation is that, in densely-occluded environments, scaling-up the cube rapidly increased the number of potential distractors, adding occluders from neighboring cells and keeping it from providing a clear view for carrying out spatial tasks. We did not found though a significant effect for WIM revealing ($p = 0.1$), probably because of the low number of occluders in the target room, making the transparency option still usable.

Using correct (sorted) transparency through depth-peeling might improve the clarity of the images, but the depth complexity (i.e. the number of layers and hence the number of rendering passes) would depend on the complexity of the objects inside the room, not on the complexity of the geometry enclosing the room, as in our case. Furthermore, note that the cut-away view provides a much more clear representation compared with the transparency-based option.

Runtime Overhead. We also measured the performance overhead of our technique. Since cells are detected during preprocessing, the WIM delimitation step introduces no noticeable runtime overhead in comparison with the adjustable cube.

Fig. 4. Box plots for task 1 (left) and task 2 (right)

WIM rendering requires (a) building the LDI of a low-polygon approximation of the cell and (b) drawing the objects with a simple fragment shader. The LDI is built using a FBO with the size of the WIM viewport, which is smaller than the immersive viewpoint viewport. The overhead was found to be less than one millisecond, which had no noticeable impact on the application frame rate.

5 Conclusions and Future Work

In this paper an enhanced version of the WIM metaphor has been presented. Our approach supports arbitrarily-complex, densely-occluded scenes by selecting the region to be included in the miniature copy using a semantic subdivision of the scene into logical structures such as rooms. The rationale of our approach is that matching the miniature copies with logical entities of the environment would help the user to accomplish spatial tasks. We have shown empirically that our approach facilitates accurate selection and manipulation of 3D objects through their WIM proxies, providing a clear, low-complexity view automatically adapted to the user's location. Our current system allows users to switch automatic WIM delimitation on and off; when turned off, the WIM shows a miniature replica of the whole scene, which can be more suitable for way-finding tasks at large scale levels. Unlike other WIM extensions using continuous scrolling, our approach preserves the extents of the miniature copy while the user remains in the same room. The room center instead of the current viewpoint is used as pivot point for hand-held manipulation and visualization of the miniature. We have found this behavior to be less distracting to the users.

There are several directions that can be pursued to extend the current work. It may be interesting to explore alternative visibility-aware decompositions of the scene suitable for outdoor environments, enabling fast identification and removal of occluding geometry, as well as cell decompositions requiring no preprocessing at all. It would be also useful to allow the user to enlarge the WIM coverage by incorporating rooms adjacent to the room containing the current position. This can be easily implemented as the outcome of the WIM delimitation algorithm is a discrete cell-and-portal graph representation of the scene.

Acknowledgements. This work has been partially funded by the Spanish Ministry of Science and Technology under grant TIN2007-67982-C02-01.

References

1. Stoakley, R., Conway, M.J., Pausch, Y.: Virtual reality on a wim: interactive worlds in miniature. In: SIGCHI 1995: SIG on Human factors in computing systems, pp. 265–272 (1995)
2. Chittaro, L., Gatla, V.K., Venkataraman, S.: The interactive 3d breakaway map: A navigation and examination aid for multi-floor 3d worlds. In: CW 2005: Proceedings of the 2005 International Conference on Cyberworlds, pp. 59–66. IEEE Computer Society, Washington (2005)

3. LaViola Jr., J.J., Feliz, D.A., Keefe, D.F., Zeleznik, R.C.: Hands-free multi-scale navigation in virtual environments. In: Proceedings of the Symposium on Interactive 3D Graphics 2001, pp. 9–15 (2001)
4. Wingrave, C.A., Haciahmetoglu, Y., Bowman, D.A.: Overcoming world in miniature limitations by a scaled and scrolling wim. 3D User Interfaces, 11–16 (2006)
5. Diepstraten, J., Weiskopf, D., Ertl, T.: Interactive cutaway illustrations. In: Proceedings of Eurographics 2003, pp. 523–532 (2003)
6. Cohen-Or, D., Chrysanthou, Y., Silva, C., Durand, F.: A survey of visibility for walkthrough applications. IEEE Transactions on Visualization and Computer Graphics 9(3), 412–431 (2003)
7. Teller, S.J., Séquin, C.H.: Visibility preprocessing for interactive walkthroughs. SIGGRAPH Computer Graphics 25(4), 61–70 (1991)
8. Hong, L., Muraki, S., Kaufman, A., Bartz, D., He, T.: Virtual voyage: interactive navigation in the human colon. In: SIGGRAPH 1997: Proceedings of the 24th annual conference on Computer graphics and interactive techniques, pp. 27–34 (1997)
9. Haumont, D., Debeir, O., Sillion, F.: Volumetric cell-and-portal generation. Computer Graphics Forum, 3–22 (2003)
10. Andújar, C., Vázquez, P., Fairén, M.: Way-finder: Guided tours through complex walkthrough models. Computer Graphics Forum 23(3), 499–508 (2004)
11. Elmqvist, N., Tsigas, P.: A taxonomy of 3d occlusion management for visualization. IEEE Transactions on Visualization and Computer Graphics 14(5), 1095–1109 (2008)
12. Elmqvist, N., Assarsson, U., Tsigas, P.: Employing dynamic transparency for 3d occlusion management: Design issues and evaluation. In: Baranauskas, C., Palanque, P., Abascal, J., Barbosa, S.D.J. (eds.) INTERACT 2007. LNCS, vol. 4662, pp. 532–545. Springer, Heidelberg (2007)
13. Coffin, C., Hollerer, T.: Interactive perspective cut-away views for general 3d scenes. In: 3DUI 2006: IEEE Symposium on 3D User Interfaces, pp. 25–28 (2006)
14. Burns, M., Finkelstein, A.: Adaptive cutaways for comprehensible rendering of polygonal scenes. ACM Transactions on Graphics 27(5), 1–7 (2008)
15. Kirsch, F., Döllner, J.: Opencsg: a library for image-based csg rendering. In: Proceedings USENIX 2005, p. 49 (2005)
16. Dong, Z., Chen, W., Bao, H., Zhang, H., Peng, Q.: Real-time voxelization for complex polygonal models. In: PG 2004: Proceedings of the 12th Pacific Conference on Computer Graphics and Applications, pp. 43–50 (2004)
17. Jones, M., Satherley, R.: Using distance fields for object representation and rendering. In: Proceedings of Eurographics 2001, pp. 37–44 (2001)
18. Andújar, C., Ayala, D., Brunet, P.: Topology simplification through discrete models. ACM Transactions on Graphics 20(6), 88–105 (2002)
19. Hable, J., Rossignac, J.: Blister: Gpu-based rendering of boolean combinations of free-form triangulated shapes. ACM Trans. Graph. 24(3), 1024–1031 (2005)
20. Shade, J., Gortler, S., He, L.W., Szeliski, R.: Layered depth images. In: SIGGRAPH 1998, pp. 231–242 (1998)
21. Everitt, C.: Introduction to interactive order-independent transparency. White Paper, NVIDIA Corporation (May 2001)
22. http://www.lsi.upc.edu/~virtual/DWIM

Interactive Context-Aware Visualization
for Mobile Devices

Mike Eissele[1], Daniel Weiskopf[2], and Thomas Ertl[1]

[1] VIS, Universität Stuttgart, Germany
[2] VISUS, Universität Stuttgart, Germany

Abstract. Utilizing context information—e.g. location, user aspects, or hardware capabilities—enables the presented generic framework to automatically control the selection and configuration of visualization techniques and therewith provide interactive illustrations, displayed on small mobile devices. For context-annotated data, provided by an underlying context-aware world model, the proposed system determines adequate visualization methods out of a database. Based on a novel analysis of a hierarchical data format definition and an evaluation of relevant context attributes, visualization templates are selected, configured, and instanced. This automatic, interactive process enables visualizations that smartly reconfigure according to changed context aspects. In addition to the generic concept, we present real-world applications that make use of this framework.

1 Introduction

Handling, controlling, and processing of various, possibly huge amounts of data on mobile devices will most likely be an upcoming trend in future. One example is the visualization of data on mobile devices, as already partially present in the form of mobile navigation devices, where users query geographical data (maps) on their mobile clients to retrieve various spatially referenced information. In general, such geo-mashup applications specifically make use of multiple geo-referenced data sources and generate a combined, unified view of the data. With the evolution of smart, mobile devices and data-sensor technology more and more data will become available and therewith enable new use cases and applications.

Currently, applications which process and use huge amounts of data make high demands on the underlying hardware infrastructure (processing power, network connectivity, etc.) and in the same way on its operating users (overwhelming feature set, non-intuitive user interface, etc.). Context-aware systems address this conflict of advanced applications and ease of use [1,2,3]. They try to assemble context information via locally integrated sensors—e.g. cameras, GPS antennas, inertial accelerometers, or WiFi receivers—or utilize external data providers to request additional data, like common information databases. For example, mobile navigation devices may use GPS to acquire its current location without requiring the user to interact with the device. In addition to pure navigation scenarios more general information retrieval systems appear that support access of arbitrary data, e.g. an intuitive access to data using a spatial context have become available via Google Earth [4] or Microsoft VirtualEarth [5]. Such

A. Butz et al. (Eds.): SG 2009, LNCS 5531, pp. 167–178, 2009.
© Springer-Verlag Berlin Heidelberg 2009

location-based, context-aware applications are available for desktop computers; the next challenge is to offer similar services for smart devices and provide mobile users with information relevant to their current context.

We propose a system to generate interactive context-aware visualization of federated data sources provided by an underlying context-aware framework. Systems that manage heterogenous context data often make use of descriptive data formats and communication protocols as, e.g., the Nexus system [6] makes use of XML and SOAP. In contrast to common flat formats, hierarchical data schemas—as implemented by Nexus—have the major advantage that even new or unknown data types are partially defined through their base type(s). Our novel selection approach particularly takes advantage of an hierarchical definition to retrieve sematic information, even about unknown data objects, to select and configure an adequate visualization out of a database of visualization techniques. This way, the system is capable to visualize any kind of data available through a federated data source—e.g. sensor values, 3D geometry, simulation data, etc.—exceeding most existing geo-mashup techniques in its generality to combine multiple heterogenous data sources. In contrast to simple, very popular geo-mashup systems [4,5] our system can, in addition to location, consider arbitrary context aspects and adapt the visualization correspondingly. In particular, client-device aspects are analyzed so that visualizations are appropriate for the utilized device—e.g. low-performance clients are provided with prerendered images from the infrastructure or clients with limited connectivity receive a reduced dataset—resulting in support for interactive context-aware visualization on mobile devices. Because of fast-changing context attributes, e.g. position or viewing direction, of mobile users context-aware visualizations that support interactive update rates are required and therefore hardware acceleration support, e.g. using graphics processing units, is already considered within the entire system design.

1.1 Nexus: A Framework for Context-Aware Applications

A generic open-source platform for context-aware applications is foreseen within the Nexus project [6], where multiple, remote data providers contribute to a federated data source, the so-called Augmented World Model (AWM) [3]. Data entities of the AWM may be captured sensor data, automatically or manually generated data of real-world objects, or data of virtual objects. This general approach places no restrictions on the data (i.e. data type or data amount) provided to or from the platform, facilitating a unified access to arbitrary data for context-aware applications.

In order to allow arbitrary services and applications to make use of the data, each data type is defined within a specific XML type description, called Augmented World Schema (AWS). The resulting complex, hierarchical schema definition contains basic types, attributes, meta data, relations to other objects, etc. In the proposed visualization service this schema definition plays an important role as it is used to interpret and find adequate visualization methods for data entities within the federated data source. To access the information contained in the AWM various data base queries are supported and transparently distributed to the relevant data providers by the federation component of the Nexus framework. Therefore, an efficient processing of, e.g., queries on entities located at a given geo-referenced real-world position is ensured.

2 Related Work

Context-aware systems and their applications are an active field of research, thus discussion on previous work is mainly concentrated on context-adaptive presentation. Mackinlay shows a system that automatically generates 2D presentations of relational data, thereby considering the effectiveness and expressiveness of the resulting visualization [7]. Sophisticated interactive 3D visualization which offers much more degrees of freedom for presentation are not discussed. Senay and Ignatius present the Vista system [8]; where the goal is to automatically generate combined visualizations from basic techniques. Several rules are defined how visualizations can be combined to achieve the most pleasant results. After definition of the input data, the system tries to find a possible visualization, considering the input data types and their correlation. Gilson et al. make use domain knowledge in form of ontologies to generate information visualizations from domain-specific web pages [9]. In contrast to our context-aware approach, both systems consider only the input data itself and static domain knowledge. In addition, the resulting visualizations are targeted for a single platform and do not offer dynamic context-aware presentations. A system based on scene-graph concepts is proposed by Reitmayer and Schmalstieg [10]. They present an extended scene graph that is automatically adapted during an update phase based on specific context settings. We propose a related concept, but focus on sophisticated visualization techniques and their interactive adaptation on mobile devices. Mandez et al. [11] make use of this system to develop context-driven visualizations. In addition, we propose to use context information to automatically find the most suitable visualization by performing a real-time reevaluation on the available techniques, which is not foreseen in the technique presented in [10]. A conceptual framework for context-sensitive visualization with focus on recognition and handling of higher-order context is proposed by Jung and Sato [2]. The approach is envisioned for interactive applications, but do not support interactive visualizations or real-time context-aware adaptation.

Further, many specific prototype applications and frameworks exist. Shibata et al. propose a framework to develop mixed and augmented reality (AR) applications [12]. Thereby, they focus on location awareness, as typical for mixed-reality applications, and computation load balancing for AR applications. Context-ware selection or configuration of visualization approaches are not considered. The development of a context-aware tourist guide is presented by Cheverst et al. [13]. They propose to change the presentation according to context aspects like location history or user interests. However, their proposed system is targeted for static non-interactive presentation of information whereas we focus on interactive visualizations. An interactive prototype for a mobile location-based information presenter is proposed by Burigat and Chittaro [1]. Their tourist guide application (LAMP3D) renders 3D VRML models interactively considering the location context, further context aspects are not analyzed.

3 Communication and Processing Infrastructure

A system that supports heterogenous mobile clients has to cope with limitations of these devices. Computation power, network bandwidth, and limited storage are the most severe ones. The proposed client-server system is designed to address these aspects. It

Fig. 1. Overview of the communication and preprocessing infrastructure to support data processing for mobile devices, implementing context-aware visualizations

supports processing of arbitrary input data and is based on a caching and preprocessing concept to prepare data based on the client's requirements and further context attributes. The server acts as a communication endpoint for heterogenous clients and optimizes the wireless transmitted data; it is further designed to work with multiple concurrently connected clients in a way that preprocessing is only done once and cached for all clients. For the processing of data queried from a federated source an appropriate technique is selected, based on the user's context, so that the resulting visualization data can efficiently be handled by client devices. Figure 1 shows an overview of the system.

For the communication with an underlying context-aware platform—our implementation makes use of Nexus [6]—a descriptive communication protocol is used. In Nexus, XML/SOAP requests are used to access the federation component, but such protocols are inappropriate for direct communication with mobile devices, as they increase latency—due to complex structure parsing—and the total amount of data transmitted. In contrast, the server-based preprocessing—as illustrated in Figure 1—allows us to preprocess the raw data once and cache it using a data structure that is more appropriate for visualization purposes. Therefore, subsequent queries to the same data objects—possibly form a different client—benefit form the cache and experience a faster server response, as the underlying context-aware framework does not have to retrieve and federate data of possibly slow, remote providers.

The proposed generic system supports multiple techniques to process data objects of the same or different type and amount via a plugin-like system. In the following, we discuss data processing for visualization on heterogenous mobile and desktop computers, but the proposed client-server system may also be used to perform other not necessarily visualization data processing.

3.1 Visualization-Technique Database

The server component has—in addition to the data queried form the AWM—access to a database of visualization templates (VDB) that implement different visualization techniques, as depicted in the bottom of Figure 1. Each individual visualization template available through the VDB has four functional parts:

1. A function to query the template for appropriateness to visualize a specific data type by providing the corresponding data schema.
2. Processor to handle raw data objects, provided by the utilized federation.
3. The implementation of the actual visualization technique.
4. I/O routines to transmit/receive all required data of the template's visualization.

These templates are utilized to preprocess and optionally calculate the final visualization, dependent on the client and its current context, which is further detailed in Section 3.2. The resulting binary data—either an intermediate binary representation of the visualization data or even a final image of the visualization—is then transmitted via a (wireless) network connection to the client. The server-based preprocessing and the implementation of techniques are tightly coupled with the underlying scene graph [14]; therefore visualizations are represented as partial scene graphs. The preprocessed intermediate data, transmitted to the client, can therefore be: raw data objects, standard scene-graph nodes, extended scene-graph nodes, or images streams.

For the integration of a new visualization a template plugin which implements the technique has to be made available on the server and, if intermediate visualization data should be transmitted, on the client side. If a specific visualization technique is only available on the server side, then the clients cannot process the technique's intermediate data and the server system reverts to basic image-stream transmission.

3.2 Technique Matching Utilizing XML Schemas

The mechanism to automatically select and configure appropriate visualization techniques is based on a hierarchical data description, formulated via an XML schema. All data objects stored in the AWM have to be defined within this schema. The AWS makes use of *substitutionGroup="..."* attributes, and *<extension base="..."/>* tags to compose extended object classes and attributes in a hierarchical manner. Figure 2 shows on the left the definition for an URL attribute type, that can be used to describe an attribute of a class object within the schema. Note that the resulting *uri* attribute can be inserted wherever the schema requests a *NexusAttribute* as it is part of the substitution group. Furthermore, it is based on (i.e. derived from) the basic *string* type. This hierarchy is fundamental to the automatic selection, as for data types where no corresponding processing template is available the system can iteratively cast the data to its base type and try to find matching techniques until a basic type, e.g. *string*, is reached.

The entire evaluation process to find possible techniques in the VDB that match the requested data type is implemented via a sequential process, as depicted in the right part of Figure 2. The illustration shows the data flow of each individual data element and the resulting data, transmitted to the clients. For each element of the data-object stream that is piped into the matching process from the AWM all available visualization templates are queried to rank the usability to visualize their requested data type. Each template of the VDB returns a scalar value to reflect the quality/appropriateness q_i of the resulting visualization, for the given type. Techniques with $q_i > 0$ are assembled to a list of possible visualizations. For data types where no corresponding visualization template is available, i.e. all available templates return $q_i = 0$, the automatic selection mechanism makes use of the fundamental hierarchical structure of the AWS: the system iteratively

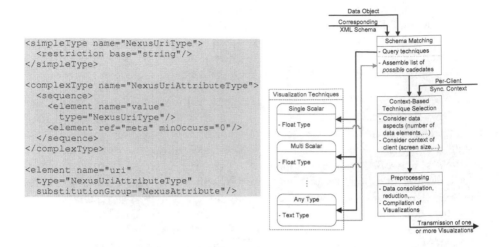

```
<simpleType name="NexusUriType">
  <restriction base="string"/>
</simpleType>

<complexType name="NexusUriAttributeType">
  <sequence>
    <element name="value"
      type="NexusUriType"/>
    <element ref="meta" minOccurs="0"/>
  </sequence>
</complexType>

<element name="uri"
  type="NexusUriAttributeType"
  substitutionGroup="NexusAttribute"/>
```

Fig. 2. XML schema matching. The left illustration shows a schema definition for an URL attribute. On the right, the data flow path during the evaluation process for relevant visualization techniques using XML-based data type descriptions (AWS) is shown.

casts the data objects to their base types and uses those to find matching techniques until at least one techniques is found and inserted into the list of possible techniques. As the attributes and classes defined in the AWS are based on only few basic types, e.g. *string*, *integer*, *float*, etc., and for each of these a basic visualization is available, it is guaranteed that the system can visualize *all* data provided by the AWM. However, the quality and usability of the result is strongly dependent on the selected visualization.

3.3 Context-Aware Visualization and Real-Time Adaptation

For the selection process of appropriate visualization techniques the amount of data and possibly other aspects, e.g. spatial distribution of the individual data elements, might also be relevant. To consider these aspects in the selection process, all techniques in the list of possible visualizations are provided with raw data from the stream of data objects, generated by a query to the AWM. Afterwards, a combination of per-client context information and properties of each technique—e.g. the amount of data objects the method can visualize simultaneously—are used to decide which visualization is finally selected as most appropriate for the current situation. This process is summarized as *Context-Based Technique Selection* in Figure 2. The necessary per-client context is made available via an aggregation of data provided by the framework (tracking system, web services, etc.) and data from local sensors (camera image, GPS location, etc.) of the connected client. In order to support real-time context information, both sources are synchronized to build the per-client context that is consistently available on the server and client. The following *Preprocessing* step (see Figure 2) executes the selected template's function to prepare the data and, dependent on the context, transmits optimized intermediate visualization data or an image stream to the client.

The aforementioned system has been designed with the application of mobile visualizations in mind. However, real-time or at least interactive visualization that depend on a possibly dynamic fast-changing context—e.g. a mobile users changes their position—has to support a fast update mechanism to adapt visualization parameters or even change the entire technique. Thus, visualizations might change although no additional data was queried, so a continuous adaptation to dynamic context aspects is required. The entire selection process can be repeated, if a changed context is detected, but this will introduce a high latency for adaptations due to the costly schema matching.

High-frequency but moderate changes in the context, e.g. position or view direction updates, are handled via parameter adjustments of utilized visualizations. For adaptation, each technique—implemented as sub scene graph—supports a specific scenegraph traversal interface utilized to receive context updates. This way, visualization techniques can adapt themselves to the changed situation. However, if the context has changed tremendously, the previously selected visualization technique may no longer be adequate to visualize the requested data.

Therefore, mainly static context information, i.e. data format and amount, is considered during the initial template selection and multiple visualizations from the list of possible techniques are instanced. These are then attached to a context-sensitive switch node, which is basically a context-aware group node where each child can be turned on or off. In consistency with the update mechanism for visualizations, switches also receive high-frequent context updates and can thus perform a context-aware selection of preinstanced techniques, as described in Section 3.2, without a noticeable delay. The continuous context updates are executed on the server, to adjust image-streaming clients and cached visualizations, and on advanced clients that are able to process scene graph structures locally. For drastic changes of the context, e.g. a changed display device, still a server-side restart of the entire selection process is needed.

Weighting of individual context aspects for visualization-appropriateness evaluation is flexibly implemented by each template and context switch in a way that access to all attributes of the per-client synchronized context is available, e.g. position, view direction, screen size, etc. Based on these values the technique adapts its parameters resulting in an adequate output; even sophisticated approaches as proposed in [7] that automatically generate different styles can be integrated. In addition, context switches can query its children to retrieve their scalar appropriateness value q_i. The returned normalized values are sorted to adjust the selection of an optimal visualization, if required.

3.4 Rendering of Context-Aware Visualizations

The final rendering of the visualization depends strongly on the client device capabilities and the available network connectivity. Several approaches exist to enable advanced visualizations on smart mobile devices, namely: *Remote Rendering, Render Local, and Hybrid Rendering* [15]. Most research done for visualization on mobile devices focuses on a single specific setup with known client devices and applications. In contrast, the proposed system for context-aware visualizations supports diverse configurations and is able to dynamically select the most appropriate one, dependent on the available context information. For instance, client-device capabilities in terms of graphics hardware support are considered in a way that if the device does not have hardware support,

entire visualization including the rendering is performed by the server and the final image stream is continuously transmitted to the client device.

As the implementations of all visualization methods are based on the same basic scene-graph API, all three rendering modes can efficiently be supported: For rendering locally on the client the required sub scene graph is transmitted with its required dependencies and executed on the client side to render the visualization utilizing OpenGL. In situations where the final rendering has to be performed remotely, the server executes the sub graph within a so-called camera node, resulting in an image of the final visualization using view parameters provided by the client's context. This final image is then optionally compressed and transmitted to the client, where it is displayed simply by extracting and copying into the frame buffer. Specific visualization techniques of the VDB may support a hybrid mode where the computation is distributed between server and client. This way, a sever-based preprocessing is used to build an optimized data structure that is then transmitted to the client for calculating final visualization allowing to minimize the amount of data that has to be transferred over network.

For evaluation of the proposed concept we integrated a number of different visualization methods into our prototype, so that in addition to 3D geometry including textures and shader programs, text strings, scalar, and vector data types are handled. All other data types of the AWS are incrementally casted to their basic type and then visualized using a text box with, if a real-world location is available, a geospatial reference pointer via a text-visualization (see Figure 4a). Thus, the resulting geo mashup of multiple heterogeneous data sources is more general as the interface offered by, e.g., GoogleEarth [4] as representation and interpretation of more complex data depends on corresponding visualization template which can be implemented without restrictions.

Another important aspect rendering has to account for is the combined visualization of multiple data types using different visualization techniques within a single image. Simply adding the result of each technique to the final image can lead to artifact due to, e.g., incorrect depth sorting. Therefore, all visualization techniques that generate geometry—like stream lines, glyphs, etc.—are required to write correct depth values to the frame buffer. This way, visualization of opaque geometry can be intermixed with each other. Visualizations that make use of (multiple) transparent primitives (like volume rendering) but do not spatially overlap with other visualizations, i.e. their bounding boxes do not intersect, are also correctly rendered. The underlying scene graph automatically detects transparent geometry and schedules its rendering after opaque objects in a back-to-front sorted manner based on bounding boxes. However, for multiple semitransparent and spatially intersecting visualizations we accept small blending artifacts due to partial incorrect depth sorting.

4 Applications and Evaluation

Two prototypical examples are implemented using the proposed system. A technical information and visualization system for a smart factory [16] where all data relevant to the manufacturing environment is managed via the Nexus platform. Further a non-technical geo-mashup application for a mobile outdoor scenario is presented. In [17] we present a non-generic context-aware visualization implementation for a specific scenario, which could also be implemented using the proposed framework.

4.1 Prototype Scenarios

To evaluate the proposed system together with partners from the field of advanced manufacturing engineering a number of example visualization techniques were implemented based on different basic concepts and deployed to different client hardware. The dominant context aspects that influence the visualization are data type, position, view direction, and client device capabilities. Furthermore, visualization often benefits when the spatial context of the presented data is shown. This context-data is often provided via virtual 3D models, but also real-time video streams are possible, as used in augmented reality where position and direction define the point of view for rendering visualizations as overlays to real-world views. Therefore, these visualization methods also support a combined visualization of scientific data and real-world camera video streams. Naturally, both content types—real-world and virtual—are adapted to the user's current position and direction to support AR setups.

The examined example scenario is targeted for the design, evaluation, and maintenance of air ventilation systems, typically installed in laboratories or manufacturing environments. In clean rooms, air flow is crucial to maintain the required conditions, e.g. particles per cubic meter of air. Direction and speed of the flow or temperature are only a few important aspects that have to be considered, especially within areas where high-tech materials are processed. Simulation and visualization of these quantities are used to optimize the production, but evaluation and maintenance of the conditions requires expensive highly-qualified personal. In contrast, the proposed system can easily present the relevant data or information—adequate for different tasks—within the related spatial context, so that even non-experts can interpret the data to some extent.

Figure 3a shows an interactive visualization of the simulated air flow within the planned manufacturing environment. The simulation data is precomputed and stored within the AWM and linked to its real-world position. The desktop application makes use of the proposed framework to access and visualize the simulation data in combination with other data available in the AWM. The additional virtual 3D model of the manufacturing environment helps users to understand the air flow inside. Additional

a) b)

Fig. 3. Context-aware data visualization for manufacturing environments. A visualization of airflow data is shown using stream ribbons in a) together with a virtual 3D model to provide a spatial context of the data. A detail of the same data is depicted in b) using a mobile device.

data, e.g. temperature inside the room, can be displayed using volume rendering to investigate possible relations between temperature values and air flow behavior. Due to the utilization of graphics hardware, such a combined visualization still performs at interactive frame rates even on moderate hardware. The total amount of data transferred to the desktop client is dominated by high-detail textures and adds up in total to roughly 12MB for the visualization depicted in Figure 3a.

In the desktop application real-world spatial context is artificially generated via a virtual 3D model of the manufacturing environment. Also interaction, i.e. change of viewing position and direction, is simulated via mouse interactions. Therefore, if the quality of the provided context data is not adequate the resulting evaluation will not be accurate. In contrast, using smart mobile clients the system is able to replace the virtual environment with a camera image stream capturing the real-world conditions (see Figure 3b and Figure 4a). Therefore, users are able to interpret and evaluate the simulation data within its relevant spatial context, misplaced interior or obvious simulation errors are easily visible. Basically, the very same techniques as for the desktop client can be used to display the data on mobile devices. Due to the limited OpenGL functionality and performance of the utilized client device (TabletPC M1300, Intel 855GM 64MB VRam) the system restricts itself to a limited number of stream ribbons to display the air flow or color-coded surfaces for the scalar temperature values in order to keep the visualization at interactive frame rates. The entire visualization is displayed in front of a live video image that provides the real-world spatial context for the visualization. The resulting visualization shown in Figure 3b runs at 20fps and requires an initial data transmission of roughly 4MB to the mobile client for the entire scenario.

Mobile clients are also preferred for maintenance of the conditions inside the manufacturing environment as rearrangements or other changes of the environment can be detected. Even untrained users can easily benefit from such visualizations using their off-the-shelf smart mobile device like phones or PDAs. The limited hardware of these devices often force to render the visualization on the server and use image streaming to transmit the final result to the client. For evaluation a camera-equipped handheld device (O^2 Xda Flame) is used to provide video-based real-world context (Figure 4a) and render the visualization as an overlay on top. However, due to restrictions like small screen size visualizations are adapted or even different for the same scenario.

Apart form the presented indoor scenario, further fields of application are possible whenever huge amount of heterogeneous data has to be evaluated. The main advantage of the proposed system is the device independency and the focus on mobile clients to allow operation within the relevant spatial context. An example of a sophisticated mobile geo-mashup visualization is shown in Figure 4b. A multi-resolution height field with 3D buildings and stream ribbons to show the air flow inside the city is rendered remotely and presented on a mobile device.

4.2 Implementation Aspects

As the entire system is based on the underlying open-source scene graph OSG [14], existing basic visualizations and even existing end-user applications can easily be adapted to make use of the presented system. In addition, the scene graph and visualizations utilize hardware accelerated OpenGL and are executed within multiple threads, therefore the server component greatly benefits from multi-core systems with hardware

a) b)

Fig. 4. A mobile application for manufacturing-condition maintenance is shown in a), representative data samples are presented. An advanced geo-mashup scenario is depicted in b) where a 3D height field is combined with a flow visualization technique.

accelerated graphics hardware. Further optimizations of the scene graph—small-feature culling, frustum culling, or state sorting—are automatically applied to visualizations. The network communication is handled via a binary, streaming-capable file format. A transfer of arbitrary scene-graph nodes and sub graphs or entire scenes are supported. As the templates are designed to handle server and client tasks, the same binary visualization code is used on both sides—if the system architectures match—which ensures a consistent visualization. The system can easily be extended with new novel visualizations, which can be instantiated at runtime. Whenever the client receives data for an unavailable template, the server might even transmit the binary plugin that matches client's architecture specified within the context data. This way, client applications can automatically be updated to benefit from new novel visualization techniques to display the heterogeneous data encoded within the transmitted scene graph structure.

5 Conclusion and Future Work

The proposed visualization approach makes use of a context-aware framework to efficiently interpret and analyze heterogeneous context-based data queried from a federated data source. In addition to the hierarchically defined data type the system also considers further context aspects like geo-referenced position, viewing direction, user preferences, client hardware, total amount of data, data entities within the current view, and much more to select and configure visualizations deployed to the clients. The open system thereby generalizes popular geo-mashup systems [5,4] in a way that multiple arbitrary data sources can be displayed via a generic data-visualization system, with respect to arbitrary context aspects, not just a geo-spatial position.

The presented application shows the advantages and the flexibility of the system to support mobile users with different qualification, different aims, and different hardware in inspecting and understanding huge amounts of data. Mobile context-aware presentation of various data enables future applications that support interactive high-quality visualization adequate for the user's current context.

In future work we will consider more context aspects and integrate further visualization methods to show the full potential of the proposed system. The research will

also include presentation techniques that consider the quality of context information and context information at an higher level of abstraction like situation descriptions. Applications are expected that are able to transparently adapt to the users current situation—e.g. in meeting, driving a car, out for lunch, etc.—and react in the most appropriate way.

References

1. Burigat, S., Chittaro, L.: Location-aware visualization of VRML models in GPS-based mobile guides. In: Web3D 2005: Proceedings of the Tenth International Conference on 3D Web Technology, pp. 57–64. ACM Press, New York (2005)
2. Jung, E., Sato, K.: A framework of context-sensitive visualization for user-centered interactive systems. In: Ardissono, L., Brna, P., Mitrović, A. (eds.) UM 2005. LNCS, vol. 3538, pp. 423–427. Springer, Heidelberg (2005)
3. Hohl, F., Kubach, U., Leonhardi, A., Rothermel, K., Schwehm, M.: Next century challenges: Nexus - an open global infrastructure for spatial-aware applications. In: MobiCom 1999: Proceedings of the Fifth Annual ACM/IEEE International Conference on Mobile Computing and Networking, pp. 249–255. ACM Press, New York (1999)
4. Google Inc.: GoogleEarth, http://earth.google.com/ (last access: Feburary 2, 2009)
5. Microsoft: Microsoft VirtualEarth, http://earth.live.com/ (last access: Feburary 2, 2009)
6. Collaborative Research Centre (SFB627): Nexus: Spatial world models for mobile context-aware applications, http://www.nexus.uni-stuttgart.de (last access: Feburary 2, 2009)
7. Mackinlay, J.: Automating the design of graphical presentations of relational information. ACM Transactions on Graphics 5(2), 110–141 (1986)
8. Senay, H., Ignatius, E.: A knowledge-based system for visualization design. IEEE Compututer Graphics and Application 14(6), 36–47 (1994)
9. Gilson, O., Silva, N., Grant, P.W., Chen, M.: From web data to visualization via ontology mapping. Computer Graphics Forum 27(3), 959–966 (2008)
10. Reitmayr, G., Schmalstieg, D.: Flexible parameterization of scene graphs. In: VR 2005: IEEE Virtual Reality Conference, pp. 51–58 (2005)
11. Méndez, E., Kalkofen, D., Schmalstieg, D.: Interactive context-driven visualization tools for augmented reality. In: ISMAR 2006: Proceedings of IEEE/ACM International Symposium on Mixed and Augmented Reality, pp. 209–218 (2006)
12. Shibata, F., Hashimoto, T., Furuno, K., Kimura, A., Tamura, H.: Scalable architecture and content description language for mobile mixed reality systems. In: Pan, Z., Cheok, D.A.D., Haller, M., Lau, R., Saito, H., Liang, R. (eds.) ICAT 2006. LNCS, vol. 4282, pp. 122–131. Springer, Heidelberg (2006)
13. Cheverst, K., Davies, N., Mitchell, K., Friday, A., Efstratiou, C.: Developing a context-aware electronic tourist guide: some issues and experiences. In: CHI 2000: Proceedings of the SIGCHI Conference on Human Factors in Computing Systems, pp. 17–24. ACM, New York (2000)
14. Osfield, R.: Open Scene Graph, http://www.openscenegraph.org (last access: Feburaey 2, 2009)
15. Diepstraten, J.: Interactive visualization methods for mobile device applications. PhD thesis, Universität Stuttgart (2006)
16. Westkämper, E., Jendoubi, L., Eissele, M., Ertl, T., Niemann, J.: Smart factories - intelligent manufacturing environments. Journal of Machine Engineering 5(1-2), 114–122 (2005)
17. Eissele, M., Kreiser, M., Ertl, T.: Context-controlled flow visualization in augmented reality. In: GI 2008: Proceedings of Graphics Interface, pp. 89–96. ACM Press, New York (2008)

The Glass Organ: Musical Instrument Augmentation for Enhanced Transparency

Christian Jacquemin[1], Rami Ajaj[1], Sylvain Le Beux[1],
Christophe d'Alessandro[1], Markus Noisternig[2], Brian F.G. Katz[1],
and Bertrand Planes[3]

[1] LIMSI-CNRS, BP 133, 91400 Orsay, France
[2] IRCAM, 1 pl. I. Stravinsky, 75004 Paris, France
[3] Artist, 41 bis quai de la Loire, 75019 Paris, France

Abstract. The Organ and Augmented Reality (ORA) project has been presented to public audiences at two immersive concerts, with both visual and audio augmentations of an historic church organ. On the visual side, the organ pipes displayed a spectral analysis of the music using visuals inspired by LED-bar VU-meters. On the audio side, the audience was immersed in a periphonic sound field, acoustically placing listeners inside the instrument. The architecture of the graphical side of the installation is made of acoustic analysis and calibration, mapping from sound levels to animation, visual calibration, real-time multi-layer graphical composition and animation. It opens new perspectives to musical instrument augmentation where the purpose is to make the instrument more legible while offering the audience enhanced artistic content.

Keywords: Augmented musical instrument, Augmented reality, Sound to graphics mapping, Real-time visualization.

1 Introduction

Augmented musical instruments are traditional instruments modified by adding controls and mono- or cross-modal outputs (e.g. animated graphics) [1,2]. Augmentation generally results in a more complex instrument (on the player's side) and a more complex spectacle (on the spectator's side). The increased functionality and controllability of the instrument might eventually distort the perceived link between the performer's gestures and the produced music and graphics. The augmentation might confuse the audience because of its lack of transparency. In contrast, the increased functionality could enhance the perceived link.

We agree on the interest of musical instrument augmentation that extends a traditional instrument, preserves and enriches its performance and composition practices. This article focuses on a rarely stressed use of augmentation that increases the comprehension and the legibility of the instrument instead of increasing its complexity and its opacity. Our research on output augmentation follows the work on ReacTable [3], an augmented input for the control of electronic musical instruments. The ReacTable is a legible, graspable, and tangible

A. Butz et al. (Eds.): SG 2009, LNCS 5531, pp. 179–190, 2009.

control interface, which facilitates the use of an electronic instrument so as to be accessible to novices. Its professional use confirms that transparency does not entail boredom and is compatible with long term use of the instrument.

This paper presents the principles and implementation of the Glass Organ, the augmentation of an historical church organ to enhance the understanding and perception of the instrument through intuitive and familiar mappings and outputs. It relies on the following main features:

- the visual augmentation is directly projected on the facade of the instrument (and not on peripheral screens),
- the visual augmentation is aligned in time and space: the visual rendering is cross-modally synchronized with an audio capture and the graphical projection is accurately aligned with the organ geometry,
- the augmentation does not affect the musician's play. It can adapt to traditional compositions and deserves the creation of new artworks,
- the augmentation is designed to gain a better understanding of the instrument's principle by visualizing hidden data such as spectral sound analysis and the spatial information distribution within the large instrument.

The aim of the Organ and Augmented Reality (ORA) project was to visually and acoustically augment the grand organ at Ste Elisabeth church in Paris. This project was funded by the city of Paris program for popular science "Science sur Seine". The aim was to explain in general sound and sound in space, with specifics relating to the context of live performances. Concert were accompanied by a series of scientific posters explaining the background and technical aspects of the project. This project involved researchers in live computer graphics and computer music, a digital visual artist, an organ player and composer, and technicians.[1] ORA has been presented to public audiences through two immersive concerts, with both visual and audio augmentation. On the visual part, the organ pipes displayed a visual spectral analysis of the music, inspired by LED-bar VU-meters. On the audio side, the audience was immersed in a periphonic sound field, acoustically placing listeners inside the instrument. This article focusses on visual augmentation, the audio side is more detailed in [4].

2 Visual Augmentation of Instruments

The augmentation of a musical instrument can either concern the interface (the capture of the performer's gestures, postures, and actions), the output (the music, the sound, or non-audio rendering) or the intermediate layer that relates the incoming stimuli with the output signals (the mapping layer). Since our approach minimizes the modification of the instrument's playing techniques, we

[1] In addition to the authors, participants included Nathalie Delprat, Lorenzo Picinali, and Nicolas Sturmel. Videos of the event can be found on http://www.youtube.com/watch?gl=FR&hl=fr&v=JlYVUtJsQRk or from the project site http://vida.limsi.fr/index.php/Orgue_Augmentee

Fig. 1. ORA Concerts, May 15th and 17th, 2008

focus on the augmentation of the mapping and output layers that can be used to enhance composition, performance, or experience.

On the composer's side, Sonofusion [2] is a programing environment and a physically-augmented violin that can be used for performing multimedia compositions. Such compositions are "written" through programing, and are controlled in real-time by the performer through the additional knobs, sliders, and joystick. Whereas this work interestingly addresses the question of multi- and cross-modal composition and performance, it results in a quite complex control system. The variety of control devices yields a multiplicity of possible mappings; therefore, the correlation between the performer's gesture and his multimedia performance might seem arbitrary to the audience at times. Musikalscope [5], a cross-modal digital instrument, is designed with a similar purpose, and is criticized by some users for the lack of transparency between its visual output and the user's input.

On the audience side, the Synesthetic Music Experience Communicator [6] (SMEC) focuses on synesthetic cross-modal compositions that attempt to reproduce some of the visual illusions experienced by synesthetes. When compared with Sonofusion, SMEC has a better motivation for the graphic renderings because they are based on reports of visual illusions by synesthetes. This work however raises the question whether we can display and share deeply personal and intimate perceptions. Is it by displaying visual illusions that we are most likely to enhance the spectators' experience?

Visual augmentation can also address the human voice. Messa di Vocce [7] analyzes the human voice in real-time in order to generate a visual representation and interface used to control audio processing algorithms. The autonomous behavior of the graphical augmentation of voice almost creates an alter ego of the performer. Such an augmentation is less arbitrary than the preceding examples, because it is governed by an "intelligent" program. Within these environments,

the spectators are however immersed by a complex story which they would not normally expect when attending a musical event.

3 Artistic Design

Visual Design. The visual artwork was designed to transform the instrument so that it would appear both as classical and contemporary, and so that visual augmentation would contrast with the baroque architecture of the instrument. Church organs are generally located high on the rear wall of the building. The audience faces the altar and listens to the music without seeing the instrument. Even if one looks at the organ, it is rare to see the actual organist playing, resulting in a very static visual performance experience. During the ORA concerts the seating was reversed, with the audience facing towards the organ at the gallery.

The acoustics of the church is an integral part of the organ's sound as perceived by the listeners. Through the use of close microphone capture, rapid signal processing, and a multichannel reproduction system, the audience is virtually placed inside the "organ" acoustic providing a unique sound experience. To outline the digital transformation of the organ music, VU-meters are projected on the visible pipes, making a reference to many audio amplifiers. These VU-meters dynamically follow the music and build a subtle visual landscape that has been reported as "hypnotic" by some members of the audience. The static and monumental instrument becomes fluid, mobile, and transparent.

Sound Effects & Spatial Audio Rendering. The organ is one of the oldest musical instruments in Western musical tradition. It provides a large pitch range, high dynamics, and can produce a great richness of different timbres; hence, it is able to imitate orchestral voices. Due to the complexity of pipe organ instruments, advances in organ building have been closely connected to the application of new technologies. In the twentieth century electronics have been applied to the organ (a) to control the key and stop mechanism of the pipes – the action is electro-pneumatic – and (b) to set the registration, *i.e.* the combination of pipe ranks. However, very little has been achieved so far for modifying the organ's sound itself. The ORA project directly processes the captured pipe organ sound in real-time using a multitude of digital audio effects and renders it via loudspeakers surrounding the audience. Therefore, the sound perceived by the listener is a common product of the pipe organ's natural sound, the processed sound, and the room acoustics. Spatial audio rendering is capable of placing inner sounds of the organ in the outer space, interacting differently with the natural room acoustic, which adds a new musical dimension.

Augmented Organ. Miranda and Wanderley [8] refer to augmented instruments[2] as *"the original instrument maintaining all its default features in the sense that it continues to make the same sounds it would normally make, but with the addition of extra features that may tremendously increase its functionality"*. With

[2] In scientific articles augmented instruments are often called hybrid instruments, hyperinstruments, or extended instruments.

this in mind, the ORA project aims to enrich the natural sound of pipe organs through real-time audio signal processing and multi-channel sound reinforcement, to meet the requirements of contemporary and experimental music.

Audio signal processing algorithms require the capture of the direct sound of the instrument. To minimize the effects of the room acoustics, multiple microphones have been placed inside the organ's case (section 4.1). The algorithms consider that separate divisions of the organ have different tonal properties (timbre, dynamics, and pitch range) and often contrast other divisions. The microphone signals are digitally converted via multi-channel audio cards with low-latency drivers; the real-time audio processing is implemented in Pure Data [9]. Selected algorithms include ring modulation, harmonizer, phaser, and granular synthesis. Audio rendering used an 8-channel full-bandwidth speaker configuration along the perimeter of the audience area with the addition of a high-powered subwoofer at the front of the church, at the location opposite from the organ.

In recent years, a variety of multi-channel spatial audio systems have been developed, e.g. quadrophony, vector base amplitude panning (VBAP), wave field synthesis, and Ambisonics. The proposed environment uses third-order Ambisonics for 2D sound projection in space. Ambisonics was invented by Gerzon [10]. While the room acoustic provides reverberation, essential to the sound of the church organ, the presence of early reflections and late reverberation (inherent to the acoustics of churches) deteriorates sound localization accuracy. Different weighting functions, as described in [11], have been applied before decoding to widen or narrow the directional response pattern. However, the sound design mainly deals with the reduced localization accuracy by focussing on non-focused sounds and spatial granular synthesis.

Musical Program. The event was designed as an organ concert, with a bit of *strangeness* added by a lively animation of the organ facade and live electronics transformations of the organ sound. The musical program followed the path of a "classical" program mixed with somewhat unusual digital augmentation. Pieces of the great classical organ repertoire (Bach, Couperin Franck, Messiaen) were alternated with a piece in 12 parts especially written by C. d'Alessandro for the event (exploiting the various musical possibilities offered by the sound capture, transformation, and diffusion system).

4 Architecture and Implementation

4.1 The Instrument

The instrument used for these performance is a large nineteen-century organ (listed as historical monument), with three manual keyboards (54 keys), a pedal board (30 keys), 41 stops, with mechanical action. It contains approximately 2500 pipes, of which only 141 are visible in the organ facade. The organ case is inscribed in a square of about 10x10 m. Pipes are organized in 4 main divisions: the "positif", a small case on the floor of the organ loft, corresponding to the first manual keyboard; the "grand orgue" and "pédale" divisions at the main

level, corresponding to the second manual keyboard and to the pedal board; and the "récit" division, a case of about the same size as the "positif", crowning the instrument, and corresponding to the third manual keyboard. The "récit" is enclosed in a swell-box.

Five microphones were placed in the instrument divisions according to figure 2 left. These divisions are relatively separate and somewhat sound isolated, so that the near-field sound captured in one region was significantly louder than that received from other regions. Therefore each region could be considered as acoustically "isolated" for sound effects purposes.

4.2 Architecture

Preliminary tests of video projection on the organ pipes showed that the pipes, despite their gray color and their specular reflections, were an appropriate surface for video-projection. The visual graphic ornamentation of the organ was using 3 video-projectors: 2 for the upper part of the instrument and 1 for the lower part (see figure 2 left). This figure also shows the rough locations where the microphones were placed to capture the direct sound of the instrument.

The sound captured inside the instrument was routed to a digital signal processing unit. Within this stage the captured sounds are processed and diffused back into the church as described in section 3. Traditional and contemporary organ music and improvisations were presented during the concerts. Classical organ music was spatialized and the reverberation time of the church was altered, resulting in the organ sound becoming independent from the organ location and the room sounding much larger than the actual Ste Elisabeth church. During the improvisation parts, the captured sounds were transformed and distorted applying real-time signal processing algorithms. As explained in section 4.4, sound spectral analysis and sampling were used to compute the levels of the projected virtual VU-meters. These values were sent to the 3D renderer, and used as parameters of the vertex programs to animate the textures projected on the pipes

Fig. 2. Architecture of the installation: sound capture and video-projection

and give the illusion of LED-bars. The right part of figure 2 shows the location of the video-projectors and the main data connections.

4.3 Graphic Rendering

Graphic rendering relies on Virtual Choreographer (VirChor)[3], a 3D graphic engine offering communication facilities with audio applications. The implementation of graphic rendering in VirChor involved the development of a calibration procedure and dedicated shaders for blending, masking, and animation. The architecture is divided into three layers: initial calibration, real-time compositing, and animation.

Calibration. The VU-meters are rendered graphically as quads that are covered by two samples of the same texture (white and colored LED-bars), depending on the desired rendering style. These quads must be registered spatially with the organ pipes. Due to the complexity of the instrument and its immobility, registration of the quads with the pipes was performed manually. Before the concert began, a still image digital photograph of the projection of a white image was taken with a camera placed on each video projector, near the projection lens. Each photo was loaded as a background image in Inkscape[4] and as many quads as visible pipes were manually aligned with the pipes in the editor. The amount of effort for this work was only significant the first time. Successive registrations (for each re-installation) amounted mostly to a slight translation of the previous ones, since attempts were made to locate the video-projectors in similar positions for each concert. The resulting SVG vector image was then converted into an XML scene graph and loaded into VirChor.

During a concert, the VU-meter levels are received from the audio analysis component (section 4.4) and are transmitted to the GPU which in turn handles the VU-meter rendering. GPU programming has offered us a flexible and concise framework for layer compositing and masking through multi-texture fragment shaders, and for interactive animation of the VU-meters through vertex shader parameterization. Moreover, the use of one quad for VU-meter per visual pipe handeled by shaders has facilitated the calibration process. Frame rate for graphic rendering was above 70 FPS and no lag could be noticed between the perceived sound and the rendered graphics.

Compositing. The graphical rendering is made of 4 layers: (1) the background, (2) the VU-meters, (3) the masks, and (4) the keystone (see left part of figure 3). The VU-meter layer is a multi-textured quad, and the background and mask layers are quads parallel to the projection plane that fill the entire display. Real-time compositing, homography, and control of background color are made through fragment shaders applied on these layers. The keystone layer (4) is a quad textured by the image generated by layers (1) to (3). The keystone layer is not necessarily parallel to the projection plane. The modification of the quad orientation is equivalent to applying a homography to the final image. This

[3] http://virchor.sf.net
[4] Inkscape is a vector graphic editor: http://www.inkscape.org

transformation enables slight adjustments in order to align the numerical rendering with the organ and compensate for any inaccuracies in the calibration phase. This transformation could be automatically computed from views of a calibration pattern [12]. Elaborate testing has shown that the background, VU-meter, and mask layers were perfectly registered with the physical organ, and thus made the keystone layer unnecessary. The mask layer is used to avoid any projection of the VU-meters onto the wooden parts of the organ, and to apply specific renderings through the background layer seen by transparency.

Animation. The VU-meter layer is made of previously calibrated quads exactly registered with all the visible pipes of the organ. The texture for VU-meter display is made of horizontal colored stripes on a transparent background (42 stripes for each pipe of the Grand Orgue and Récit and 32 stripes for each pipe of the Positif). The purpose of the animation is to mimic real LED-bar VU-meters that are controlled by the energy of their associated spectral band (see next section). The VU-meter levels received from the sound analysis and mapping components are sampled to activate or deactivate the bars. The level sampling performed in the vertex shader and applied to each quad was based on a list of *sampling values*. Considering that the height of a VU-meter texture is between 0 and 1, a sampling value is the height of a transparent interval between two stripes that represent 2 bars. A texture for 42 LED-bars has 43 sampling values. The sampling values are then transmitted to the fragment shader that only displays the bars below the sampled instantaneous value and the bar associated with the sampled maximal value. The resulting perception by the audience is that LED-bars are activated and deactivated.

Each virtual VU-meter receives the instantaneous value and the maximum value for the past 500ms (typical peak-hold function). They are sampled into 3 values by the vertex shader: the instantaneous sampled value, and the sampled values below and above the maximal value. These samples are sent to the fragment shader that displays the texture between 0 and the first sampled value and between the second and third sampled values (see right part of figure 3).

Fig. 3. Multi-layer composition and VU-meter animation through sampling

Fig. 4. Spectral sound analysis

4.4 Analysis and Mapping

This section describes the real-time audio analysis and mapping for VU-meter visualization. Most of the approximately 2500 organ pipes are covered by organ case, while only the 141 of the facade are visible to the audience. As such, a direct mapping of frequency played to visual pipe is not relevant, due to the large number of hidden pipes. In the context of ORA, the main purpose of the correspondence between audio data and graphical visualization was:

1. to metaphorically display the energy levels of the lowest spectral bands on the largest pipes (resp. display the highest bands on the smallest pipes)[5],
2. to maintain the spatial distribution of the played pipes by separating the projected spectral bands in zones, corresponding to the microphone capture regions and thereby retaining the notion of played pipe location,
3. to visualize the energy of each spectral band in the shape of a classical audio VU-meter (as in many audio hardware amplifiers and equalizers). The display was based on the instantaneous value of the energy and its last maximal value with a slower refreshing rate.

Analysis. In order to estimate the mapping of sound level values to VU-meter projection, pre-recordings have been analyzed (figure 4). This analysis allowed us to roughly estimate the overall range of the various sections and to cut these spectral ranges into different frequency bands, according to the evolution of the harmonic amplitudes over frequency. The analysis resulted in a maximum spectral range of 16 kHz for the Positif and Récit sections of the organ, and 12 kHz and 10 kHz for the central and lateral parts of the Grand Orgue.

Each spectral band is further divided into subbands corresponding to the number of visually augmented pipes, *i.e.* 33 for Positif and Récit, 20 for the lateral and 35 for the central Grand Orgue. The subbands were not equally distributed over frequency range (warping) in order to gain a better energy balance between low and high frequencies. For re-calibration the energy of the lowest subband (the largest pipe) was used as reference signal.

Mapping. The real-time spectral analysis consists of three stages: estimation of the power spectral density for each subband, mapping, and broadcasting over IP. The concert mapping process is described on figure 5.

[5] Since only few pipes are visible, the exact note of a pipe was not necessarily falling into the frequency band displayed on its surface.

Fig. 5. Mapping between sound analysis and graphics

Power spectral density (PSD). The PSD is estimated via periodograms as proposed by Welch [13]. The buffered and windowed input signal is Fourier transformed (Fast Fourier Transform, FFT) and averaged over consecutive frames. Assuming ergodicity the time average gives a good estimation of the PSD. One has to note, that through long term averaging the estimated subband levels are not sensitive to short peaks, they represent the root mean square (RMS) value. The decay of the recursive averaging has been set such that the VU-meter values changed smoothly for visual representation. The actual averaging was such that every incoming frame was added to the last three buffered frames.

Frequency band division. These periodograms are then transmitted as five 512 point spectra in order to correct the spectral tilt. The second part of the processing performs the division of the Welch periodograms into 141 frequency bands. Since the number of visible pipes in each section of the organ was inferior to 512 (resp. 33, 20, 35, 20, and 33) an additional averaging must be made in order to map the whole frequency range to the pipes of the organ. According to the spectral tilt, lower frequency bands (app. below 1.5 kHz) had more energy, thus only 3 frequency bands were added for the biggest pipes, whereas up to 30-40 bands were added for the highest frequency range (app. above 8 kHz).

Calibration. The third and most critical part is the calibration of the VU-meter activations through a scaling of the frequency band dynamics to values ranging from 0 to 1. The null value corresponds to an empty VU-meter (no sound energy in this frequency band), and 1 to a full VU-meter (maximum overall amplitude for this frequency band). To calibrate the output, so that 0 would correspond to no sound, we applied the pre-calculated decibel shifts computed from frequency band analysis of the initial recordings. The 1 value corresponds approximately to a 30 dB amplitude dynamic in each frequency band. After the shift, a division by 30 is made so that every VU-meter would vary from the lowest to the highest position on the associated organ pipe during the concert. This method raised the following difficulties:

1. for each session, the microphones were located in a position slightly different from the preceding one, thus slightly changing the various amplitude levels due to the close proximity to different pipes,

2. the mixing desk dealt with both audio effects and mapping, and due to the slight presence of feedback between microphones and loudspeakers, maximum levels were configurated according to the 3D audio composition part for every concert. This turned out to change the offsets of the VU-meter calibration for each concert,

3. the dynamics of the pipes depended on the loudness of the concert pieces. These variations resulted either in a saturation or in a lack of reaction of the corresponding VU-meters,

4. the electric bellows system for pressurized air supply for the organ generated a low-frequency noise,

5. even though the microphones were inside the organ, there was some interference between the sound of the instrument and the sounds inside the church (audience applause and loudspeakers). Some of the spectators noticed the action of their hand claps on the visualization, eventually using this unintended mapping to transform the instrument into an applause meter.

To cope with these problems, before the beginning of the concert, approximately half an hour was devoted to the manual correction of the different shifts for each pipe, with the air pressurizer switched on. In order to deal with the variations of dynamics between the concert pieces, we decided to monitor the dynamics of each organ section with a slider. Last, the applause effects were cancelled through a downward shift of all the section sliders after each piece.

Broadcast. The third and last part of the process was the concatenation of all frequency band values into a list. Values were scaled between 0 and 1 and doubled, in order to give the spectator the impression of a real VU-meter with an instantaneous value and a peak-hold maximum value. Hence two lists of 141 values were sent to the visual module through ethernet (current frequency bands amplitudes and corresponding last maxima).

5 Perspectives

Technically, the geometrical and musical calibrations could be improved and automatized. By equipping the instrument with fiducials, the quads could be automatically re-aligned with the organ pipes if the video-projectors are slightly displaced. On the mapping side, the background noise detection could be improved by automatically detecting the decibel amplitudes of the different frequency bands and calibrating the lowest values of the VU-meters. Automatic individual maximum detection would allow for amplitude calibration so that the VU-meters take the full range of graphical animation during the whole concert.

The ORA project has shown that the audience is receptive to a new mode of instrument augmentation that does not burden the artistic expression with additional complexity, but instead subtly reveals hidden data, and makes the performance both more appealing and more understandable. This work could be extended in several directions. First, graphical ornamentation could be applied to smaller and non-static musical instruments by tracking their spatial location.

Second, graphical visualization could concern other physical data such as air pressure, keystrokes, or valve closings and openings that would require more sensors in the instrument than just microphones. Visualization could also concern the fine capture of ambient sounds such as audience noise, acoustic reflections, or even external sound sources such as street noise.

References

1. Bouillot, N., Wozniewski, M., Settel, Z., Cooperstock, J.R.: A mobile wireless augmented guitar. In: NIME 2007: Proc. of the 7th international conference on New interfaces for musical expression, Genova, Italy (June 2007)
2. Thompson, J., Overholt, D.: Sonofusion: Development of a multimedia composition for the overtone violin. In: Proc. of the ICMC 2007 International Computer Music Conference, Copenhagen, Denmark, vol. 2 (August 2007)
3. Jordà, S., Geiger, G., Alonso, M., Kaltenbrunner, M.: The reactable: exploring the synergy between live music performance and tabletop tangible interfaces. In: TEI 2007: Proc. of the 1st international conference on Tangible and embedded interaction, pp. 139–146. ACM Press, New York (2007)
4. d'Alessandro, C., Noisternig, M., Le Beux, S., Katz, B., Picinali, L., Jacquemin, C., Ajaj, R., Planes, B., Strurmel, N., Delprat, N.: The ORA project: Audio-visual live electronics and the pipe organ. In: ICMC 2009 (submitted, 2009)
5. Fels, S., Nishimoto, K., Mase, K.: Musikalscope: A graphical musical instrument. IEEE MultiMedia 5, 26–35 (1998)
6. Lewis Charles Hill, I.: Synesthetic Music Experience Communicator. PhD thesis, Iowa State University, Ames, IA, USA (2006)
7. Levin, G., Lieberman, Z.: In-situ speech visualization in real-time interactive installation and performance. In: NPAR 2004: Proc. of the 3rd international symposium on Non-photorealistic animation and rendering, pp. 7–14. ACM Press, New York (2004)
8. Miranda, E.R., Wanderley, M.: New Digital Musical Instruments: Control And Interaction Beyond the Keyboard. Computer Music and Digital Audio Series. A-R Editions, Inc., Madison (2006)
9. Puckette, M.S.: Pure data: Another integrated computer music environment. In: Proc. International Computer Music Conference, pp. 37–41 (1996)
10. Gerzon, M.A.: Periphony: With-height sound reproduction. J. Audio Eng. Soc. 21(1), 2–10 (1973)
11. Noisternig, M., Sontacchi, A., Musil, T., Höldrich, R.: A 3D ambisonic based binaural sound reproduction system. In: Proc. AES 24th International Conference, Banff, Canada (2003)
12. Raskar, R., Beardsley, P.: A self-correcting projector. In: Proc. of the 2001 IEEE Computer Society Conference on Computer Vision and Pattern Recognition (CVPR 2001), Kauai, HI, USA, pp. 504–508. IEEE Computer Society, Los Alamitos (2001)
13. Welch, P.: The use of fast fourier transform for the estimation of power spectra: A method based on time averaging over short, modified periodograms. IEEE Trans. Audio Electroacoust AU-15, 70–73 (1967)

Part-VI
Short Presentations

A Rendering Method for 3D Origami Models Using Face Overlapping Relations

Yohsuke Furuta, Jun Mitani, and Yukio Fukui

Graduate School of Systems and Information Engineering, University of Tsukuba,
1-1-1 Tennodai, Tsukuba, Ibaraki, 305-8573, Japan
furuta@npal.cs.tsukuba.ac.jp,
{mitani,fukui}@cs.tsukuba.ac.jp

Abstract. When we construct a model of origami (a model of a folded sheet of paper) in a computer, it is usual to represent the model as a set of polygons having zero thickness. One of the typical characteristics of origami is that there are many instances where multiple faces are located on a same plane. In these cases, the usual z-buffer rendering method fails as multiple faces have the same depth. Furthermore, many penetrations between faces located close to each other frequently occur when the origami is folded almost flat. However, it is difficult to remove all such penetrations with moving or fixing the geometry of the model. In this paper, we propose a new rendering method that solves these problems one at a time by using the OR matrix. This is a matrix constructed from a crease pattern, and it represents the overlapping relation between every two faces.

Keywords: computer graphics, rendering, origami.

1 Introduction

Origami is an ancient Japanese tradition that is both a play activity and an art form involving the folding of a square sheet of paper. These days, origami is becoming popular all over the world. To describe the folding process or to show the folded shape of an origami, diagrams drawn by hand have been used for long time. If we could use three dimensional computer graphics (3DCG) instead of diagrams, it would help users to understand the shape of an origami more accurately, because they would be able to see the model from arbitrary angles. Hence we have developed a system that constructs a model of an origami in a computer and displays the model on a screen[1]. In this system, the origami model is represented as a set of polygons having zero thickness, as is commonly the case for 3DCG systems. One of the characteristics of origami is that there are many instances for which multiple faces are located on a same plane (or on very near planes). In these cases, multiple faces have the same depth (or almost the same depth). This causes problems, in that the usual z-buffer rendering method fails to render the model correctly. The reasons for this problem are:

A. Butz et al. (Eds.): SG 2009, LNCS 5531, pp. 193–202, 2009.

(1) Most origami pieces are folded flat (we call them "flat Origami"). Even though the completed shape is not flat, there are parts where multiple faces are located on a almost same plane. In these origami models, multiple faces have the almost same depth in the z-buffer (Fig.1).

(2) Some origami models such as a Twist Fold (Fig.2) have a circle or multiple circles in the overlapping order of faces. For example, the face (A) is on (B), (B) is on (C), (C) is on (D), and (D) is on (A) in the folded shape in Figure 2. In this case, we cannot say which face is located lowest or uppermost.

Although problem (1) can be solved by using the painter's algorithm (also known as a priority fill) which draws faces in the order of face overlapping order or by adding an appropriate offset to each face according to the overlapping order, these methods cannot solve problem (2), namely that which face is located uppermost is not defined. The problems we mentioned above exist in origami pieces that are folded flat.

In the meantime, as the complete flat shape of an origami hardly looks solid and it is difficult for users to understand the configuration (Fig.3(a)), it is desirable to modify the model to have solidity by unfolding it a little (open its edge angles a little) as shown in Fig.3(b). We call origami in this state of being almost (but not completely) flat as "nearly flat origami" hereinafter. Although the shape of nearly flat origami is helpful in understanding the corresponding configuration, many penetrations between faces commonly appear when the geometry of the flat origami model is modified (Fig.3(c)).

Fig. 1. An example of origami pieces, 'Crane'. As multiple faces are located on a same plane, the z-buffer method fails.

Fig. 2. The crease pattern and folded shape of a 'Twist fold'

Fig. 3. (a) Flat origami. (b) Nearly flat origami. (c) Nearly flat origami with penetrations between faces.

To avoid this problem, we have to fix the geometry of the model by determining all penetrations and moving vertices correctly. This, however, becomes difficult when many faces are located very closely in a small area as is often seen in origami models. In this paper, we propose a new rendering method that solves the problems mentioned above. With our method, a flat origami model, which has a circle or multiple circles in the face overlapping order can be rendered correctly and an origami model which has many penetrations between faces can be rendered as if the penetrations are removed without modifying the geometry. The proposed method uses a matrix to represent the relative overlapping relation between every pair of faces (we call the matrix the "OR matrix" hereinafter) and the face ID buffer, which is a 2 dimensional array for storing face IDs which are located uppermost at each pixel. The OR matrix can be obtained from ORIPA[2], which is an application designed for building an origami model from its crease pattern (we introduce ORIPA in the next section). The face ID buffer has the same size as the frame buffer we use for rendering.

2 Related Work

Recently we can find many studies about origami. In 2006, 4OSME (The Fourth International Conference on Origami in Science, Mathematics, and Education) was held in Pasadena. As the name of the conference indicates, an origami is a topic of science, mathematics, and education today. Nowadays, it is not unusual to use a computer for studying origami.

Miyazaki et al. developed a system with which a user can fold a virtual origami on a PC with a simple mouse interface [3]. The system keeps information about the face overlap order during operation and renders the origami model using Painter's algorithm, referring to the face overlap order. Although this system works well for some simple origami, the shape that this system can fold is limited and a model that has circles in the face overlap order cannot be dealt with. Tachi developed a system "Rigid Origami Simulator" [4] that simulates the movement of folding an origami assuming that it is consists of a set of rigid polygons connected by hinges. As this system uses polygons and renders the model using the

(a) (b)

Fig. 4. (a) Main window of ORIPA with the crease pattern of Crane. (b) The image of the folded shape generated by ORIPA.

(a) (b) (c)

Fig. 5. (a) A simple crease pattern. (b) Side view of the folded one. (c) The OR matrix.

standard z-buffer method, flat origami cannot be rendered correctly. FOLIO[1] is a system that makes use of the concept in Miyazaki's system. As FOLIO uses a spring-mass model for representing the origami shape, the polygons slightly change shape during operations. By allowing slight deformations, an intuitive interface is realized and a user can easily build a complicated model. Our system uses the same interface as FOLIO for modifying an origami shape, as is mentioned in Section 3. As FOLIO also uses the standard z-buffer method for rendering, the image of the origami in which multiple faces are located on a same plane is incorrect as is shown in Fig.1. We also describe about the interface of the system in Section 3.1.

ORIPA is a dedicated editor for inputting origami crease patterns that was developed by Mitani[2] (Fig.4). ORIPA has a feature that judges whether the input crease pattern can be folded into a flat pattern. When the crease pattern can be folded into a flat pattern, ORIPA calculates the folded shape and exports the data. As our method uses the data exported by ORIPA, we will describe the details of the data here. The data output by ORIPA contains 2 dimensional coordinates, x and y, of vertices of a folded origami model. And it also contains a 2 dimensional matrix that represents the overlap relation between every pair of faces. When the number of faces of an origami model is N, the size of the matrix is $N \times N$. The element m_{ij} takes one of the 3 states as shown in Fig.5. ORIPA also has a renderer to get an origami shape [5] (Fig.4(b)). But the method is applied only to flat origami; our method can treat non-flat origami. By the way,

the algorithm that applies gradations in the faces is used in our system (in Section 3.3).

For example, the OR matrix of the Fig.5(a) (folded in three layers) becomes Fig.5(c). Our method refers to this OR matrix to determine the overlap relation between two faces. Although ORIPA itself has a feature to render the folded shapes of the origami, it targets only flat origami. Our method targets not only rendering the flat origami but also rendering nearly flat origami and non-flat origami in a single system.

3 Method

The flow of our system is as follows:

(1) A user inputs crease pattern of target origami on ORIPA.
(2) System obtains the data of the folded origami which contains the coordinates of vertices and the OR matrix from ORIPA.
(3) Based on the OR matrix and the position of the user's viewpoint, the system stores the ID of the face which can be seen from the viewpoint into each pixel of the face ID buffer using the scanline algorithm.
(4) Render the origami model to the frame buffer based on the values stored in the face ID buffer.
(5) As the need arises, the user changes the view angle or changes the shape of the origami by rotating faces around the user specified edge, Then the system updates the rendering window by taking steps from 3.

In the following subsections, we describe the details of our method.

3.1 Constructing an Origami Model

To construct an origami model as a set of polygons, we use ORIPA. Firstly, a user input results in the crease pattern on ORIPA as shown in Fig.4(a). As we introduced in Section 2, ORIPA has a feature to calculate the folded shape of flat origami from the crease pattern. We can obtain the following data from ORIPA.

- X and Y coordinates of vertices composing polygons of folded origami shape. As we are assuming that the folded model is flat, coordinates are in 2D.
- The OR matrix that represents the overlap relations between every pair of faces.

If necessary, the user can change the shape of origami by using a mouse. We implemented the user interface in the same way as FOLIO. Firstly, the user specifies an edge as a rotational axis. Then a face rotates around the edge by a user's dragging operation (Fig.6). The associated faces also move at the same time because neighboring vertices are connected by virtual springs. However, some penetrations may occur after the operation because we do not check collisions between faces.

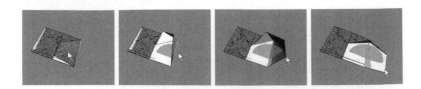

Fig. 6. User interface of modeling by our system

3.2 Render to the Face ID Buffer

During the user operation, we render the model to the face ID buffer referring to the OR matrix. Firstly, we project each polygon of the origami model to the face ID buffer and scan the pixels inside the polygon using the standard scanline algorithm. If a value of the scanlined pixel is empty, the ID of the scanlined face (assume the ID is i) is stored at the pixel of the buffer. If a value (assume j) is already stored at the pixel, the m_{ij}th element of the OR matrix is referred. Then the ID ($= i$) is stored only if the value is "U"(Upper), which means that the face F_i is located upper than F_j. (When the view position is located at the backside of the origami, in other words, the origami piece is viewed from the backside, the operation mentioned above is inverted.)

3.3 Render to the Frame Buffer

After adopting the operation described in the previous subsection, the face ID that should be displayed at each pixel of the frame buffer is stored in the face ID buffer. According to the face ID, we calculate the color considering the color of the face and the direction of the normal. Then we assign colors to each pixel of the frame buffer. To add shade, we multiply the pseudo brightness B' of each vertex of the polygonal faces. The value of B' is set using the following equation proposed by [5],

$$B' = (1 - w_b) + \frac{M - V + 2}{4} w_b \tag{1}$$

M and V are the number of mountains and valleys, respectively, of folded lines connected to the vertex on the contour of a face. This equation is based on a generally experienced rule; the vicinity of the valley folded lines becomes dark because little light reaches the area; on the other hand, the vicinity of the mountain folded lines becomes bright. Since the values $M - V$ of the inner vertex can take the values -2 or 2 [6], the value of B' becomes $1 - w_b$ or 1. The w_b is the weight of the parameter, and is set equal to 0.4 in our system. The color of each pixel in a face is calculated by linearly interpolating the value of vertices along the contour.

The method described until now does not use depth values (z values) of faces but refers to the overlapping relation between two faces of origami models. Hence even if a face placed below penetrates a face placed above, the penetration does not affect the rendering results as shown in Fig.7. On the other hand, we have to

(a) (b) (c)

Fig. 7. (a) Rendered with standard z-buffer method. (b) Rendered by referring OR matrix. (c) Rendered with edges.

take care when drawing contours of polygons onto the frame buffer. We cannot use the depth value and it becomes invalid to draw with polygonal lines by connecting contour vertices when a part of a line should be hidden by other faces. So we extract boundary lines from the face ID buffer using the Roberts filter. The extracted edges on the face ID buffer are translated to the frame buffer. Fig.7 shows the example of the result.

3.4 Utilizing Both the OR Matrix and the Depth Values of Faces

In the previous section, we described a method that renders origami models with reference to the OR matrix, but not using the depth values of faces. This is based on the assumption that the model is flat or nearly flat origami. This approach does not work well for non-flat origami or an origami which contains both flat and non-flat states.

Hence we utilize both the OR matrix and the depth values of faces so that the system can render both states appropriately. To enable this, we allocate a z-buffer that stores the depth values of each pixel, the same as in the standard z-buffer method. When the system renders a polygon, the depth value is stored using the scanline algorithm. When the depth of the face is smaller than the already stored value, the stored value is updated with the smaller value and the face ID buffer is also updated with the face ID at the same time. At that time, if the z value is close to the stored value, it means that the face already exists is located close to the new face. In this case, we do not use the z buffer but refer to the OR matrix to update the face ID buffer. Finally, the frame buffer is rendered using the face ID buffer. The threshold of difference of depth between the two faces for deciding which shall be referred to between the depth value or the OR matrix was set to about 3% of the size of a sheet of origami, which was decided, based on our heuristic.

4 Result

We implemented the three rendering methods, the z-buffer method that was implemented in software (referred to hereinafter as the "Z-method"), a method that refers to the OR matrix without using the z-buffer as described in subsection 3.1, 3.2, and 3.3 (referred to hereinafter as the "OR-method"), and the combination of both methods as described in subsection 3.4 (referred to hereinafter as the

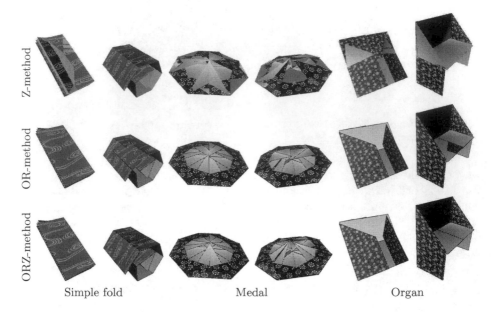

Fig. 8. Results of the methods. Tops are results with Z-method, the middles are with OR-method. The bottoms are with ORZ-method.

"ORZ-method") using Java. We evaluated these methods on a PC (CPU: Intel Dual-Core Xeon 2.66 GHz × 2, RAM: DDR-2 FB-DIMM 9GB, GPU: NVIDIA GeForce 7300 GT). The size of buffer we used was 2048 × 1536 pixels, and the z-buffer had 32 bit depth. Fig.8 shows the results of the rendered origami pieces using 3 different methods; the Z-method, the OR-method, and the ORZ-method respectively. We used 3 models (Simple fold, Medal, and Organ) and 2 states (nearly flat, and non-flat) for evaluation.

We can see the Z-method failed to render the nearly flat origami with a lot of noise (it is the motivation of our study) in Fig.8. On the other hand, the results using the OR-method are fine. Penetrations of nearly flat status of the Simple fold shown in the result of the Z-method are eliminated, and the result looks natural. However, the results of the non-flat origami are incorrect. The backside faces that should not be seen are rendered in front. This problem of the OR-method is solved by the ORZ-method. Although a geometrical conflict can be seen in the middle image of Organ, all other models are rendered correctly. The times required for constructiong the OR Matrices and rendering were shown in Table 1. The matrix calculation is done only once before the start of the renderings. When the origami has n faces, the size of its OR Matrix becomes $n \times n$. Although the Z-method was fastest as expected, the difference was not so great, and a model can be rendered in real-time rate with all 3 methods.

We also tested a unique origami model, "an Origami Tessellation", that is a flat origami including many circles in the face overlapping order. The crease pattern of an origami tessellation is generated from a tiled plane as shown in Fig.9.

Table 1. Rendering time in milliseconds (average over 30 frames)

	Simple fold	Medal	Organ
OR Matrix calculation	5	158	24
Z-method	241	472	277
OR-method	246	610	316
ORZ-method	254	646	346
number of Polygons	48	129	60

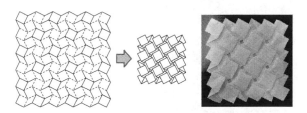

Fig. 9. The crease pattern and the photo of the origami tesselation

Z-method OR-method ORZ-method

Fig. 10. Results of the origami tesselation

The details are described by Thomas Hull[7], and an application that generates the crease pattern for the origami tessellation is available on the Web[8]. The result of rendering this model is shown in Fig.10. Although the Z-method fails, we can see that both the OR-method and the ORZ-method render the model correctly.

5 Conclusion and Future Work

In this paper we have proposed a new rendering method that solves the problems of rendering origami models in which multiple faces are located on a same plane or on very near planes by using the OR matrix. By referring to the OR matrix, not using the z-buffer, we can also eliminate penetrations between faces. We implemented our system on a computer and showed that our method can generate appropriate images. The limitation of our approach is that we have to firstly input the crease pattern on ORIPA. Also the crease pattern has to satisfy the condition that it is foldable into a flat configuration. Although we did not consider changes of topology of origami models during modification of the

model, these would be supported if we could update the OR matrix at the time of operation. As we use simple rendering algorithms in this paper, it would be desirable to render origami more photo-realistically.

References

1. Furuta, Y., Kimoto, H., Mitani, J., Fukui, Y.: Computer model and mouse interface for interactive virtual origami operation. IPSJ Journal 48(12), 3658–3669 (2007)
2. Mitani, J.: Development of origami pattern editor (oripa) and a method for estimating a folded configuration of origami from the crease pattern. IPSJ Journal 48(9), 3309–3317 (2007)
3. Miyazaki, S., Yasuda, T., Yokoi, S., Toriwaki, J.: An origami playing simulator in the virtual space. The Journal of Visualization and Computer Animation 7(1), 25–42 (1996)
4. Tachi, T.: Simulation of rigid origami. Appear in proceedings of the 4OSME, Pasadena USA (September 2006)
5. Mitani, J.: Rendering method for flat origami. In: Eurographics 2008: Annex to the Conference Proceedings, The 29th annual conference of the European Association for Computer Graphics, pp. 291–294 (April 2008)
6. Justin, J.: Towards a mathematical theory of origami. In: Proceedings of the Second International Meeting of Origami Science and Scientific Origami, pp. 15–29 (1994)
7. Hull, T.: Origami 3: Third International Meeting of Orgami Science, Mathematics, and Education Sponsored by Origami USA. A K Peters Ltd. (2002)
8. Bateman, A.: Paper mosaics, http://www.papermosaics.co.uk/

A Visual Analytics Tool for Software Project Structure and Relationships among Classes

Juan García, Antonio González Torres, Diego Alonso Gómez Aguilar,
Roberto Therón, and Francisco J. García Peñalvo

Departamento de Informática y Automática, Universidad de Salamanca, Plaza de la
Merced s/n. 37008, Salamanca, Spain
{ganajuan,agtorres,dialgoag,theron,fgarcia}@usal.es
http://visusal.usal.es

Abstract. This paper aims to support the software development and
maintenance process with the assistance of a visual analytics tool pro-
posal. The proposal focuses on providing detailed information about the
software project structure, class relationships, class coupling, class level
metrics and source code. It discloses project structure details and offers
interaction techniques in order to quickly review source code classes and
obtain insight of their relationships and coupling. The data used in the
analysis and visualization has been extracted from Software Configura-
tion Management (SCM) tool repositories. Finally, a case study and the
results of applying our tool to several software project revisions are dis-
cussed.

Keywords: Visual Analytics, Software Visualization, Mining Software
Repositories.

1 Introduction

The proposal presented in this paper focuses on the application of visual ana-
lytics to software project structures, software class hierarchy, and software class
dependency through several revisions. It takes into consideration that most soft-
ware projects have not been well documented and that normally only the source
code is made available to developers. Without the documentation available, the
programmers when interested in modifying, updating or improving one of these
projects must comprehend the software project structure, hierarchy of classes,
relationships among them and class coupling. Our proposal design (figure 1)
is composed by a software repository miner, an evolution analyzer tool and a
visual analytics tool. The software repository miner with assistance of the soft-
ware evolution analyzer tool automatically extracts source code from software
project repositories, and applies software evolution analysis to collect relevant
information about software project structure, class hierarchy, coupling relation-
ships, class source code and other information to calculate class level metrics.

A. Butz et al. (Eds.): SG 2009, LNCS 5531, pp. 203–212, 2009.

Fig. 1. A visual analytics tool for the analysis of software project structure and relationships among classes

Then, the resulting data is processed and displayed by the visual analytics tool, which uses several interaction techniques to support navigation, interpretation of visual elements and understanding relationships among data elements in their full context [1]. The user by means of interaction techniques can filter, transform, browse and discover relationships, as well as inspect relevant source code fragments.

1.1 Contributions and Structure of This Paper

The analysis performed by the software evolution analyzer is limited to Java source code. Additionally, the visual analytics tool representations have been designed for single inheritance programming languages. However, the contributions of our proposal are of great value for project managers and software developers in the understanding of software project structure, hierarchical class relationships and class coupling. Moreover, it contributes to the comparison of structure changes on software projects and among class relationships through several revisions. The following are the most important contributions of this proposal:

- The representation of software project structure and packages, hierarchy and implementation relationships between software items. It visualizes the hierarchical project structure using a nested packages representation and allows filtering of hierarchical levels. This visualization supports the representation of the relationship between a class, its superclass and the interfaces. It takes into account if the superclass and interfaces are located in the software project under analysis, in the Java API or in an external library.
- A scalable visualization that integrates the inspection of class level metrics and class coupling with source code browsing in one view.

The use of visual analytics on this proposal seeks to collaborate with project managers and developers by supplying a means to reveal class relationships, therein a quick method to inspect class code and get basic metric details. It

provides views at all levels of a software project; the software project structure, project packages structure, software item relationships, and source code. This paper is structured in 5 sections, as follows: section 2 reviews related works, section 3 discusses our tool proposal; section 4 presents a case study in which our proposal is used to review a Java open source software project, and section 5 discusses the conclusions and future work.

2 Related Work

Visual Analytics facilitates analytical reasoning by means of automated analysis techniques and interactive visualizations to synthesize information and derive insight from massive, dynamic, ambiguous, and often conflicting data; detect the expected and discover the unexpected; provide timely, defensible, and understandable assessments; and communicate assessment effectively for action [2]. It can rather be seen as an integral approach combining visualization, human factors (e.g., interaction, cognition, perception, collaboration, presentation, and dissemination) and data analysis (information gathering, data preprocessing, knowledge representation, interaction and decision making) [3]. The following sections review related works about software evolution and software visualization. Our proposal uses a software evolution approach for gathering and analyzing data and software visualization techniques to synthesize information, and provide an interactive means to discover relevant patterns and relationships.

2.1 Software Evolution

Software evolution is the process of software change and improvement over years and releases [4], while software evolution analysis is concerned with software changes, their causes, and their effects [5]. Besides, Software Configuration Management (SCM) tools have traditionally been used to record changes in software repositories; including time, date, affected modules, how long the modification took and information about who performed the change [6]. SCM tools provide mechanisms to extract project source code from several revisions that can be used by the software evolution analysis process. SCM software repositories have been the information source for several researches in mining software repositories [7]. A framework for mining software repositories that focuses on the data available and its extraction according to user roles is proposed in [9]. A detailed literature survey on evolutionary changes of software is presented in [7], which takes into consideration the purpose of mining software repositories, the methodology employed in the mining process and the evaluation of the approach carried out. The thesis carried out by Hassan [8] is a good reference to understand how extracting information from SCM tools repositories helps to assist developers and support managers.

2.2 Software Visualization

Software visualization (Softvis) deals with program visualization (i.e. visualization of software architectures, visualization of software evolution, and visualization of software metrics and source code browsers), algorithm animation, visual programming, and programming by example [10]. It represents artifacts related to software and its development process, including program code, requirements and design documentation, changes to source code, and bug reports [11]. Well-designed software visualizations allow navigating software repositories and achieving an insight of what is going on in the project. A fundamental problem in visualizing software changes is choosing effective visual representations or metaphors and making combinations that show different data perspectives filtered by: developer, basic statistics about changes, size of the changes, activities carried out by developers, etc. [12]. The visualization literature offers an extensive number of proposals to represent hierarchies. A classical hierarchical visualization is Treemap, a space-filling visualization technique that represents large hierarchical data sets via a two-dimensional rectangular map, providing a compact visual representation of complex data spaces through both area and color [13]. This visualization and its variants have also been applied to the exploration of hierarchical relationships in software systems [14] The understanding of software structural dependencies is critical in the maintenance of software systems. Some proposals have engaged in the analysis of structural dependencies using software items ranking. The idea behind this is to recognize potential interesting classes to developers investigating source code elements [15]. Other proposals have focused on the visualization of dependencies using a dependency structure matrix [16] and still others propose an evolutionary approach applied to the visualization of software item dependency [17]. Many different authors use distinct visual representations to address the visualization of metrics. One of these representations uses a treemap variant for the visualization of software metrics [18], while another uses a representation called the evolution matrix [19]. Moreover, the visualization of metrics and software structure is carried using a graph representation in [20].

3 Description

The intent of this investigation is to support software project managers and developers regarding the project structure, inheritance and coupling relationship among software classes. In addition it supports internal class cohesion, code browsing, as well as basic static class level metrics such as LCOM2 and LCOM3 [21], SLOC, NOM, CBO-in and CBO-out coupling. We define CBO-in and CBO-out as variants of the CBO metric [21]. CBO-in measures the number of classes that depend on the class under consideration and CBO-out measures the number of classes on which the class under consideration depends. The scope of this research is limited to single inheritance programming languages. Our visual analytics tool is supported by two visualizations; one is committed to the representation of software project structures, class and interface relationships;

Fig. 2. Software project structure and class dependency

while the other is devoted to individual packages visualization, class inheritance, class level metrics, class coupling and source code exploration. Software project structures are hierarchical by nature; smaller packages are contained in larger packages, and these by the software project itself. Our proposal for software project structure visualization supports the representation of the relationship between a class, its superclass and the interfaces it implements. It takes into account if the class, superclass and interfaces are located in the software project under analysis, in the Java API or in an external library. We have considered the proposal presented in [17] and redefined the class relationships as self-to-self, library to library, Java API to Java API, self to library, self to Java API, library to Java API, Java API to library, library to self and Java API to self. Self refers to the project under analysis, library to an external library or another project and Java API to the Java API itself. Moreover, we have also considered the implementation of interfaces and classes, interfaces, enums and annotations as the software items that can participate in inheritance and implementation. A description of the visualization discussed above, at the class and interface level, is presented on figure 2. It shows three packages containing i and c ovals linked by black lines. Ovals labeled with c letters represent classes and ovals labeled with i letters represent interfaces and the small black oval in one of the line ends represents the linking to a parent class or to an interface. Furthermore, the size of oval represents the number of relationships with other software items. The visualization for individual packages uses a treemap representation for the visualization of inheritance, table lens for the display of class level metrics, and a graph representation for the CBO-in and CBO-out coupling, and source code exploration. Software classes, in single inheritance languages, inherit characteristics from their parents. Furthermore, classes also inherit characteristics from all ascendants along the way to the root class of the given programming language. Hence the decision of using a hierarchical representation for class inheritance was straightforward.

4 Case Study: Analysis of a Software Project Using Views from the Structure to the Source Code

This section discusses the application of the proposal to jFreeChart, an open source software project that was registered at http://www.sourceforge.net on November 2000 and currently has nearly 900 classes and 1851 revisions. jFreeChart is a visualization tool committed to the creation of business graphs, and freely released with the full source code provided under the terms of LGPL. The project is maintained by a team of nine developers. To test our tool proposal we have downloaded and analyzed some randomly chosen revisions. First, we are going to describe the tool that represents the structure of software projects, and then we are going to discuss class relationships, class coupling and source code browsing. The figure 3 shows the representation of two software projects and the Java API (the light brown area). One of the projects is jEdit (which is not discussed on this paper) and jFreeChart. The Java API is represented due to the inherent dependency with the other software projects. This tool allows hiding or showing software projects and packages. When the user selects a software project, it can show all its packages; then the user is able to recursively expand packages until it gets into the deeper level and classes are shown. Figure 3 shows a global view of the representation where the package jfreechart.source is selected. Once the user has selected the package jfreechart.source, the classes and their parents are shown for inspection and analysis on the integrated representation view of inheritance, class level metrics and source code (it only includes data of classes that belongs to the current project or the Java API). Then, the user can search for a specific class using the search engine included on the visualization or browsing the visual elements on the treemap representation either the table lens. The user can select a class from the table lens using the metric

Fig. 3. Representation of two software projects and the Java API

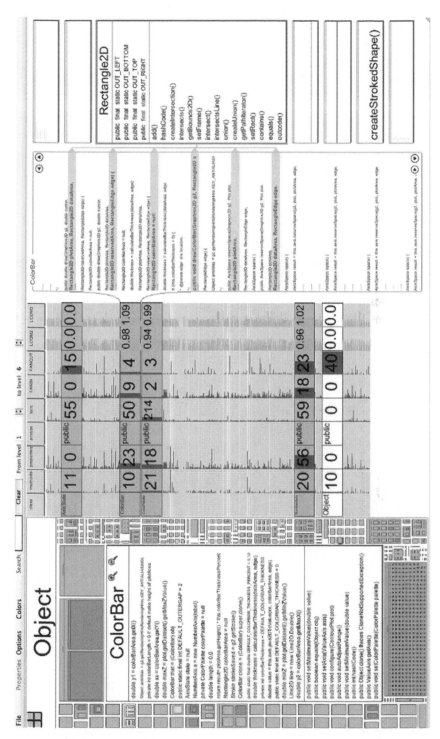

Fig. 4. Class relationships, coupling, class level metrics, and source code inspection

values as reference. Afterwards, when a class has been selected a semantic zoom is performed on the item representing that class, and its attributes and methods are shown. Figure 4 shows on the right panel of the visualization the source code of a class that has been selected from the table lens.

The source code view highlights the class coupling to other classes (CBO-out, FANOUT in the table lens), and the semantic zoom, displayed on the left, shows the methods and attributes of the selected class. Furthermore, the coupling is represented on the table lens by emphasizing those coupled classes, and blurring the other ones. In addition, attributes and methods of the coupled classes are shown for further analysis. Moreover, we are interested on analyzing the most coupled classes to detect those ones that could represent an issue during the maintenance process. We start by filtering out the classes with highest coupling values (CBO-out metric) to keep the most coupled ones, which could difficult maintenance tasks. Then, we apply a decreasing order to the coupling values of the resulting classes and the source code of each class is individually analyzed, as well as its coupled classes. Figure 5 depicts the most coupled classes of the jfreechart.source package. It hides the source code and only displays those lines that represent direct class coupling (CBO-out). Furthermore, after analyzing those classes we discovered that they have been frequently modified or updated; which is probably the main reason why they are strongly coupled. Project designers, instead of just adding new methods or functionality to the same classes, should have defined new classes to avoid strongly coupled classes. An important discovery, is that the resulting classes, after applying the filter, do not have high depth level values, resulting on less specialized classes. Consequently, it could be beneficial that the new classes added to the project to increase functionality inherits from other classes already present in the project. Furthermore, the results provided by the cohesion metric are relatively high. Source code viewer is located in the right of the visualization; it allows inspecting source code and the classes to which the class under analysis is coupled. The source code viewer

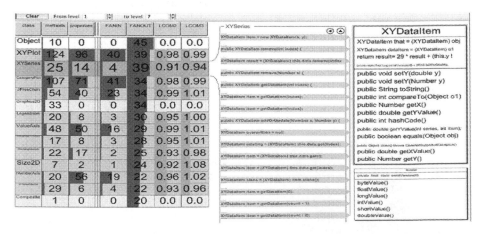

Fig. 5. Most coupled classes on the package jfreechart.source

supports filtering out code lines to display only the object declarations of coupled classes; when the user passes the mouse over an object declaration its associated class attributes and methods are displayed on the right. In addition, if the user clicks on the coupled class on the right all object declarations of class on the left are highlighted. The visualization tool covers some concepts to be analyzed. From left to right the analysis starts with an overview of the whole hierarchy of classes followed by the table lens that display some basic software quality metrics applied to the classes in the project. Finally, code inspection and direct coupling improves the accuracy of the analysis and provide a quick method to obtain details at the code level.

5 Conclusions and Future Work

Our visual analytics tool supports the understanding of software project structures, class relationships and source code to help managers and developers in the maintenance and improvement of software systems. The tool proposal is composed by a software miner and analyzer tool, and a software visualization tool. The software miner tool extracts and analyzes evolutionary source code from software repositories. The software visualization tool provides interactive representations for the software project structure, the class relationships, class coupling and class level metrics. Furthermore, we provide a means to review the class source code, as well as a preview of the source code of coupled classes. According to our analysis described in the case study, it is easy to navigate through the software project structure, review packages and sub-packages, explore class inheritance and implementation, analyze class level metrics, and browse class source code. Future improvements include the representation of coupling traces, more complex coupling and cohesion metrics. Furthermore, our tool is intended to evolve as a complete visualization tool to provide additional insights about software project structures and software evolution.

Acknowledgments. This work was partially supported by the Ministerio de Educación y Ciencia (project GRACCIE (CONSOLIDER-INGENIO, CSD 2007-00067)) and by the Junta de Castilla y León (projects GR47 and GR34).

References

1. Leung, Y., Apperlley, M.: A review and taxonomy of distortion-oriented presentation techniques. ACM Transactions on Computer-Human Interaction 1, 126–160 (1994)
2. James, J.T., Kristin, A.C.: Illuminating the Path: The Research and Development Agenda for Visual Analytics, National Visualization and Analytics Center (2005)
3. Daniel, K., Gennady, A., Jean-Daniel, F., Carsten, G., Jörn, K., Guy, M.: Visual Analytics: Definition, Process, and Challenges. In: Kerren, A., Stasko, J.T., Fekete, J.-D., North, C. (eds.) Information Visualization. LNCS, vol. 4950, pp. 154–175. Springer, Heidelberg (2008)
4. Fernández-Ramil, J., Lozano, A., Wermelinger, M., Capiluppi, A.: Empirical Studies of Open Source Evolution. Software Evolution, 263–288 (2008)

5. D'Ambros, M., Gall, H., Lanza, M., Pinzger, M.: Analysing Software Repositories to Understand Software Evolution. Software Evolution, 37–67 (2008)
6. Estublier, J.: Software configuration management: A roadmap. The Future of Software Engineering (2000)
7. Kagdi, H., Collard, M., Maletic, J.: A survey and taxonomy of approaches for mining software repositories in the context of software evolution. Journal of software maintenance and evolution: Research and practice 19(2), 77–131 (2007)
8. Hassan, A.E.: Mining Software Repositories to Assist Developers and Support Managers. University of Waterloo, Waterloo, Ontario, Canada (2005)
9. Daniel, M.G., Cubranic, D., Storey, M.D.: A framework for describing and understanding mining tools in software development. In: MSR 2005: Proceedings of the 2005 international workshop on Mining software repositories, Saint Louis, Missouri, USA, pp. 1–5. ACM Press, New York (2005)
10. Maletic, J.I., Marcus, A., Collard, M.L.: A task oriented view of software visualization. In: VISSOFT 2002: 1st International Workshop on Visualizing Software for Understanding and Analysis, p. 32. IEEE Computer Society, Washington (2002)
11. Diehl, S.: Software Visualization: Visualizing the Structure, Behaviour, and Evolution of Software. Springer, New York (2007)
12. Eick, S.G., Graves, T.L., Karr, A.F., Mockus, A., Schuster, P.: Visualizing software changes. IEEE Transactions on Software Engineering 28(4), 396–412 (2002)
13. Shneiderman, B.: Tree visualization with treemaps: a 2-d space-filling approach. ACM Transactions on Graphics 11(1), 92–99 (1992)
14. Michael, B., Oliver, D.: Exploring Relations within Software Systems Using Treemap Enhanced Hierarchical Graphs. In: VISSOFT 2005: Proceedings of the 3rd IEEE International Workshop on Visualizing Software for Understanding and Analysis. IEEE Computer Society Press, Los Alamitos (2005)
15. Martin, P.R.: Topology Analysis of Software Dependencies. ACM Transactions on Software Engineering and Methodology 17(4) (2008)
16. Pei-Breivold, H., Crnkovic, I., Land, R., Larsson, S.: Using Dependency Model to Support Software Architecture Evolution. In: 4th International ERCIM Workshop on Software Evolution and Evolvability (Evol 2008), L'Aquila, Italy. IEEE, Los Alamitos (2008)
17. Rysselberghe, F.V., Demeyer, S.: Studying Versioning Information to Understand Inheritance Hierarchy Changes. In: MSR 2007: Proceedings of the Fourth International Workshop on Mining Software Repositories, Minneapolis, MN, USA. IEEE Computer Society, Los Alamitos (2007)
18. Michael, B., Oliver, D., Claus, L.: Voronoi treemaps for the visualization of software metrics. In: SoftVis 2005: Proceedings of the 2005 ACM symposium on Software visualization, Saint Louis, Missouri, USA, pp. 165–172. ACM Press, New York (2005)
19. Lanza, M.: The evolution matrix: recovering software evolution using software visualization techniques. In: IWPSE 2001: Proceedings of the 4th International Workshop on Principles of Software Evolution, Tokyo, Japan, pp. 37–42. ACM Press, New York (2001)
20. Heorhiy, B., Alexandru, T.: The Metric Lens: Visualizing Metrics and Structure on Software Diagrams. In: WCRE 2008: Proceedings of the 15th Working Conference on Reverse Engineering, Antwerp, Belgium, pp. 339–340. IEEE Computer Society, Los Alamitos (2008)
21. Chidamber, S.R., Kemerer, C.F.: A Metrics suite for object Oriented Design. IEEE Transactions on Software Engineering 20(6), 476–493 (1994)

Magnet Mail: A Visualization System for Email Information Retrieval

Paulo Castro and Adriano Lopes

Universidade Nova de Lisboa
CITI, Departamento de Informática, Faculdade de Ciências e Tecnologia
2829-516 Caparica, Portugal
paccastro@gmail.com, alopes@di.fct.unl.pt

Abstract. We present Magnet Mail (MM), a visualization system to retrieve information from email archives via a zoomable interface. MM allows users to infer relationships among their email documents based on searching keywords. The prototype interacts with a mass-market email system and uses a magnet metaphor to simulate user interaction with emails. The graphical implementation relies mostly on the Piccolo toolkit.

Keywords: Email, Document Visualization, Magnet, Piccolo.

1 Introduction

Email is a popular means of communication among people, whether in the context of personal relations or as a crucial tool for business and academia. It is an inexpensive, fast an efficient mechanism of communication and therefore it leads to a proliferation of its use. This creates a large amount of electronic data in a inbox of a particular person so management problems arise when that person faces the need of searching, comparing and understanding the similarity of themes or topics in or intra-emails.

Most of the email interfaces provide little help to manage messages effectively. In some way, they are limited on their usability because (a) they denote the use of hierarchical folders and (b) they return results in a textual or list-based format. Most of them do not provide proper hints about email similarities or patterns, which can be dramatic when an inbox has a large collection of email messages as it is normal nowadays.

It should be recognized however that recent steps have been taken in order to add user-friendly features to common email interfaces, namely, sorting, filtering and searching facilities. But still these developments are more just add-ons than real solutions. Users want to easily navigate across large email collections and to infer patterns so object manipulation is crucial for that matter.

In general, a document visualization system uses automated methods for indexing documents from a large collection and presenting them graphically. One of the goals is to provide users an efficient overview of contents and themes so

A. Butz et al. (Eds.): SG 2009, LNCS 5531, pp. 213–222, 2009.

they can have a quick understanding of documents instead of forcing the reading immediately. To do so, a straightforward strategy is to decompose documents through statistical methods and then to generate vectors of meaningful representations of data. The results are mapped into a sort of spatial form in the visualization system, which by itself provides an interactive environment where users can interact with data, redefining queries and so on.

In this paper, we propose Magnet Mail (MM), a document visualization system related to the email paradigm. The organization of the paper is as follows: Sect. 2 highlights related work, which is followed by the description of MM in Sect. 3. Then in Sect. 4 we present preliminary tests and results and finally in Sect. 5 we draw some conclusions and present future work.

2 Related Work

Most of the solutions to enhance interactivity with email client applications have a close look at content of messages not just the header information. In terms of data visualization, we can spot three major approaches:

- thread-based visualizations, as shown in the Thread Arcs tool [8].
- time-based visualizations, as shown in the Themail tool [11] .
- social-network visualizations, as depicted in the *Enronic* application [4].

In the following we refer to some of the tools related to the above approaches.

In the Thread Arcs tool, relations among emails are visualized according to threads of replies, shown as chain of emails that are related to each other. Each message in a conversational thread is a node, which are ordered in a manner that the oldest email is placed on the left and the newest on the right. Arcs link each child to its parent (the email the child replies to). Hence the system can highlight the progress of a conversation and a user can select an email in the thread [8].

The EzMail tool [10] is a multi-view interface for email messages running in conjunction with an email client application. Messages are seen as components of threads and it provides contextual information and conversational history.

Themail allows visualization of a personal email content over time. It relies on the content of messages to build a visual display of interactions over time. The interface shows a series of columns of keywords arranged along a timeline. Keywords are shown in different colors and sizes depending on their frequency and distinct conversations over time [11].

Mailview is a tool that display emails in a chronologically based visualization. It includes focus+context views, dynamic filters and coordinated views [3].

The Enronic email visualization and clustering tool unifies information visualization techniques with various algorithms for processing an e-mail corpus (as a motivating data set), including social network inference, message categorization, and community analysis [4]. The Enronic application uses the Prefuse toolkit [5].

FaMailiar is a tool to visualize email data over time, focusing on discovering communication rhythms and patterns. Some features include daily email

averages, daily quality of emails, frequency of email exchanges, comparative frequency of email exchanges [6].

Despite the important contributions of such tools, there is space for improvement, in particular concerning user interaction. For instance, Thread Arcs is based on a thread concept and most of common email users are not familiarized with such concept. We are in favor of using a common day metaphor, easily understandable, to display and manage email messages.

For that purpose, we were inspired by Dust and Magnet [12] (which is also based on the WebVIBE system [7]) to develop a new concept but totally focus on the email domain. Dust and Magnet is a system that uses the zoomable user interface toolkit called Piccolo [1] and applies a magnet metaphor to display multivariate information. In the system, data are represented as particles of iron dust and data variables are represented as magnets, and it provides interactive techniques to display and manipulate data in the working area.

In respect to using Piccolo in the email domain, it is worth to mention a semantically zoomable interface proposed by Diep and Jacob. This application shows emails as rectangular nodes and allows users to drag them or pan the entire viewing area [2]. Another example is the FaMailiar tool mentioned above.

3 Magnet Mail

MM is a document visualization system targeting email archives. With this new approach we aim to reduce the user effort for searching and browsing email messages. MM enables a global overview of an email collection instead of providing just a few block of results as many systems do. On the other hand, it provides a comprehensible metaphor to interact with data. This implies the use of interactive and graphical capabilities, although the typical textual list-based format is still preserved.

The main design challenges we set were:

– User-friendly interaction.
– Searching keywords as a mechanism to infer relationships among emails.
– Method to classify email importance.
– Representation of most common keywords in email messages.
– Preview of email content as well as associated details.

3.1 User Interface

The magnetism metaphor is crucial for MM user interaction. In the MM interface, magnets represent keyword strings and email envelops represent email messages. We consider the following features:

Magnetism. Users are able to drag magnets in the visualization area. Each magnet will attract or repulse emails according to its attribute value. The higher the matched attribute is, the fastest the email is attracted to the corresponding magnet. The magnitude of attraction between the magnet and

the email envelop is computed via an attraction algorithm (see Sect. 3.4). Also, users can reformulate keyword strings and magnet attraction values, in order to get more detailed and filtering results.

Viewing. The viewing facilities include (a) zooming-out to get a better overview of the display zone and zooming-in to get a closer and detailed view; (b) panning; (c) overall view of email items on display and consequently providing context; (d) detailed view of emails contents; (e) mixing the typical list-based viewing information with the graphical-style display.

Highlighting. Use of a color scale to highlight the importance of the emails related to a particular magnet. The strongest the color attributed to the email, the more important the email is in relation to the keyword the magnet represents. Additionally, to check and markup results in order to distinguish important emails. Hence, users can track and trace an email in the display zone.

Data. To provide a ranking system, based on the term frequency, for the most common searching keywords in emails. Thus, it is possible to compare the similarity of themes or topics among emails. Additionally, users can benefit from useful features available in Microsoft Outlook by linking a selected email object with the Microsoft Outlook email message.

Fig. 1 shows a screenshot depicting the MM implementation. The interface is divided into four main areas: (a) *graphical interaction area*, where users visualize graphical information and at the same time can interact with the system

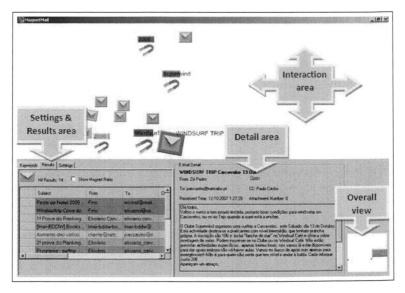

Fig. 1. A screenshot of the MM user interface: mails and magnets are located in the interaction area, and there are a tabular view of results, a detailed view of a particular email, and the overall viewing area from which we can pan or zoom the display in the interaction area

via zooming, panning and selecting features; (b) *settings and results area*, for example to define a list of searching keywords and associated properties; (c) *detail area*, with detailed information about selected items of interest; and finally (d) *overall view area* to give spatial context to data visualization. For the sake of screen space optimization, the *settings and results area* is divided into three tabs: one tab for searching keywords, another one for MM settings and the last one for list-based viewing of information.

3.2 Interaction

Magnets and emails. In the interaction area, there are as many magnets as the number of keywords defined by the user (magnet=keyword).

Each magnet object is associated to three visual attributes: label (the keyword), size, and color (a keyword will have a color scale associated). The size of the object is proportional to the importance of the keyword. The bigger the object, the stronger the keyword, and consequently more easily it will attract or repulse email objects. If the user sets a negative importance to a keyword, then the magnet object will repel emails containing that keyword.

The mail envelop represents a single email document. These objects are not user-defined directly but they are a consequence of keywords. There are as many email objects as the number of retrieved emails of the query.

After defining a keyword (see Fig. 2), the magnet is placed in the interaction area, alongside the set of emails that match the query result. The keywords previously defined will attract or repel the returning results, based on the importance they have. Initially, the email collection is placed at the same position, just as a pile of documents. Then, it is the direct user manipulation of the magnets that changes the location of each email. Users can grab and drag an email, as well as magnets, so they play an active role in the process. For instance, with a new positioning of the email collection, a user can easily figure out that the closer an email is to a keyword, the greater the probability is that this particular keyword is the most related to the email (among all returning results). Fig. 3 depicts the notion of relationship between a keyword and emails.

Notice however that, if there are just few user actions and a couple of emails have exactly the same frequency related to a particular magnet, then those emails will stay at same position. To minimize such problem, when the user rolls the cursor over an email envelop, it will have bigger shape and it is shown snipped information. Hence, the email envelop is highlighted (see Fig. 3).

Graphical and tabular visualization. As Fig. 1 shows, there are two complementary ways to visualize query results: graphical and tabular. In the case of graphical visualization, the displayed results rely mostly on direct object manipulation of magnets. For tabular visualization, retrieved results are displayed as usual, that is, as a list-based view. Here, the results can be ordered according to the search frequency of emails in relation to each magnet.

The idea of providing both types of visualization does not necessarily imply that one overshadows the other. On the contrary, the goal is to be complementary. The graphical approach provides a user-friendly mechanism to analyze the

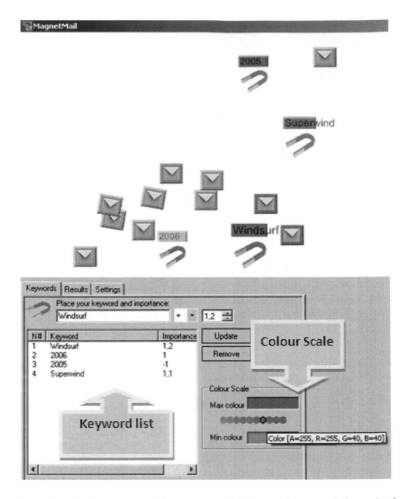

Fig. 2. Example of the magnet definition in tab *Keywords*: user defines the keyword and associates an importance and color scale to each one

Fig. 3. Example of the keyword *windsurf* represented as a magnet attracting or repulsing various email documents. Snippet information about an highlighted email (*right*) is shown when the user rolls the cursor over it.

information but the tabular approach provides a more detailed information and can be easily ordered.

Color scale. As mentioned, every keyword is associated to a color scale (see Fig. 2). The scale is mainly used to set the color of email objects. By default, the setting of color scale is an automatic process, but the user is entitled to change it if he/she wants to. The color of each email object is defined on the basis of the relationship email-magnet and the color scale of the keyword/magnet. The stronger the color the more related the email is to the magnet. As far as magnet color is concerned, it is used the "maximum" color of its scale.

The color scale to be used may change if the user demands in the tabular view the sorting of frequencies in respect to a particular magnet. The new color scale is the one of the selected magnet. But when there is no selected magnet, the color scale is considered to be neutral. In this case, users can not infer the importance of emails via color feature.

Example of interaction. Fig. 4 presents some steps of interaction with MM, with four screenshots of MM.

3.3 System Architecture

Having in mind a real usage, we have decided that MM would interact with a mass-market email system, the Microsoft Outlook. Hence, the target file archives

Fig. 4. Example of steps of interaction with four MM screenshots. On *top left*, the user drags the magnet previously set. Then, on *top right*, emails with some kind of relationship with the magnet are attracted to the magnet as the user moves it. On *bottom left*, the user realizes that the closer e-mail has a better ranking so probably it is the most relevant e-mail of interest. Finally, on *bottom right*, the user can analyze in more detail the chosen email.

are Microsoft Personal Storage files (PST) and therefore MM data repository stores the users' email information originated from their personal folders.

When the user manipulates data in the interaction area, it is necessary to calculate each object position (emails and magnets) in that area. To do so, pairs of keyword and its importance value set by the user are stored in a keyword-vector, and then a statistical algorithm of term frequency calculates the frequency-vector. Basically, this algorithm obtains a vector of matched results of each keyword string within each email message. Then both keyword and frequency vectors are used to calculate the location of each email object in the interactive area, alongside with the positioning algorithm that uses electromagnetism laws (see Sect. 3.4).

The graphical implementation of MM is also supported by Piccolo [1].

3.4 Magnetism Metaphor

In order to simulate the magnetism phenomena, we have set the following:

- Keywords play the role of magnets and email messages the role of particles, which are attracted or repulsed.
- Each magnet creates a magnetic field to exercise a force over the particles.
- The force exert by a magnet varies from strong to weak according to a user-defined parameter.
- A magnet influences the position of every particle that lies on its magnetic field, but a magnet could not influence a position of other magnet shown in the interactive area. Likewise, the position of a particle is influenced by all magnets shown in the interactive area, but particles are not influenced by the position and interaction to each other.

In the end, there is a net force due to the magnet field created by all magnets. The positions of emails are then influenced by the exercised force. When moving the magnets, the emails will be repeatedly pulled close together or pushed further apart until the system comes to an equilibrium state. Once that is reached, we obtain the new positions of all items in the interactive area. This can be mapped as a graph, where the forces exerted by magnets are the edges and the emails are the nodes, and therefore graph interactivity can be modeled with the help of common force-based algorithms. We rely on mechanical and electromagnetic laws, and we consider edges as springs and nodes as electrically charged particles. More specifically, we use the Hookes and Coulombs laws [9] respectively.

4 Tests and Results

Evaluating a visualization system is a difficult task. We have not extensively evaluated MM yet but we have carried out some preliminary tests with users. At this point in time we are particularly keen on knowing how usable the prototype can be and to figure out its potentiality.

The case study consisted of an MM experimentation, where a group of 30 users aged from 21 to 30 years old have followed a case scenario task list. Additionally,

the users have followed a MM video demonstration. Once they performed their tasks, they were invited to fill in a simple questionnaire and to rate questions from 1 (min) to 5 (max). Figure 4 presents some steps of user interaction, with four screenshots of MM.

This exercise allowed us to grasp major MM features, potentialities and pitfalls. Just to give a glimpse, we present the average marks to the following questions:

1. *How easy you found to use this interface?* – 3.91
2. *How satisfied you were with the search results set?* – 3.73
3. *How ambiguous you thought the search results set was?* – 3.36
4. *How do you rate the time spent to perform a search?* – 3.27
5. *How do you rate the potentialities of Magnet Mail?* – 3.27
6. *How do you rate the Magnet Mail originality?* – *4.09*

In general, it has been revealed that users classify MM as an useful and easy-to-use tool, and highlighted its originality. The users also felt that the time to return query results must be reduced, particularly when the email collection is big. Also, they point out that color mapping is not as effective as it should be, and the tabular view should include more complex grouping, filtering and sorting features as one can experience with spreadsheets.

5 Conclusions and Future Work

We have presented a prototype to visualize email archives with emphasis on user-friendly graphical interaction. It uses a common magnet metaphor, which easily translates the relationship between searching keywords and related email messages. Not only users can overview an email collection with no reading effort but to obtain details of email messages they query about. This is not the usual scenario found in many other tools as they just use textual or list-based representations of email collections. Additionally, with MM, users can rate the importance of searching keywords they specify. Ultimately, they are able to play an active role in managing and understanding their own email archives.

Based on the preliminary tests we have carried out with users, we found that users are responsive to accept MM as an easy-to-use and original tool to analyze email collections.

Nevertheless, there are a few problems we have to look at in the future. The scalability is a major one: if a huge volume of search results is placed in the interaction area, many icons would overlap, so it makes difficult to interact with. In that respect, it is worth to study the idea of grouping emails. On the other hand, there is a need to test other positioning algorithms in order to reduce its time cost.

The use of color to codify emails and magnets is another aspect that requires further improvement, even prior to an extensive evaluation task that needs to be done. Finally, we are considering to extend the MM prototype to web-search.

Acknowledgments

This work was partially supported by the research institute CITI.

References

1. Bederson, B.B., Grosjean, J., Meyer, J.: Toolkit Design for Interactive Structured Graphics. IEEE Transactions on Software Engineering 30(8) (August 2004)
2. Diep, E., Jacob, R.J.K.: Visualizing E-mail with a Semantically Zoomable Interface. In: Proceedings of the IEEE Symposium on Information Visualization, pp. 215–216. IEEE Computer Society, Los Alamitos (2004)
3. Frau, S., Roberts, J.C., Boukhelifa, N.: Dynamic coordinated email visualization. In: Skala, V. (ed.) 13th International Conference on Computer Graphics, Visualization and Computer Vision, Plzen, Czech Republic, pp. 187–193 (2005)
4. Heer, J.: Exploring Enron: Visual Data Mining of Email (January 2009), http://jheer.org/enron/
5. Heer, J., Card, S.K., Landay, J.A.: Prefuse: A Toolkit for Interactive Information Visualization. In: ACM Human Factors in Computing Systems, pp. 421–430. ACM Press, New York (2005)
6. Mandic, M., Kerne, A.: faMailiar & Intimacy-Based Email Visualization. In: IEEE Symposium on Information Visualization, pp. 14–14. IEEE Computer Society Press, Los Alamitos (2004)
7. Mouse, E., Lewis, M.: Why Information Retrieval Visualizations Sometimes Fail. In: IEEE International Conference on Systems, Man, and Cybernetics, vol. 2, pp. 1680–1685. IEEE Computer Society Press, Los Alamitos (1997)
8. Kerr, B.: Thread arcs: An email thread visualization. In: Proceedings of the IEEE Symposium on Information Visualization, pp. 27–38. IEEE Computer Society Press, Los Alamitos (2003)
9. Rojansky, V.: Electromagnetism Fields and Waves. Dover Publications (1979)
10. Samiei, M., Dill, J., Kirkpatrick, A.: EzMail: using information visualization techniques to help manage email. In: Proceedings of 8th International Conference on Information Visualisation, pp. 477–482. IEEE Computer Society Press, Los Alamitos (2004)
11. Viégas, F.B., Scott, G., Donath, J.: Visualizing email content: portraying relationships from conversational histories. In: Proceedings of the SIGCHI conference on Human Factors in Computing Systems, pp. 979–988. ACM Press, New York (2006)
12. Yi, J.S., Melton, R., Stasko, J., Jacko, J.: Dust & Magnet: multivariate information visualization using a magnet metaphor. Information Visualization 4(4), 239–256 (2005)

Calligraphic Shortcuts for Comics Creation

Ricardo Lopes[1], Tiago Cardoso[2], Nelson Silva[2], and Manuel J. Fonseca[1]

[1] Department of Information Systems and Computer Science
INESC-ID/IST/Technical University of Lisbon
R. Alves Redol, 9, 1000-029 Lisboa, Portugal
rval@ist.utl.pt, mjf@inesc-id.pt
[2] inEvo, I & D, Lisboa, Portugal
{tiago.cardoso,nelson.silva}@inevo.pt

Abstract. The interactive creation of comics on the World Wide Web has become increasingly relevant over the last few years as a way for amateur creators to produce, share and distribute their comics. However, web applications that allow this kind of creation still restrict users interaction by not considering the repetition of previous elements across a comics story. Moreover, they use very simple methods for creating new content, therefore not allowing visually complex and rich comics.

In this paper, we present a solution that seeks to converge the creation of web comics with the basic principles of traditional paper comics. To that end, we propose a new approach that combines rich interaction methods and geometric transformations for free hand drawings with a retrieval mechanism based on calligraphic shortcuts, to retrieve previous elements of comics.

Experimental evaluation with users demonstrated that our approach is better suited for these problems than existent applications. Our solution allows creating comics online with higher flexibility and efficiency, while achieving visually more complex and rich content.

1 Introduction

Creating comics online is becoming increasingly popular in an online amateur context. Currently there is a growing number of web applications that allow a new kind of anonymous comics artists. These authors can easily use this technology as their only mean of production and distribution to a large number of worldwide readers.

However, web applications for comics creation still show some limitations. The most frequent technique for creating comics online is the arrangement and annotation of images that can be picked up from a fixed and narrow predefined group. These kind of techniques restrict users interaction on the reuse of previous elements of the story and on the freedom of creation.

Current solutions are not providing a natural way to mimic the repetition of elements, an inherent need of traditional comics. Also, by restricting users interaction, these web applications are not allowing the creation of complex and appealing comic strips, like those created using paper.

A. Butz et al. (Eds.): SG 2009, LNCS 5531, pp. 223–232, 2009.

To overcome these limitations, we propose a new approach for creating comics online, which builds upon the basic principles of traditional comics creation. Our approach combines sketch retrieval using calligraphic shortcuts with rich interaction methods for free hand drawing and editing. By using calligraphic shortcuts to reuse previous elements, we aim to improve users experience in traditional calligraphic retrieval mechanisms. The final goals of our approach are to enable users to create comics in a more flexible and efficient way, while instigating them to easily compose visually complex scenes.

The rest of this paper is organized as follows: Section 2 provides an overview of related work in comics creation. In section 3 we describe our approach for calligraphic shortcuts, by defining its concept and mechanisms, confronting it with previous works. Section 4 presents experimental results from tests with users. Finally we discuss our conclusions and future directions.

2 Related Work

With this work, we want that the creative process and the achieved results from both methods of creating comics (traditional and online) converge. To that end, we first studied some techniques for creating comics on physical format, *i.e.*, paper. From previous work done in compiling and analysing these type of techniques, we can see that the comics medium has a specific visual nature, defined throughout the years by different artists [1,2]. They have been using the same visual conventions to represent information, such as, sound, speech, movement, emotions and time, which constitutes the vocabulary of a universal language for comics creation. In these studies, authors describe the narrative structure of comics as a deliberate sequence of juxtaposed images, intended to convey information. Moreover, by analysing these studies and other narrative structures, we observed that repeating visual elements throughout one or several comic strips is a mandatory process, while creating traditional comics. In summary, the existence of a visual vocabulary and the need for repetition along the story, highlights the need for reusing visual elements.

Regarding comics in digital format, we studied Williams et. al. work [3], where authors propose a comics creation interface to acquire unique story-scripts from casual Internet users, called the ComicKit. This application allows users to create comics by combining multiple visual elements available into the system database. Users can pick the next element to insert into the story by searching images in the database, using keywords. ComicKit uses the most frequent technique exploited in this type of systems, the combination and manipulation of predefined images. Comeks [4] and HyperComics [5] are other examples of this type of solution. However, all of these systems fail in providing adequate support for the reuse of previously created elements. Users can create elements (*e.g.*, characters, objects, etc.) by combining multiple images, but they cannot reuse them in the same or in another comic strip. Additionally, these systems fail in allowing the creation of visually complex comics, since users' creativity is limited not by their skills, but by the set of available images and by systems functionalities.

Other solutions, like the Comics Sketch [6], tries to stimulate users to create richer comic strips by supporting free hand drawing. Results available in the website, show that users explore this kind of freedom and are able to draw more complex comics than with the previously described solutions. However, Comics Sketch does not provide any mechanism for the reuse of previous elements, failing to help users on the creation of comics in a flexible and efficient way.

Looking at the majority of web comics creation systems, we can observe two things. First, there is no support to allow the reuse of visual elements, a need strongly inherent to the traditional comics creation process. Second, this type of systems restricts users interaction and, by consequence, the visual richness of resulting comic strips.

Our approach offers a new methodology for creating comics online, by combining free hand drawing and editing with a calligraphic retrieval mechanism based on shortcuts. This solution overcomes the main drawbacks of analyzed works by allowing a richer visual composition and simple mechanisms to include previous drawings in comic strips.

3 Calligraphic Shortcuts

In this section, we describe the concept of calligraphic shortcuts for classification and retrieval of drawings, as a more flexible way of reusing previous visual elements for comics creation. Our solution takes advantage of the use of a calligraphic interface, to provide a seamless integration between creation and reuse, since users can sketch to define new visual elements or to retrieve previous drawings.

3.1 Concept

From our previous work on drawing retrieval, we observed that users liked the interaction paradigm very much (use of sketches as queries) in contrast to more traditional approaches, based on query-by-example [7]. It is better suited to retrieve drawings because it takes advantage of users' visual memory and explores their ability to sketch as a query mechanism. This previous retrieval solution uses an automatic visual classification scheme based on geometry and spatial relationships (topology) to describe drawings and sketched queries. The new approach presented in this paper is based on our previous work on drawing retrieval. We still use geometry and topology to describe drawings and queries contents, but we explore a new way of accessing drawings using calligraphic shortcuts.

While analyzing experimental evaluations of our previous work, we noticed that users typically sketch a very small set of shapes to define a query, making the comparison between a very simple query and a complex drawing difficult. We believe that this behaviour can be explained by users expectations. Typically, users draw the minimal common elements, but on the other hand, they are expecting to get a large set of results semantically similar to the sketched query. For example, if a user is searching for an air plane, he wants to see all the available ones. So, he sketches a query with all the common features he knows

from air planes, creating a visual abstraction of all the different instances he knows. By sketching this query, the user is creating a visual meaning of air plane, simplifying elements from all the others he is aware of. Unfortunately the user does not know that there are a large number of air plane drawings that do not share the geometric or spatial similarity with his mental and visual abstraction.

To overcome this, we decided to extend our drawing retrieval scheme by making the creation of visual abstractions explicit, *i.e.*, allowing the creation of calligraphic shortcuts, somehow similar to what Mark Gross [8] did for the retrieval of architectural buildings. With our new approach, when users store any drawing(s) for future reuse, they can bind a simple sketch to it(them). Users are free to create a simpler abstraction of the original drawing or any other association that they deems logic. From this point on, a sketch of the calligraphic shortcut can be used to retrieve the (complex) original drawings associated to it.

Figure 1 illustrates an example of classifying and retrieving drawing(s) using calligraphic shortcuts, in our web application. To classify a drawing, users select any elements in the canvas, draw an additional shape (top right of *(a)* in Figure 1) and store both. Our application also provides a set of suggestions for shortcuts, similar to what users are drawing. This can help users classify drawings using previous shortcuts (bottom right of *(a)* in Figure 1) or to avoid similar shortcuts, thus reducing ambiguity among shortcuts. Our suggestions include previous shortcuts similar to the one being created, the list of most used and the most recently created.

To retrieve the original drawings, associated to shortcuts, users can sketch a query similar to the calligraphic shortcut (*(b)* in Figure 1) and then select the desired drawing from the returned results (bottom of *(b)* in Figure 1). Retrieved drawings can then be edited using the potentialities of the system editor, to match users needs (*e.g.* resize, change head or hands position, etc.). Additionally, this new version of the reused element can be stored for later reuse.

(a) (b)

Fig. 1. Examples of classifying (a) and retrieving (b) using calligraphic shortcuts

As illustrated in Figure 1, previous calligraphic shortcuts can be used to classify more than one drawing, allowing users to group, under the same shortcut, any drawing they consider similar (*e.g.*, cars, people, dialogue balloons). Drawings can now be grouped into the same shortcut, if users consider they are similar visually or semantically. For example, users can classify a group of very different drawings using the same calligraphic shortcut, because they have a meaning tied to emotions or any other abstract idea. With the use of calligraphic shortcuts, original drawings are not only described by their geometry and topology, but also by the meaning they have to users.

Additionally, to this new retrieval functionality using shortcuts, we also included in our final solution the traditional retrieval method, developed before. So, users can still retrieve previous visual elements by sketching queries similar to drawings (and not to shortcuts). This way, our solution remains also valid for users who do not see advantages in shortcuts or are not willing to classify visual elements by sketching yet another drawing (the shortcut).

3.2 Architecture

The architecture of our approach for creating comics is composed of two modules: the editor for the edition of comics (client side) and the retriever to support the reuse of previous drawings (server side). In the retriever module, we use our existing system for retrieving clip-art drawings, called Indagare [9,10], that offer support for our traditional retrieval mechanism. To extend this solution with the new calligraphic shortcuts, we added a top layer, responsible for creating and recognizing calligraphic shortcuts.

This layer is a service module that offers three functionalities: new drawings classification (with or without shortcuts), previous shorcuts suggestion and previous drawings retrieval. Our new service layer is invoked by the editor module, when users want to classify or retrieve drawings into the current comic strip. Figure 2 illustrates the architecture of our retriever module, integrated with the Indagare server.

Fig. 2. Architecture of the Retriever Module: Indagare and services layers

4 Experimental Evaluation

We developed a prototype for creating comics online, which combines our new approach based on calligraphic shortcuts, for reusing visual elements, and a free hand drawing editor, to support the rich creation of comics. This editor supports operations such as, free hand drawing, elements transformations, visual layers, strokes grouping, textual elements, zoom and computer assisted drawing. The combination of all of these guarantees a new method for creating comics with more flexibility, efficiency and freedom than current web applications.

To evaluate our overall solution, we performed experimental evaluation with users using the resulting prototype (called ReCCO). We intended to evaluate two aspects: first we wanted to test our shortcuts retrieval mechanism in the context of amateur comics creation, against the most functional solution online. Second, we wanted to evaluate our overall solution and see if it improves the flexibility and efficiency during the creation of comics online.

To that end, we conducted a series of user tests, in which participants performed a task in our prototype (ReCCO) and in another application, Comics Sketch [6]. The task consisted in the illustration of a predefined scripted story, composed of six frames. Users created the same story in both applications. However, while half of them created first in ReCOO and then in the Comics Sketch, the other half did it in the reverse order. With this we tried to avoid biasing results, since users learn how to do the task from one application to the other. After users perform the task, we did a questionnaire and an interview to collect their feedback about the applications evaluated.

We selected 8 participants who represent the adequate user profile of our application. We preferred to perform tests with few "specialized" users, which are used to create comics (in an amateur environment), than to collect a larger number of users without any experience on comics creation. Selected users like to create comics in an amateur context and are used to sketch in a computer, using a mouse or a Tablet. Then, we divided the participants in two groups, according to the order they will use each application. The group R/CS started with our prototype an then Comics Sketch, while the CS/R group evaluated in the reverse order.

Figure 3 shows values for creating each individual frame in the comic strip, while Figure 4 presents the time needed to create the entire comic strip.

These results demonstrate that, with ReCCO, users spent more time creating the first frame than the following ones. This difference is due to the calligraphic retrieval mechanism. We observed that in the first frame the majority of users spent time drawing all visual content and storing the desired elements that will be part of the overall story. In the following frames, these elements were already created, and users only had to retrieve and reuse, saving time. Comparing now both applications, we can see a significant difference in times for individual frames and for the complete strip. On average, users take less 15 minutes in the ReCCO system than in the Comics Sketch to create a complete comic strip. This difference is explained not only by the new retrieval mechanism but also by the edition techniques we have in our editor module, which allow a more

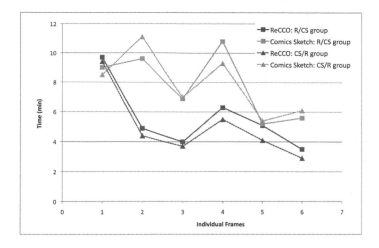

Fig. 3. Creation times per frame

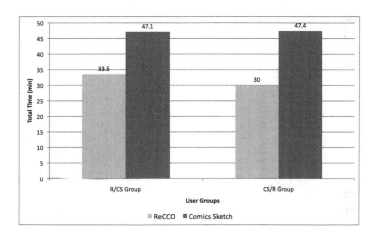

Fig. 4. Creation times for the overall strip

powerful interaction. Indeed, while our system offers a large set of functionalities to support free hand drawing creation and manipulation (*e.g.* visual layers, text elements, computer assisted drawing, etc.), the other application only offers free hand drawing and edition of stroke attributes, such as color or thickness.

We then tried to collect some measures for the retrieval mechanism. To that end, we first defined a set of expected results through previous conditioned pilot-tests. Figure 5 shows the results achieved for the retrieval mechanism. As we can see, we obtained results similar to the expected, regarding the number of stored and retrieved elements. These experimental values demonstrate that the calligraphic retrieval of previous drawings was understood and fully explored by users.

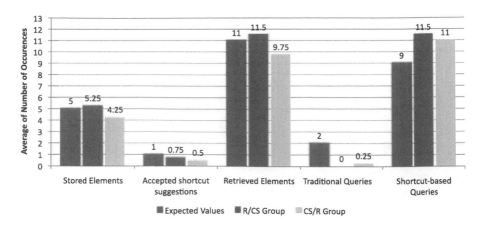

Fig. 5. Results for the evaluation of the retrieval mechanisms

In what concerns the comparison between the traditional retrieval mechanism and the calligraphic shortcuts, our results are better than expected. All users chose to always store drawings with a shortcut. Because of this, the vast majority of sketched queries were shortcut related. Through our questionnaires and interviews we were able to find the reasons for this behaviour. Users told us that a simpler and more specific sketch is an easier and faster option for creating retrieval queries, specially when one has to repeat the same several times in a comic strip. Answers to our questionnaires showed that the calligraphic shortcuts mechanism was well received, with 88% of users stating that shorcuts made the drawing retrieval easier. Furthermore, 75% of the inquired participants agreed that shortcuts allowed a better organization of stored elements. Even the 25% that thought the process of creating shortcuts was difficult, chose to do it due to its advantages.

The values we obtained for the number of accepted shortcuts suggestions were slightly smaller than expected. We believe that further tests would improve these results. These additional tests must account the continuous process of reusing individual elements across multiple comic strips. As explained before, the shortcut suggestion mechanism is aimed at a continuous and longer use of our application.

Finally, the vast majority of the participants chose the comic strip created with ReCCO as their favourite and most visually pleasing. The main reasons behind this choice can be traced to the complexity obtained in the final frames. Through observation we also noted that, with our prototype and due to the presence of more operations, users became more demanding and detail oriented with their comic strips. Figure 6 shows the same frame created by the same user, using ReCCO and Comics Sketch.

Although, we did not evaluate the scalability of the solution, the retrieval mechanism used [7] proved to perform well with large sets of drawings. In terms of ambiguity among shortcuts, due to the increase in their number, we believe

Fig. 6. Example of frames created during experimental evaluation with ReCCO (left) and Comics sketch (right)

that the suggestion mechanism will obviate that. While users create new shortcuts, our system is permanently searching the database for similar shortcuts and showing them to users. This way, users can create shortcuts different from existing ones, avoiding collisions and consequent ambiguity.

5 Conclusions and Future Work

In this paper, we described a new approach for creating and retrieving comics online. This approach combines a rich creation model, based on free hand drawing, with a calligraphic retrieval mechanism for reuse of previous elements. We propose a new mechanism based on calligraphic shortcuts to make the retrieval and reuse of previous visual elements easier. Experimental results show that our solution allows users to create richer comics strips in a shorter time, than using normal approaches without retrieval mechanisms.

Additionally, obtained results allow us to conclude that the calligraphic retrieval of previous drawings is a flexible and valid solution for the need of repeating elements during a comic strip. We also observed in the experimental evaluation, that participants used the shortcuts retrieval mechanism in exclusive, forgetting the traditional one. Thus, we can claim that the shortcut concept is natural and advantageous to users, proving that, in a free drawing application where elements are stored by users, the shortcut-based retrieval is the best solution for reusing elements.

The co-existence of the calligraphic shortcuts mechanism with the traditional one has caused some problems to users. Sometimes, queries were recognized as being part of some complex drawings, and the system returns elements not desired by users. This happens because users create very simple shortcuts that can easily occur in a complex drawing. To solve this ambiguity, we can adapt our approach to exclusively classify and retrieve drawings using shortcuts. Our experimental results encourage us to take this option. However, further studies would have to be conducted to account all the usability issues.

Acknowledgments

This work was funded in part by the Portuguese Foundation for Science and Technology, project A-CSCW, PTDC/EIA/67589/2006.

References

1. Mccloud, S.: Understanding Comics. Perennial Currents (1994)
2. Eisner, W.: Graphic Storytelling. Poorhouse Press (1996)
3. Williams, R., Barry, B., Singh, P.: Comic kit: acquiring story scripts using common sense feedback. In: IUI 2005: Proceedings of the 10th international conference on Intelligent user interfaces, pp. 302–304. ACM, New York (2005)
4. Salovaara, A.: Appropriation of a mms-based comic creator: from system functionalities to resources for action. In: CHI 2007: Proceedings of the SIGCHI conference on Human factors in computing systems, pp. 1117–1126. ACM, New York (2007)
5. Games, P.: Hypercomics (October 2007), http://www.hypercomics.com/tools
6. inEvo: Comics sketch (December 2008), http://mainada.net/comics
7. Fonseca, M.J.: Sketch-Based Retrieval in Large Sets of Drawings. PhD thesis, Instituto Superior Técnico / Technical University of Lisbon (July 2004)
8. Gross, M.D.: The electronic cocktail napkin - a computational environment for working with design diagrams. Design Studies 17(1), 53–69 (1996)
9. Sousa, P., Fonseca, M.J.: Sketch-based retrieval of drawings using topological proximity. In: Proc. International Workshop on Visual Languages and Computing (VLC 2008), Boston, USA, Knowledge Systems Institute (September 2008)
10. Sousa, P., Fonseca, M.J.: Geometric matching for clip-art drawing retrieval. Journal of Visual Communication and Image Representation (JVCI) 20(2), 71–83 (2009)

Feature-Driven Volume Fairing

Shigeo Takahashi[1], Jun Kobayashi[1], and Issei Fujishiro[2]

[1] The University of Tokyo, Japan
[2] Keio University, Japan

Abstract. Volume datasets have been a primary representation for scientific visualization with the advent of rendering algorithms such as marching cubes and ray casting. Nonetheless, illuminating the underlying spatial structures still requires careful adjustment of visualization parameters each time when a different dataset is provided. This paper introduces a new framework, called feature-driven volume fairing, which transforms any 3D scalar field into a canonical form to be used as communication media of scientific volume data. The transformation is accomplished by first modulating the topological structure of the volume so that the associated isosurfaces never incur internal voids, and then geometrically elongating the significant feature regions over the range of scalar field values. This framework allows us to elucidate spatial structures in the volume instantly using a predefined set of visualization parameters, and further enables data compression of the volume with a smaller number of quantization levels for efficient data transmission.

1 Introduction

Volume datasets have become a primary representation of scientific data with the advent of visualization algorithms such as marching cubes and ray casting. Nonetheless, even with any visualization strategies, illuminating spatial structures inherent in such datasets clearly needs careful adjustment of visualization parameters. For example, transfer function design has intensively been studied in the computer visualization community since the late 1990's [1], while we still need to prepare different sets of visualization parameters when new datasets are provided.

This paper introduces a novel framework, called *feature-driven volume fairing*, which transforms any 3D scalar field into a canonical form to be used as communication media of scientific volume data. The transformation is accomplished by modulating arrangement of features in the volume, and thus allows us to easily visualize the modulated data with a set of naive visualization parameters. The key tool to our approach is the contour tree that enables systematic transformation of the given scalar field by accounting for the topological evolution of isosurfaces. The actual fairing process consists of three modulation steps; topological modulation, geometrical modulation, and smoothing modulation. The topological modulation transforms the given volume data so that the associated isosurfaces never incur internal voids as the scalar field value decreases. This is useful because we can intentionally discriminate such internal voids from their

A. Butz et al. (Eds.): SG 2009, LNCS 5531, pp. 233–242, 2009.

Fig. 1. Effects of volume fairing process for the nucleon dataset (of resolution 41^3) (http://www.volvis.org/). (a) An original volume dataset. (b) The dataset after topological modulation. (c) The dataset after geometrical modulation. (d) The dataset after smoothing modulation. Isosurfaces at uniformly spaced scalar field values (top), rendered image with periodical accentuated opacity transfer function (middle), and the corresponding contour trees while edges of internal voids are drawn in blue (bottom).

exterior layers in the rendering process after this modulation step. On the other hand, the geometrical modulation accentuates significant regions while suppressing the remaining regions, by rearranging their corresponding scalar field values to be spaced rather uniformly over their entire range. Finally, the modulated scalar field is smoothed out spatially by solving the Poisson equation based on the discrete differences between a pair of neighboring voxels. This threefold modulation process also allows us to compress the size of the datasets for efficient data transmission, just by cutting out a few lower quantization bits of all the bits for the entire range of scalar field values.

Fig. 1 presents the effects of our feature-driven fairing process for the nucleon volume dataset, where the two-body distribution probability of a nucleon in the atomic nucleus ^{16}O is simulated. We can notice from the figure that the modulated volume (Fig. 1(d)) can systematically reveal its unique internal structures while we are likely to miss them in the original dataset since the internal structures are occluded by multiple exterior isosurfaces (Fig. 1(a)).

Fig. 2. Schemes for transmitting scientific volume datasets. (a) The existing scheme. (b) Our new scheme.

Unlike the existing volume rendering scheme (Fig. 2(a)), once the sender/generator has successfully transformed the given volume dataset to its canonical form using the volume fairing technique, the receiver/user can instantly elucidate its associated features with a set of predefined visualization parameters (Fig. 2(b)). Providing effective data representation for this communication model is the primary issue to be tackled in this study.

This paper is organized as follows: Section 2 provides a brief survey on researches related to this work. Section 3 describes an algorithm for transforming the given volume dataset to its canonical form by modulating the arrangement of features over the range of scalar field values. Section 4 presents several experimental results together with an application to the data compression. Section 5 concludes this paper and refers to possible future developments of this work.

2 Related Work

Our research can be thought of as an attempt to leverage topological filtering for advancing *collaborative* volume exploration in *distributed* environments.

Facilitating collaborative volume exploration requires an effective way to share among colleagues, feature structures acquired from target volume datasets. An extreme case for this purpose is just to exchange resultant visualization images, at the sacrifice of progressive exploration style. Geometry fitting and arbitrary slicing have also been commonly used to provide an efficient interface for mutual understanding of explicitly-extracted features. Many reports on topological enhancements can be found in the literature, including topologically-enhanced isosurfacing [2], solid fitting [3], and cross-sectioning [4].

However, to avoid excess cutout of information at the sender side, and to expect further findings through the "first personal examination" at the receiver side, volumes themselves still serve as most meaningful communication media. Representative accompanying communication media used so far are transfer functions [1], which can convey the acquired volumetric features implicitly in

the form of color and opacity. Topological analysis has been used mostly in the context of transfer function design [5,6], whose merit lies in that the designed transfer functions can delineate global structures in the volume as well as its local features, thereby making good contrast with other transfer function design methods that only allow for local features such as curvature [7].

3 Feature-Based Volume Modulation

This section presents an algorithm for transforming a given volume dataset to its canonical form to provide a standard communication media for scientific data. As described earlier, the volume fairing consists of three stages: topological modulation, geometrical modulation, and smoothing modulation. In the remainder of this section, requirements for our approach are first described in Section 3.1 and then the details of the algorithm are provided through Sections 3.2-3.4.

3.1 Requirements

Here, we strive to summarize the list of requirements for the canonical representation of volume datasets in our framework. Our initial intention is to develop a standard representation of scientific volume datasets for elucidating significant features with a set of naive visualization parameters, even when the accompanying features are imperceptibly embedded in the 3D volumes. This means that, once a sender/generator successfully transforms the scientific volume data in such a way, a receiver/user significantly reduces his or her amount of user interaction for adjusting the visualization parameters. This will be the ideal communication scheme for exchanging scientific data we are going to pursue in this study.

In the present framework, the predefined setting of visualization parameters is assumed to be a set of scalar field values uniformly sampled over the entire range when extracting isosurfaces using the marching cubes algorithm, and periodically accentuated opacity and uniformly changed color transfer functions when rendering using the ray casting technique. This motivates us to elongate the regions of interest over the range of scalar field values, so that we can identify significant features even with the uniform sampling of the scalar field range.

The above transformation, which is referred to as *geometrical modulation* in this paper, can optimize the distribution of feature regions over the entire range of scalar field values. However, it cannot separate isosurfaces that compose a multi-layered structure. This case incurs undesirable results in the above framework since we cannot accentuate the internal features while suppressing their exteriors using naive one-dimensional transfer functions. For making full use of such naive transfer functions, our algorithm intentionally decomposes such a nested structure into distinct exterior and interior isosurfaces. This modulation, called *topological modulation* in this paper, rearranges the spatial structures in the volume dataset by successfully eliminating the multi-layered isosurface structure while maintaining the global isosurface evolution. Nonetheless, these processes cannot necessarily maintain the spatial smoothness in the volume data.

We alleviate this problem by postponing a smoothing modulation stage by taking advantage of the optimization process based on the Poisson equation.

This threefold modulation process will allow receivers/users to easily highlight significant features of a given dataset only with a set of naive visualization parameters, irrespective of what the sender/generator did in the volume faring process beforehand. An outgrowth of this fairing process is the ability to reduce the data size by simply cutting out a few lower quantization bits of all the bits for the entire dynamic range of scalar field values. This consequently enables efficient data transmission through the network.

3.2 Topological Modulation

The topological modulation transforms the topological transitions of isosurfaces in order to eliminate inclusion relationships among significant isosurfaces at any scalar field value. For that purpose, we introduce a contour tree representation [2,8] since it faithfully represents such topological transition of isosurfaces. Fig. 3(a) represents an example of such a contour tree representation while the positions of the associated nodes, which correspond to topological changes in the isosurfaces, are arranged from top to bottom as the corresponding scalar field value decreases. Actually, the topological modulation is equivalent to converting each downward branch of the contour tree in Fig. 3(a) (in blue) to an upward branch (in orange) as shown in Fig. 3(b). This is fully justified because the downward branches inevitably introduce internal voids into some exterior isosurfaces by taking account of their spatial embeddings into 3D space [3,6]. In addition, this rearranged contour tree allows us to peel the given volume from outside to inside by tracking the tree from bottom to top. For example, as shown in Fig. 3, the internal void outlined in red has successfully been transformed to the solid part.

(a) (b)

Fig. 3. Contour trees (a) before and (b) after topological modulation: (a) A downward branch represents the topological transition where some isosurface is about to have internal voids. (b) By converting the downward edges (in blue) to upward ones (in orange), we can eliminate the multi-layered isosurface structure.

The actual conversion process of the contour tree begins with identifying the extremal node that corresponds to the outermost isosurface of the given volume (Fig. 3(a)). We then traverse the tree using this extremal node as a starting point, and update the height coordinate of each intermediate node with its geodesic distance from the starting node on the contour tree. This coordinate transformation along with an appropriate normalization of the height range will provide us with the final topologically modulated contour tree (Fig. 3(b)). Note that we employ the algorithm in [5] for extracting the simplified version of the contour trees, in order to delineate the global topological transitions of isosurfaces embedded in the given volume data. Fig. 1(b) represents the nucleon dataset and its contour tree after the topological modulation process.

3.3 Geometrical Modulation

The next task is to conduct the geometrical modulation, which elongates the feature regions while preserving their relative order over the range of scalar field values. This makes it possible to retrieve the important configuration of isosurfaces by rather sparsely sampling the range of scalar field values. For finding well-balanced distribution of such features over the range, we first suppose a function $y = f(x)$ that maps the current scalar field value x to its modulated value y. The geometrical modulation begins with the preparation of an initial linear mapping between x and y (Fig. 4(a)), and its associated constant derivative (Fig. 4(b)). The derivative is then accentuated around some specific feature values by adding Gaussian-like kernel distributions accordingly (Fig. 4(c)). The final mapping $y = f(x)$ between the original and modulated scalar field values is obtained by integrating the above accentuated derivatives, followed by the normalization of the modulated dynamic range of the scalar field values (Fig. 4(d)).

In our framework, saddle critical values comprising isosurface splitting and merging are used as feature values (in red in Fig. 4(c)) to be accentuated in the volume fairing process. This is reasonable because we can illuminate the spatial configuration of feature isosurfaces easily with the predefined setting of

Fig. 4. Geometrical modulation. (a) An initial linear mapping between the old and new scalar field values. (b) Its constant derivative. (c) The accentuated derivative by adding Gaussian-like kernel function around the feature values (in red). (d) The final feature-driven modulation of scalar field values.

Table 1. Computation times (in seconds)

Dataset	Size	Topological	Geometrical	Smoothing	Total
Nucleon	41^3	5.06	0.01	0.18	5.24
Analytic function	33^3	1.01	0.01	0.09	1.11
Proton & hydrogen-atom	61^3	1.99	0.02	1.32	3.33
Anti-proton & hydrogen-atom	129^3	17.29	0.17	144.84	162.30

visualization parameters. Fig. 1(c) represents the contour tree and its associated visualization results after the geometrical modulation.

3.4 Smoothing Modulation

Basically, the volume fairing process has been done by modulating the associated contour tree as described above, and then the scalar field value of each voxel is changed accordingly by referring to the corresponding node on the modulated contour tree. Nonetheless, only with this modulation, the resultant 3D scalar field is not necessarily smooth enough, and thus contains unexpected artifacts as shown in Fig. 1(c). For removing such artifacts, we postponed an optimization process based on the Poisson equation. Such optimization processes have been introduced in the high dynamic range data compression [9], and further applied to the compression of depth information such as the range image data compression [10,11]. The present approach, on the other hand, tries to develop a method of smoothing out the input 3D scalar field while referring to the modulated contour tree as guidelines for the coherent fairing.

The actual reconstruction of the 3D scalar field is accomplished by integrating the given gradients while minimizing the associated integration errors. Solving the following Poisson equation allows us to obtain the optimized 3D field of scalar values $f(x, y, z)$:

$$\nabla^2 f = div\,\mathbf{g}, \quad \text{where} \quad \mathbf{g} = \nabla f = (\frac{\partial f}{\partial x}, \frac{\partial f}{\partial y}, \frac{\partial f}{\partial z}). \tag{1}$$

Here, each of the partial derivatives can be obtained by calculating the discrete central difference in the corresponding scalar field value. Note that, for solving the Poisson equation in (1), we introduce a Neumann boundary condition to the outermost voxels of the given dataset. By solving the Poisson equation, we can reconstruct the smooth 3D scalar field, as shown in Fig. 1(d).

4 Results

This section provides several experimental results to demonstrate the effectiveness of the present framework. Note that all the given volume datasets are assumed to have an 8-bit quantization representation (256 discrete levels) of the scalar field values. Our prototype system has been implemented on a laptop PC

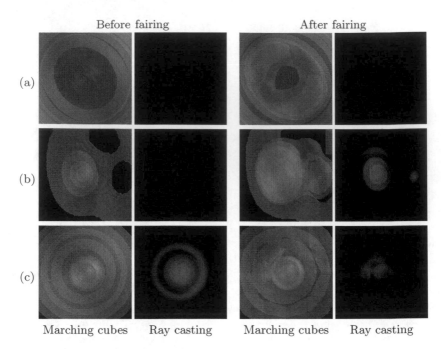

Fig. 5. (a) Analytic function dataset (of resolution 33^3), (b) proton and hydrogen-atom collision dataset (of resolution 61^3), and (c) anti-proton and hydrogen-atom collision dataset (of resolution 129^3), before and after the volume fairing process. Isosurfaces at uniformly spaced scalar field values (left), and rendered image with periodical opacity transfer function (right) in each column.

with Intel Core2Duo T9500 CPUs running at 2.60GHz and 4GB RAM. Table 1 summarizes the computation times required for each of the three modulation processes on the above computational environment.

4.1 Visualizing Modulated Datasets

Let us examine how the present volume fairing scheme will alleviate the need to adjust the visualization parameters. For each case, we applied the marching cubes algorithm for isosurface extraction, and the ray casting algorithm for illuminating internal structures. For extracting isosurfaces, we uniformly sample the entire range of scalar field values to reveal isosurface transition. For illuminating the spatial structures with cast rays, we employ an opacity transfer function where hat-like elevations are placed at even intervals over the entire range of the scalar field values. Note that the color transfer function is set to be a naive one where the hue is uniformly changed over the scalar field range.

Furthermore, for each rendering process, we put more emphasis on voxels having larger scalar field values because, in our setting, interior feature regions have larger scalar field values than the exterior regions. For example, we assign more alpha values to isosurfaces at larger scalar field values, and we augment

Fig. 6. Compression of the nucleon dataset by cutting off lower quantization bits. The original dataset (top) and the modulated dataset (bottom).

the height of the hat-like elevation in the opacity transfer function as the scalar field value increases.

Fig. 5 presents visualization results of the analytic function (Fig. 5(a)), proton and hydrogen-atom collision (Fig. 5(b)), and anti-proton and hydrogen-atom collision datasets (Fig. 5(c)), before and after the volume fairing process was conducted. The modulated datasets can exhibit clear views of the configuration of feature isosurfaces while the original dataset often fails to illuminate important features in the associated rendering results. Note that the anti-proton and hydrogen-atom collision dataset contains a fourfold nested structure of isosurfaces, which has not been appropriately visualized so far without the use of more visualization parameters for multi-dimensional transfer functions.

4.2 Data Compression

Our volume faring process provides a well-balanced distribution of scalar field values, and thus the resultant canonical dataset can readily be compressed by simply cutting out lower quantization bits for the scalar field values, while still maintaining the global features embedded in the original dataset. Fig. 6 represents the rendered image obtained from the original and compressed nucleon dataset through the aforementioned setting of transfer functions. The figure indicates that the important nested structure in the original dataset has been obscured when the number of quantization bits is reduced to 4, while the modulated dataset still retains a clear view of such features in a reasonable manner.

5 Conclusion and Future Work

This paper has presented a new framework, called feature-driven volume fairing, which allows us to illuminate the underlying features in the scientific volume datasets with naive visualization parameters once the datasets have been appropriately transformed to their canonical forms. The transformation has been

accomplished by modulating the topological structure of the given volume first, then by elongating scalar field ranges containing significant features, and finally by smoothing the spatial distribution of scalar field values. Several experimental results suggest that the present methodology has the potential to serve as an efficient communication model of the scientific data through the network.

One interesting extension of this work is to accommodate more complicated datasets such as multivariate and time-varying volumes. Smoothing non-grid voxel samples with the Poisson equations should be handled. More sophistication of the system interface also remains to be investigated. The implementation of a more systematic data transmission together with the capability of demand-driven data queries poses another potential extension of the present framework.

Acknowledgements. This work was partially supported by Grants-in-Aid for Scientific Research (B) No. 18300026 and No. 20300033.

References

1. Pfister, H., et al.: The transfer function bake-off. IEEE Computer Graphics & Applications 21(3), 16–22 (2001)
2. Bajaj, C.L., Pascucci, V., Schikore, D.R.: The contour spectrum. In: Proc. IEEE Visualization 1997, pp. 167–173 (1997)
3. Takahashi, S., Fujishiro, I., Takeshima, Y.: Interval volume decomposer: A topological approach to volume traversal. In: Proc. SPIE Conf. Visualization and Data Analysis 2005., vol. 5669, pp. 103–114 (2005)
4. Mori, Y., Takahashi, S., Igarashi, T., Takeshima, Y., Fujishiro, I.: Automatic cross-sectioning based on topological volume skeletonization. In: Butz, A., Fisher, B., Krüger, A., Olivier, P. (eds.) SG 2005. LNCS, vol. 3638, pp. 175–184. Springer, Heidelberg (2005)
5. Takahashi, S., Takeshima, Y., Fujishiro, I.: Topological volume skeletonization and its application to transfer function design. Graphical Models 66(1), 22–49 (2004)
6. Takeshima, Y., Takahashi, S., Fujishiro, I., Nielson, G.M.: Introducing topological attributes for objective-based visualization of simulated datasets. In: Proc. 4th International Workshop on Volume Graphics (VG 2005), vol. 236, pp. 137–145 (2005)
7. Kindlmann, G., Whitaker, R., Tasdizen, T., Moller, T.: Curvature-based transfer function for direct volume rendering: Methods and applications. In: Proc. IEEE Visualization 2003, pp. 513–520 (2003)
8. Carr, H., Snoeyink, J., Axen, U.: Computing contour trees in all dimensions. Computational Geometry: Theory and Applications 24(2), 75–94 (2003)
9. Fattal, R., Lischinski, D., Werman, M.: Gradient domain high dynamic range compression. ACM Trans. Graphics 21(3), 249–256 (2002)
10. Kerber, J., Belyaev, A., Seidel, H.P.: Feature preserving depth compression of range images. In: Proc. 23rd Spring Conf. Computer Graphics, pp. 110–114 (2007)
11. Weyrich, T., Deng, J., Barnes, C., Rusinkiewicz, S., Finkelstein, A.: Digital bas-relief from 3D scenes. ACM Trans. Graphics 26(3), Article No. 32 (2007)

GPSel: A Gestural Perceptual-Based Path Selection Technique

Hoda Dehmeshki and Wolfgang Stuerzlinger

Department of Computer Science and Engineering
York University, Toronto, Canada
hoda@cse.yorku.ca
www.cse.yorku.ca/~wolfgang

Abstract. This paper introduces a gestural perceptual-based approach
to select objects, i.e., nodes and/or edges along paths. Based on known
results from perception research, we propose a model to detect perceptu-
ally salient paths formed by the Gestalt principles of good continuity and
closure. Then we introduce gestural interaction techniques that enable
users to select single or multiple perceptual paths, as well as resolving
ambiguities in selection. The result of a user study shows that our system
outperforms current techniques for path selection.

1 Introduction

Node-link diagrams are fundamental tools to visualize relational data. Objects
and their relationships are depicted as nodes and edges, respectively. Such dia-
grams are used in a large variety of application domains such as software engi-
neering, social network analysis, and data modeling.

Many algorithms for drawing comprehensive graphs by minimizing certain
aesthetic criteria such as edge crossing and bending [4] have been developed.
However, it is not always computationally feasible to find an optimum solution
that satisfies all criteria. Hence users often direct the algorithm by relocating
groups of objects (i.e., nodes and/or nodes) or imposing constraints [8,25,19,23].
Both alternatives require manual selection of object groups. Group selection is
also required prior to many standard operations such as deletion, translation,
annotation, changing properties, rotation, navigation [16] and zooming [6].

In graphical user interfaces, standard group selection techniques are shift-
select, rectangle selection, and lasso. Shift-select, i.e., clicking on objects while
holding the Shift key down, is impractical if the number of targets is large. In
rectangle selection, the user performs a drag operation along the diagonal of
the selection region. This technique works poorly in the graph domain, because
the frequent presence of nearby non-targets often necessitates subsequent de-
selection(s) or disjoint selection steps. Also, layouts are often non-axis aligned.
Lasso involves dragging a closed path around the targets, while avoiding inclusion
of none-targets. Auto-complete lasso [22] automatically closes the path as the
user performs a lasso, which makes it more efficient. As explained by the Steering

A. Butz et al. (Eds.): SG 2009, LNCS 5531, pp. 243–252, 2009.

law [1], lasso tends to be inefficient for path selection, especially for long paths, since nearby distracters make the traversal "tunnel" small, which necessitates a reduction of movement speed.

This paper introduces a new gestural path selection technique called *GPSel*. Based on established models from perception research, we present an algorithm to detect salient perceptual paths formed by the Gestalt principles of good continuity and closure. Then, we introduce gesture-based interaction techniques which allow users to select (partial or complete) good continuity paths, multiple paths, and resolving ambiguities. Finally we present a user study that shows GPSel outperforms current techniques for visually salient groups.

2 Related Work

2.1 Perceptual Grouping in Graphs

Perceptual grouping is defined as the human ability to detect structure(s) among visual items. The most fundamental approach for perceptual grouping is Gestalt psychology, which is described via a set of principles [18]. This paper focuses on two prominent principles: good continuity and closure. Good continuity states that visual items which are along smooth curves are perceived as a group. Closure states that the humans visual system tends to seek closed areas.

The good continuity principle has been used in graph drawing algorithm as it significantly improves comprehension of graphs [21,24] and recognition of shortest paths [29]. It also has been used to make certain paths more apparent, see Fig. 1. Two important aesthetic criteria that are frequently employed by graph drawing algorithms are to minimize the number of bends in polyline edges [28] and to maximize the *angular resolution* [15]. Angular resolution refers to the minimum angle between two edges sharing a node. These criteria try to keep paths as straight as possible. Hence, they create perceptual groups of objects, i.e., nodes or edges, which conform to the Gestalt principle of good continuity.

Fig. 1. The effect of good continuity on graph comprehension. Perceiving the shortest path between nodes x and a is significantly easier than that between nodes x and b.

2.2 Good Continuity Group Detection

Extracting linear and curvilinear structures from edges or dots has been intensively studied both in computer vision and perception research. Studies in

computer vision have suggested that grouping edges into (curvi-)linear structures is based on local rather than global straightness and smoothness [3,5,14]. This idea has been supported by several experimental studies in perception research [12,9,11,10]. Field *et al.* conducted several experiments to determine the rules that govern the perception of good continuity groups [12]. The results show that the ability to detect a path is significantly reduced when the relative orientation between successive elements differs by more than 30°. Also, "end-to-end" alignment of the elements significantly increases the observer's ability to perceive them along a path. Feldman presented a mathematical model for subjective judgment of curvilinearity among three and four dots [9,11]. The model is a gaussian function of angles between successive dots. Experimental results in [10] suggests that perceived curvilinear configuration can be accurately modeled using a *local* 4-dot window moving along the chain of dots.

2.3 Interaction Techniques for Path Selection

The standard techniques for selection in graphical user interfaces are rectangle selection and lasso. However, these two techniques are not very well suited to path selection. Several researchers designed techniques to target this problem.

Accot and Zhai introduced a novel technique where the user drags a continuous gesture across all desired objects [2]. Their technique is time consuming and error-prone when there are too many targets, the size of each object is small, or the targets are spread over a large distance. Saund and Moran [27] developed a technique for the selection of contour groups in freehand sketch editors, called path tracing. In this technique, users can select a group by drawing a gesture that traces an approximate path over the target group. This technique can be applied in the graph domain. However, in the presence of nearby distracters the gesture has to be similar in shape and size to the target path. Hence, similar to Accot's work [2], it is inefficient when selecting a long path.

A number of advanced graph editors provide semi-automatic path selection techniques that leverage internal information in graphs. One commonly-used approach is text querying where the user types in specific information about the desired path and runs a query. This technique requires both the user and the system to have a deep understanding of the content visualized in the graph.

Google Maps takes a more interactive approach in its Route Planning system: the user types in a source and a destination address; the system computes and suggests the fastest route between them. The user can then iteratively modify the route by clicking on it and dragging the mouse/pen over a point (called a waypoint) on the desired route. After each modification, the system re-computes and suggests a new route composed of shortest paths between waypoints (including the source and destination). This technique is application-dependant and also limited to selection of shortest paths. If the user has other criteria in mind (e.g., a path going through parks and green areas for cycling or the path with the least turns) the technique will often require too many waypoints.

Dehmeshki and Stuerzlinger developed a system that introduces perceptual-based object group selection techniques in a traditional desktop system, i.e. with

a mouse as input device [7]. It utilizes a nearest neighboring graph to detect (curvi-)linear groups, and proposes a set of click-based interaction techniques to select among the detected group(s). Three key elements distinguish this system from the new work presented here. First, the mouse-based system is based on a model that depends also on inter-object distances, to be able to deal with object clusters. This is not really appropriate for the graph domain. Second, the system relies heavily on double- and triple-clicks, which is not appropriate for pen-based systems. Lastly, the user interface of the mouse-based system selects all groups that an object belongs to, but does not consider the direction of the grouping. This increases the need to disambiguate the selection, which results in more user effort. In the present system, the use of gestures with their *inherent* directionality greatly reduces the effort to specify the group the user intends to select.

3 GPSel: Gestural Interaction

3.1 Good Continuity Path Selection

To select a *complete* good continuity path, the user performs a straight gesture crossing one of the end nodes, called *anchor*, in the same direction as the target path. The technique uses a method to detect good continuity paths starting from the anchor, which will be described later in this document.

To select a *partial* good continuity path, the user first selects the complete path, then limits the selection by performing a second straight gesture across the last target node and in the opposite direction of the first gesture. All objects between the first and the second gestures remain selected, while objects beyond the second gesture are de-selected. Figure 2 shows an example: in Fig. 2-a, the user makes a flick gesture over node $N1$ to select the diagonal path. In Fig. 2-b, the path corresponding to the selection is highlighted. In Fig. 2-c, the user performs a second gesture starting on node $N2$. As shown in Fig. 2-d, nodes between $N1$ and $N2$ remain selected, while nodes beyond $N2$ are de-selected.

Fig. 2. Good continuity path selection. a) The user performs a straight gesture crossing node *N1* along the diagonal path. b) The path is selected. c) Performing a second gesture starting on object $N2$ deselects objects beyond it, shown in d).

3.2 Resolving Ambiguity in Path Selection

When a gesture corresponds to multiple good continuity paths, GPSel selects all of them, and allows the user to disambiguate by performing another gesture over a node that belongs to the target path. Figure 3 illustrates an example: performing a gesture over node $N1$ selects both good continuity paths sharing $N1$; performing another gesture over node $N2$ deselects the undesired branch.

Fig. 3. Resolving ambiguity. a) Targets are shown with thick borders. b) Performing a gesture on $N1$ selects its two corresponding perceptual paths. c) A second gesture over node $N2$ deselects the undesired sub-path, as shown in (d). Graph from [17].

3.3 Compact Cyclic Path Selection

Our interaction technique also enables the user to select compact cyclic paths. In its simplest form, a circular gesture in the interior region of a closed path selects that path. If the gesture is performed *around* a node or *over* an edge, all objects along the closed paths shared by that object are selected. This interaction technique works only for planar areas, i.e., no crossing edges. This is not a significant limitation as planarity is by far the most important aesthetic criterion [24] and hence one of the main design criteria for graph drawing algorithms. Figure 4 shows three examples of cyclic path selection.

Fig. 4. Examples of Cyclic Path Selection. A circular gesture (a) in an interior area, (b) around a node or, (c) on an edge selects the corresponding cyclic paths.

3.4 Edges vs. Nodes Group Selection

The above interaction techniques select both the corresponding nodes *and* edges by default. In order to select only nodes or edges, GPSel utilizes a marking menu [20]. If the user holds the pen still for a short interval of time (approximately one third of a second) a marking menu with three items 'select edges', 'select nodes', and 'select both' appears under the pen's tip. The user then selects a menu option by making a straight gesture towards the desired item. Expert users who know the location of an item can select it by immediately moving toward the item before the menu appears.

4 GPSel: Detecting Groups

4.1 Good Continuity Group Detection

The algorithm computes a linear coefficient (LC) for each set of four nodes which are along any paths that starts from the anchor node and is aligned with the direction of the gesture. This coefficient indicates how strongly the nodes are perceived as a straight line. LC is defined by:

$$LC = \exp\left(-\frac{(a1^2 + a2^2 - 2ra1a2)}{2s^2(1 - r^2)}\right),$$

where $a1$ and $a2$ are angles between successive edges (see Fig. 5), r and s are constants. This is based on Feldman's model for linear grouping of four consecutive dots [11]. For groups of only 3 nodes a simpler formula is used [9].

Fig. 5. Illustration of parameters used in the definition of collinearity

We extended this idea to model arc groupings. In the above equation, we substitute every inter-line angle α_i by $(\alpha_i - \alpha_{Avg})$ where α_{Avg} is the average of all line angles α_i's. Hence, a uniform curvilinear path gets a higher grouping coefficient than a sinuate path.

In an extra step, the initial collinear and curvilinear sets are repetitively merged to form longer groups.

4.2 Compact Cyclic Path Group Detection

We employ an effective algorithm for detecting compact cyclic paths [26]. When the user performs a circular gesture, the algorithm finds the closest node and its closest edge to the gesture. Then it starts tracing a path from the detected node and the edge. If there are multiple paths originating from a node, it selects the edge that has maximum turning toward the gesture.

5 Experiment

We conducted a within subject study to assess the efficiency of GPSel for se-
lecting *good continuity* paths in comparison to rectangle selection and lasso. We
considered rectangle selection and lasso as comparison points, since these are
the standard techniques supported by almost all graph editors.

Generating Test Graphs

Since we were interested in evaluating the performance of our technique in a
practical application context we focused on automatically drawn graphs based on
real data sets. The graphs were undirected and abstract. On average, they had 41
nodes and 46 edges. Figure 6 shows several examples. While randomly generated
graphs seem to be a feasible alternative, they are typically not representative of
real data.

Fig. 6. Example graphs used in the experiment

Tasks

In each task, the participants were shown a graph and asked to select targets
(a good continuity path or a closed loop) using auto-complete lasso, rectangle
selection, or GPSel. Targets and distracters were displayed in green and black,
respectively. If only targets were selected, a brief sound was played and the
experiment moved on to the next task. Selection time was measured from the
first pen down event after a graph was displayed to the time when the targets
were selected.

Hypothesis

We hypothesized that GPSel is significantly faster than lasso and rectangle se-
lection. The reason is that it requires only a flick gesture, whereas the other

two require tracing the whole path in different ways. Moreover, the presence of nearby distracters increases the difficulty of rectangle selection and lasso.

Experimental Design

We used a fully crossed within-participant factorial design. There were two independent variables: Selection Technique (GPSel, auto-complete lasso, and rectangle selection) and Target Length (small ≈ 250, medium ≈ 400, and large ≈ 750 pixels). The dependant variable was Selection Time. We used a 3x3 Latin Square to counterbalance the order of selection techniques. Participants were first trained for 10-20 minutes on all three techniques with 7 practice layouts. The main experiment used 12 different graphs which were shown for each technique. This sequence was then repeated 3 times. Hence, each participant performed a total of $12 \times 3 \times 3 = 108$ selections during the main experiment.

Apparatus

The experiments were conducted on a Tablet-PC with a Pentium M 1.6 Ghz processor and 1 GB memory. Screen resolution was set to 1024x768 and a pen was used as input device. The software was written in Python and Tkinter.

Participants

Twelve students from a local university campus were recruited to participate in the experiment. None of them had used our technique before. Most of them were unfamiliar with auto-complete lasso.

Results

The repeated measures ANOVA reveals that there is a significant difference between techniques, $F_{2,22} = 4.32, p \ll 0.001$. The mean selection time for GPSel is 0.305 seconds, whereas the means for lasso and rectangle selection are 3.242 and 3.445 seconds, respectively, see Fig. 7-Left. According to a Tukey-Kramer test, only the difference between GPSel and the other two is significant.

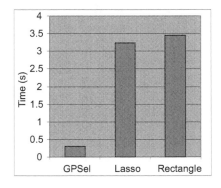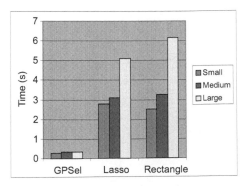

Fig. 7. Left: Comparing average Selection Time among Techniques. Right: The effect of Targets Length on Selection Time for each Technique.

There is a strong interaction between Selection Time and Target Length $F_{4,44} = 12.90, p \ll 0.001$. While Target Length had no effect on GPSel, it dramatically increased lasso and rectangle selection time, see Fig. 7-Right.

6 Discussion

The most likely explanation for the results is that GPSel requires considerably shorter pen movement and hence significantly reduces the user's effort. For rectangle selection, the user has to traverse at least the diagonal of the area covered by the target group, while for lasso selection, the user has to traverse at least a major portion of the circumference of the area.

The trial graphs ranged from small to average size. We believe that GPSel can be easily applied to reasonably sized graphs, i.e, graphs that fit on a single screen with readable labels. This is often defined to mean up to approximately 100 nodes [13]. While the computation in GPSel is affected with increasing degrees for nodes, our pilot study shows that the delay introduced by the computation is small enough to be unnoticeable.

7 Conclusion and Future Work

This paper introduces GPSel, a novel perceptual-based approach for path selection in graphs. This technique enables users to select perceptually salient paths by just drawing gestures over nodes and edges. Our user study showed that it outperforms current techniques for selecting complete salient paths.

As future work, we plan to extend the current system to facilitate selection of groups with arbitrary configurations. Additionally, we will do a complete user study to asses GPSel in other scenarios, such as partial and arbitrary paths selection. Finally, we plan to investigate extensions to cover large graphs, directed graphs, and graphs with different vertex types.

References

1. Accot, J., Zhai, S.: Beyond fitts' law: models for trajectory-based hci tasks. In: CHI, pp. 295–302 (1997)
2. Accot, J., Zhai, S.: More than dotting the i's — foundations for crossing-based interfaces. In: CHI, pp. 73–80 (2002)
3. Alter, T.D., Basri, R.: Extracting salient curves from images: An analysis of the saliency network. Int. J. Computer Vision 27(1), 51–69 (1998)
4. Battista, G., Eades, P., Tamassia, R., Tollis, I.: Graph Drawing: Algorithms for the Visualization of Graphs. Prentice-Hall, Englewood Cliffs (1999)
5. Boldt, M., Weiss, R., Riseman, E.M.: Token-based extraction of straight lines. IEEE Trans. Systems, Man and Cybernetics 19(6), 1581–1594 (1989)
6. Carriere, J., Kazman, R.: Interacting with huge hierarchies: Beyond cone trees. In: Information Visualization, pp. 74–81 (1995)
7. Dehmeshki, H., Stuerzlinger, W.: Intelligent mouse-based object group selection. In: Smart Graphics, pp. 33–44 (2008)

8. Dengler, E., Friedell, M., Marks, J.: Constraint-driven diagram layout. In: Visual Languages (1993)
9. Feldman, J.: Perceptual models of small dot clusters. Partitioning Data Sets: DI-MACS Series in Discrete Math. and Theoretical Computer (63), 1171–1182 (1995)
10. Feldman, J.: Bayesian contour integration. Perception and Psychophysics (63), 1171–1182 (2001)
11. Feldman, J.: Curvelinearity, covariance, and regularity in perceptual groups. Vision Research 37(20), 2835–2848 (1997)
12. Field, D.J., Hayes, A., Hess, R.F.: Contour integration by the human visual system: Evidence for a local association field. Vision Research 33(2), 173–193 (1993)
13. Gansner, E., North, S.: An open graph visualization system and its applications to software engineering. Software Practice and Experience 30(11), 1203–1233 (2000)
14. Gigus, Z., Malik, J.: Detecting curvilinear structure in images. Technical report, EECS Department, University of California, Berkeley (1991)
15. Gutwenger, C., Mutzel, P.: Planar polyline drawings with good angular resolution. In: Whitesides, S.H. (ed.) GD 1998. LNCS, vol. 1547, pp. 167–182. Springer, Heidelberg (1999)
16. Henry, T., Hudson, S.: Interactive graph layout. In: UIST, pp. 55–64 (1991)
17. Kamada, T., Kawai, S.: An algorithm for drawing general undirected graphs. Information Processing Letters 31(1), 7–15 (1989)
18. Koffka, K.: Principles of Gestalt Psychology. Routledge and Kegan Paul (1935)
19. Kosak, C., Marks, J., Shieber, S.: Automating the layout of network diagrams with specified visual organization. IEEE Trans. Systems, Man and Cybernetics 24(3), 440–454 (1994)
20. Kurtenbach, G., Buxton, W.: The limits of expert performance using hierarchic marking menus. In: CHI, pp. 482–487 (1993)
21. Lemon, K., Allen, E., Carver1, J., Bradshaw, G.: An empirical study of the effects of gestalt principles on diagram understandability. In: ESEM, pp. 156–165 (2007)
22. Mizobuchi, S., Yasumura, M.: Tapping vs. circling selections on pen-based devices: evidence for different performance-shaping factors. In: CHI, pp. 607–614 (2004)
23. Nascimento, H., Eades, P.: User hints for directed graph drawing. In: Goodrich, M.T., Kobourov, S.G. (eds.) GD 2002. LNCS, vol. 2528, pp. 205–219. Springer, Heidelberg (2002)
24. Purchase, H.: Which aesthetic has the greatest effect on human understanding. In: DiBattista, G. (ed.) GD 1997. LNCS, vol. 1353, pp. 248–261. Springer, Heidelberg (1997)
25. Ryall, K., Marks, J., Shieber, S.: An interactive constraint-based system for drawing graphs. In: UIST, pp. 97–104 (1997)
26. Saund, E.: Finding perceptually closed paths in sketches and drawings. IEEE Trans. Pattern Anal. Mach. Intell. 25(4) (2003)
27. Saund, E., Moran, T.: A perceptually-supported sketch editor. In: UIST, pp. 175–184 (1994)
28. Tamassia, R.: On embedding a graph in the grid with the minimum number of bends. SIAM J. Comput. 16(3), 421–444 (1987)
29. Ware, C., Purchase, H., Colpoys, L., McGill, M.: Cognitive measurements of graph aesthetics. Information Visualization 1(2), 103–110 (2002)

Sketch-Based Interface for Crowd Animation

Masaki Oshita and Yusuke Ogiwara

Kyushu Institute of Technology
680-4 Kawazu, Iizuka, Fukuoka, 820-8502, Japan
oshita@ces.kyutech.ac.jp, ogiwara@cg.ces.kyutech.ac.jp

Abstract. In this paper, we propose a novel interface for controlling crowd animation. Crowd animation is widely used in movie production and computer games. However, to make an intended crowd animation, a lot of agent model parameters have to be tuned through trial and error. Our method estimates crowd parameters based on a few example paths given by a user through a sketch-based interface. The parameters include guiding paths, moving speed, distance between agents, and adjustments of the distance (crowd regularity). Based on the computed parameters, a crowd animation is generated using an agent model. We demonstrate the effectiveness of our method through our experiments.

Keywords: Crowd Animation, Sketch-based Interface, Agent Model.

1 Introduction

Recently, crowd animation has been widely used for movie production and computer games. Using crowd animation techniques, a user can create an animation in which a large number of characters move around and interact with each other for scenes such as soldiers in combat, pedestrians on a street, stadium audiences, etc. Crowd animation can be created using commercial or in-house animation systems. For the majority of systems, an agent model [1][2] is used for controlling characters (agents). An agent model controls individual agents based on application dependent rules such as following a leader, keeping a distance between other agents, avoiding obstacles, etc. As a result of the movements of individual agents, a natural crowd behavior is generated. However, to make an animation, a user has to tune various parameters for the agent model such as initial positions, paths, moving speed, distance, etc. These parameters are usually tuned through a graphical user interface which the animation system provides. Because a small parameter change can cause a drastic change in the animation, and users cannot predict the result when they change a parameter, the parameter tuning process can be very arduous work.

To solve this problem, we propose a crowd animation system in which users can specify the parameters intuitively thorough a sketch-based interface using a pen-tablet or mouse device (Figure 1). A user of our system is asked to give a few example paths for the agents to roughly follow. The system automatically estimates parameters that satisfy given paths. Based on the given paths, parameters such as guiding path,

A. Butz et al. (Eds.): SG 2009, LNCS 5531, pp. 253–262, 2009.

(a) input paths

Fig. 1. Overview of our system. The parameters for crowd control are estimated from a few example paths that are given by a user (a). Based on the parameters and an agent model, a crowd animation is generated (b). The user can make a crowd animation interactively.

moving speed, standard distance between agents, and distance deviation are computed. By using the estimated parameters and the agent model, a crowd animation is generated. Using our system, a user can make crowd animations interactively by giving just a few example paths.

In this paper, we describe our interface design (Section 3), the parameters that our method uses and how to compute them (Section 4), and our agent model (Section 5). We also show experimental results and the effectiveness of our system (Section 6).

2 Related Work

Crowd animation is an important topic in the computer graphics field. There has been a lot of research on crowd animation. As explained in the previous section, agent models have been widely used in research [1][2]. More advanced crowd models such as path planning, collision avoidance and vision-based control have also been developed.

Currently, an animator can make a crowd animation using commercial animation systems such as Maya, Max, or Softimage. However, they have to describe scripts for a crowd model and for the user interface. This is a very tedious task. Recently, an animation system specializing in crowd animation, MASSIVE [3], has been widely used for movie production. MASSIVE employs an agent model that uses sophisticated decision rule trees. A user can edit the decision rule trees using a graphical interface. However, it is difficult to construct or modify these.

There has been research on user interfaces for controlling animated crowds. Ulicny et al. [4] proposed a brush interface with which a user can specify parameters for individual agents in a crowd by painting them. However, the parameter values that are applied to these agents have to be set with a conventional interface. Moreover, the user cannot specify crowd movements such as individual paths, speed, distance between agents, regularity of crowd, etc., because those parameters not only depend on agents but also depend on positions in the scene. Sung et al. [5] proposed a crowd animation system in which a user can specify agent behaviors on each region of a

scene. However, the user cannot specify parameters and behaviors which depend on the agents themselves. Moreover, the user still has to specify rules and parameters for each region manually.

There is also research into automatic estimation of crowd parameters. Several research groups [6][7][8] proposed methods for making a crowd animation based on movies of real pedestrians shot from above. Their methods estimate the moving velocity and direction of each point in the scene. Agents are controlled based on the computed vector field. Their method can make a natural crowd animation based on real pedestrians. However, a user has to prepare a movie of pedestrians, which is difficult to shoot. Jin et al. [9] proposed a crowd animation system in which a user can specify the moving velocity and direction on any point in the scene. The system generates a vector field for crowd control. These methods can control crowd movements such as paths and widths of crowds. However, they cannot control detailed agent movements such as distance between agents and regularity of agents, both of which our method can control. In addition, our method determines such parameters based on the example paths given by the user.

3 Interface Design

Our system is designed so that the user's intention is reflected in the generated animation. In this section, we describe the interface design and explain how it works. The implementation is explained in the following sections.

A user of our system is asked to input one primary path and a few additional paths as example paths for the crowd. The primary path (red path in Figure 1 (a)) specifies the rough path of the overall crowd. The additional paths (blue paths in Figure 1 (a)) are for specifying the crowd behaviors or paths of individual agents in more detail.

First, a user can specify the initial distribution of agents by drawing an outline of the region where the user wants to put the agents. The user then inputs one primary path and any additional paths. The system generates a new crowd animation when the user inputs new paths. The user can also undo and redo the paths. Therefore, the user can create a crowd animation in an interactive manner.

The general path and moving speed are controlled by the primary path. The crowd follows the primary path, and the moving speed of agents is based on the input speed. The agents walk slowly where the user inputs the path slowly.

The distances between agents, regularity of distances, and individual paths are controlled by the additional paths. First, the distances between agents varies based on the width of all given paths. As shown in Figure 2, when the width of the paths is wide, the agents spread out, and when the width is narrow, the agents get closer to each other. We designed this interface because we can assume that users usually intend to spread the agents out when they specify wide paths.

Second, the regularity varies based on the smoothness of the additional paths. As shown in Figure 3, where the paths are rough (zigzag), the agents move irregularly, which means that the distances between agents are not uniform. On the other hand, where the paths are smooth, the agents keep the distances between each other uniform.

(a) spread crowd (b) close crowd

Fig. 2. Control of the distance between agents

(a) irregular crowd (b) regular crowd

Fig. 3. Control of the regularity of agents

(a) agent paths of two additional paths (b) agent paths of four additional paths

Fig. 4. Control of paths of agents

We designed this interface because users intend to move agents irregularly when they specify non-smooth paths.

Finally, the paths of individual agents are based on the additional paths. The path of each agent is affected by the additional paths that are close to the initial position of the agent. The more additional paths the user gives, the more they can control the movements of the agents, as shown in Figure 4. The green paths in Figure 4 represent the guiding paths generated for each agent. This is explained further in the next section.

Usually a user inputs at least one or two additional paths to specify the distance and regularity. When users want to specify agents' paths in more detail, they add more additional paths.

4 Crowd Parameter Estimation

This section describes our method for computing crowd parameters. We explain the crowd parameters that are used in our method. We then explain how to compute them.

4.1 Crowd Parameter

We use an agent model [1][2] for controlling crowds. There has been research on many possible types of parameters. In our agent model, we use the crowd parameters that are shown in Table 1. All crowd parameters vary according to points along the guiding paths, which means that the crowd movements vary during the animation. We represent the varying parameters as a series of variables. The subscript $k = 1...K$ of all parameters represents the index number of points where K is the total number of points. Each agent is controlled by the parameters of the closest point. In addition, some parameters vary depending on the agents, so each agent has a different value. The subscript $j = 1...M$ of the parameters represents the index number of the agents where M is the total number of agents.

Table 1. Crowd parameters

Name	Variables	Uniform or Individual
Guiding path	$\mathbf{P}_j = \{\mathbf{p}_{j,1}, \cdots, \mathbf{p}_{j,k}, \cdots, \mathbf{p}_{j,K}\}$	Individual
Moving speed	v_k	Uniform
Standard distance to other agents	s_k	Uniform
Adjustment of distance to other agents	$a_{j,k}$	Individual

4.2 Input Path

As explained in Section 3, the crowd parameters are computed from one primary path and a number of additional paths given by the user. The paths that the user draws on the screen are projected on the ground to compute the positions in the scene coordinates. $\mathbf{Q}_i = \{\mathbf{q}_{i,1}, \cdots, \mathbf{q}_{i,k}, \cdots, \mathbf{q}_{i,K}\}$ represents the points of the paths. The subscript $i = 1...N$ represents the index number of each path where $i = 1$ is the primary path and $i = 2...N$ are the additional paths. The subscript $k = 1...K$ represents the index number of the sampling points. Sampling points of all additional paths are normalized based on the primary path so that the points of all paths are aligned with the same number. The primary path also has $T_i = \{t_{i,1}, \cdots, t_{i,k}, \cdots, t_{i,K}\}$, times when each point is given (drawn) by the user.

For computing crowd parameters, the system computes smoothed additional paths first. $\overline{\mathbf{Q}}_i = \{\overline{\mathbf{q}}_{i,1}, \cdots, \overline{\mathbf{q}}_{i,k}, \cdots, \overline{\mathbf{q}}_{i,K}\}$ represents smoothed additional paths computed from \mathbf{Q}_i. The reasons that we use smoothed paths are explained later. There are a number of methods for smoothing a path. We use a spring model in our implementation. On

each iterative step, each sampling point is moved slightly to make the angle at the point smaller, and to maintain the distance to the original path. By repeating this step until the points converge, a smoothed path is computed.

The initial positions of all agents \mathbf{o}_j and the number of agents M are computed from the outline of the region that the user draws first. The system distributes agents in the region with a fixed distance.

The crowd parameters are computed from \mathbf{o}_j, \mathbf{Q}_i, T_i, and $\overline{\mathbf{Q}}_i$. In the following section, we describe how we compute each parameter.

4.3 Guiding Path

The guiding path $\mathbf{P}_j = \left\{ \mathbf{p}_{j,1}, \cdots, \mathbf{p}_{j,k}, \cdots, \mathbf{p}_{j,K} \right\}$ controls the moving path of each agent. Each agent moves so that it follows the guiding path. Note that each agent may not follow the guiding path exactly, since it is also affected by other factors such as keeping a distance with other agents, and avoiding obstacles.

The guiding path for each agent is computed by blending given paths, which are the primary path and all smoothed additional paths. We use the smoothed path instead of original paths, because a user may input a zigzag path intending irregular crowd movements but not intending a zigzag movement. Smoothed guiding paths are suitable for most animations. The blending weights of all paths for each agent are computed based on the distances between the paths and the initial position of the agent. Individual agents are affected by paths close to them.

Computation of a guiding path is as follows. First, blending weights of all smoothed paths for each agent is computed by

$$w_{i,j} = \frac{1}{l_{i,j}^2}, \quad \overline{w}_{i,j} = \frac{w_{i,j}}{\displaystyle\sum_{i=1} w_{i,j}}. \tag{1}$$

where $l_{i,j}$ is the distance between the j-th path $\overline{\mathbf{Q}}_j$ and the initial position of the i-th agent \mathbf{o}_i. We decided to use an inverse quadratic function for computing weights. The blending weights $\overline{w}_{i,j}$ are computed by normalizing the weights. Finally, each point of the guiding path $\mathbf{p}_{j,k}$ is computed by blending the positions of all paths with their matching blending weights $\overline{w}_{i,j}$. This process is repeated for all agents j.

4.4 Moving Speed

The moving speed v_k affects the crowd's maximum speed. It is simply computed from the user's drawing speed of the primary path by using the equation,

$$v_k = \frac{\left| \mathbf{q}_{1,k} - \mathbf{q}_{1,k-1} \right|}{t_{1,k} - t_{1,k-1}}. \tag{2}$$

4.5 Standard Distance between Agents

The standard distance between agents s_k is for controlling the distance between agents. This is a common parameter for all agents. The distance of each agent is altered by the adjustment of distance $a_{j,k}$ which is explained next.

The standard distance s_k is computed from the width of all paths as explained in Section 3. First, the widths of the all paths w_k are computed for each point $k = 1...K$ on the primary path \mathbf{Q}_1. w_k is computed by finding the farthest pair from $\{\overline{\mathbf{q}}_{i,k}\}(i=1,\cdots,K)$ and by computing the distance between that pair. The standard distance s_k is then computed in proportion to w_k as follows,

$$s_k = s_{scale} \log\left(w_k + 1\right) + s_{min} . \tag{3}$$

where s_{min}, s_{scale} are the minimum distance and distance scaling, respectively. We use a logarithmic function to avoid s_k becoming too big. s_{min} is set so that it prevents collisions between agents. $s_{min} = 2m$ is used in our experiments.

4.6 Adjustment of Distance between Agents

The adjustment of the distance $a_{j,k}$ is an agent specific parameter to vary the distances between agents. This parameter is based on the roughness/smoothness of the additional paths as explained in Section 3. We compute the adjustment from the distance between the original path and the smoothed path. If a given path is smooth, this value should be close to zero. Otherwise, it becomes large.

Computation of adjustment of distance $a_{j,k}$ is as follows. First, at each k-th point of each j-th additional path, the distance $d_{j,k}$ between the original path \mathbf{Q}_i and smoothed path $\overline{\mathbf{Q}}_i$ is computed. Since the distance varies from zero to the maximum distance on a zigzag path, to compute the maximum distance at each point, we find a maximum distance within a path window α. α is computed so that the path window becomes about two meters. The distance $D_{j,k}$ is computed as follows,

$$D_{j,k} = \max\left(\left|\mathbf{q}_{i,k-\alpha} - \overline{\mathbf{q}}_{i,k-\alpha}\right|,\cdots,\left|\mathbf{q}_{i,k} - \overline{\mathbf{q}}_{i,k}\right|\cdots,\left|\mathbf{q}_{i,k+\alpha} - \overline{\mathbf{q}}_{i,k+\alpha}\right|\right) . \tag{4}$$

Second, the magnitude of adjustment at each k-th point A_k is computed by taking the average of the distance between the original and smooth paths. Finally, the adjustment of the distance of the j-th agent at the k-th point $a_{j,k}$ is computed. To make variations in response to the magnitude of A_k, a random value from 0.5 to 1.0 is multiplied as follows where $random(a,b)$ is a random function.

$$A_k = \sum_{i=2}^{N} D_{i,k} \bigg/ N , \quad a_{j,k} = random(0.5, 1.0) A_k . \tag{5}$$

5 Crowd Animation

This section describes how our system generates a crowd animation using an agent model. There are many variations of agent models [1][2]. We decided to introduce the following three rules as controlling rules.

- Each agent follows a specific guiding path.
- Each agent keeps a specific distance from other agents.
- Each agent avoids obstacles.

On some agent models, a rule for making agents follow a leader is introduced. However, instead of such a rule, we decided to use the first rule, because using guiding paths can result in similar movements and a user can control the agents' paths more specifically by manipulating guiding paths.

For each agent, three kinds of forces: $\mathbf{f}^{path}{}_j$, $\mathbf{f}^{distance}{}_j$, and $\mathbf{f}^{avoid}{}_j$, are computed based on the above three rules. $\mathbf{f}^{path}{}_j$ is the force for making an agent follow a guiding path. This is computed so that the agent moves toward the next sampling point of the path $\mathbf{p}_{j,n}$. $\mathbf{f}^{distance}{}_j$ is the force for making an agent keep their distance from other agents. The distance constraint between two agents is computed by taking an average of the distance parameters of the two agents (j -th and j' -th agents),

$$d_{j,j'} = s_{j,k} + \frac{e_{j,k} + e_{j',k}}{2}. \tag{6}$$

The force for the j-th agent $\mathbf{f}^{distance}{}_j$ is computed from all nearby agents as follows.

$$\mathbf{f}^{distance}{}_j = \sum_{j'=1}^{M} \begin{cases} k_{distance} \left(\mathbf{x}_{j'} - \mathbf{x}_j \right) \left(1 - \dfrac{d_{j,j'}}{|\mathbf{x}_{j'} - \mathbf{x}_j|} \right) & if \ |\mathbf{x}_{j'} - \mathbf{x}_j| < \beta d_{j,j'} \\ 0 & if \ |\mathbf{x}_{j'} - \mathbf{x}_j| \ge \beta d_{j,j'} \end{cases} \tag{7}$$

where $k_{distance}$ is a constant magnitude of force. β defines the range of nearby agents. On our implementation, we use $\beta = 1.5$. $\mathbf{f}^{avoid}{}_j$ is the force for making an agent avoid obstacles. This force is computed using a similar equation to equation (7). Finally, the force on each agent \mathbf{f}_j is computed by summing up all the forces.

On our agent model, an acceleration \mathbf{a}_j is computed from the force \mathbf{f}_j. The position \mathbf{x}_j and velocity \mathbf{v}_j is updated based on the acceleration \mathbf{a}_j. The velocity is restricted by the maximum moving speed v_k.

$$\mathbf{a}_j = \frac{\mathbf{f}_j}{\Delta t}, \ \mathbf{v}_j' = \mathbf{a}_j \Delta t + \mathbf{v}_j, \ \mathbf{v}_j' = v_k \frac{\mathbf{v}_j'}{|\mathbf{v}_j'|} \ if \ |\mathbf{v}_j'| > v_k, \ \mathbf{x}_j' = \mathbf{v}_j' \Delta t + \mathbf{x}_j \tag{8}$$

where Δt is the time between the current frame and the previous frame. Orientation of the agent \mathbf{r}_j is computed based on the velocity \mathbf{v}_j' .

To render a character on the scene, we need a posture of the character in addition to position \mathbf{x}_j and orientation \mathbf{r}_j . In our implementation, we simply use a walking motion clip to represent the posture of each agent on each frame.

6 Experimental Results and Discussion

We have implemented the proposed method using C++ and OpenGL. The system generates crowd animation interactively. We have done preliminary experiments to show the effectiveness of our system. As well as the sketch-based interface, we also developed a conventional interface for our system so that the user could specify the crowd parameters of our methods directly with the mouse and keyboard.

To evaluate the effectiveness of our interface, we measured the times for creating a crowd animation. Four undergraduate and graduate students participated in the experiments. The subjects were asked to create a crowd animation that matched an example movie using both our sketch-based interface and the conventional interface. The subjects were asked to stop when the generated animation looked close enough to the example movie according to the judge, and the time was measured. The example crowd animations were created using our system in advance. On our experiments we used two example animations: simple and complex. They are shown in the accompanying movie.

Table 2. Average time for making a crowd animation (minutes : seconds)

Interface	Simple crowd	Complex crowd
Proposed interface	0:51	1:50
Conventional interface	10:00	30:30

Table 2 shows the results of our experiments. According to the results, our interface is more effective than the conventional interface. Moreover, the more complex the crowd movements, the more effective our interface is.

Currently our method is specialized for crowd animations where agents travel as a group. In practical crowd animation, the agents perform various actions and interact with each other (e.g., combat, conversation, reaction of audience, etc.). These kinds of actions can be realized by user commands or behavioral models. User commands can be given through a conventional interface or possibly a gesture-based interface. To use behavioral models, complex rules and parameters have to be tuned by the user. This would be difficult through a sketch-based interface. We developed the sketch-based system explained in this paper, because we thought that a sketch-based interface would be the most suitable for controlling a traveling group. As a future work, we want to extend our system so that a user can give action commands to agents through a sketch-based interface. A sketch-based interface for describing behavioral rules is also an interesting future work.

7 Conclusion

In this paper, we have proposed an intuitive sketch-based interface for controlling crowd movements. We have implemented our method and demonstrated the effectiveness of our interface. Currently, the main target application of our method is for animation production. However, this technique can be used for various applications such as computer games, communications across metaverses, behavioral simulations and so on, because even non-professional users can use our interface very easily. Our future work includes improvement of the agent model, addition of crowd parameters and estimations, support for action commands through the sketch-based interface, and addition of group parameters for animating multiple groups.

References

1. Reynolds, C.W.: Flocks, Herds, and Schools: A Distributed Behavioral Model. In: SIGGRAPH 1987, pp. 25–34 (1987)
2. Musse, S.R., Thalmann, D.: Hierarchical Model for Real-Time Simulation of Virtual Human Crowds. IEEE Trans. Visualization and Computer Graphics 7(2), 152–164 (2001)
3. MASSIVE, http://www.massivesoftware.com/
4. Ulicny, B., de Heras Ciechomski, P., Thalmann, D.: Crowdbrush: Interactive Authoring of Real-time Crowd Scenes. In: ACM SIGGRAPH Symposium on Computer Animation 2004, pp. 243–252 (2004)
5. Sung, M., Gleicher, M., Chenney, S.: Scalable Behaviors for Crowd Simulation. Computer Graphics Forum 23(3), 519–528 (2004)
6. Courty, N., Corpetti, T.: Crowd Motion Capture. Computer Animation and Virtual Worlds 18(4-5), 361–370 (2007)
7. Lee, K.H., Choi, M.G., Hong, Q., Lee, J.: Group behavior from video: a data-driven approach to crowd simulation. In: Proc. of the 2007 ACM SIGGRAPH/Eurographics Symposium on Computer Animation, pp. 109–118 (2007)
8. Lerner, A., Chrysanthou, Y., Lischi, D.: Crowds by example. Computer Graphics Forum 26(3), 655–664 (2007)
9. Jin, X., Xu, J., Wang, C.C.L., Huang, S., Zhang, J.: Interactive Control of Large-Crowd Navigation in Virtual Environments Using Vector Fields. IEEE Computer Graphics and Applications 28(6), 37–46 (2008)

EML3D: An XML Based Markup Language for 3D Object Manipulation in Second Life

Arturo Nakasone and Helmut Prendinger

National Institute of Informatics
2-1-2 Hitotsubashi, Chiyoda-ku, Tokyo 101-8430, Japan
arturonakasone@nii.ac.jp, helmut@nii.ac.jp

Abstract. Recently, virtual worlds like "Second Life" have received a lot of attention not only as environments that promote social interaction, but also as media in which scientific research can be performed effectively. In this latter aspect, they offer several advantages over traditional 3D visual applications, such as the capacity of supporting true collaborative endeavors in which real people, through the use of graphical avatars, can simultaneously discuss and analyze data, thereby enhancing their collaborative experience. Unfortunately, processing capabilities of current virtual worlds are limited when trying to visualize this data as 3D objects. External applications to solve this problem have been developed, but their functionality is obscure and they require good understanding in programming languages. To overcome these inconveniences for common users, we have developed EML3D (Environment Markup Language 3D), a markup language that provides a tool to manipulate virtual objects in Second Life in an easy and stable way.

1 Introduction

With the advancement in 3D graphics processing, virtual worlds, which can be defined as "electronic environments that visually mimic physical spaces" [1], are being considered as one of the most promising tools to develop social and scientific research. Depending on the virtual world system provider, the usage of virtual worlds ranges from private company training operations to open social interaction platforms. Recently, one kind of networked 3D virtual world is gaining popularity among the people who have socializing as their primary objective. These virtual worlds are getting more and more attention from the public not only because of their social interaction potential, but also because of the capability to endow people with the power of creating and manipulating their own environment or ecology [9]. The most popular of these general virtual worlds is Linden Labs' Second Life[1] [16] , in which many individuals and corporations have already created their virtual presence.

[1] At the beginning of September 2008, just over 15 million accounts were registered. In January 2008 residents spent a total of 28,274,505 hours "inworld", and, on average, 38,000 residents were logged in at any particular moment.

A. Butz et al. (Eds.): SG 2009, LNCS 5531, pp. 263–272, 2009.

In a virtual world, data have to be represented as 3D objects with certain visual attributes, and placed in certain appropriate positions in the environment. Unfortunately, virtual worlds are limited in their capability to properly visualize large-scale scientific data as 3D objects mainly due to processing restrictions and implementation objectives. Other alternatives in the form of external applications and libraries have been developed to overcome this problem. However, much of these libraries' functionality is still obscure and they require a fairly good degree of understanding in programming language to be properly utilized.

In order to facilitate the creation and manipulation of 3D objects in virtual world environments (e.g. Second Life) for common users, we have developed EML3D, a web service application tool which provides an XML based markup language that allows the user to create and manipulate his/her virtual objects in an easy, stable, and powerful way. The rest of the paper is organized as follows: Section 2 provides a summary of the research work currently being done in the virtual reality field. Section 3 describes EML3D in detail by explaining the execution of two simple scripts. Section 4 introduces a real scientific visualization case in with EML3D was used. Finally, we conclude the paper by giving an overview of EML3D and the functional improvements that we are currently implementing.

2 Related Work

While there are almost no tools that provide automatic and flexible content creation for virtual worlds, e.g. for Second Life, researchers in the domain of Virtual Reality (VR) have supplied this need by: (a) creating their own customized virtually populated environments that suits their specific objectives, (b) using well-known commercial 3D game engine technologies, or (c) using 3D web standards such as X3D [11] to fulfill their visual requirements.

To develop their own object creation and behavior models, most researchers opted for constructing their own virtual environment and creating their own languages (some of them based on XML) to manipulate it. For instance, Biermann et al. [2] proposed a very specialized semantic based method for creating and manipulating parametric parts for complex VR object constructions. Piza et al. [13] defined an interesting way to create spaces (or rooms) and objects based on simple human-like instructions. Seo and Kim [17] defined scenes through a language called PVML and Python scripts. Their application defined several primitives that could be created through their client interface (cube, sphere, cone, and cylinder). Finally, Garcia-Rojas et al. [6] created a visual interface to define scenes which virtual characters inhabit. This allowed users to create objects in their scenario without having to worry about their textual specification. All these applications offer interesting solutions from the object manipulation perspective, but they are available for their own particular environment only.

Looking at the advantages of 3D graphical interface provided by game engines, other researchers have used them as their visual interface to implement their own object behavior or environment manipulation solutions. Cavazza et al. [4] created

scenarios using the Unreal Tournament engine [18], defining object behaviors based on AI techniques and the interception of game events. In the case of Herwig and Paar [7], they promoted a collaborative way to plan and visualize landscape transformations using the Unreal Tournament engine as well. Game engines offer very good functionality for content manipulation, but they are generally restricted to their game rules and are difficult to distribute.

By using the power of 3D visualization standards over the web like X3D, yet other researchers have addressed the issue of having distributable 3D content in an efficient way. Jourdain et al. [8] proposed a way to overcome the collaboration limitation in visualization tools through the sharing of X3D data through the web. Farrimond and Hetherington [5] implemented a tool for students to create their own church-like buildings. They make use of an XML based language to define building characteristics like towers, navels, chancels, and so on. The XML file is processed into a web 3D standard format file (either VRML97 [11] or X3D). In general, web tools are limited to the type of collaboration paradigm offered by the web itself and they lack the sense of co-presence that can be attained in virtual worlds.

2.1 Some Solutions Already Explored in Second Life

According to Bourke [3], there is a growing demand for scientific collaborative visualization as a shared experience. Nevertheless, in most cases, this visualization lacks the more powerful interactions researchers implemented in their individual proprietary software. In order to properly address these constraints, there are several characteristics that any application that supports collaborative scientific visualization in virtual worlds should have. Among them is the efficient processing of raw data into visual entities. Bourke [3] developed some visualization samples in Second Life including fractals and molecules, but faced several problems regarding the storage and processing of raw data. This was mainly due to technical restrictions of Second Life (size of object scripts and data arrays). In order justify the benefit of using Second Life as a platform for scientific data visualization, a way to overcome these world-internal limitations still has to be found.

3 EML3D: Easy and Robust Object Manipulation in Second Life

Since we were not able (or liable) to address the issue of improving processing capabilities in Second Life, our development strategy focused on providing an easy-to-use tool that would allow dynamic object creation, overcoming the technical limitations of Second Life itself. EML3D's objective as a language is to provide a tool to the common user to define environment changes in Second Life. These changes, performed through object manipulation, can be indicated either by passive environment event handling or by active command execution.

The EML3D instruction parser and executor are implemented as a web service. This web service has a simple interface consisting of 4 methods: StartControl, ProcessScript, ExecuteScript, and StopControl, which have to be called in that order. The StartControl method initializes a persistent Control Manager object (i.e. the Control object), returning a SessionID number. This number is used to uniquely identify the Control object that has been instantiated. Since the EML3D web service stores different Control objects according to the number of users that have accessed it, once a user has initialized a Control object, he/she must use the SessionID number to reference his/her own Control object every time he/she wants to process and execute EML3D scripts (from now on, scripts).

As long as the Control object is instantiated, the user can send and execute as many scripts as desired. A script must be processed and stored before executing it. Therefore, the user must call the ProcessScript method to load the script into the Control object memory. Once the script has been processed, it can be executed by calling the ExecuteScript method. In the case of having several scripts to be executed, the user simply needs to call the ProcessScript - ExecuteScript pair of methods for each script. EML3D provides two ways to load a script: either as a new script or as an addition to what is already stored in the Control object memory. When the user has finished processing and executing his/her scripts, he/she must call the StopControl method in order to liberate the resources used by the Control object and eliminate the Control object itself from the EML3D web service.

3.1 EML3D Design Diagram

The functionality of EML3D was encapsulated into an object called the Control Manager object. This object is in charge of: (a) parsing the script stream that comes from the ProcessScript method and storing all its information in memory, (b) retrieving the commands from memory and sending them to Second Life to be executed, and (c) capturing the events that take place in Second Life and processing them. Figure 1 shows the design diagram for EML3D, which contains the main components for the Control object and its main functions.

Once a request for Control object instantiation has been received in the web service, it generates a dummy thread in order to keep the Control object alive. The Control Manager object has four main components, which process and execute the scripts: the Script Parser, the Script State Execution Module, the State Variables Storage, and the Visualization Module. The Script Parser is in charge of parsing the script, so that it can be checked for syntactic or semantic errors. As the script is being parsed, the Script State Execution Module converts the information found in the script into memory objects, which are stored in the State Variables Storage. When the ExecuteScript method is executed, the ScriptState Execution Module retrieves the objects from the storage and sends them to the Visualization Module. This module, in turn, converts the visualization instructions contained in the objects into specific library commands that are sent to Second Life to be executed. In addition, when an event is detected in Second

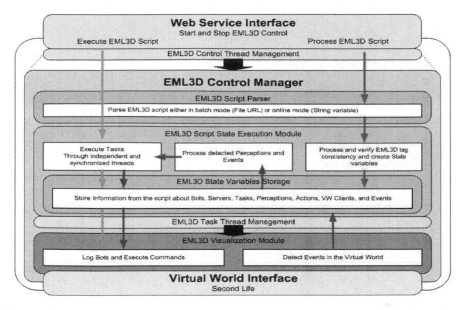

Fig. 1. EML3D Design Diagram. The red arrow describes the execution of the ProcessScript method, the green arrow describes the ExecuteScript method, and the purple arrow describes the process associated with the detection of events in Second Life.

Life, this is passed to the Script State Execution Module to be processed, and determine if objects need to be executed.

Our whole solution has been programmed in C sharp and we also offer the possibility of using EML3D as a DLL library. The library we use to connect and access Second Life is an open source initiative called libsecondlife, and can be obtained at [10].

3.2 Creating a Sphere – A Simple EML3D Action Script

In order to introduce the power and ease-of-use of EML3D, we will give a rather simple, yet complete example of an EML3D action script and explain the concepts implemented in it. The script is shown in Figure 2.

An EML3D script is an XML file that begins and ends with the *eml3d* tag. As in the case of HTML, the EML3D script has two main parts: the *head* and the *body*, marked by the head and body tags respectively. The head component includes the definition of information that is necessary for EML3D to connect to Second Life, whereas the body component includes the instructions to be executed.

The following information must always be present in the head of any script:

– *Owner of the Script*: EML3D allows users to specify who may execute scripts in the web service through a simple text based security file. The *owner* tag specifies the last name, first name, and password of the owner of the script.

```
<eml3d>
  <head>
    <owner lastname="Doe" firstname="John" password="password"></owner>
    <server id="SL" uri="" type="SL"></server>
    <creatorbot id="SLCREATOR" lastname="Doe" firstname="John" password="password"></creatorbot>
  </head>
  <body startImmediately="MYFIRSTTASK">
    <task id="MYFIRSTTASK" serverid="SL" creatorbotid="SLCREATOR">
      <sequential>
        <action id="CREATE_SOMETHING">
          <command name="CREATEPRIM">
            <param name="ID" value="MYFIRSTPRIM"></param>
            <param name="PRIMTYPE" value="SPHERE"></param>
            <param name="POSITIONTYPE" value="RELATIVE"></param>
            <param name="POSITION" value="0:0:2.5"></param>
          </command>
          <command name="DELETEPRIM">
            <param name="ID" value="MYFIRSTPRIM"></param>
          </command>
        </action>
      </sequential>
    </task>
  </body>
</eml3d>
```

Fig. 2. A simple EML3D action script. The script only contains two instructions to execute: a *CREATEPRIM* instruction, and a *DELETEPRIM* instruction.

If this information is not found in the security file, the user will not be able to execute the file.

- *Server Information*: The *server* tag allows users to define to which virtual world server they wish to connect. A script can contain more than one server definition in it. Even though we currently support a connection to Second Life (which is defined only by the value of SL in the type attribute), other servers are also being considered and tested, like the Open Simulator initiative [14].
- *Creator Bot Information*: In order to interact with Second Life, EML3D has to use a "bot" (a computer-controlled avatar) to log in. In the *creatorbot* tag, we specify the information needed to connect to Second Life: the last name, first name, and password of the avatar. This avatar must have been previously created to operate in Second Life and must have the proper permissions.

The body component is mainly composed of tasks and perceptions. A task is the minimum unit of execution from the bot point of view. In other words, any command to be executed by a bot must be included in a task. A task must also contain information about the creator bot that will be used to execute the task and the server that the creator bot will log in. This scheme allows tasks in the same script to be executed through different bots which increases its execution performance. In order to immediately start the execution of a task, we include a tag attribute in the body called *startImmediately*, whose value is the id of the task that we want to get executed. In our example, we only have one task called *MYFIRSTTASK*, so this task will be executed as soon as we call the ExecuteScript method.

In order to add complexity to the execution of an instruction, EML3D implements three tag structures that allow users to execute instructions either in sequence, in parallel, or by random selection of one of a group of instructions. These structures are defined by the *sequential*, *parallel*, and *selected* tags and

mimic the functionality provided by our other application for agent control in multimedia presentations, MPML3D [12,18].

A command is an individual visualization instruction executed in Second Life. In our example, we have two commands: the *CREATEPRIM* command, which creates a primitive in the virtual world, and *DELETEPRIM*, which deletes the same primitive from the virtual world. These commands are embedded into a structure called action. An *action* tag let users define sets of commands that will be sequentially executed into a single unit. Actions allow an easier reference to commands if, for example, users need to create or manipulate complex objects as one.

3.3 Perceiving a Greeting – A Simple EML3D Perception Script

Task execution in EML3D is not only started by a direct request of the owner of the script, but can also be triggered by an event in Second Life. In order to allow events to be perceived in EML3D, we introduce two implemented concepts: "perception" and "perceptor bots". Figure 3 shows a sample script that makes use of these concepts.

A perceptor bot is a bot that is logged in before any instruction of the script is executed. Normally, this bot is also the creator bot, but that is not always the case. To define a perceptor bot, we need to specify the id of a previously defined creator bot, and the server to which it will attempt to log in. In the example shown above, we have created a perceptor bot called *SLPERCEPTOR*, which is the same as our previously created creator bot.

A perception is the minimum unit of event handling from the script perspective. Perceptions are composed by a set of event objects, which defines events that can be captured from Second Life. In our example, we have defined a perception that contains only one event: the *CHATCHANNEL* event. This predefined

```
<eml3d>
  <head>
    <owner lastname="Doe" firstname="John" password="password"></owner>
    <server id="SL" url="" type="SL"></server>
    <creatorbot id="SLCREATOR" lastname="Doe" firstname="John" password="password"></creatorbot>
    <perceptorbot id="SLPERCEPTOR" creatorbotid="SLCREATOR" serverid="SL"></perceptorbot>
  </head>
  <body startImmediately="MYFIRSTTASK">
    <perception id="LISTEN">
      <event id="GREETING" type="CHATCHANNEL">
        <condition variable="MESSAGE" value="Hello"></condition>
        <condition variable="LISTENER" value="SLPERCEPTOR"></condition>
      </event>
    </perception>
    <task id="MYSECONDTASK" serverid="SL" creatorbotid="SLCREATOR" starton="LISTEN">
      <sequential>
        <action id="SAY_SOMETHING">
          <command name="SPEAK">
            <param name="CHANNEL" value="0"></param>
            <param name="TEXT" value="Hello. This is a nice primitive I created!"></param>
            <param name="CHATTYPE" value="NORMAL"></param>
          </command>
        </action>
      </sequential>
    </task>
  </body>
</eml3d>
```

Fig. 3. A simple EML3D perception script. In this script, the perceptor bot is the same as the creator bot utilized. The bot answers to a "*Hello*" message, which is defined in the perception. When the perception is "activated", it executes the *MYSECONDTASK* task by defining this starting condition using the *startOn* attribute of the task.

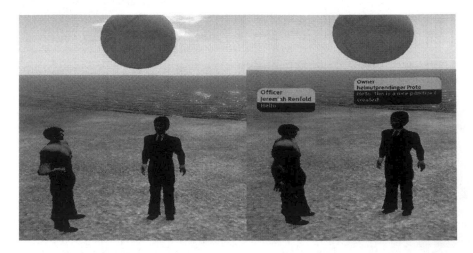

Fig. 4. The result of the execution of both sample scripts (Figs. 2 and 3) in Second Life. Left side: A sphere is created by the creator bot (right). Right side: the perceptor bot (same as the creator bot) answers to the greeting of the user by saying: *"Hello. This is a nice primitive I created!"*.

event handler captures any message that passes through Second Life. Events can be defined to be triggered depending on certain conditions like the content of a message. In EML3D, this is specified through the use of *condition* tags. For our *CHATCHANNEL* event, we have defined two conditions: (1) the intercepted message must be the word *"Hello"*, and (2) the bot that listens to this message must be our perceptor bot. When the perception is activated by fulfilling these conditions, it can be used to execute a task through the use of the *startOn* attribute. The value of this attribute should be the id of the perception that needs to be triggered in order to execute the task.

The result of the execution of both the action and the perception scripts in Second Life are shown in Figure 4.

4 Using EML3D in a Realistic Scientific Visualization Case

As a virtual content creation tool for common users, EML3D has been proved not only to be an easy-to-use alternative to complex programmable libraries, but also as a stable solution for displaying (rather) large-scale data in virtual worlds, thus facilitating collaborative visualization of scientific data. Currently, EML3D is being successfully tested in our AstroSim project. AstroSim (Astrophysics Simulation) was conceived as a joint research project between our institute (NII), the National Astronomical Observatory of Japan, and the Institute for Advanced Study in Princeton. The primary objective of the project is the development of a Second Life based application, in which astrophysics phenomena involving the simulation of stars' kinematics can be visualized. Specifically, the

Fig. 5. A Globular Star Cluster Visualization in Second Life using EML3D. Users can not only watch the actual simulation, but they are also immersed in it via star manipulation. The avatar located at the center is the actual creator bot.

application supports collaborative visualization and easy data manipulation of a scaled-down version of a globular star cluster evolution simulation for educational and presentational purposes. Figure 5 shows an AstroSim scenario that was generated by using EML3D.

5 Conclusions and Future Work

In this paper, we have presented EML3D, a web service application tool providing an XML based markup language that allows content producers to create and manipulate virtual objects in an easy, stable, and powerful way. We have also detailed the main functionality of EML3D by describing two simple scripts and their execution results. The current set of commands offered by EML3D is mostly object-level (i.e. are used for direct object manipulation in Second Life). Due to limitations in the libsecondlife library software, some commands have restricted functionality or could not be implemented at all. For example, direct commands to control the environment's weather or day time were not provided, and we could not implement such functionality. Nevertheless, it is expected that as the library gets more stable, we will be able to extend the capabilities of EML3D by providing simple interfaces to actions that users can perform using the Second Life client software.

Moreover, we are planning to extend the object level capabilities of EML3D by creating a new set of functional tags, known as EML3DX (EML3D Extension), which will include objects and attributes for creating complex object structures and defining object behaviors and events.

To download our library, please refer to our web site at [15].

References

1. Bainbridge, W.: The scientific research potential of virtual worlds. Science 317, 472–476 (2007)
2. Biermann, P., Fröhlich, C., Latoschik, M.E., Wachsmuth, I.: Semantic information and local constraints for parametric parts in interactive virtual construction. In: Proceedings of the 8th International Symposium on Smart Graphics 2007, pp. 124–134 (2007)
3. Bourke, P.: Evaluating second life as a tool for collaborative scientific visualization. Computer Games and Allied Technology (2008)
4. Cavazza, M., Lugrin, J., Hartley, S., Libardi, P., Barnes, M.J., Le Bras, M., Le Renard, M., Bec, L., Nandi, A.: Alterne: Intelligent virtual environments for virtual reality art. In: Butz, A., Krüger, A., Olivier, P. (eds.) SG 2004. LNCS, vol. 3031, pp. 21–30. Springer, Heidelberg (2004)
5. Farrimond, B., Hetherington, R.: Compiling 3d models of european heritage from user domain xml. In: Proceedings of the Ninth International Conference on Information Visualization, pp. 163–171 (2005)
6. Garcia-Rojas, A., Gutierrez, M., Thalmann, D.: Visual creation of inhabited 3d environments: An ontology-based approach. The Visual Computer: International Journal of Computer Graphics 24(7), 719–726 (2008)
7. Herwig, A., Paar, P.: Game engines: Tools for landscape visualization and planning? In: Trends in GIS and Virtualization in Environmental Planning and Design, pp. 161–172 (2002)
8. Jourdain, S., Forest, J., Mouton, C., Nouailhas, B., Moniot, G., Kolb, F., Chabridon, S., Simatic, M., Abid, Z., Mallet, L.: Sharex3d, a scientific collaborative 3d viewer over http. In: Proceedings of the 13th International Symposium on 3D Web Technology, pp. 35–41 (2008)
9. Kumar, S., Chhugani, J., Kim, C., Kim, D., Nguyen, A., Dubey, P., Bienia, C., Kim, Y.: Second life and the new generation of virtual worlds. Computer 9, 46–53 (2008)
10. libsecondlife, http://libsecondlife.org
11. Web3D Consortium - X3D and VRML97 Standard, http://www.web3d.org/x3d
12. Nischt, M., Prendinger, H., André, E., Ishizuka, M.: MPML3D: a reactive framework for the Multimodal Presentation Markup Language. In: Gratch, J., Young, M., Aylett, R.S., Ballin, D., Olivier, P. (eds.) IVA 2006. LNCS (LNAI), vol. 4133, pp. 218–229. Springer, Heidelberg (2006)
13. Piza, I., Ramos, F., Zuniga, F.: A method for 3d-scene generation using a human-like language. In: International Conference on Cyberworlds (CW 2006), pp. 50–57 (2006)
14. Open Simulator, http://www.opensimulator.org/
15. Prendinger Laboratory, http://www.prendingerlab.net
16. Second Life, http://secondlife.com/
17. Seo, J., Kim, G.: Explorative construction of virtual worlds: an interactive kernel approach. In: Proceedings of the 2004 ACM SIGGRAPH International Conference on Virtual Reality Continuum and its applications in Industry, pp. 395–401 (2004)
18. Ullrich, S., Bruegmann, K., Prendinger, H., Ishizuka, M.: Extending mpml3d to second life. In: Prendinger, H., Lester, J.C., Ishizuka, M. (eds.) IVA 2008. LNCS (LNAI), vol. 5208, pp. 281–288. Springer, Heidelberg (2008)

Part-VII
Art Exhibition and Demos

Creating dream.Medusa to Encourage Dialogue in Performance

Robyn Taylor[1], Pierre Boulanger[1], and Patrick Olivier[2]

[1] Advanced Man-Machine Interface Laboratory,
Department of Computing Science, University of Alberta
T6G 2E8 Edmonton, Alberta, Canada
{robyn,pierreb}@cs.ualberta.ca
[2] Computing Science, Culture Lab, Newcastle University,
Newcastle upon Tyne, UK
p.l.olivier@ncl.ac.uk

Abstract. In a lucid dream, a dreamer becomes conscious that she can interact with and control events in the dream environment. Using gestural control devices and responsive video visualization of vocal interaction, our interactive performance, *dream.Medusa*, invites four participants selected from the observing audience to experience a simulated lucid dream. The participatory nature of the *dream.Medusa* performance facilitates a dialogical exchange between performer and participants in order to collaboratively create an aesthetic experience.

1 Introduction

Technologically mediated performance practice allows performing artists to create interfaces that augment their voices [3] [7], and movements [1] [5], with responsive audio-visual content. "New media" performance often mixes traditional artforms such as music or dance with digital content, using modern interactive technology to allow an expertly rehearsed creative team of performers and technical staff to control and manipulate responsive multimedia elements.

Participatory performance systems, such as Sheridan's iPoi [4] or Winkler's Light Around the Edges installation [9] add an additional layer of interactivity to multimedia performance. Facilitating audience involvement, these works allow participating audience members' behaviours to modify and manipulate the development of the ongoing interaction allows audience members to experience performances in new and exciting ways – not only as passive spectators, but as active co-creators and collaborators, shaping and developing the performance itself.

2 The *dream.Medusa* Performance

Originally created as part of an installation exploring the stages of sleep and dreaming, our interactive work, *dream.Medusa*, is a participatory performance

A. Butz et al. (Eds.): SG 2009, LNCS 5531, pp. 275–278, 2009.

which allows four audience members to share in the creation of an audio-visual experience which is meant to evoke the qualities of a lucid dream [8]. The staging environment and multimedia content is designed to be hypnotic and immersive. Ethereal music, vivid imagery (videos of jellyfish moving rhythmically through water) and a performance space draped in soft and welcoming fabrics are intended to transport participants to a dreamlike state. As in a lucid dream, participants drift in and out of control of their surroundings, at times being able to enact change in their environment.

The four participants are selected from the audience, having no previous experience with the interface. Each participant controls an independent aspect of a real-time video editing system which they interact with by manipulating deliberately mysterious controller objects containing Nintendo Wiimotes. A live singer (Taylor) affects the video playback using a visualization routine which maps vocal timbre to colour, modifying the colours of the videos. The participants are instructed to explore the interaction space, learning how their actions affect the visualization over the course of the performance. Collectively, the group's interactions with the responsive environment and one another choreograph the visual component of the performance.

3 Dialogue in Performance

From an artistic standpoint, using technology to allow participants to contribute to the ongoing development of a live performance in a concrete and tangible way is intriguing. From my[1] experience and background as a performing musician, I felt that adding a participatory component to my artistic practice would enable me to explore the creative connection between performer and audience in a unique manner.

I began my career in the performing arts in a very traditional way. I spent many years studying and working as a singer, eventually choosing to specialize in jazz and cabaret music. I felt that these genres gave me opportunity to engage in improvisation and spontaneous expressivity. I enjoyed the close collaboration between myself and my fellow musicians, as well as the ability to observe and react to the feedback given by an intimate audience.

I began to feel that the most critical aspect of my role as performer was my ability to engage my fellow musicians and my audience in a dialogical process – each performance was uniquely shaped by the momentary experience of singing that particular piece, with that particular group of musicians, in that particular location in front of the individuals that formed that particular audience at that particular time. Each performance was dependent not only upon the way I used my voice to communicate via music, but as well by the way the audience received that communication and responded in turn via their energy and attentiveness.

Wright *et. al* address this property of aesthetic experience, stating that "self and others, technology and setting are creatively constructed as multiple centres of value, emotions and feelings and the experience is completed simultaneously

[1] Here "I" and "me" refer to Robyn Taylor.

by self and others, not determined solely by one or the other." [10], p.7. As a musician, I feel that the most valid moments in performance occur when this relationship between performer and audience is fully actualized, enabling the artist to connect with her observers and share emotions in an authentic way. In these moments, the very room feels alive, and the sense of complete absorption in the creative experience is palpable.

4 Dialogue in *dream.Medusa*

Technologically mediated participatory performance, as well as being interesting due to its potential for engaging participants in a form of creative play and ludic activity [2] can be argued to be a literal interpretation of this dialogue between a performer and her audience. The performer communicates via the tools of their artistic craft, while the participants are afforded the opportunity to communicate in response via the controller interface. Ideally, the emerging dialogue between performer and participants could evolve in an improvisational fashion, allowing the collaborative team to react and play off one another much as jazz musicans 'jam'.

By giving several audience members the ability to literally co-create the performance content in *dream.Medusa*, we hoped to enhance this interplay between performer and audience in order to better illustrate and explore how the experience is shaped by their relationship. As well, we hoped that giving the participants direct influence on the performance's development would increase their level of engagement and commitment to the performance process.

During a performance of *dream.Medusa*, dialogues emerge between the four participants as well as between each participant and myself. The participants and I sit closely together, well within view of one another. We can interact via gesture, eye contact, or even whispers during the development of the performance. As the performer, I am highly attuned to the behaviours of my participants. I attempt to respond to their manipulations of the video, and adjust my vocalization in reaction to their creative contributions as I would if they were fellow musicians. Participants can choose to coordinate their interactions with myself or with one another to create intentionally multi-faceted effects, or they can choose to act in isolation. The action we take together shapes the character of the performance. The collaborative medium gives untrained, novice participants the opportunity to step beyond their role as audience members, and more clearly illustrates how a performance is dependent upon a multitude of small contributions.

It is our goal that the dialogues which develop during *dream.Medusa* will enrich the participants' investment in the performance. We hope that the ability to explicitly contribute and collaborate during the course of the performance's development increases the participants' level of engagement, creative agency, and sense of ownership of the aesthetic experience. We are now using *dream.Medusa* to form part of a larger body of research investigating participants' perception of their experiences enacting collaborative performances in public spaces [6].

Acknowledgements

This work was funded by the Natural Sciences and Engineering Research Council of Canada, Alberta Ingenuity, and iCore. We would also like to acknowledge the support of Culture Lab and the School of Computing Science, Newcastle University, UK.

References

1. Camurri, A., Coletta, P., Ricchetti, M., Volpe, G.: Expressiveness and Physicality in Interaction. Journal of New Music Research 29(3), 187–198 (2000)
2. Gaver, W.W., Bowers, J., Boucher, A., Gellerson, H., Pennington, S., Schmidt, A., Steed, A., Villars, N., Walker, B.: The drift table: designing for ludic en- gagement. In: Conference on Human Factors in Computing Systems: CHI 2004 extended abstracts on Human factors in computing systems, vol. 24, pp. 885–900 (2004)
3. Levin, G., Lieberman, Z.: In-situ speech visualization in real-time interactive installation and performance. In: Proceedings of The 3rd Inter- national Symposium on Non-Photorealistic Animation and Rendering, pp. 7–14. ACM Press, New York (2004)
4. Sheridan, J.G., Bryan-Kinns, N., Baylss, A.: Encouraging Witting Participation and Performance in Digital Live Art. In: 21st British HCI Group Annual Conference, Lancaster, UK, September 3-7, pp. 13–23 (2007)
5. Tanaka, A.: Musical Performance Practice on Sensor-based Instruments. In: Trends in Gestural Control of Music, pp. 389-405 (2000)
6. Taylor, R., Boulanger, P., Olivier, P., Wallace, J.: Exploring Participatory Performance to Inform the Design of Collaborative Public Interfaces. In: Conference on Human Factors in Computing Systems: CHI 2009 extended abstracts on Human factors in computing systems (in press, 2009)
7. Taylor, R., Boulanger, P.: Deep Surrender: Musically Controlled Responsive Video. In: Proc. of the 6th International Symposium on Smart Graphics, pp. 62–69 (2006)
8. Taylor, R., Boulanger, P., Olivier, P.: Dream.Medusa: A Participatory Performance. In: 8th International Symposium on Smart Graphics, Rennes, pp. 200–206 (2008)
9. Winkler, T.: Audience participation and response in movement-sensing installations. In: Proc. of the International Computer Music Conference (December 2000)
10. Wright, P., Wallace, J., McCarthy, J.: Aesthetics and experience-centered design. ACM Transactions on Computer-Human Interaction (TOCHI) 15(4), Article No. 18 (2008)

The Sound Brush Made of Bamboo

Young-Mi Kim and Jong-Soo Choi

Graduate School of Advanced Imaging Science, Multimedia, and Film,
Chung-Ang University,
#221 Huksuk-Dong, Dongjak-Ku, Seoul, 156-756, Korea (R.O.K)
{frontier,jschoi}@imagelab.cau.ac.kr

Abstract. This paper is about the study on an artwork, a black-and white drawing that has been expressed through a digital algorithm. Black-white drawings were popular during the Chosun era (1392-1910) reigned by kings and officials. The Oriental fine art, pursuing harmony with nature, is expressed in a moderate and restrained way, hence anyone would find it very soft and thus readily acceptable. Unlike the western paintings that fill the canvus to the very full, the oriental paintings treat even the blank space as a part making up a balanced painting. The four gracious plants, a Maehwa blossom, an orchid, a chrysanthemum, and a bamboo, used to be frequent subjects of gentlemen's paintings as they symbolized the virtues of the old times. This artwork features Daegum, the decent traditional musical instrument which used to be played in loyal palaces or guest rooms of prestigious officials' residences, and a bamboo which was a frequent motive of gentlemen's paintings in the past. Daegum and the bamboo, expressed in a modern style in this work, make people appreciate the life that is full and rich. So, one can say they have been used here to make this "well-being art." The artist's intention is to be delivered through the sound of Daegum that carries the spiritual values of the Oriental culture, the bamboo painting and the spontaneous play by a computer.

1 Introduction

Based on the concept of this work, the bamboo was painted according to the strength and the length of the breath of a Daegum player. Of the four gracious plants, this work took the bamboo as its motive. Bending little by little but not being broken to-tally, the bamboo was selected as it also keeps its leaves green throughout the four seasons, empty inside and pointing up to the heaven, which resembles the ancient gentlemen's spirit. The bamboo forests, being full of nature's spirit and believed to cleanse body and mind, were considered good places for meditation in leisure by Oriental people like Koreans, Chinese and Japanese. In the era of digitalization, however, bamboos seemed to stay just a traditional symbol. As people seek well-being in the modern culture, black-and-white paintings and calligraphies have been gradually received and now are being established as a culture on their own.

The very tool that draws the bamboo is also made of bamboo and is called Daegum. In other words, the painting is not drawn on a paper using a brush but

A. Butz et al. (Eds.): SG 2009, LNCS 5531, pp. 279–282, 2009.

drawn by Dae-gum play, that is, according to the strength and the length of the breath of a Daegum player. The sound of Daegum is clear and deep, just like the spirit of the upright, incorruptible gentlemen who cared only about their nation and the king. Daegum is one of the representative musical instruments that were played in palaces during Chosun Dynasty. Literary men learned how to write or paint, and also, how to play Daegum. It was taken as it was believed to cultivate good minds, just like the four gracious plants. In the Oriental culture, if a person plays a musical instrument, another person would paint a picture according to what he feels as he listens to the music and tries to figure out the music player's thoughts and then they would talk about it together. In this work, the Daegum player is the audience and the computer paints the picture in accordance with the music played.

Fig. 1. A bamboo: (a) painting drawn by a brush; and (b) painting drawn by sound

2 The Interface and the System of the Instrument

2.1 The Structure of Daegum

1. The position on which the lips are placed, the breath is blown into and the sound is Released from (the red part).
2. The end position of Daegum from which the cable of the microphone comes out (the red part).
3. The holes where sounds can be tuned.

Fig. 2. The structure of Daegum

2.2 Design Development

Being a traditional musical instrument, Daegum is played out in a sitting posture so that the player can calm himself/herself down. Just like a flute, it is blown from aside. Chwigoo (the position where lips are placed on) should not be covered

completely by lips but only by the lower lip so that the breath can be blown into it. A bamboo is hol-low inside and therefore the sound resonates from within and comes out of Chwigoo. So, the ultra tiny microphone is installed inside Chwigoo, so that the computer rece-ives and recognizes the strength and length of the breath of a player, and then classi-fies them into 5 different sounds. The strength of the breath determines the shading of the ink and the length of the breath determines the length of the bamboo's knot.

Fig. 3. The artwork as it is drawn according to a performer's play

3 Analysis System

The system has three parts, which are sound data's I/O, Decibel Descriptor, and Ac-tion Script which can display black-and-white drawing on the screen . Generally, computer sound card has Audio Controller, ADC(Analog to Digital Converter), and DAC(Digital to Analog Converter). In sound card, Audio Controller execute the trans-fer or recording data. In addition, DAC convert the digital to analog signal whereas ADC does the analog to digital. Computer use the digital signal. However ADC con-vert the analog to digital data because the input signal by microphone is an analogl. On the contrary, speaker use the analog signal. However DAC convert the digital and analog because the output signal from computer is a digital. Decibel descriptor quantize at digital sounds using levels. And this control the drawing actions. this is a key in system because this control the user voice at real-time. The input signal by microphone can display the various drawing as the user sound's amplitude and time is different. For example, the user sound's amplitude is the higher, the drawing line is the

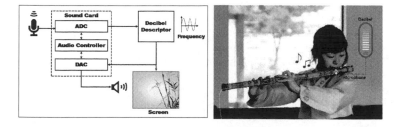

Fig. 4. Procedures: (a) Block diagram; and (b) How to input computer signals

thicker. The others, the user sound's time is the longer, the drawing line is the longer. Finally, we can display the bamboo's steps like black-and-white drawing on the screen using the drawing action(included the drawing position and angle) quantized by Decibel descriptor.

4 Conclusions

Having been played by high-ranking gentlemen in Chosun Dynasty, Daegum, these days, has still a limited access only by those who major in Korean traditional music. There were many trials and errors due to the limited experience with Daegum. Without given musical notes, the artist's intention had to be understood. In order to arrive at the image and the shape intended for the work, the concept of the software had to be understood, which is also necessary to comprehend i.e. social policies and cultural attempts that are realized through software [1]. Su Dongpo (1036-1101), the famous Chinese artist, stressed that "To paint a bam-boo, one has to first grow a bamboo in his mind and paint it only when his mind is aligned with it." The same bamboo can have a different look and feel depending on who has drawn it. Likewise, depending on the painter's intention and emotional state, a painting could look or feel different. Just like a hand-drawn picture cannot be re-peated or duplicated, any participant can draw a different picture and express his in-tention as he listens to different performers' play. If we appreciate this work in the similar way, we get close to the thoughts and lives of the painters of those times who used to draw the four gracious plants. The painting in this artwork should be painted in a leisurely way just like when one drinks tea after tea leaves have been sufficiently soaked. Only then one can feel the deep taste and aroma and experience the "well-being" art.

Acknowledgment

This work was supported by Korean Research Foundation under BK21 project, Seoul R&BD Program(TR080601), Seoul Future Contents Conver-gence (SFCC) Cluster established by Seoul R&BD Program(10570).

References

1. Han, J.: Low-cost multi-touch sensing through frustrated total internal reflection. In: Proc. ACM User Interface Software and Technology. ACM Press, New York (2005)
2. Elsea, P.: Lobjects. MaxMSP Objects, California University (2002), ftp://arts.ucsc.edupubemslobjectsLObjs_doc.pdf

Nyoro-Nyoro San: Sprits in Your Belongings

Kazushi Mukaiyama

Media Architecture Department, Faculty of System Information Science,
Future University Hakodate,
116-2 Kamedanakanocho Hakodate, Hokkaido 041-8655, Japan
kazushi@fun.ac.jp
http://www.kazushi.info/

Abstract. This is an interactive art work using with a table-top interface. "Nyoro-Nyoro" are sprits living in your belongings like a wallet, cell-phone and so on. They usually hide in your belongings. But, when you put your belongings on the magic table which I made, they will show you themselves like snails. But please carefully remember that they're so shy and they will hide quickly if you try to capture them.

Keywords: art, interaction, mixed realty.

1 Concept

This works aim to entertain people using with computer vision techniques.[1] And it makes people feels there're sprits (enjoyable characters) in your belongings. "Nyoro-Nyoro" means a expression word of squirm sound in Japanese.

2 Description

There is a table wnich projected white screen from a LCD projector installed ceiling.(Fig. 1) The top of this table is sensed objects with a infrared camera. When audience comes and put his/her belongings on the table, A camera captures contour of his/her belongings. If there're nothing to move in the capture area which means the top of table in several seconds, Nyoro-Nyoro san, sprits appear from his/her belongings. Actually sprits are just computer graphics image and his/her belonging size decides their form. Sprits form consist of 2 kind of parts, arms (with eye) and legs. These parts are decided automatically, depending his/her belonging contour. Arms (with eye) put on upper edge of contour and legs put on lower edge of contour. Therefore, program makes various forms even if it use simple parts.(Fig. 2) After Nyoro-Nyoro san appearing, they waves their arms and legs. Then audience enjoys their behavior. If audience tries to get his/her belongings back, Nyoro-Nyoro san disappear quickly such as escape from caputure because a camera always detects moving objects.

A. Butz et al. (Eds.): SG 2009, LNCS 5531, pp. 283–285, 2009.

Fig. 1. Full View

Fig. 2. One appeared from a man's necktie

3 Equipments

One white table with a milk surface acrylic screen. (w1500 x d750 x h700 mm, changeable)

One Windows desktop computer with Flash Player and Visual Studio(.net framework)

One LCD projector

One USB camera (attached a infrared filter)

Two infrared LED lamps

4 Setting

To sense infrared with camera, exhibition space is required darker or stable ambient lights without sun.(Fig. 3)

1. Install a LCD projector and a USB camera to the ceiling.
2. Install infrared LED lamps under the table.
3. Project contents to the screen on the table.

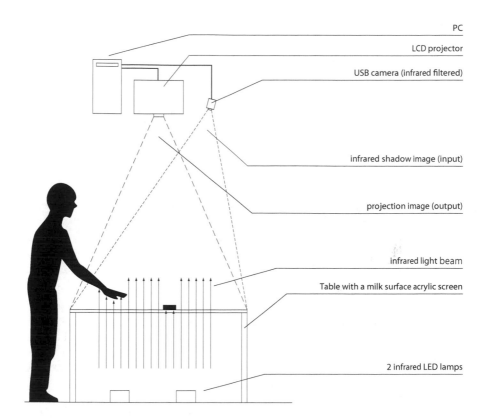

Fig. 3. Setting diagram

Reference

1. Open CV, http://sourceforge.net/projects/opencvlibrary/

ePaper Project: Virtual Exploration

Inbal Rief and Shahar Hesse

studio97designgroup, Design Strategy & Experience Design,
P.O. Box 3125, Ramamt Hasharon 47130, Israel
inbal@studio97.co.il

Abstract. We describe a design process of envisioning the ePaper (a future newspaper appliance) through the use of two animated scenarios, each featuring different usage and personal preferences. The animations have triggered a creative discussion at Deutsche Telekom business functions on the ePaper's value as a future device.

Keywords: ePaper, e-paper, e-ink, animation, design.

1 Introduction

1954, Humphrey Bogart as *Linus Larrabee* in the movie "Sabrina" makes a call from a functional mobile phone, in the back of his limousine [1]. A few decades later, mobile phone technology has saturated the market with market penetration exceeding 100% [2]. Mobile phones are perhaps the greatest example of recent technology's absorption into every-day life. However, a quick glance at the chronicle of printing and printing processes reveals that, with its timeline of centuries, it has nonetheless failed accommodate emerging technology to upgrade our reading patterns. Or is it us, the readers, who are unwilling abandon the traditional paper format?

The ePaper is a dedicated mobile device, designed to mimic the appearance of ordinary ink on paper [3], and to challenge the conventional printed newsletter experience. We have joined this unique effort to apply virtual research and envision the future use of the ePaper, via two animated scenarios, each featuring different usage and user configured preferences. The design challenge was to outline the advantages of this conceptual digital device, not as another model of momentary superior gadgetry, but as an advanced alternative that offers an extraordinary convergence between traditional print media and new technological potential, without losing the appreciation of the inherent qualities of the printed page.

Our goal was to trigger a preliminary discussion on the ePaper's value as a potential device. In the following sections we share our working process on the ePaper animations.

2 Design Process

We began our design process by identifying research questions in three key directions: the ePaper's **conceptual form**, its **graphical user-interface** and the

A. Butz et al. (Eds.): SG 2009, LNCS 5531, pp. 286–289, 2009.

scenarios that bind them together. Exploring these three directions enabled us to synthesize and formulate our creative direction.

2.1 The ePaper's Scenarios

We joined the ePaper project in the post conceptual analysis phase, in which initial scenarios were proposed by DT-Labs. For two of these scenarios, we created short, empathic storyboards that depict the persona's projected use of the ePaper, closely bound to projected behavior patterns, and realistic scenarios. The storyboards illustrated simple interactions with the ePaper in the context of social settings.

The leading characters in the two scenarios are *Karl*, an enthusiastic entrepreneur, and *Otto*, a senior citizen. The scenarios demonstrate how both characters success-fully integrate the new-found capabilities offered to them, into their daily routine. Secondary characters and other 'statistics' were staged to strengthen the comparison between the ePaper and the traditional newspaper.

Having profiled *Karl*, *Otto*, and the other characters, we approached the design of the characters' visual appearance according to pre-conceived creative guidelines (Fig. 1).

Fig. 1. Karl's (L) and Otto's (R) designed characters

2.2 The ePaper's Conceptual Form

To simulate a forward-looking ePaper device was quite a challenge, and we rationally pre-defined our focus on creating an emotional experience, rather than emphasizing detailed functionality. We retained the ePaper vision as a conceptual design, rather than enter the arena of full-blown product design.

Allowing design assumptions and ergonomic features, such as display size and the e-ink technology, we sketched rough concepts to examine our direction and form for the ePaper. Next, we rendered the selected design in 3D, in order to achieve a more persuasive visual when juxtaposed with the 2-Dimensional character designs [Fig. 2].

2.3 The ePaper's Graphical User-Interface

Continuing with our focus on the emotional experience, we designed a set of visual content compositions that supported the scenarios' flow, and the ePaper's core

features. Intuitive navigation, personalization, news aggregation, adaptive content, media support and other features are sampled throughout the e-Paper demonstration layouts. In order to achieve visual consistency, we based the layouts on a wireframe grid [Fig. 2 shows two of the ePaper layouts].

Fig. 2. ePaper conceptual form and layouts

2.4 Assembling All

When we finalized our research directions, we were ready to construct the animated scenarios. For our envisioned ePaper and drawn characters we chose to incorporate real-scene photos (train station, hotel lobby, club, cafe', cinema and more) to enhance the sense of feasibility, and to attain immediate recognition of location for the observer. It was a creative decision to minimize the characters movement in the animations in order to give a total spotlight to the ePaper's positioning [Fig. 3 and Fig. 4 show screenshots from the completed animations].

2002, in the sci-fi thriller Minority Report, a subway passenger scans an issue of USA Today that is a plastic video screen, thin, foldable and wireless, with constantly changing text [4]. We have an ePaper challenger!

Fig. 3. A Screenshot from Karl's Animated Scenario

Fig. 4. A Screenshot from Otto's Animated Scenario

Acknowledgments

We would like to thank DT-Labs for giving us the opportunity to take part in envisioning the ePaper product. We would like to acknowledge studio97designgroup, and especially Dov Wallace, the senior animator of this project, for his devoted creative work.

References

1. Wilder, Billy: Sabrina (1954)
2. Deans, H., David: Digital Lifescapes, EU Mobile Phone Market Saturation Issues (2008), http://dhdeans.blogspot.com/2008/01/eu-mobile-phone-market-saturation.html
3. Wikipedia: Electronic Paper
4. Spielberg, Steven: Minority Report (2002)

A Framework for Review, Annotation, and Classification of Continuous Video in Context

Tobias Lensing, Lutz Dickmann, and Stéphane Beauregard

University of Bremen, Bibliothekstrasse 1, 28359 Bremen, Germany
{tlensing,dickmann,stephane.beauregard}@tzi.de
http://www.informatik.uni-bremen.de/

Abstract. We present a multi-modal video analysis framework for *life-logging* research. Domain-specific approaches and alternative software solutions are referenced, then we briefly outline the concept and realization of our OS X-based software for experimental research on segmentation of continuous video using sensor context. The framework facilitates visual inspection, basic data annotation, and the development of sensor fusion-based machine learning algorithms.

Keywords: Artificial Intelligence, Information Visualization, Human Computer Interaction, Visual Analytics.

1 Introduction

The *Memex* vision describes reviewing memories with an interactive workstation, related illustrations show a head-mounted camera [1]. Civil [2,3] and military research [4] alike have since advanced *life-logging*, a research domain focused on the aggregation of digital personal memories and on their context-based indexing. A motivation for the work reported here is to investigate how continuous digital video (in contrast to still images) from wearables can be segmented into meaningful chunks by exploiting contextual information from complementary measurement streams—provided, e.g., by audio microphones, GPS receivers, infra-red (IR) or MEMS inertial and pressure sensors.

We outline our implementation of a multi-modal video analysis framework for visual inspection, annotation, and experimental development plus evaluation of pattern recognition algorithms. Our focus here is a fundamental task commonly not addressed in problem-specific research papers due to scope restrictions, namely the systematic preparation of an infrastructure that facilitates practical experiments in a data-intensive domain like life-logging.

A brief state-of-the-art discussion follows that characterizes multi-modal analysis of continuous video in the life-logging domain and references a similar framework suitable for the respective set of tasks. We outline our own concept and implementation in Sect. 2, then discuss our work in Sect. 3.

State of the Art. The *SenseCam* [5] project is a prominent reference for research on sensor-equipped wearables to record daily life memories. A prototype

A. Butz et al. (Eds.): SG 2009, LNCS 5531, pp. 290–294, 2009.

records low-resolution still images (in the order of roughly 1,900 per day and user) in regular intervals and upon events inferred from sensor data. It logs data from an accelerometer and an IR sensor. Structuring still image collections here means to find representative keyframes, form groups, and index data by context categories [6,7]. Visual life-logs compiled with this device imply a relatively low data rate in comparison to digital video, so still image-centric frameworks are not *per se* useful when we aggregate > 15 frames per second. Classical video summarization techniques [8,9] again may resort to cut detection in movies for automatic segmentation—which does not hold for continuous video—and typically disregard additional information streams. Kubat et al. (2007) introduce a software tool named *TotalRecall*[1] that facilitiates semi-automatic annotation of large audio-visual corpora [10]. The system aligns recordings from stationary cameras and microphones for semi-automatic labeling. Our focus on experimental algorithm design for more diverse multi-modal logs from wearables may be accomodated with slight adaptations, the functionality is broadly in line with our requirements and goals. However, the tool is reserved for exclusive research as it has not been released to the public.

2 Concept and Implementation

We assess that while a coherent framework with the desired characteristics is not publicly available, most necessary components can be obtained from the open source/public license communities (but different encodings and distinct workflows need to be interfaced for practical applications). Our working hypothesis thus is that we can build a research toolkit with the problem-specific functionality using open software packages that run on a suitable common platform, achieving consistent integration by adequate framework design and data management facilities.

Our development platform of choice is OS X since (a) OS X is fully POSIX-compliant and is among the prime target platforms of open source scientific computing projects; (b) the entire system UI is OpenGL-based and hardware-accelerated; (c) native support for high performance linear algebra operations is given; (d) a complementing focus on interface design issues should acknowledge the prevalent role of OS X platforms in design-related disciplines. The interdisciplinary origin of our software development efforts is elaborated on in another publication [12]. Our Cocoa-based implementation adheres to the model/view/controller paradigm and is written in Objective-C/C++, which allows seamless integration of libraries in the ANSI C or C++ dialects, in our case most notably OpenCV (for feature extraction and analysis), FFmpeg (for video decoding), and the C Clustering Library (for efficient clustering). Python bindings allow quick experiments with a wide range of algorithms from the Python-friendly scientific computing community. An example application shown in Fig. 1 demonstrates the versatility of the Cocoa-based approach, where spatial

[1] Note the (unintended) analogy with our project name *AutoMemento* which was defined independently.

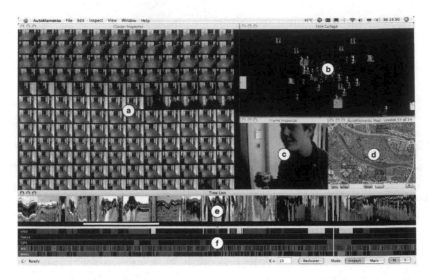

Fig. 1. An already implemented application based on our framework (labeled screenshot): (a) a cluster inspector, (b) a 3-D collage of detected 'faces', (c) a frame inspector, (d) a map inspector, (e) 'liquid' videogram [11] with position indicator, (f) several feature timelines with intermediate clustering results with experimental metrics being tested on HSV, motion vector, and face occurence histograms as well as location; also displaying a meta timeline with merged segments.

coordinates can be easily plotted via the Google Maps API[2]. A *Decoder* reads input data, in the case of video is also accesses raw compressed-domain digital video features (e.g., motion vector fields) and performs color space conversion. The *Indexer* of our framework enables disk-cached random access and encapsulates further feature extraction via a variety of custom *Extractor* classes used to calculate distinct problem-specific types of features from the available information streams. A *Clusterer* partitions the time series with exchangeable *similarity metrics* and constraint sets. It updates timeline visualizations during processing for live progress indication. Timelines and multi-purpose inspection windows are parts of our OpenGL-based UI system that uses a custom scene graph. The *Clusterer* is yet to be complemented by a *FlowAnalyzer* for time series analysis models like HMMs or echo state networks (ESNs) [13] for dynamical pattern recognition.

3 Discussion and Conclusion

The proposed system suits a pattern recognition-centric research domain like life-logging in that it facilitates fundamental tasks like training set annotation,

[2] The map hack assumes an Internet connection, bridges with Javascript within a WebKit view, and is for demo purposes only. NB: The partially occluded logotype in the research prototype screenshot should read Google Inc.

feature extraction, and review of raw data with analysis results. Its architecture and bindings accomodate experimental algorithm design for segmentation and classification of multi-modal streams. Time series of data from various sources (GPS, MEMS devices, IR, audio, but also weather data or incoming personal messages) can be incorporated in the extensible system. The (frame-wise) disk cache-based data management approach allows rapid data access within windows limited primarily by disk space (we experiment with intervals of approximately 30 minutes of continuous video). This places constraints on the time scales that can be considered, so super-sampling schemes have yet to be realized for long-term recordings. Even without that, our software engineering approach already represents a successful enabling step for a range of experiments in multi-modal video analysis. Our current work on dynamical machine learning techniques motivates ESN [13] integration into the framework. Beyond present OpenCV functionality, in future research we also seek to add as feature streams the results of advanced computer vision techniques. These may exploit GPU hardware acceleration for, e.g., fine-grained motion vector estimation, foreground vs. background image segmentation, structure from motion, or ego-motion estimation.

References

1. Bush, V.: As we may think. The Atlantic Monthly 176(1) (7 1945); NB: Illustrations with the mentioned head-mounted camera appear in Life Magazine 11 (1945)
2. Mann, S.: Wearable computing: A first step toward personal imaging. IEEE Computer 30(2), 25–32 (1997)
3. Billinghurst, M., Starner, T.: Wearable devices: New ways to manage information. Computer 32(1), 57–64 (1999)
4. Maeda, M.: DARPA ASSIST. This is an electronic document (Feburary 28, 2005), http://assist.mitre.org/ (retrieved: Mar 18, 2009)
5. Microsoft Research Sensors and Devices Group: Microsoft Research SenseCam. This is an electronic document,
http://research.microsoft.com/sendev/projects/sensecam/
(retrieved: March 18, 2009)
6. Smeaton, A.F.: Content vs. context for multimedia semantics: The case of sensecam image structuring. In: Proceedings of The First International Conference on Semantics And Digital Media Technology, pp. 1–10 (2006)
7. Doherty, A., Byrne, D., Smeaton, A.F., Jones, G., Hughes., M.: Investigating keyframe selection methods in the novel domain of passively captured visual lifelogs. In: Proc. Intl. Conference on Image and Video Retrieval (2008)
8. Lienhart, R., Pfeiffer, S., Effelsberg, W.: Video abstracting. Communications of the ACM 40(12), 54–62 (1997)
9. Ferman, A.M., Tekalp, A.M.: Efficient filtering and clustering methods for temporal video segmentation and visual summarization. Journal of Visual Communication and Image Representation 9(4), 336–351 (1998)
10. Kubat, R., DeCamp, P., Roy, B.: TotalRecall: Visualization and semi-automatic annotation of very large audio-visual corpora. In: ICMI 2007: Proceedings of the 9th international conference on Multimodal interfaces, pp. 208–215 (2007)

11. MacNeil, R.: Generating multimedia presentations automatically using TYRO, the constraint, case-based designer's apprentice. In: Proc. VL, pp. 74–79 (1991)
12. Dickmann, L., Fernan, M.J., Kanakis, A., Kessler, A., Sulak, O., von Maydell, P., Beauregard, S.: Context-aware classification of continuous video from wearables. In: Proc. Conference on Designing for User Experience (DUX 2007) (2007)
13. Jaeger, H.: Discovering multiscale dynamical features with hierarchical echo state networks. Technical Report 10, Jacobs University/SES (2007)

Virtual Reality for Consensus Building: Case Studies

Thea Lorentzen[1], Yoshihiro Kobayashi[2], and Yuji Ito[1]

[1] FORUM8 Co., Ltd., Nakameguro GT Tower 15F
2-1-1 Kamimeguro Meguro-ku Tokyo, Japan 150-0032
[2] Arizona State University
School of Architecture and Landscape Architecture
P.O. Box 871605, Tempe, Arizona, 85287-1605

Abstract. This demonstration presents a real-time virtual reality (VR) system that has primarily been used as a tool for simulating and negotiating transportation-related designs. Visualization creation and presentation methods are briefly described. Case studies include applications to infrastructure, traffic, and environmental planning, as well as evacuation analysis. An emphasis is placed on using VR as a tool for translating technical information to non-experts and, ideally, enabling members of the public to better participate in decision making.

Keywords: VR, transportation visualization, real-time simulation.

1 Introduction

The closer a model can come to appearing real, the less interpretation is necessary. Here we will explore the use of virtual reality as a common visual and experiential language for discussing and improving civil engineering design.

Virtual reality is usually described as a technology that allows users to interact with a simulated world. Leaving the hardware aside, VR can also be defined in terms of human experience, and the sense of being present in an environment [1]. Recent work in transportation visualization is evolving from a focus on how projects look towards a desire to see how they actually work [2]. Particularly when VR is utilized for conveying a sense of presence, an understanding of the nature of movement through and evacuation from public spaces can help demystify large-scale project plans. As transportation infrastructures and environments are shared resources, the goal is to create interactive VR models that are able to not only improve designs, but also lift barriers to non-expert participation in the planning process.

2 Methods

2.1 VR Space Design

The development of a 3D real-time VR software program called UC-win/Road [3] provided the engine and interface for simulation creation. As a first step in

A. Butz et al. (Eds.): SG 2009, LNCS 5531, pp. 295–298, 2009.

creating a virtual environment, terrain data and road alignment design information are imported. Road cross-sectional elements are designed and applied to the road network, and intersections are automatically generated. The 3D space is enhanced by models, textures and the adjustment of visual options such as weather and sun position. Traffic agents are automatically generated on roads and human agents move through space on pre-defined routes. Models can be animated and preparing several 3D data sets allows changes to be shown sequentially.

2.2 Presentation

The VR space can be observed within the software's interface on a desktop PC. Free navigation in real-time allows users to observe the 3D environment from any location and angle. Scripts and scenarios are designed to present planning alternatives and driving situations. Video, image, and sound output are also possible. For basic simulations, vehicles act as intelligent agents and obey traffic rules. Yet when a car is controlled by an external device, the user can drive freely through a road network or scenario, and a responsive VR space enhances the user's sense of presence. Such devices include gaming pads, steering wheels and pedals, and full-size driving simulators.

3 Case Studies

3.1 Large-Scale Infrastructure and Traffic Planning

A 1 x 1 mile square digital model of downtown Phoenix, USA assists urban planning research and provides a platform for interdisciplinary discussion (Figure 1). Buildings are modeled prior to construction, and scenarios can predict, for example, how traffic will build up during future events at the convention center and opera house.

The Daishi Junction project simulated a new interchange and nearby construction on the route between Tokyo and Kawasaki, Japan (Figure 1). Road alignments were input so that the plans could be analyzed for safety from a driver's perspective. Road signs were edited and tested out virtually within the interface in order to improve their placement and visibility in real life.

Fig. 1. Large-scale Infrastructure and Traffic Planning: Digital Phoenix Project by UC-win/Road III [4] *(left)*, Simulation Carried Out at the Daishi Junction and Ventilation Place [5] *(right)*

3.2 Environmental Design

A VR model of Sakai City, Japan is being developed in order to gain consensus for an "Eco-town" urban revitalization project. The visualization includes a reallocation of road space for greener transportation methods including an LRT and bus lines, and pedestrian and bicycle paths (Figure 2). The model is edited for presentation at monthly meetings where citizens can attend and voice their opinions.

Similarly, the Ministry of Water Resources in Shanghai created visualization data to gain approval and grant money for an environmental remediation project in the Yunnan province (Figure 2). A model of the environment as it could look in its natural state helped convince authorities to invest in cleaning up polluted areas.

Fig. 2. Environmental Design: Sakai City Oshoji LRT Project VR Data [6] *(left)*, 3D Exhibition of North Grand Canal Ecological Rehabilitation [7] *(right)*

3.3 Evacuation Analysis

Evacuation visualization was performed to assuage safety concerns prior to the construction of a 6 km long tunnel connecting Qingdao and Huangdao, China (Figure 3). Results from an evacuation analysis program, EXODUS [8], were imported into the VR platform. Evacuation routes and real-time location coordinates were then shown in 3D space to replicate accident scenarios.

Similarly, a reassessment of tunnel infrastructure in Japan has included analyzing and simulating the behavior of different age groups in crisis situations

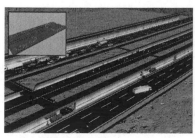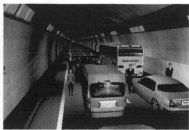

Fig. 3. Evacuation Analysis: Qingdao JiaoZhou Bay Tunnel Project [9] *(left)*, Simulation of an Evacuation in an Aging Society using 3D VR [10] *(right)*

(Figure 3). With a growing elderly population, pedestrian dynamics have shifted and of particular concern is mobility in evacuation. The tunnel environment was created in VR space and safety measures, such as repainting doorways, were proposed to improve the calculated evacuation times.

4 Conclusion

Various kinds of visualization can contribute to designing safer and more sustainable spaces. VR modeling, particularly with its interactive component, can enable non-engineers to understand transportation and environmental plans in a way that might not be possible through more static visual presentation methods.

Acknowledgement

Thank you to FORUM8's Road Support Group, and particularly Sam Marginson and Reid Baker, for their help.

References

1. Steuer, J.: Defining Virtual Reality: Dimensions Determining Telepresence. In: Biocca, F., Levy, M.R. (eds.) Communication in the Age of Virtual Reality, pp. 33–56. Lawrence Erlbaum Associates, Philadelphia (1995)
2. Hughes, R.: Visualization in Transportation: Current Practice and Future Directions. Transportation Research Record: Journal of the Transportation Research Board 1899, 167–174 (2004)
3. FORUM8 Co., Ltd., UC-win/Road (3/20/2009), http://www.forum8.com/
4. Arizona State University, College of Design, Digital Phoenix Project by UC-win/Road III (2009), http://www.digitalphoenix-asu.net/dp/
5. Metropolitan Expressway Company Limited, Kanagawa Construction Bureau, Simulation Carried Out at the Daishi Junction and Ventilation Place (2007) (in Japanese)
6. Osaka University, Graduate School of Engineering, Division of Sustainable Energy and Environmental Engineering, Sakai City Oshoji LRT Project VR Data (2009) (in Japanese)
7. Haihe River Water Conservation Commission, Ministry of Water Resources (China), 3D Exhibition of North Grand Canal Ecological Rehabilitation (2008) (in Chinese)
8. University of Greenwich, School of Computing and Mathematical Sciences, Fire Safety Engineering Group, EXODUS (3/20/2009), http://fseg.gre.ac.uk/
9. Nepoch Consultants, Qingdao JiaoZhou Bay Tunnel Project (2008) (in Chinese)
10. Taisei Engineering Co. Ltd., Simulation of an Evacuation in an Aging Society using 3D VR (2009) (in Japanese)

Author Index